Cardiff

London

Calais
Bruges • Antwerp
Brussels

Cherbourg
Dieppe
Le Havre
Rouen
Plestin-les-
Grèves

Quimper
Pontoise
Concarneau • Quimperlé
Pont-Aven • Le Pouldu
Paris
Saint-Cloud

Saint-Nazaire
Orléans

FRANCE

Bordeaux

Montpellier
Arles
Marseille
Toulon
Cerbère

0 100 150 miles

PACIFIC OCEAN

MARQUESAS ISLANDS
• Hiva Oa

Bora Bora • Tahiti
SOCIETY ISLANDS

Nouméa

OCEAN

Perth

Sydney

Adelaide

Auckland

Melbourne

GAUGUIN'S PORTS OF CALL

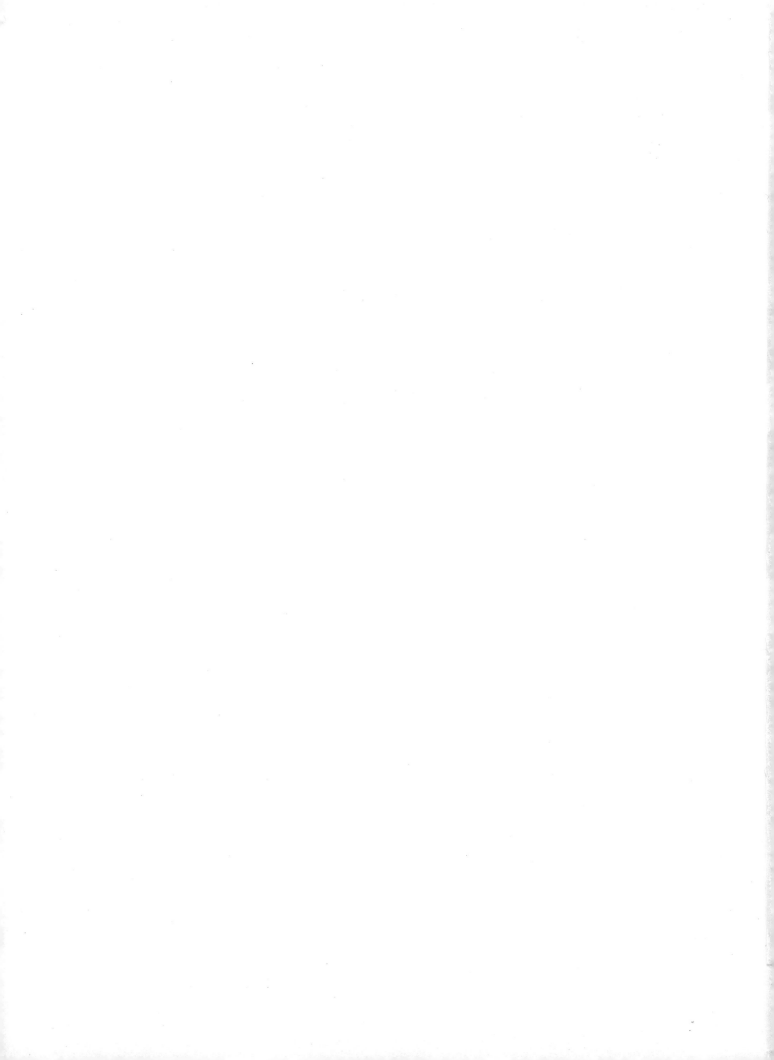

THE LURE OF THE EXOTIC

GAUGUIN IN NEW YORK COLLECTIONS

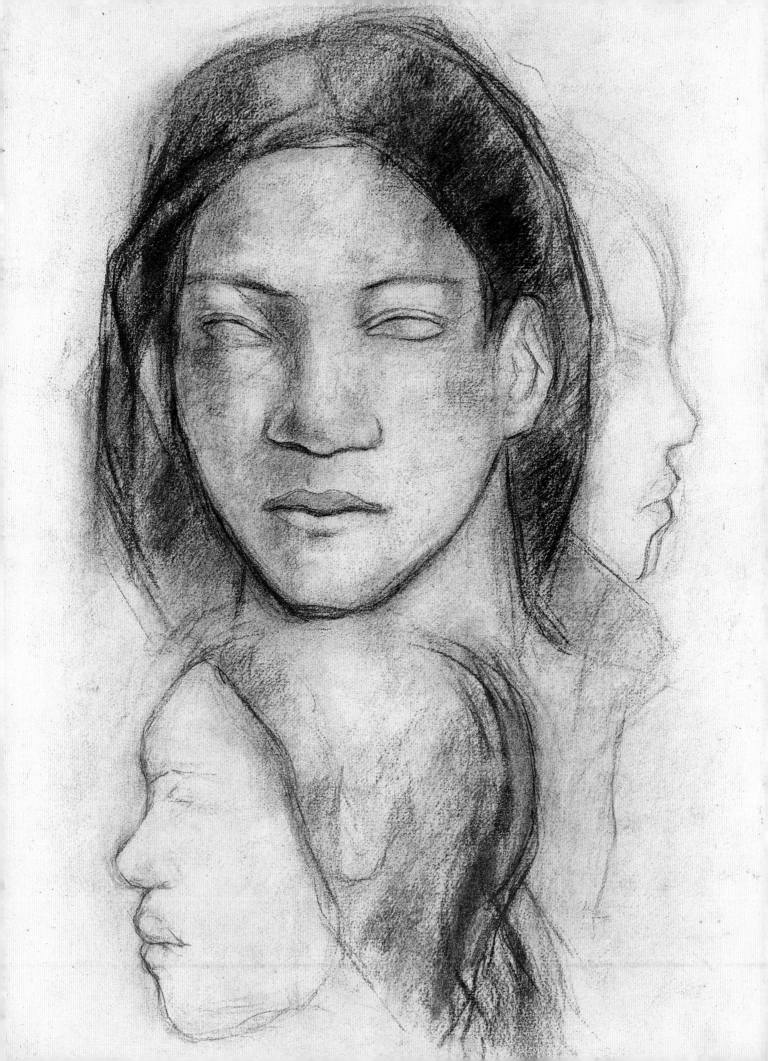

THE LURE OF THE EXOTIC
GAUGUIN IN NEW YORK COLLECTIONS

Colta Ives and Susan Alyson Stein
with Charlotte Hale and Marjorie Shelley

THE METROPOLITAN MUSEUM OF ART, NEW YORK

YALE UNIVERSITY PRESS, NEW HAVEN AND LONDON

This volume has been published in conjunction with the exhibition
"Gauguin in New York Collections: The Lure of the Exotic" organized by
The Metropolitan Museum of Art, New York, and held there from June 18–October 20, 2002.

The exhibition is made possible by ꜱᴜᴇᴢ

The exhibition catalogue is made possible by The Drue E. Heinz Fund

Published by The Metropolitan Museum of Art, New York

John P. O'Neill, Editor in Chief
Carol Fuerstein, Editor
Bruce Campbell, Designer
Gwen Roginsky, Peter Antony, Sally VanDevanter, Production
Minjee Cho, Desktop Publishing
Jean Wagner, Bibliographer

New photography of works in the Metropolitan Museum collection by Mark Morosse, the Photograph Studio,
The Metropolitan Museum of Art.

Typeset in Bodoni Book and Lithos
Printed on 130 gsm R-400
Separations by Professional Graphics, Rockford, Illinois
Printed by Brizzolis Arte en Gráficas, Madrid
Bound by Encuadenación Ramos, S.A., Madrid
Printing and binding coordinated by Ediciones El Viso, S.A., Madrid

New translations from French by Jane Marie Todd

Jacket/cover illustration: cat. no. 61, *Te Au No Areois (The Seed of the Areoi)*
Frontispiece: cat. no. 104, *Tahitian Faces (Frontal View and Profile)*

Library of Congress Cataloging-in-Publication Data

The lure of the exotic: Gauguin in New York collections / Colta Ives . . . [et al.].
 p. cm.
 Includes bibliographical references and index.
 ɪꜱʙɴ 1-58839-061-6 (hc.)—ɪꜱʙɴ 1-58839-062-4 (pbk.)—ɪꜱʙɴ 0-300-09371-3 (Yale)
 1. Gauguin, Paul, 1848–1903—Exhibitions. 2. Art—New York (State)—Exhibitions. I.
Ives, Colta Feller. II. Metropolitan Museum of Art (New York, N.Y.)

N6853.G34 A4 2002
759.4—dc21 2002067751

CONTENTS

SPONSOR'S STATEMENT — vi

DIRECTOR'S FOREWORD PHILIPPE DE MONTEBELLO — vii

LENDERS TO THE EXHIBITION — viii

ACKNOWLEDGMENTS COLTA IVES, SUSAN ALYSON STEIN — ix

NOTE TO THE READER — x

GAUGUIN'S PORTS OF CALL COLTA IVES

 Introduction — 3

 Gauguin in Paris and the Île de France — 13

 Gauguin in Brittany: Pont-Aven, 1886, 1888–90, 1894 — 29

 Gauguin in Martinique, 1897 — 45

 Gauguin in Arles, 1888 — 57

 Gauguin in Brittany: Le Pouldu, 1889 — 65

 Gauguin in Tahiti: 1891–93, 1895–1901 — 77

 Gauguin in the Marquesas: Hiva Oa, 1901–3 — 139

FROM THE BEGINNING: COLLECTING AND EXHIBITING
GAUGUIN IN NEW YORK SUSAN ALYSON STEIN — 151

GAUGUIN'S PAINTINGS IN THE METROPOLITAN MUSEUM OF ART:
RECENT REVELATIONS THROUGH TECHNICAL EXAMINATION
CHARLOTTE HALE — 175

GAUGUIN'S WORKS ON PAPER: OBSERVATIONS ON MATERIALS
AND TECHNIQUES MARJORIE SHELLEY — 197

 Table: Analysis of Certain Materials Found in Gauguin's Works on Paper
 Examined for This Study SILVIA A. CENTENO — 216

Works in the Exhibition — 219

Notes — 227

Bibliography — 237

Index — 241

Photograph Credits — 246

SPONSOR'S STATEMENT

SUEZ, a global services group, active in promoting sustainable development, providing global solutions in energy and water and waste services for businesses, individuals, and municipalities, is proud to sponsor the exhibition "Gauguin in New York Collections: The Lure of the Exotic" at The Metropolitan Museum of Art, New York.

More than four decades have passed since the last major New York exhibition of Gauguin's work. This exhibition of more than a hundred works includes sixty-odd objects from the Metropolitan Museum's collection that will be displayed together for the first time.

Our hope at SUEZ is that this exhibition, drawn from some of the greatest New York collections, will provide insights into Gauguin's work and his life's travels. Not only do the wide-ranging locales he depicted show the global nature of his roaming, but they also influenced his breadth of styles, variously characterized as Impressionist to Post-Impressionist and Synthetist to Symbolist.

SUEZ chose to underwrite an exhibition of works by Gauguin for reasons beyond the artist's aesthetic and cultural achievement. His origins as a European (though he was one-quarter Peruvian) remind us of SUEZ's beginnings as a French and Belgian concern. His extensive travels to distant, less technologically advanced places remind us of our own efforts to bring expertise to widespread areas of the world. And we find in his appreciation for a natural, unspoiled environment a true consonance with our own mandate to assure people in 130 countries of pure water, ample and clean energy, and the swift and ecologically sensitive disposal of waste.

Other reasons we have chosen to sponsor this exhibition are to mark our commitment to the United States, where we have substantial operations and ten thousand employees, and furthermore to celebrate an important series of events for SUEZ in the United States, including notably the listing of our shares on the New York Stock Exchange.

Gérard Mestrallet
Chairman and CEO, SUEZ

DIRECTOR'S FOREWORD

World traveler and aficionado of diverse arts, Gauguin no doubt would have enjoyed seeing his own works positioned among the broad-ranging collections of the Metropolitan Museum. Like many of the most ingenious artists of relatively recent times, from Delacroix in the nineteenth century to Picasso in the twentieth, Gauguin looked far and wide for inspiration. Egyptian tomb painters, temple sculptors of Borobudur and the Parthenon, woodcarvers from the Marquesas, Japanese printmakers, and Peruvian potters all seem to shake hands with Old Masters in the purview of Gauguin's art. As a result, art historians have enjoyed the challenge of puzzling out the artist's far-flung sources, a pursuit nearly as intriguing as the study of the subjects, circumstances, and materials involved in each of his works. Indeed, few artists provide so many pleasurable pathways to follow as does Gauguin, who offers us an adventurous life story, copious writings of genuine literary merit, and a rich production of paintings, drawings, prints, and sculptures of wood and ceramic.

It hardly seems possible that there has not been a major exhibition of Gauguin's work in New York since the retrospective mounted at this museum in 1959. Our present tribute anticipates celebrations that will mark the centennial of the artist's death in 2003 and signals as well the ninetieth anniversary of his debut in New York's art collections. As this volume attests, Gauguin is now superbly represented in many public and private collections of our city and state. It is due to the generosity of these lenders and to the welcome sponsorship of SUEZ that we are now able to experience so fully the daring splendor of his achievement. We are also indebted to The Drue E. Heinz Fund for its contribution toward this catalogue. The organization of the exhibition results from the exceptional efforts of curators Colta Ives and Susan Alyson Stein, who have been joined in the authorship of this publication by conservators Charlotte Hale and Marjorie Shelley.

Philippe de Montebello
Director, The Metropolitan Museum of Art

LENDERS TO THE EXHIBITION

PUBLIC COLLECTIONS

Buffalo, Albright-Knox Art Gallery 22, 42, 64, 111

Hempstead, Hofstra Museum, Hofstra University 2

New York City

 Brooklyn Museum of Art 23, 54, 84

 Solomon R. Guggenheim Museum 53

 The Metropolitan Museum of Art 1, 11, 13, 17, 18, 20, 21, 25–27, 30, 35–37,
 39, 40, 42, 45, 48, 55–58, 62, 65, 66, 68, 71, 74, 76, 78–83, 89, 90, 94, 95, 97,
 101–05, 107, 110, 117–19

 The Pierpont Morgan Library 12, 34, 96, 99, 115, 116

 The Museum of Modern Art 16, 38, 46, 61, 67, 69, 70, 72

Port Washington, Nassau County Division of Museum Services at the Sands Point Preserve 33

Poughkeepsie, Frances Lehman Loeb Art Center, Vassar College 24

Rochester, Memorial Art Gallery of the University of Rochester 75, 77

PRIVATE COLLECTIONS

Richard Adler 15

Mr. and Mrs. Joe Allbritton 28

Robert A. Ellison Jr. 31

Sarah-Ann and Werner H. Kramarsky 43

The Honorable Samuel J. and Mrs. Ethel LeFrak 98, 100

Mrs. Alex Lewyt 49–52, 91

I. Mavrommatis Family 59

Joan Whitney Payson Collection 73

The Henry and Rose Pearlman Foundation Inc. 32, 112

Ms. Marcia Riklis 44

Lawrence Saphire 8

Mr. and Mrs. Herbert D. Schimmel 85

Judy and Michael Steinhardt 47

Mr. and Mrs. Richard M. Thune 106

Malcolm Weiner 7

The Whitehead Collection 60

Anonymous lenders 3–6, 9, 10, 14, 19, 29, 41, 63, 86–88, 92, 93, 108, 109, 113, 114

ACKNOWLEDGMENTS

The present exhibition and the catalogue that accompanies it began as a more modest undertaking but grew in scope and breadth owing to the warm reception that the project received from lenders, from the professional community, and from our colleagues within the Museum. Indeed, so enthusiastic was the response to the concept of the exhibition throughout New York State that we are able to reveal—to an unanticipated extent—the protean nature of Gauguin's achievements in all his media and from virtually all periods of his career. In the first instance, we are immensely grateful to each of the some forty lenders who generously collaborated in this effort (they are listed on page viii in this catalogue); in particular we would like to acknowledge the Albright-Knox Art Gallery, Buffalo, and The Museum of Modern Art, New York, for their outstanding cooperation.

Many friends and colleagues provided indispensable assistance. We are indebted to those who directed us to works of interest, who negotiated loans on our behalf, and who graciously shared with us their resources, expertise, and knowledge. We extend our sincere thanks to: Mark Aronson, William Beadleston, Henrik Bjerre, Carolyn Boyle-Turner, Calvin Brown, Barbara Buckley, Christopher Burge, Rupert Burgess, Aviva Burnstock, Erin Butin, Elizabeth Childs, Carol Christensen, James Coddington, Cara Denison, Lisa Dennison, Benjamin Doller, Douglas Druick, Elizabeth Easton, Inge Fiedler, Richard Field, Michael Findlay, Anne Birgitte Fonsmark, Claire Frèches, Julia Frey, Patricia Garland, Franck Giraud, Gabriel Harnist, Ella Hendriks, Susan Hirschfeld, Ann Hoenigswald, Ay-Whang Hsia, Lucy Ives, Carol Ivory, Adrienne Jeske, Vojtěch Jirat-Wasiutyński, Stephen Kornhauser, Diana Kunkel, Dominique Lévy, Faith Lewis, Kristin Lister, Nicholas Maclean, Maureen McCormick, Lita Ming; Charles S. Moffett, H. Travers Newton, David C. Norman, Robert Parks, Roy Perry, Catherine Puget, Eleanor Rait, Anne Roquebert, Cora Rosevear, Jennifer Russell, Bart Ryckbosch, Nicole Salazar, Polly Sartori, Bertha Saunders, Elizabeth Steele, Harriet Stratis, Anna Swinbourne, Patricia Tang, Melody Clarke Teppola, Frances Terpak, Louis van Tilborgh, Kenneth Wayne, Bogomila Welsh-Ovcharov, Erin Williams, David and Constance Yates, Eric Zafran, Peter Zegers, and Frank Zuccari.

At The Metropolitan Museum of Art, we enjoyed the benefit of working closely with our coauthors, Charlotte Hale and Marjorie Shelley, whose contributions to this undertaking extend well beyond their insightful essays in the present publication. We were also fortunate to have had the capable administrative assistance of Molly Carrott; her dedication and efficiency were a great asset throughout the planning of this project. In addition, we thank Kathryn Calley Galitz for her helpful research assistance. The catalogue was produced under the direction of John P. O'Neill. Carol Fuerstein brought her intelligence, experience, and skill to editing of this publication; she was ably assisted by Margaret Donovan and Joan Holt. The production team of Gwen Roginsky, Peter Antony, and the indefatigable Sally VanDevanter, expertly guided the book into print; additional

thanks are due to Minjee Cho, who handled the desktop publishing. Bruce Campbell created the attractive design, and Jean Wagner meticulously edited the notes and bibliography. Adam Hart, Design Department, was responsible for the map.

Other colleagues at the Metropolitan Museum made significant contributions to the realization of the exhibition: Philippe de Montebello and Mahrukh Tarapor, Director's Office; Everett Fahy, Gary Tinterow, and Rebecca A. Rabinow, European Paintings; Laurence B. Kanter, Robert Lehman Collection; James David Draper and Clare Vincent, European Sculpture and Decorative Arts; Virginia-Lee Webb, Arts of Africa, Oceania, and the Americas; Steven M. Kossak, Denise Patry Leidy, Asian Art; Hubert von Sonnenburg, Lucy Belloli, George Bisacca, Silvia A. Centeno, Alison Gilchrest, Dorothy Mahon; Paintings Conservation; Mark T. Wypyski, Objects Conservation; Yana Van Dyke, Paper Conservation; William S. Lieberman, Modern Art; Linda M. Sylling, Facilities Management; Aileen K. Chuk, Registrar's Office; Jeanie M. James, Archives; Barbara Bridgers, Mark Morosse, and Peter Zeray, Photograph Studio; Kenneth Soehner, Thomas J. Watson Library. The handsome design of the installation and its graphics are the work of Michael Batista and Jill Hammarberg of the Design Department.

Finally, we record our gratitude to SUEZ for its generous funding of the exhibition and to The Drue E. Heinz Fund for its support of the catalogue.

Colta Ives
Curator, Department of Drawings and Prints

Susan Alyson Stein
Associate Curator, Department of European Paintings

Note to the Reader

Titles respect those provided by the artist, when known, and defer to titles given in scholarly books or by owners. Credit lines have been supplied by owners. Listings of media and dimensions are based on direct observation in most cases. Height precedes width in the dimensions. The list of works in the exhibition (pp. tk–tk) provides more complete information than that given in captions to illustrations.

References are abbreviated throughout the catalogue and are provided in full in the bibliography, which also includes material not cited in the text. Catalogues raisonnés and standard references are indicated by the initial letter of the author's name; a key to these abbreviations precedes the bibliography.

Quotations in the catalogue section are from Gauguin's writings unless otherwise noted.

Publications and exhibitions cited in the list of works in the exhibition are limited to standard references and to major shows held in New York.

Full names and life dates of individuals cited in the text, when known, can be found in the index.

THE LURE OF THE EXOTIC

GAUGUIN IN NEW YORK COLLECTIONS

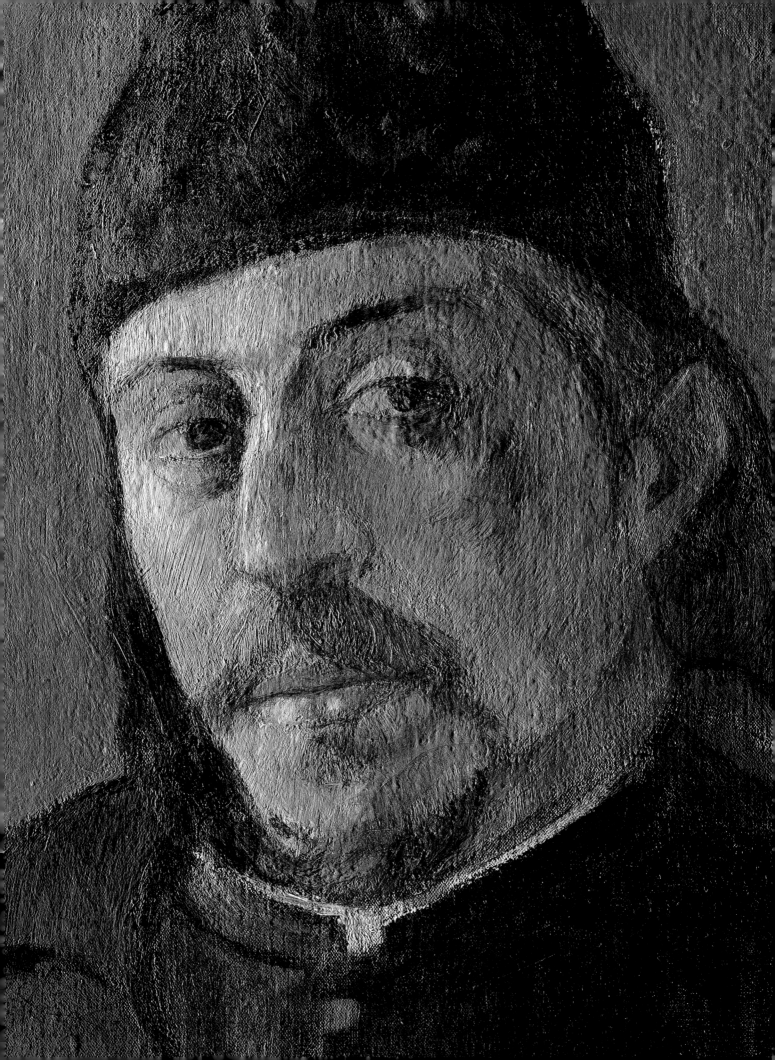

GAUGUIN'S PORTS OF CALL

COLTA IVES

. . . a sailor's eyes, brimming with dreams . . .
Jules Huret, 1891

How safe they are on dry land, those academic painters with their trompe l'oeil of nature.
We alone are sailing free on the ghost-ship, with all our fantastical imperfections.
Paul Gauguin, 1888

In view of the far-flung travels of his youth, Gauguin appears to have been uniquely qualified to become the legendary painter who left his family and a career in finance to live like a native on an island in the South Seas. He began sailing to far-off lands in childhood, when he crossed the ocean from Paris to Peru to stay for five years with relatives. At the age of seventeen he joined the merchant marine and subsequently signed up with the military to call on ports in South America, India, the Mediterranean, the Black Sea, and the North Sea during a span of six years. A decade later, when prospects failed him in Paris, he took to the French provinces of Brittany and Provence, venturing also a brief excursion to Panama and Martinique. Soon afterward he set his sights on the far reaches of Polynesia, returning to France only once after settling in Tahiti. In the end he made his resting place the most distant point from landfall on the globe, the Marquesas Islands.

Originating in, or at least intensified by, his mixed parentage and early, worldwide travel was Gauguin's belief in his difference. Repeatedly, he referred to himself as "a savage" and with considerable pride pointed out his uniquely exotic origins.[1] "If I tell you that by the female's side, I descend from a Borgia of Aragon, viceroy of Peru, you will say that it is not true and I am pretentious."[2] But this was indeed so. And, given the facts that his father was an anarchic journalist and his half-Spanish mother was the daughter of Flora Tristan, an early socialist, labor organizer, and feminist, he could not have been expected to last long as a bourgeois financier. When Gauguin finally discovered his passion for art, he found he had only one course: to create objects and images that, like him, were entirely *different*. He took deep pride in the originality of his work and in the unique artistic identity he also created.

"He's in another world," Camille Pissarro remarked of Gauguin in wonderment.[3] Indeed, it was Gauguin's chief mission to liberate art from the confines of the here and now. He sought to replace the concrete truths of the everyday with the amorphous, subjective reality of imagination and dreams. "I am not a painter who copies nature," he

Opposite page:
Self-Portrait with Palette, ca. 1894 (cat. no. 10, detail). Oil on canvas. Private Collection

3

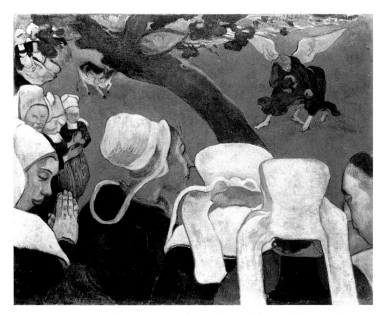

Fig. 1. *The Vision after the Sermon (Jacob Wrestling with the Angel)*, 1888. Oil on canvas, 28¾ x 36¼ in. (72 x 92 cm). The National Gallery of Scotland, Edinburgh

reminded his dealer Ambroise Vollard. "With me everything happens in my crazy imagination."[4] His beliefs cultivated by readings of Baudelaire and the Symbolist poets, Gauguin faulted Impressionists and Neo-Impressionists for having "focused their efforts around the eye, not in the mysterious center of thought."[5] To him the most effective communications bypassed tiresome specifics to reveal universal truths through universal symbols and the immediate stimulation of color and form that excited the mind like the sound of music. However strange his works appeared, their elements were, as he said, "Absolutely intentional! They are necessary, and everything in my work is calculated after long meditation. It's music if you like! I obtain symphonies, harmonies that represent nothing absolutely real in the vulgar sense of the word, [but] . . . should make one think the way music makes one think, without the help of ideas or images, simply by the mysterious affinities between our brains and such arrangements of colors and lines."[6]

Given the diversity and range of Gauguin's art, it is surprising to find that, overall, his efforts were quite programmatic. Even as he boasted of breaking with the artistic currents of his time, he strove to position his work within the mainstream of art history, for much of what he produced was firmly bound to tradition by the very nature of its opposition. In essence, he wished to do what the finest painters of the past had done. "Why," Gauguin asked, "should we follow their example? . . . for the sole reason that they refused to follow anybody else's example. All great artists have always done exactly the same," he explained.

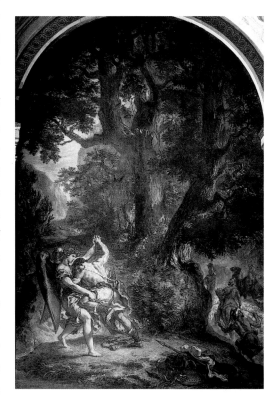

Fig. 2. Eugène Delacroix (French, 1798–1863). *Jacob Wrestling with the Angel*, 1856–61. Oil and wax on plaster, 300 x 194 in. (751 x 485 cm). Church of Saint-Sulpice, Paris

4

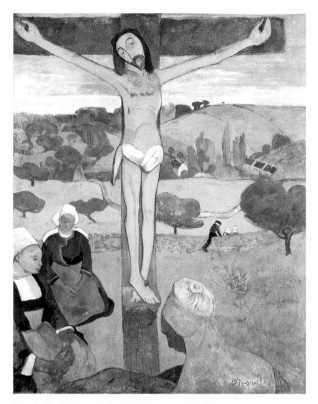

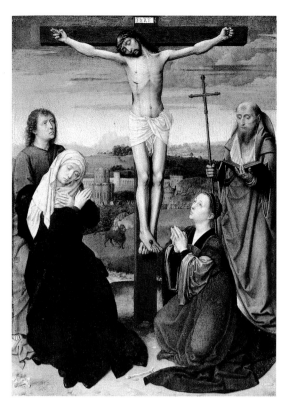

Fig. 3. *The Yellow Christ*, 1889 (cat. no. 22). Oil on canvas. Albright-Knox Art Gallery, Buffalo, New York, General Purchase Funds, 1946 1946:4

Fig. 4. Gerard David (Netherlandish, ca. 1445–1523). *The Crucifixion.* Oil on wood, 21 x 15 in. (53.3 x 38.1 cm). The Metropolitan Museum of Art, New York, Rogers Fund, 1909 09.157

"Raphael, Rembrandt, Velázquez, Botticelli, Cranach, they all distorted nature."[7] Therefore, time and again, just like the old masters, Gauguin took as his subjects the icons of art: gods and goddesses, fabled heroes, and ideal beauties whose images he shattered and then ingeniously re-formed.

In his first radical challenge to convention, the *Vision after the Sermon* of 1888 (fig. 1), Gauguin posed some of the questions that most perplexed him: what is reality? what is imagination? what is the stuff of dreams? This painting of Breton villagers at a wrestling match of the sort that was popular in Brittany imagines the spectators imagining the contest as the biblical one between Jacob and the Angel. Their religious devotion inspires them to transcend reality to reach the more exalted level of spirituality. The Old Testament story in which Jacob himself is uncertain of the distinction between reality and imagination had often been depicted in art, notably in Delacroix's energetic and richly colored mural in the Paris church of Saint-Sulpice (fig. 2), which brings Jacob's dream so vividly to life that one might imagine the combatants to be modern-day wrestlers. Gauguin, we see, turned the dynamic of the illustration around, so that symbolism, rather than realism, drove the picture. "I act a little like the Bible," he later said, "in which the doctrine . . . reveals itself under a *symbolic form* presenting a double aspect: one form which immediately materialized

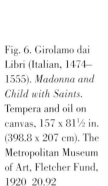

Fig. 5. *Ia Orana Maria (Hail Mary),* 1891 (cat. no. 55). Oil on canvas. The Metropolitan Museum of Art, New York, Bequest of Sam A. Lewisohn, 1951 51.112.2

Fig. 6. Girolamo dai Libri (Italian, 1474–1555). *Madonna and Child with Saints.* Tempera and oil on canvas, 157 x 81½ in. (398.8 x 207 cm). The Metropolitan Museum of Art, Fletcher Fund, 1920 20.92

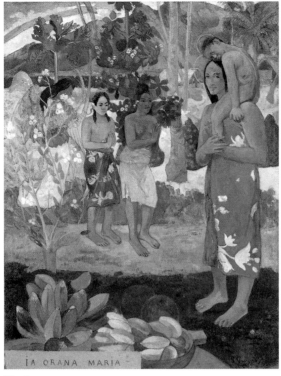

Fig. 5

Fig. 6

the pure Idea in order to render it more sensible . . . and then the second aspect giving its Spirit."[8]

A year after completing the *Vision* Gauguin again painted Breton peasants stirred by imagination and spiritual belief. In the *Yellow Christ* (cat. no. 22; fig. 3) he pictured the carved crucifix that hung in Pont-Aven's Trémolo chapel in a wheat field encircled women praying as if they were mourners at the foot of Christ's cross. The transfer of the wooden icon from the dark, stone chapel to the open-air landscape confused its symbolism with the actuality of the Crucifixion and suggested that its worshipers, in their religious fervor, might now be imagining themselves witnesses to the Crucifixion.

In Tahiti, as in Britanny, Gauguin conveyed the natives' free interpretations of reality, to which they might respond on many different levels. His painting *Ia Orana Maria* of 1891 (cat. no. 55) represents the encounter of two Tahitian women with a mother carrying her child. Inspired by imagination and faith in the teachings of Christian missionaries, they welcome a visionary Madonna and Child, whom they address in the Tahitian words of the picture's title. *"Ia orana"* remains Tahiti's most commonly pronounced salutation, and the women's greeting can be translated as either "Hello Mary" or "Hail Mary," depending upon the strength of one's conviction. Like the tree trunk in the *Vision after the Sermon,* which separates the imagined angel and Jacob from their awed observers, a flowering bush in *Ia Orana Maria* sets apart and even obscures the figure of an extravagantly winged angel. This heavenly presence and the halos of mother and child signal the conversion of the commonplace into the miraculous.

6

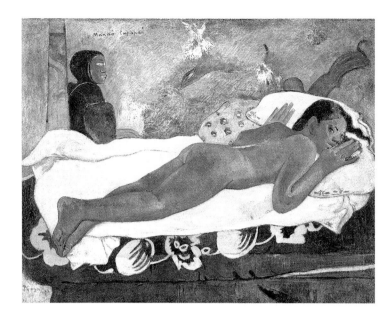

Fig. 7. *Manao Tupapau (Spirit of the Dead Watching)*, 1892 (cat. no. 64). Oil on burlap mounted on canvas. Albright-Knox Art Gallery, Buffalo, New York, A. Conger Goodyear Collection, 1965 1965:1

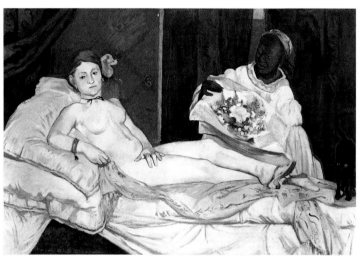

Fig. 8. *Olympia*, after Manet. 1890–91. Oil on canvas, 35 x 51¼ in. (89 x 130 cm). Private Collection

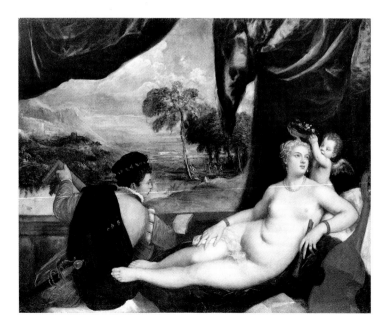

Fig. 9. Titian and Workshop. *Venus and the Lute Player*. Oil on canvas, 65 x 82½ in. (165.1 x 209.6 cm). The Metropolitan Museum of Art, New York, Munsey Fund, 1936 36.29

Fig. 10. *Te Poi Poi (Morning)*, 1892 (cat. no. 73). Oil on canvas. From the collection of Joan Whitney Payson

A more dramatic report of the power of imagination is offered in Gauguin's frightful nighttime vision, *Manao Tupapau (Spirit of the Dead Watching)* (cat. no. 64; fig. 7), in which a Tahitian girl, seeing the glow of shooting stars or phosphorescences, believes herself haunted by spirits. Shown stretched out on a bed and rigid with fear, this young vahine is claimed by Gauguin in his journals to have been his native wife. For the purposes of his painting (and for his writing, too), she embodies the subjective reality of the dreamworld and the ideal of womanhood. Just as Manet had presented *Olympia* as the decadent Old World's Aphrodite, Gauguin now introduced Teha'amana as the innocent New World's Venus.

At the very center of Gauguin's art are his many, often monumental depictions of women and his creative revisions of the traditional female icons: Venus, Eve, the Madonna, and, to a lesser extent, the Old Testament's spied-upon nude bather Susanna (fig. 11). He may be said to have contributed to and thus continued a tradition of perpetual reinvention that went back much further than Titian's curvaceous *Venus* (fig. 9) and sped on to Picasso's fragmented *Demoiselles d'Avignon*. Gauguin was resolute in his role as iconoclast, quickly upping the ante on the tartly painted courtesan in Manet's *Olympia*, which he copied just before leaving France for Tahiti (fig. 8). As his *Ia Orana Maria* revised the nearly twenty-centuries-old theme of the Adoration (see fig. 6) and his *Yellow Christ* restaged the Crucifixion (fig. 4), so *Manao Tupapau* cast anew the Venus of standard mythology.

It is no wonder that Gauguin's contemporaries found his art maddeningly confusing; he was at work on several different fronts at the same time. The "coarse sailor" of Gauguin's self-characterization[9] was not only hugely intelligent but also well read, well traveled, and well versed in the history of art. Inventively, he turned his departure

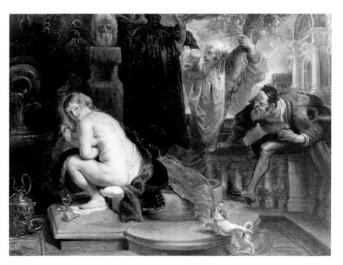

Fig. 11. Workshop of Peter Paul Rubens. *Susanna and the Elders.* Oil on wood, 18¼ x 25⅜ in. (46.4 x 64.5 cm). The Metropolitan Museum of Art, New York, Marquand Collection, Gift of Henry G. Marquand, 1890 91.26.4

from France and physical break with Western culture into an opportunity to supplant old European icons with new, exotic ones. It is fascinating, even amusing, to compare the goddesses and odalisques of older masters (see fig. 13) with their new-fashioned South Seas counterparts. We must take Gauguin at his word that he recognized beauty in the flat-footed, barrel-chested Eves in Polynesia's Garden of Eden.

The complexity of Gauguin's feelings for and relations with women will always be a topic for analysis and speculation. His many amorous attachments and offspring attest that this grandson, son, and husband of strong-willed women was readily bewitched. Dominating the tribe of powerful women in Gauguin's art is the *Oviri*, or *Savage* (fig. 14), which he sculpted in ceramic in 1894, after returning to Paris from his first trip to Tahiti. There are many variants in his work of this nude with ovoid head, copious hair, and arms clasped to her body. Strangely enough, her rather grotesque form appears to descend from Botticelli's *Venus* (fig. 15), a reproduction of which Gauguin had tacked to the wall of his room in Le Pouldu.[10] The artist obviously attached great significance to his ceramic *Oviri*, for he requested that it be placed on the site of his burial. This stocky nude, her massive head and saucerlike eyes resembling those of a South Seas idol, perhaps should be viewed as Gauguin's personal goddess, his vahine Venus. Might he have known that Tahiti, when discovered by Europeans, had been named "New Cythera" after the island of Venus's birth? The fabled shell on which this goddess of love is supposed to have sailed gracefully in to shore does not materialize to support Gauguin's sculpted goddess, who perches awkwardly upon a small block. Beneath her feet lies a dying beast from which she appears to have seized an innocent newborn. If the *Oviri* stands for the power of the "primitive" world to rescue Gauguin from the devouring decadence of the Old World and sustain his rebirth, she is indeed a potent symbol and an appropriate tiki to mark his grave.

After collecting exotic imagery on his first trip to Tahiti, Gauguin settled into a more pensive examination of his situation during the second. This quest for meaning continued to be inspired by the South Pacific but drifted dreamily into farther

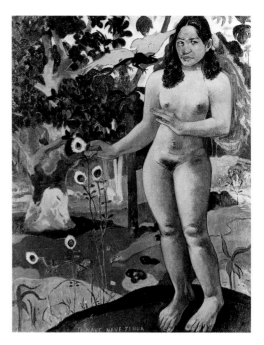

Fig. 12. *Nave Nave Fenua (Delightful Land)*, 1892. Oil on coarse canvas, 35⅞ x 28¼ in. (91 x 72 cm). Ohara Museum of Art, Kurashiki, Japan

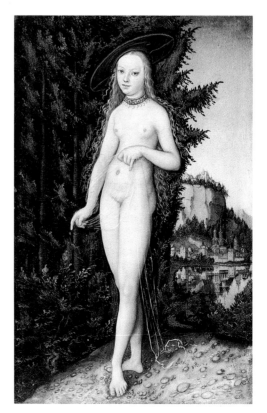

Fig. 13. Lucas Cranach the Elder (German, 1472–1553). *Venus Standing in a Landscape*, 1529. Oil on wood, 15 x 9⅞ in. (38 x 25 cm). Musée du Louvre, Paris

shores of imagination, time, and place. His questions "Where do we come from? What are we? Where are we going?" were inscribed not only literally on the great mural he painted in 1898 but also figuratively on virtually all of his works.

From the beginning to the end of his artistic career Gauguin is seen struggling with family and colleagues, critics, art dealers, and officials of church and state over the forms of his art and the shape of his life. We do not know if such combativeness was brought on primarily by adversity or by the artist's own nature, but, probably, it resulted from both. Gauguin's battles with others, with himself (mind and body), and with the mysterious unknown rumble beneath even his most harmonious creations and supply the frisson of their uneasy charm. The artist seems to have been constantly challenged by art, and the world, and life. There was the ongoing compulsion to create something *original*.

In 1888 Gauguin wrote to his friend Émile Schuffenecker of the "struggles in [his] thoughts," associating them with "bursts of flame . . . from a glowing furnace."[11] And that same year, when he painted Jacob wrestling with an angel, he must have seen the conflict as his own.

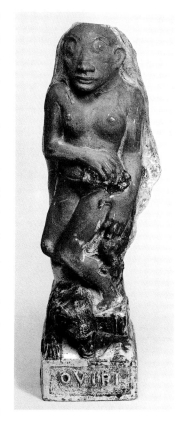

Fig. 14. *Oviri (Savage)*, 1895. Partially glazed stoneware, h. 29⅛ in. (74 cm). Musée d'Orsay, Paris

The profound admiration Gauguin felt for Delacroix seems to have been owed largely to the older painter's triumph on the battlefield of artistic practice. Gauguin praised Delacroix for his "great struggle," how "he tramples . . . natural laws and permits himself to go off in pure fantasy." And, comparing his own battles with those of Delacroix, he wrote, "I enjoy imagining Delacroix having arrived in the world thirty years later and undertaking the struggle that I dared to undertake."[12] Even as he painted the wrestling match between Jacob and the Angel, Gauguin predicted his art would be misunderstood, but he was confident that he would emerge from the fray victorious. "Clearly the path of symbolism is full of dangers, and I have not yet ventured more than the tip of my toe in that direction; but symbolism is fundamental to my nature, and one should always follow one's temperament. I know quite well that I shall be *less and less* understood. But what does it matter if I set

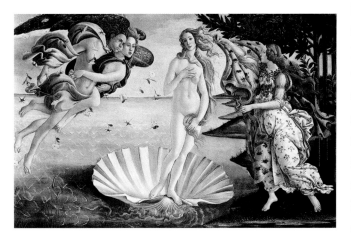

Fig. 15. Sandro Botticelli (Italian, 1445–1510). *The Birth of Venus*, ca. 1485–86. Tempera on canvas, 67⅞ x 109⅜ in. (172.5 x 278.5 cm). Galleria degli Uffizi, Florence

myself apart from other people? For most I shall be an enigma, but for a few I shall be a poet and sooner or later what is good wins recognition. Whatever happens, I tell you that I will manage to do *first rate things,* I can feel it and we shall see. You know very well that where art is concerned I am always basically right."[13]

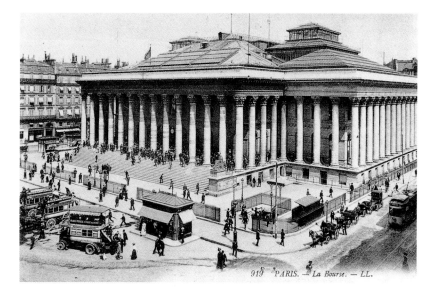

Fig. 16. Stock Exchange, Paris, ca. 1880–90.
Postcard. Research Library, Getty Research
Institute, Los Angeles

Fig. 17. View of the Trocadéro, Exposition
Universelle, Paris 1889. Photograph by
Neurdein Frères. Research Library,
Getty Research Institute, Los Angeles

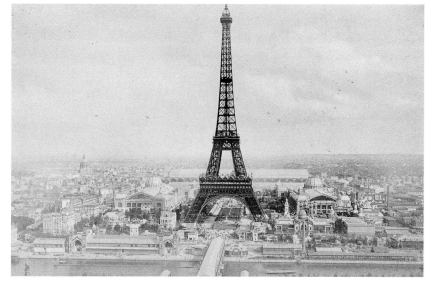

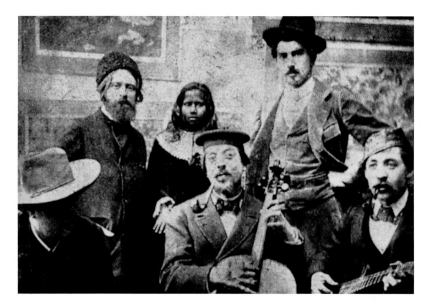

Fig. 18. Left to right: Gauguin (in "Buffalo
Bill" hat), Paul Sérusier, Annah la Javanaise,
Fritz Schnedklud, Georges Lacombe, and
the musician Larrivel in the painter's studio
at 6, rue Vercingétorix, Paris, 1894. Musée
Gauguin, Papeari

GAUGUIN IN PARIS AND THE ÎLE DE FRANCE

Born in Paris, amid the tumult of the 1848 revolution, Gauguin in fact spent very little time in the French capital until he left the military in 1871, at the end of the Franco-Prussian War. His infancy in Lima, Peru, his childhood in the Catholic schools of Orléans, and his youth as a sailor on the high seas could hardly have prepared him for a position in the world of finance. And yet, upon his return to Paris as a young man of twenty-three, this was the work his guardian cut out for him. Gauguin held on to jobs in brokering and banking for more than ten years, when, in the wake of the 1882 stock-market collapse, his prospects as a businessman dissolved. Thereupon ended a decade of stable, bourgeois life, during which he married a Danish wife, Mette, fathered five children, amassed an admirable art collection, and took up Sunday painting. After that, as his life became a series of displacements and endless uncertainties, Gauguin seemed only to pass through the city of Paris, on his way to somewhere else.

Although he made a virtue of his escape from urban life and its "decadence," Gauguin, for a while, was entirely in the city's thrall. His introduction to the Impressionist painters by his guardian, Gustave Arosa, a financier, photographer, and enthusiastic art collector, led Gauguin, too, to buy paintings by Pissarro, Renoir, Manet, Cassatt, and Cézanne. He first exhibited a work of his own in the Salon of 1876, a scant three years after the launch of his self-taught practice. He then showed with the Impressionists in 1879 and thereafter periodically contributed to their presentations, as either an artist or a lender, until their final public group effort in 1886. No doubt to his great satisfaction, he became part of the heady crowd that gathered around Degas at the Café de la Nouvelle-Athènes, and soon he found soul mates among the period's cleverest artists, poets, and writers.

In 1881 Gauguin wrote to Pissarro, the painter who had become his mentor, of his zest for city life: "It's absolutely obligatory to live in Paris to paint, in order to keep up with the ideas."[1] Nevertheless, not more than five years later, as an unemployed and penniless artist, Gauguin found himself perpetually seeking more distant and remote spots where unspoiled scenery and unsophisticated sensibilities could be found in abundance but expenses were fortunately few. To his wife, then returned with their children to her own family's home in Copenhagen, he wrote, "What I want most of all is to flee Paris, which is a wilderness for a poor man. My reputation as an artist is growing day by day, but meanwhile I sometimes go three days without eating."[2] To the end of his days Gauguin maintained contact with his Parisian friends and agents, but after 1885 his visits to the city seem to have been motivated only by his desire to exhibit and promote his art, to explain and extol it, and of necessity to sell it, in order to support the next phase of his journey.

The approbation of Paris, capital of the avant-garde, was crucial to Gauguin, and although he was doomed to disappointment, he courted it doggedly, returning to the city frequently between sojourns in Brittany, Provence, and Martinique. His first significant commercial success came in 1881 with his sale of three painings to Paul Durand-Ruel, the Impressionists' principal dealer. Later he was promoted by Vincent van Gogh's brother, Theo, who, as manager of the gallery Boussod, Valadon et Cie, arranged his showings and sales between 1887 and 1890. A former business colleague and fellow painter, Émile Schuffenecker also proved helpful by finding a spot where he and Gauguin and their friends could mount a group show on the grounds of the 1889 Exposition Universelle. French colonial pavilions at the Paris fair, with their displays from exotic lands, delighted and inspired Gauguin, but he was mortified by the reception received by his own work, which, together with Impressionist and Synthetist pictures, was presented as part of the interior decoration of Volpini's Café des Arts. Months after the reviews were

in he was still distressed: "Of all my struggles this year, nothing remains save the jeers of Paris; even here [in Brittany], I can hear them, and I am so discouraged that I no longer dare to paint."[3]

To Gauguin, Paris was both arena and marketplace. He might experiment with ceramics and printmaking there, but the endless distractions of the city made it difficult for him to paint. For that, he required solitude. Paris was a place for discourse, self-promotion, and business.[4] And, in such matters, there was use to be made of the Paris press. Whenever he was in town Gauguin made a point of airing his opinions and views on the current state of the arts in the pages of *Le moderniste illustré, Mercure de France, Essais d'art libre, Journal des artistes, Le soir,* and *L'écho de Paris.*[5] His return from Tahiti in 1891 became an occasion for a particularly high-pitched campaign resulting in the publication of his largely fictional journal of the trip, *Noa Noa,* and his study of native beliefs, *L'ancien culte mahorie,* mostly cribbed from the studies of an expert.[6] His determination to make his thoughts known to Parisian readers continued right to the end of his life, with desperate but futile attempts to publish further memoirs—efforts launched from his house on stilts in the Marquesas.

Gauguin discovered the graphic arts, as well as the press, to be an effective means of disseminating his ideas and images, beginning with the album of lithographed souvenirs of Britanny, Martinique, and Arles he showed in 1889 at the Exposition Universelle. He renewed his printmaking when he came back to Paris from his first trip to Tahiti by producing the innovative carved woodblock prints of his *Noa Noa* suite and publishing pictures in the periodicals *L'estampe originale, L'épreuve,* and *L'ymagier.*

In the summer of 1893 Gauguin bore home to France the treasures of his South Seas venture: more than forty rolled canvases, which he immediately began to mount in painted frames. Their exhibition at the Galerie Durand-Ruel opened in November of 1893 to mixed reviews. Gauguin's writer-friends greeted the show warmly, but the more common response was puzzlement or even derision. The painter himself seemed pleased that the show "provoked passion and jealousy," but sales barely covered expenses.[7] Undaunted, he continued to seek every possible opportunity to present his work publicly, showing it

over the course of the next two years, for example, at the gallery Le Barc de Boutteville, with the dealer Vollard, at the salon of the Société Nationale des Beaux-Arts, and at the exhibition of La Libre Esthétique in Brussels. In December of 1894 he arranged a week-long exhibition in his own apartment, and, finally, as he had done previous to his first departure for Tahiti, Gauguin arranged a public auction of his work at the Hôtel Drouot. Despite the encouragement of so influential a supporter as Degas, who had purchased three paintings, eight monotypes, and the suite of *Noa Noa* woodcuts in the preceding eleven weeks, most of the offerings went unsold.[8]

All the while Gauguin continued to cultivate a larger-than-life persona like the one he had invented in self-portraits, where he alternately cast himself as a martyred saint or bedeviled sinner. The campaign included the adoption of a braggadocio air and attention-getting costumes. After discovering Brittany, he clomped about Paris attired in an embroidered Breton vest and a pair of wooden clogs. Later he was inspired by an American showman at the Paris Exposition Universelle to top off his outfit with a Buffalo Bill hat (fig. 18). Back from Tahiti he swaggered through town sporting an astrakhan hat, a brass-buttoned cape, and a cane (see fig. 20; cat. no. 13), completing his ensemble with a teenage girl from Ceylon, Annah la Javanaise, and her pet monkey.

However, Gauguin's final appearance in France was, by all accounts, a bitter disappointment. He was able to collect a small inheritance from his uncle but failed to connect with his wife and children. (Mette rejected his invitation for a reunion in Paris; he refused to set foot in Copenhagen.) A six-month visit to Brittany was marred by disaster: first, the fracture of his leg in a dustup with sailors; then, the devastating loss of his lawsuit undertaken to regain the artworks he had left four years earlier in Le Pouldu. The innkeeper Marie Henry successfully claimed the more than thirty works put in her "safekeeping" as payment for her hospitality to Gauguin and his friends.

Although he was said to be egotistical and brash, there was apparently much about Gauguin's company to be enjoyed. He passed long years relatively alone and isolated in Polynesia, but in Paris he seems always to have had about him a large and convivial group of friends. He

attended regular dinners of the Symbolist painters and writers (the Têtes de Bois) and the Tuesday gatherings at Mallarmé's. On Thursdays he held his own soirées in rooms on the top floor of 6, rue Vercingétorix, which he had painted chrome yellow and arrayed with paintings by himself, Cézanne, Redon, and Van Gogh, amid his uncle Zizi's collection of spears, tomahawks, boomerangs, rocks, and shells.[9] There were always welcome-home dinners and farewell banquets, and when he departed for Tahiti the last time, late in June of 1895, his friends saw him off at the station. His busy public activities had left him little time to paint, and barely enough money to set out to sea again, once he realized that in Paris there was nothing further for him to do.

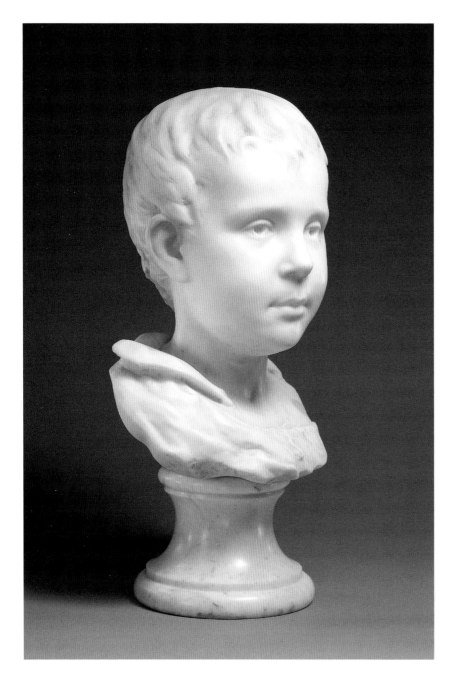

Cat. no. 1. *Emil Gauguin (Born 1874), the Artist's Son, as a Child*, 1877–78
Marble
The Metropolitan Museum of Art, New York, Gift of Joseph M. May Memorial Association Inc., 1963 63.113

I hope that the children are well. . . . It is summer now and you must be with them vacationing in the country. I expect Emil is so busy that he cannot write a few words to his father. At his age, I wrote to my mother whenever I was away and I knew how to find some affectionate words for her. But, there you have it . . . I was raised in another time with less self-concern and a little more heart.

Letter to Mette Gauguin, the artist's wife, from Tahiti,
August 1892; Malingue 1946, no. CXXXI

. . . in the academies and most of the studios . . . they have broken up the study of painting into two categories. First, you learn to draw; then you learn to paint—which amounts to saying that you come back and color within prepared contour lines, more or less like painting a statue after it's been carved. I must say that so far the only thing I've understood in that exercise is that color is nothing more than an accessory.

"Notes Synthétiques" 1884–85; Guérin 1978, p. 10

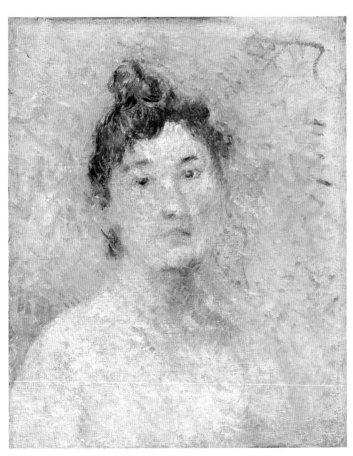

Cat. no. 2. *Portrait of a Woman,* ca. 1880
Oil on canvas
Hofstra Museum, Hofstra University, Gift of Mr. and Mrs. Alexander
Rittmaster HU64.169

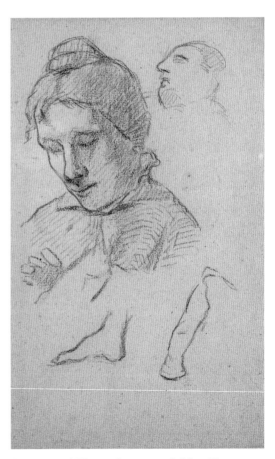

Cat. no. 3. *A Woman Sewing and Other Figure Studies,* ca. 1880
Fabricated black crayon
Private Collection

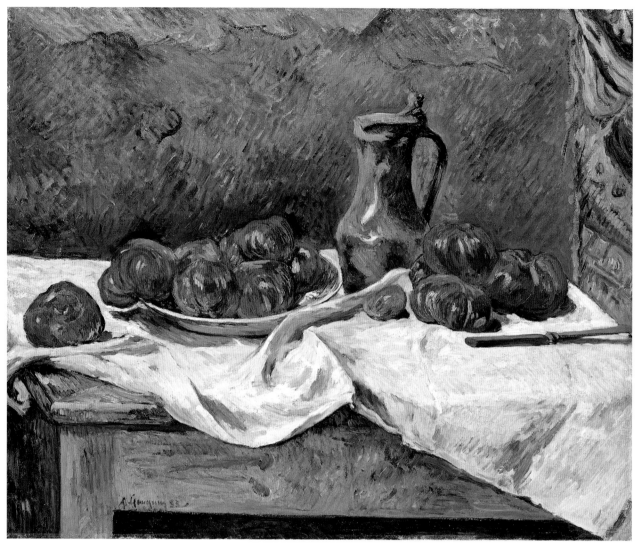

Cat. no. 4. *Tomatoes and a Pewter
Tankard on a Table*, 1883
Oil on canvas
Private Collection

*Colors are still more eloquent than lines, although less dominant, because
of their power over the eye. There are tones that are noble, others that are
common, harmonies that are calm and consoling, others that excite you by
their boldness. . . .*

Letter to Émile Schuffenecker, from Copenhagen,
January 14, 1885; Guérin 1978, p. 4

Work freely and madly; you will make progress and sooner or later people will learn to recognize your worth—if you have any. Above all, don't sweat over a painting; a great sentiment can be rendered immediately. Dream on it and look for the simplest form in which you can express it.
Letter to Émile Schuffenecker, from Copenhagen,
January 14, 1885; Guérin 1978, p. 5

Cat. no. 5. *Portrait of a Seated Man*, 1884
Oil on canvas
Private Collection

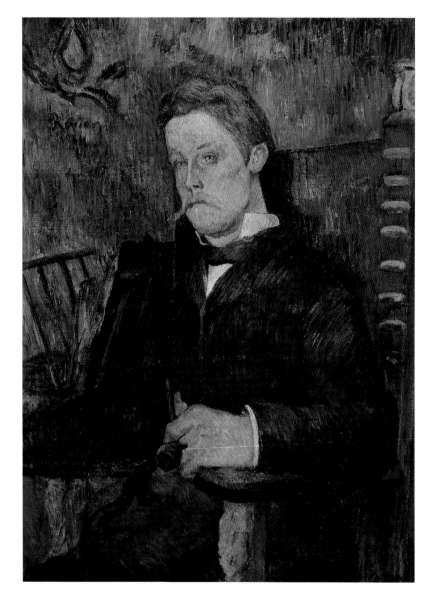

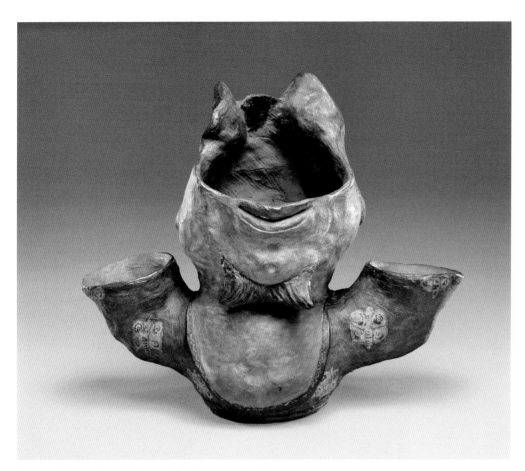

Cat. no. 6. *Vessel in the Shape of a Grotesque Head,*
ca. 1887–88
Polychromed stoneware
Private Collection

M. Bracquemond the engraver has put me in touch with a ceramicist who plans to make some artistic vases. Charmed with my sculpture he begged me to make him some works according to my taste this winter which when sold would be divided half and half. Perhaps this will be something important to fall back on in the future.

Letter to Mette, from Paris, end of May 1886; Malingue 1946, no. XXXVIII

If you are anxious to see all the little products of my folly come out of the oven, they are ready—fifty-five pieces which turned out well—you will certainly howl at these monstrosities but I'm convinced they will interest you.

Letter to Félix Bracquemond from Paris, end of 1886 or early 1887; Merlhès 1984, no. 116

Cat. no. 7. *Portrait of Annette Belfils*, 1890
Conté crayon and red chalk
Malcolm Weiner Collection

Mlle Belfils was to become the wife of Gauguin's most faithful friend
and agent, Daniel de Monfreid.

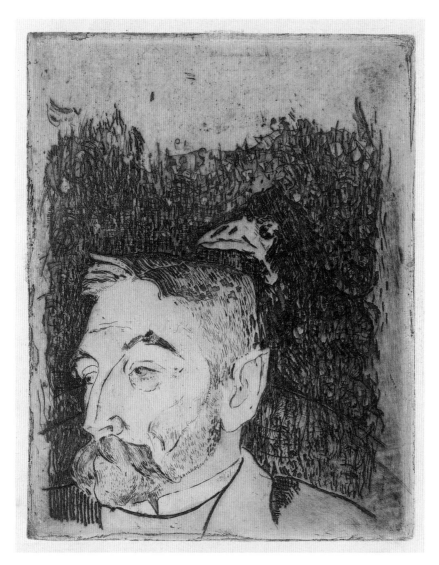

Cat. no. 8. *Portrait of Stéphane Mallarmé*, 1891
Etching, drypoint, and aquatint
Lawrence Saphire

Yesterday a dinner party was given for me with forty-five people present—painters and writers—all presided over by Mallarmé. Little poems and toasts [were given] and the warmest compliments for me.
> Letter to "Mon adorée Mette," from Paris, March 24, 1891; Malingue 1946, no. CXXIII

During the farewell banquet for Gauguin in Paris at the Café Voltaire, Mallarmé's translation of Poe's *The Raven* was recited, as it was again two months later, at a benefit performance in Gauguin's honor of the Théâtre d'Art. Years later, when the artist sent to a friend an impression of his etched portrait of Mallarmé (with a raven perched upon his shoulder), he presented it with a note:

. . . in memory of him [Mallarmé], may I offer you these few hastily sketched lines, a dim recollection of a noble, beloved, clear-eyed face in the darkness. . . .
> Letter to André Fontainas, from Tahiti, March 1899, Malingue 1946, no. CLXX

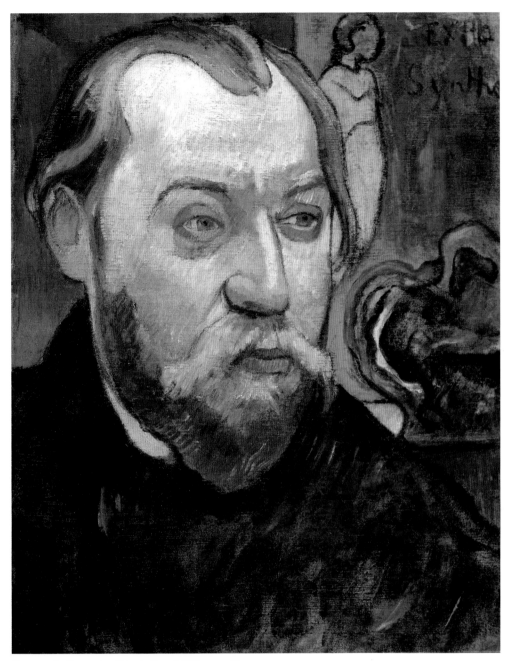

Cat. no. 9. *Portrait of Louis Roy,* 1893 or earlier
Oil on canvas
Private Collection

Louis Roy was one of the eight painters who exhibited with Gauguin at the Café des Arts on the grounds of the Exposition Universelle in Paris in 1889. In the background of this portrait, reference is made to their exhibition by the poster that announced the show of the Groupe Impressioniste et Synthétiste. The portrait was displayed at the Galerie Barc de Bouteville in Paris late in 1893, not long before Gauguin began to carve the *Noa Noa* woodcuts, which Roy helped him to print.

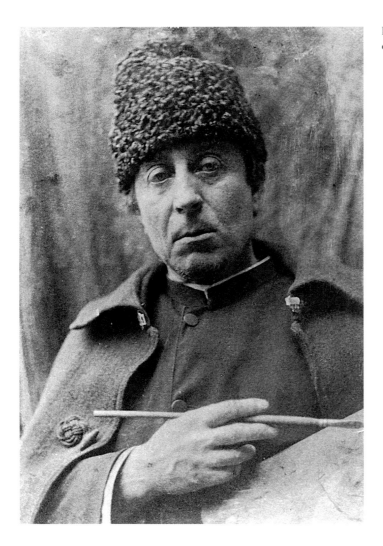

Fig. 19. The artist with his palette,
ca. 1894. Musée d'Orsay, Paris

I know that people will understand me less and less. What does it matter if I become remote from other people; for most of them I'll be a riddle, for a few I'll be a poet, and sooner or later what is good comes into its own.

Letter to Émile Schuffenecker, from Quimperlé, October 16, 1888; Guérin 1978, p. 25

The self-esteem one acquires and a well-earned feeling of one's own strength are the only consolation—in this world. Income, after all—most brutes have that.

Letter to Émile Schuffenecker, from Pont-Aven, August 14, 1888; Guérin 1978, p. 22

. . . what I can say is that today I am one of the artists who astonish people the most. . . .

Letter to Mette, from Le Pouldu, late June 1889; Guérin 1978, p. 27

No one has ever protected me because people think that I am strong and also because I have been too proud.

Letter to Daniel de Monfreid, from Tahiti, April 1896; Guérin 1978, p. 117

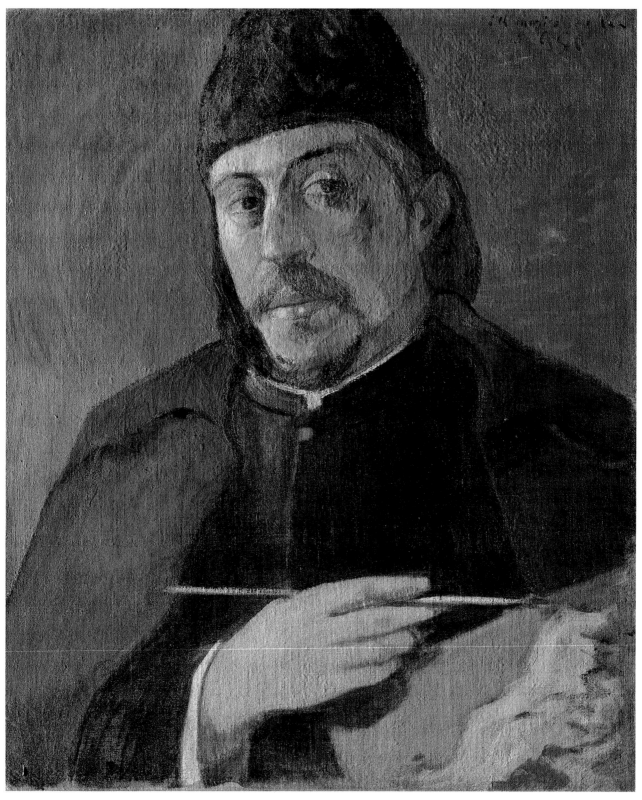

Cat. no. 10. *Self-Portrait with Palette*, ca. 1894
Oil on canvas
Private Collection

Galeries Durand-Ruel

16, RUE LAFFITTE

PARIS

*Monsieur Paul Gauguin
vous prie de lui faire
l'honneur d'assister, le jeudi
9 Novembre, à 2 heures de
l'après-midi, à l'ouverture
de son Exposition.*

Paris, le 3 Novembre 1893.

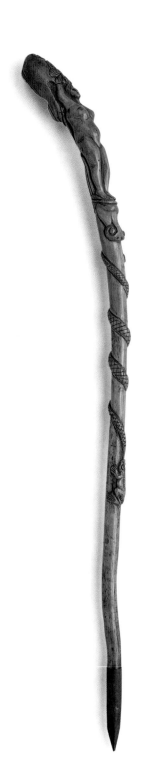

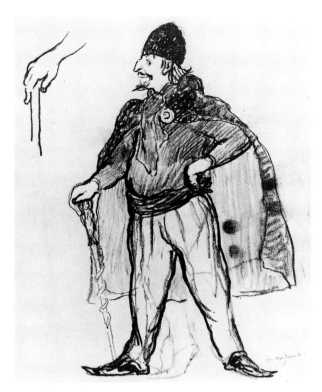

Fig. 20. Manzana Pissarro. *Gauguin with a Cape and Walking Stick Attending His Exhibition at Galeries Durand-Ruel*, November 1893. Black chalk and pastel, 10⅜ x 8¼ in. (26.5 x 21 cm). Private Collection

Cat. no. 13. *Walking Stick with a Female Nude and a Breton Sabot on the Handle*, ca. 1888–92
Boxwood, mother-of-pearl, and iron
The Metropolitan Museum of Art, New York, Bequest of
Miss Adelaide Milton de Groot (1876–1967), 1967
67.187.45a, b

I was whittling one day with a knife, carving dagger handles without the dagger, all sorts of little fancies incomprehensible to grown people. A good woman who was a friend of ours exclaimed in admiration, "He's going to be a great sculptor!"

Memoirs, 1902–3, published as *Avant et après,* 1923

Fig. 21. Breton women crossing the river at the Moulin de Plessis, Pont-Aven, ca. 1890–1900. Postcard. Musée de Pont-Aven

Fig. 22. The Moulin Neuf, Pont-Aven, ca. 1890–1900. Postcard. Musée de Pont-Aven

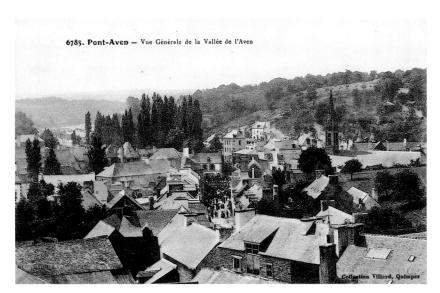

Fig. 23. View of the valley of the Aven River and the village of Pont-Aven, ca. 1890–1900. Postcard. Musée de Pont-Aven

GAUGUIN IN BRITTANY: PONT-AVEN 1886, 1888–90, 1894

Within the ever-lengthening distance that Gauguin put between himself and Paris, his journey to the western peninsula of Brittany counted for much more than the three hundred miles actually traversed. It was in this remote region of France that the shape and content of his art became defined. In the small villages of Pont-Aven and Le Pouldu, Gauguin's pictures turned into moody, downright quirky, creations only loosely tied to distinctive local sights. The shapes of things were exaggerated or crudely simplified, boldly outlined, and filled in with vivid pools of color. The effect was unnerving, more provocative than pleasant, and very far from the pastel patches and dots of Pissarro's and Seurat's painting that Gauguin was glad to leave behind in Paris.

With its rocky coastline jutting out into the rough waters of the Atlantic, "Little Britain" was, in many ways, as far as one could go from Paris and yet still be in France. Historically and culturally detached, its people remained rooted in their Celtic origins, with their own language and costume; even today travel writers speak of superstitious Druidic strains in local customs and beliefs and of the persistent cultivation of regionalism in widespread Celtic clubs.

Although as a child in Peru he had some contact with the Incas and as a sailor visited far-flung ports, there is no clear evidence that Gauguin had any particular interest in exotic or "primitive" cultures until his arrival in Brittany. Once there, however, he seems to have become fascinated with the somber, insular community, its rituals of work and prayer, and the local crafts of wood carving and making painted ceramics, which he, too, ventured to practice.

Gauguin made four or five trips to Brittany between 1886 and 1890, each lasting from two to nine months.[1] He stationed himself first in the village of Pont-Aven, nestled in the valley of the Aven River, where he and his friend Charles Laval joined the parade of artists attracted to the area by charming scenery, cheap living, and a picturesque people willing to pose for and put up with bohemians.

Later, in 1889, Gauguin moved his activity downriver, to the coastal hamlet of Le Pouldu.

The rolling, pastoral landscape of Pont-Aven and its placid villagers' quaint costumes and cottages all entered Gauguin's art immediately, for he regularly set out from his room at the Pension Gloanec in the heart of town to survey the surrounding hills. Brittany's crisp air and bright light seem to have sharpened his focus and intensified his palette. The sheer simplicity of the life he led there must have been a relief and possibly encouraged him to simplify his art. Both the atmosphere and the offering of new subject matter proved invigorating.

By 1888, within the community of artists in Pont-Aven, Gauguin had become something of a celebrity, as his pictures at this date had evolved into imaginative abstractions, strangely vivid and stark. The year was an intensely productive one for Gauguin, one that saw the completion of some seventy-five paintings, many of which showed the influence of the young painter Émile Bernard in their darkly outlined, puzzle-cut forms. It was also the year Paul Sérusier brought back to Paris a small landscape painting he made in Pont-Aven on Gauguin's instruction; entitled the *Talisman* (Musée d'Orsay, Paris), it indeed became the talisman of the next wave of daring artists, led by Bonnard and Vuillard.

With his mystical *Vision after the Sermon* (fig. 1), Gauguin struck a new and resonant chord that announced his disengagement from Impressionism, Neo-Impressionism, and anything else that might have been considered Parisian painting. "This year," he told Schuffenecker, " I have sacrificed everything—execution, color—for style, because I wished to force myself to do something other than what I know how to do."[2] Earlier that year he had announced to his wife, "I have to work seven or eight months straight, steeped in the character of the people and the region they live in, which is essential in order to produce good paintings."[3]

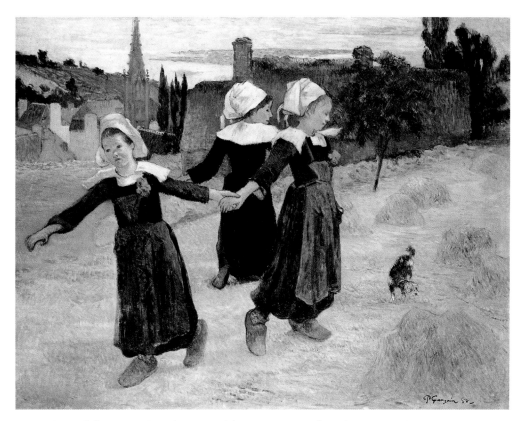

Fig. 24. *Breton Girls Dancing, Pont-Aven*, 1888. Oil on canvas, 28 x 36½ in. (71.4 x 92.8 cm).
National Gallery of Art, Washington

I am working a lot here and successfully too, I am respected as the best painter in Pont-Aven;
it is true that that does not bring me a sou more than before. But it may be paving the way for
the future. At any rate I am acquiring a respectable reputation and everyone here . . . vies for
my advice. . . . This life is not making me fatter; I now weigh less than you. . . . Money problems
discourage me completely. . . .

Letter to Mette, from Pont-Aven, July 1886; Malingue 1946, no. XLII

In Brittany, Gauguin discovered the wellspring of his art: his intense desire to capture the soul of a naive culture. From then on, his steps were guided by this impulse, which carried him to the South Seas twice but returned him to the Breton region for a six-month visit in 1894, between voyages to the tropics, and prompted him to revive motifs from his first Pont-Aven and Le Pouldu paintings. To the far reaches of the Marquesas he carried a snow scene that he had painted of Pont-Aven. After his death, in 1903, it was found propped up on an easel in his rain-forest studio, where it had been placed perhaps to remind him where he had been and how far he had come. "I like Brittany," Gauguin wrote to Schuffenecker from Pont-Aven early in 1888. "Here I find a savage, primitive quality. When my wooden shoes echo on this granite ground, I hear the dull, muted, powerful sound I am looking for in painting."[4]

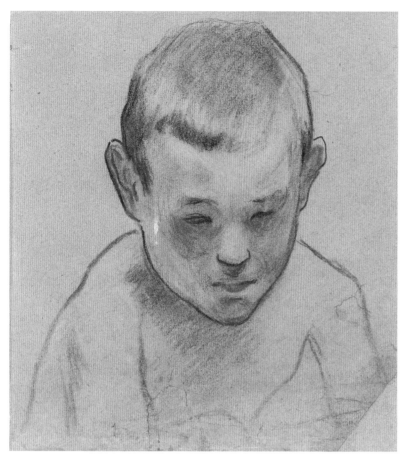

Cat. no. 14. *Head of a Breton Boy,* 1888
Compressed charcoal, red chalk, pastel, and white gouache with touches of graphite
Private Collection

The children Gauguin portrayed in Brittany probably reminded him of his own three sons and his daughter, who were with their mother in Copenhagen. While he was in Paris the painter had made a final, desperate attempt to keep his children by his side:

> *When our son came down with smallpox, I had twenty centimes in my pocket and for three days [we] had been eating dry bread, on credit. Panic-stricken, I thought of asking a company that puts up posters in railway stations to hire me as a bill-poster. My bourgeois look made the manager laugh. But I told him very seriously that I had a sick child and that I wanted to work. So I posted bills for five francs a day; meanwhile Clovis was confined to bed with fever, and in the evening I came home to take care of him. . . . Don't worry about the boy; he's getting better and better and I'm not thinking of sending him to you; on the contrary, as and when my billposting brings in more money, I intend to take some of the other children back. It's my right, you know.*
>
> Letter to Mette, from Paris, about April 25, 1886; Malingue 1946, no. XXXV

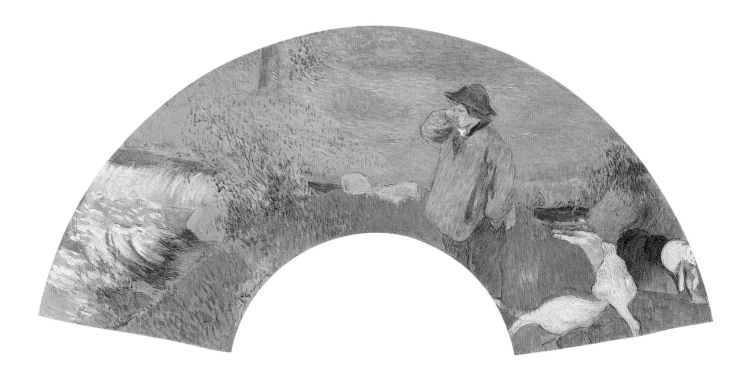

Cat. no. 15. *Design for a Fan: Breton Shepherd Boy,* 1888
Gouache over graphite
Richard Adler

Describing a fan that had been designed by his Impressionist mentor, Camille Pissarro,
Gauguin wrote:

> *There's a charming fan. . . . A simple, half-opened gate separating two very green (Pissarro green)*
> *meadows, and passing through it a gaggle of geese nervously looking about as they ask themselves,*
> *"are we heading toward Seurat's or Millet's?" They all end up waddling off to Pissarro's.*
>
> Memoirs, 1902–3, published as *Avant et après,* 1923; Cachin 1992, p. 183

> *I am unfamiliar with poetic ideas; probably I lack this sense. I find EVERYTHING poetic and*
> *I glimpse poetry in the corners of my heart. These corners are sometimes mysterious to me.*
>
> Letter to Vincent van Gogh, from Pont-Aven, about September 7, 1888; Merlhès 1984, no. 165

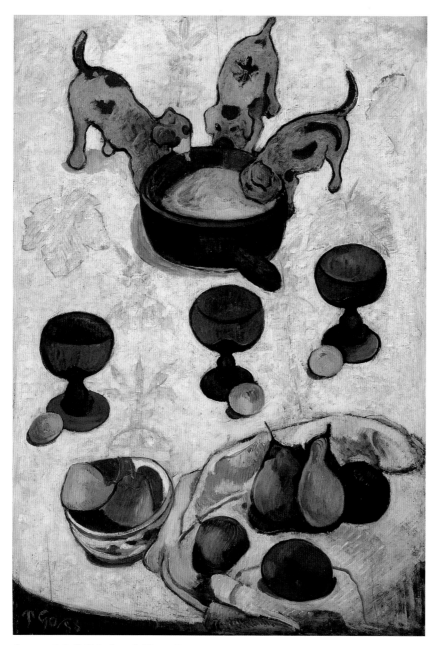

Cat. no. 16. *Still Life with Three Puppies*, 1888
Oil on wood
The Museum of Modern Art, New York, Mrs. Simon Guggenheim
Fund, 1952

This evening, when I have my dinner, the animal in me will be sated but my thirst for art will never
be quenched.
 Letter to Émile Schuffenecker, from Pont-Aven, September 1888; Malingue 1946, appendix, p. 330

In order to practice something new, you have to return to the original source, to the childhood
of mankind.
 Interview with Eugène Tardieu, May 13, 1895; Guérin 1978, p. 110

Cat. no. 17. *The Joys of Brittany*
From the Volpini Suite: *Dessins litho-
graphiques,* 1889
Lithograph on zinc; first edition
The Metropolitan Museum of Art,
New York, Rogers Fund, 1922
22.82.2–11

Cat. no. 18. *A Farm in
Britanny,* probably 1894
Oil on canvas
The Metropolitan Museum of Art, New
York, Bequest of Margaret Seligman
Lewisohn, in memory of her husband,
Sam A. Lewisohn, 1954 54.143.2

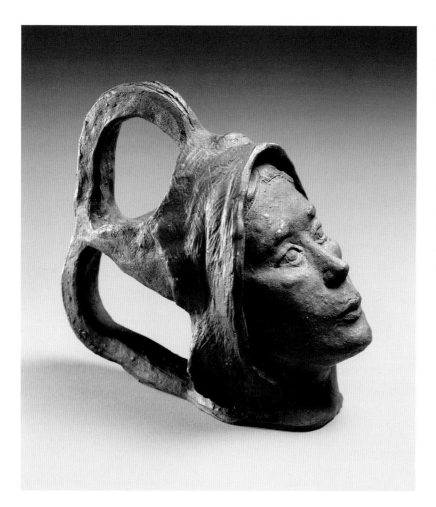

Cat. no. 19. *Vessel in the Form of the Head of a Breton Girl*, 1886–87
Unglazed stoneware decorated with black slip and gold paint
Private Collection

You must remember that there are two temperaments within me, the Indian and the sensitive man. The latter has disappeared, which allows the Indian to proceed straight ahead without wavering.

Letter to Mette, from Paris,
February 1888;
Malingue 1946, no. LXI

In Paris I saw Maury again. . . . He owned a very beautiful collection of vases (Inca pottery). . . . My mother had also kept a few Peruvian vases. . . .

Memoirs, 1902–3, published as *Avant et après*, 1923;
Guérin 1978, p. 237

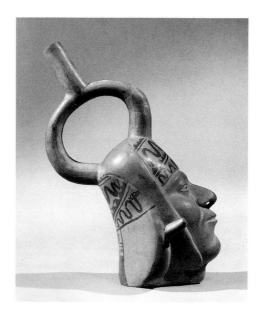

Fig. 25. *Portrait-Head Bottle.* Peru (Moche), 4th–6th century. Ceramic, h. 11 in. (27.8 cm). The Metropolitan Museum of Art, New York, Gift of Nathan Cummings, 1964 64.228.22

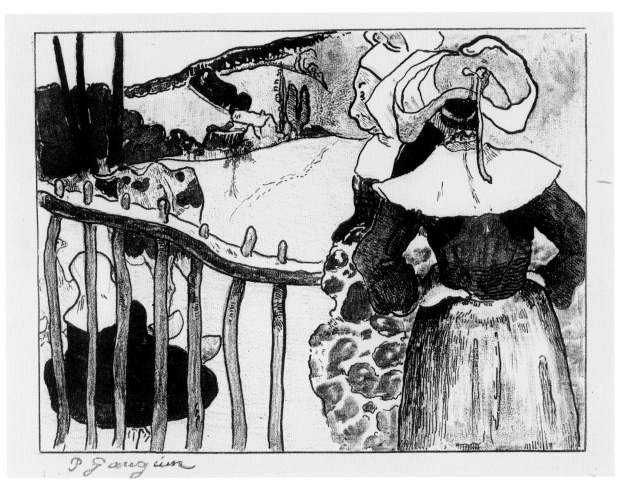

Cat. no. 20. *Breton Women by a Fence*
From the Volpini Suite: *Dessins lithographiques*, 1889
Lithograph on zinc; first edition
The Metropolitan Museum of Art, New York,
Rogers Fund, 1922 22.82.2–2

Ceramics are not futile things. In the remotest times, among the American Indians, the art of pottery making was always popular. God made man out of a little clay. With a little clay you can make metal, precious stones, with a little clay and also a little genius!

"Notes sur l'art à l'Exposition Universelle," *Le moderniste illustré*, July 4 and 11, 1889; Guérin 1978, p. 30

I had glimpsed the possibility of giving the ceramic art new impetus through the creation of new handmade shapes. . . . My goal was to transform the eternal Greek vase . . . to replace the potter at his wheel by intelligent hands which could impart the life of a face to a vase and yet remain true to the character of the material used. . . .

"Une lettre de Paul Gauguin à propos de Sèvres et du dernier four," *Le soir*, April 25, 1895; Guérin 1978, p. 106

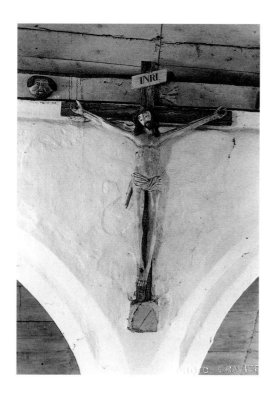

Fig. 26. *Crucifixion.* French,
17th century. Polychromed
wood sculpture, 74½ x 52½ in.
(189 x 133 cm). Trémalo Chapel,
Pont-Aven

Cat. no. 21. *Wayside Shrine in Brittany,* 1898–99
Woodcut executed in Tahiti in recollection of Breton shrine
The Metropolitan Museum of Art, New York, Harris Brisbane Dick
Fund, 1936 36.7.2

Cat. no. 22. *The Yellow Christ,*
1889
Oil on canvas
Albright-Knox Art Gallery, Buffalo,
New York, General Purchase Funds,
1946 1946:4

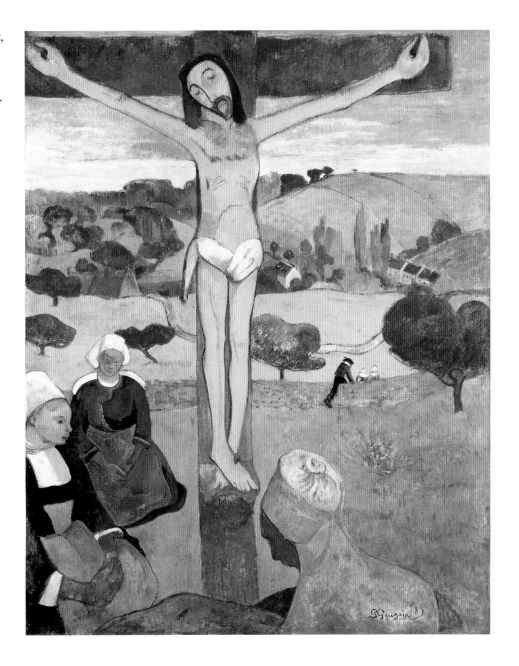

I've done only one religious picture this year. It's advisable to try out all kinds of things from time to
time to keep one's powers of imagination alive, and afterward one looks at nature with fresh delight.
Letter to Vincent van Gogh, from Le Pouldu, [October 20, 1889];
Cachin 1992, p. 142

Cat. no. 23. *("Leda") Design for a Plate: Shame on Those Who Evil Think*
Cover illustration for the Volpini Suite: *Dessins lithographiques*, 1889
Lithograph on zinc with additions in watercolor; proof impression
Brooklyn Museum of Art, Museum Collection Fund 38.116

Cat. no. 24. *Jugs in "Chaplet" Stoneware*, ca. 1887–89
Gouache, watercolor, and charcoal
Collection of the Frances Lehman Loeb Art Center, Vassar College;
bequest of Sarah Hamlin Stern, class of 1938, in memory of her
husband, Henry Root Stern, Jr. 1994.2.1

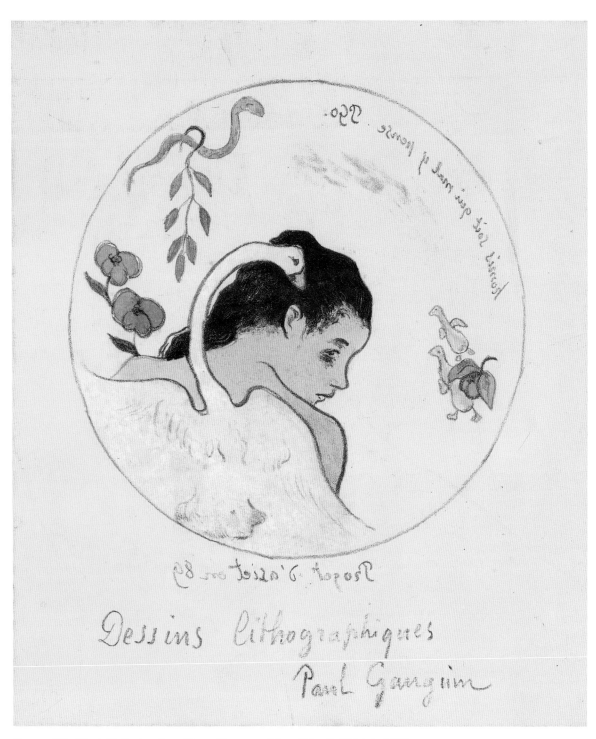

Cat. no. 25. *("Leda") Design for a Plate: Shame on Those Who Evil Think,* 1889
Cover illustration for the Volpini suite: *Dessins lithographiques,* 1889
Lithograph on zinc with additions in watercolor and gouache; first edition
The Metropolitan Museum of Art, New York, Rogers Fund, 1922 22.82.2–1

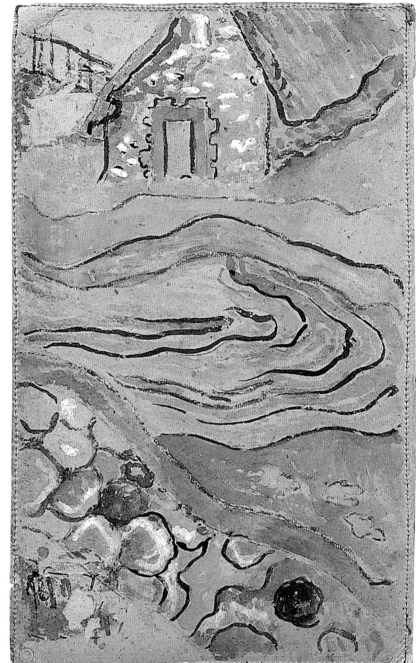

Cat. no. 26. *The Artist's Portfolio, Pont-Aven,* 1894
Two inside covers decorated in watercolor
and gouache over charcoal with graphite;
outer cover bound in leather, inscribed
in pen and ink
The Metropolitan Museum of Art, New
York, Promised Gift of Leon D. and
Debra R. Black, and Purchase, Joseph
Pulitzer and Florence B. Selden Bequests,
and 1999 Benefit Fund, 2000 2000.255

Gauguin returned from Tahiti to France in mid-1893 and passed
the following summer in Britanny. A fractured leg suffered in a
brawl with sailors kept the artist from standing at his easel but
allowed him to produce drawings and prints likely to have been
held in this portfolio. The inscription on the cover records its
mock-heroic presentation to the innkeeper Marie Jeanne Gloanec,
perhaps as the grand finale to a bibulous evening Gauguin spent
with his artist cronies:

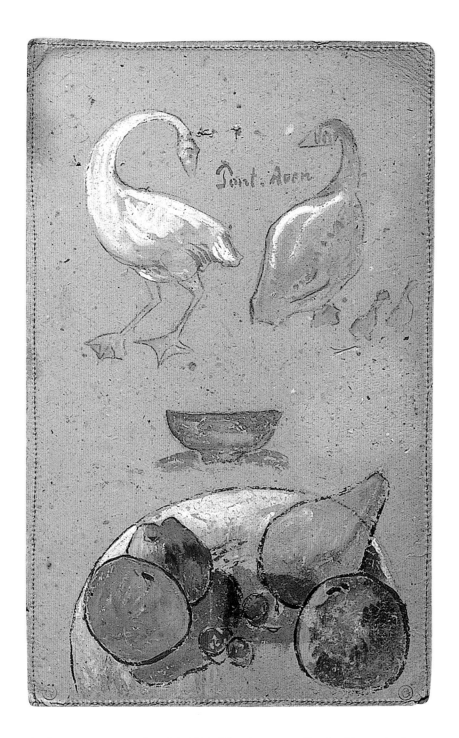

On the FIELD OF ART June 25, 1894. We painters proudly of noble race in the great mysterious book of nature, born Paul Gauguin, known as PGO; born Eric Forbes-Robertson known as the Celt; born Roderic O'Conor; born Seguin, the Jovial have decided [that] from this day forward this book [held] in territory neutral to the literary, pictorial, and musical arts, will collect the thoughts, drawings, and signatures of all those who in good faith associate themselves with our work in order to find themselves once again at the divine source of all harmony; accordingly, we have (PGO) deposited this book, so that it may be preserved from any insult in the hands of Marie (Jeanne) Madame Gloanec in the presence of whom we have signed: Armand Seguin / Eric Forbes-Robertson / Roderic O'Conor / PGO

Fig. 27. Worker's hut, Martinique, ca. 1880.
Research Library, Getty Research Institute,
Los Angeles 95.R.97

Fig. 28. The port, Saint-Pierre, Martinique,
ca. 1870–90. Research Library, Getty
Research Institute, Los Angeles 97.R.50

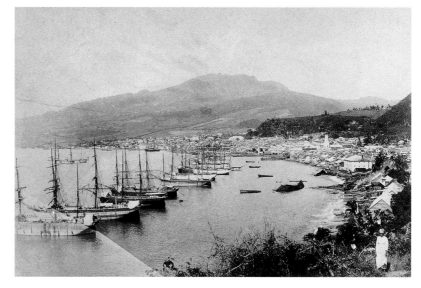

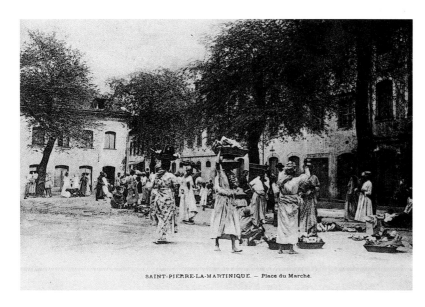

SAINT-PIERRE-LA-MARTINIQUE. — Place du Marché.

Fig. 29. The marketplace, Saint-Pierre,
Martinique, late 19th century. Photograph
courtesy Wildenstein and Co., New York

GAUGUIN IN MARTINIQUE, 1887

Gauguin's five- to six-month sojourn on the island of Martinique in mid-1887 might be considered a dress rehearsal for the trip he made to Tahiti four years later. Both voyages were motivated by the same desire, to find fresh and remarkable sights to inspire art, in a location where living was easy and cost little. In the lush, tropical landscape of Martinique and in the thrall of the island's exotic, dark-skinned women, Gauguin seems to have discovered his calling.

Early in April 1887, accompanied by a young painter-disciple, Charles Laval, whom he had met the previous year in Brittany, Gauguin set out from France destined for Panama, where he hoped his brother-in-law might help him settle. However, this plan (like so many Gauguin naively undertook) proved unrealistic, and he was forced to seek work with the company that was excavating the canal, only to be laid off after a fortnight. When all other efforts to find comfortable circumstances failed, Gauguin and Laval tried their prospects on Martinique, where their ship had set anchor briefly on the voyage out.

In Le Carbet, about two miles from the island's commercial center of Saint-Pierre, the two men found an abandoned hut where Gauguin could in most ways make good his parting words to his wife: "I am off to Panama to live like a *savage*."[1] At some remove from the predominantly white community of the French colony's Little Paris, Gauguin and Laval stationed themselves near the shoreline footpath regularly trafficked by the local *porteuses* who carried crops from the plantations to Saint-Pierre's markets. The comings and goings of these black women, wrapped in colorful skirts and madras scarves, balancing fruit-laden baskets atop their heads, soon became a focus of Gauguin's art. In the roughly fifteen paintings he produced in Martinique the *porteuses* are shown seated, crouching, or striding among the mango trees and coconut palms, sometimes absorbed into the verdant landscape, sometimes silhouetted against expanses of water and sand.

In Martinique, Gauguin must have experienced comforting recollections of his early childhood in Lima, Peru. And, for the first time as an artist, he faced a genuine tropical paradise where the land and its people begged to be painted in all their luxuriance of form, color, sunlight, and shadow. Like Tahiti, Martinique had lost its innocence in waves of colonization, but at a distance from the busy ports it was possible to imagine the island's uncomplicated past.

Had it not been for an attack of dysentery and fever that laid Gauguin low for a month and threatened to worsen, he might have stayed on in Martinique indefinitely. In a letter to Émile Schuffenecker, he imagined a future life there, "my family and me, very agreeably, making, from time to time, a trip to France. [Only] twelve to fourteen days [away] by sea."[2] And to his wife he wrote, "I cannot tell you how enthusiastic I am about life in the French colonies and I am sure that you would feel the same. . . . With only a little money we would have all we needed to be happy . . . and eat like gluttons. . . . I would hope very much to see you here one day with the children—Don't laugh out loud: there are schools in Martinique and whites are pampered as if they were as rare as white blackbirds—Write to me *two times a month*. I embrace you tenderly, also the children—Paul Gauguin [Now] you cannot say that I have written you a disagreeable letter."[3]

Long after he came back to Paris in November 1887, Gauguin continued to refer to this trip not only by repeating the motifs of Martinique in his new paintings, sculptures, and ceramics but also by envisioning his return to the island to realize the Studio of the Tropics that he and Van Gogh imagined: "If I am so lucky, I will go to Martinique; I am convinced that now I will paint beautiful things there. And if I get a large sum I will even buy a house there in which to establish a studio where friends could find an easy life for next to nothing."[4] Even after he decided to make his next voyage one to Tahiti, Gauguin recalled the importance of his earlier journey, "I had a decisive experience in Martinique. It was only there that I felt like my real self, and one must look for me in the works I brought back from there rather than those from Brittany, if one wants to know who I am."[5]

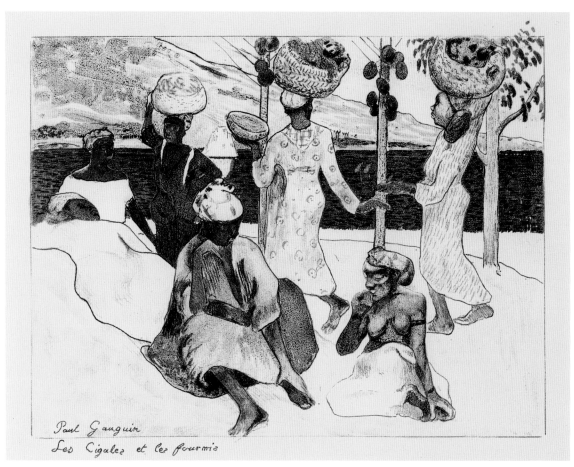

Cat. no. 27. *The Grasshoppers and the Ants:*
A Souvenir of Martinique
From the Volpini Suite: *Dessins lithographiques,* 1889
Lithograph on zinc; first edition
The Metropolitan Museum of Art, New York,
Rogers Fund, 1922 22.82.2–4

We have been in Martinique, home of the Creole gods, for the last three weeks. The shapes and
forms of the people are most appealing to me, and every day there are constant comings and
goings of negresses in cheap finery, whose movements are infinitely graceful and varied. For the
time being I have restricted myself to making sketch after sketch of them, so as to penetrate their
true character, after which I shall have them pose for me. They chatter constantly, even when they
have heavy loads on their heads. Their gestures are very unusual and their hands play an
important role in harmony with their swaying hips.

Letter to Émile Schuffenecker, from Martinique, early July 1887; Merlhès 1984, no. 129

Speaking of Martinique, there's a nice life. If I could only have an outlet in France for 8000 francs' worth of paintings, then we could live here, the whole family, as happy as could be, and I believe you could even find pupils. The people are so affable and gay. . . .
Letter to Mette, from Panama, early May 1887; Guérin 1978, p. 19

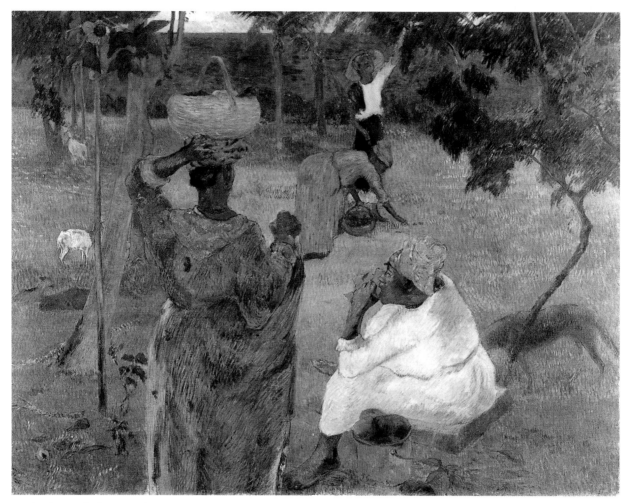

Fig. 30. *Among the Mangoes, Martinique,* 1887. Oil on canvas, 35 x 46 in.

(89 x 117 cm). Van Gogh Museum, Amsterdam

Theo van Gogh purchased this painting from Gauguin about
two months after the artist's return from Martinique and hung
the picture in the Paris apartment he shared with his brother,
Vincent.

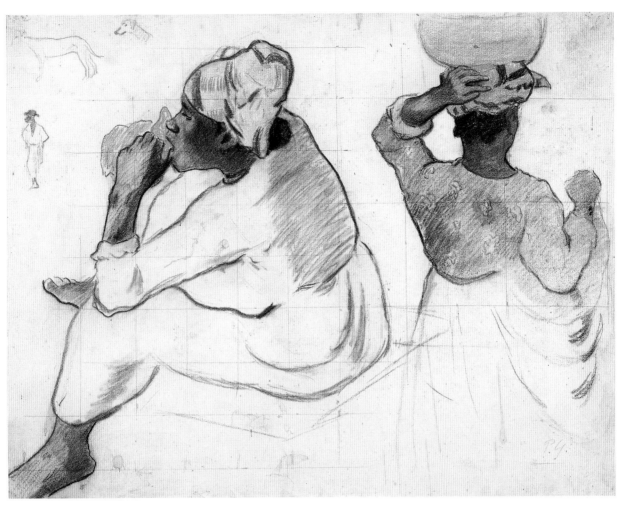

Cat. no. 29. *Martinique Women with Mangoes*, ca. 1887
Black chalk and pastel with touches of watercolor
Private Collection

Right now we are living in a Negro hut and it's a paradise compared to the isthmus.
Below us is the sea, bordered by coconut palms; above us, all kinds of fruit trees. . . .
Negroes and Negresses go about all day with their creole songs and their endless
chatter. . . . Nature is at its richest, the climate is warm but there is intermittent
coolness. . . . We have begun to work and in time I hope to send you some interesting
paintings. . . .
 Letter to Mette, from Saint-Pierre, Martinique, June 20, 1887; Guérin 1978, p. 19

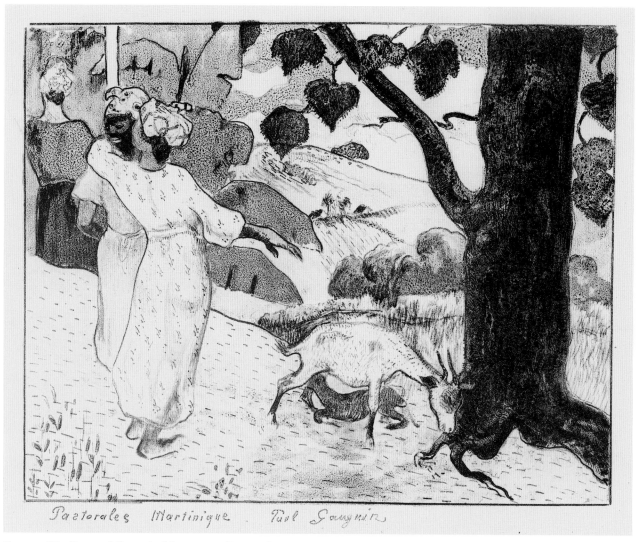

Cat. no. 30. *Pastoral Scene in Martinique (Pastorales Martinique)*
From the Volpini Suite: *Dessins lithographiques*, 1889
Lithograph on zinc; first edition
The Metropolitan Museum of Art, New York, Rogers Fund, 1922 22.82.2–5

Decoration involves so much poetry. Yes, gentlemen, it takes a tremendous imagination to decorate any surface tastefully, and it is a far more abstract art than the servile imitation of nature. . . .

 . . . Let's take a little piece of clay. In its plain, raw state, there's nothing very interesting about it; but put it in a kiln, and like a cooked lobster it changes color . . . the quality of a piece of pottery lies in the firing. . . . So the substance that emerges from the fire takes on the character of the kiln and thus becomes graver, more serious the longer it stays in Hell.

<div align="right">

"Notes sur l'art à l'Exposition Universelle," *Le moderniste illustré*,
July 4 and 11, 1889; Guérin 1978, pp. 30–31

</div>

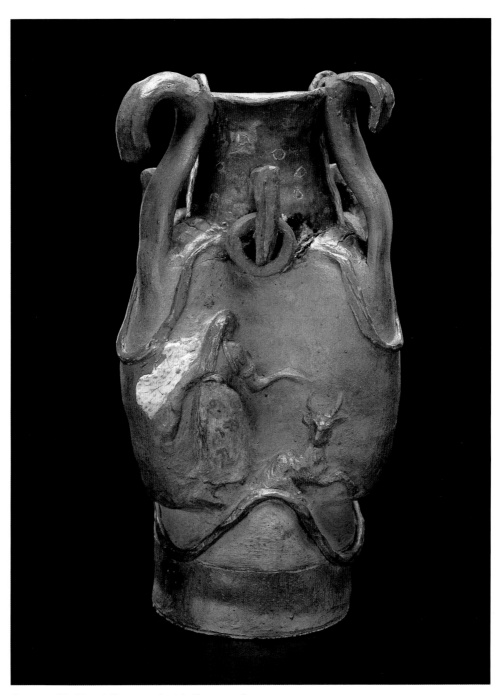

Cat. no. 31. *Vessel Decorated with Goats and
Girls from Martinique*, ca. 1887–89
Stoneware with color glaze and slip
Robert A. Ellison Jr.

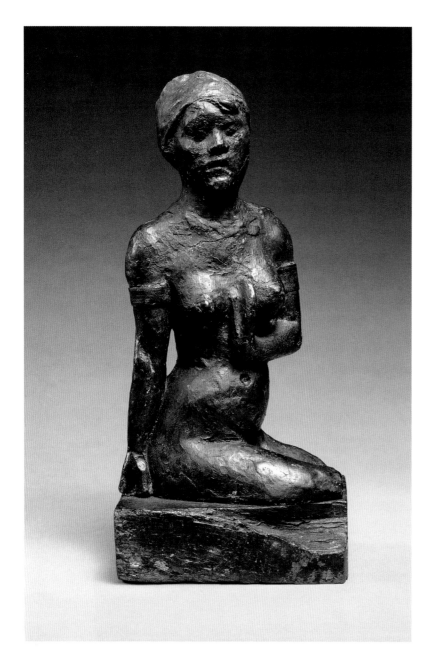

Cat. no. 32. *Statuette of a Martinique Woman*, ca. 1889
Painted terracotta and bronze on a wood base
The Henry and Rose Pearlman Foundation Inc.

. . . a young sixteen-year-old Negress, very pretty indeed, came to offer me a guava split in half and squeezed at one end. I was going to eat it as soon as the girl had left when a native lawyer who happened to be there took the fruit from my hands and threw it away: "You are a European, sir, and don't know the country," he said to me, "one must not eat a piece of fruit unless he knows where it comes from. For example, this fruit has a history: the Negress has squashed it on her breast, and surely you would be in her power afterwards."

Letter to Mette, from Saint-Pierre, Martinique, June 20, 1887; Malingue 1946, no. LIII

Cat. no. 33. *The Black Woman,*
1889
Glazed stoneware
Nassau County Division of Museum
Services at the Sands Point Preserve,
Port Washington, New York

The kneeling woman, who
cradles Gauguin's head in her
lap as if she were Salomé
holding the severed head of
John the Baptist, evokes the
painter's trip to Martinique
and his exposure to majestic
works of Southeast Asian
sculpture.

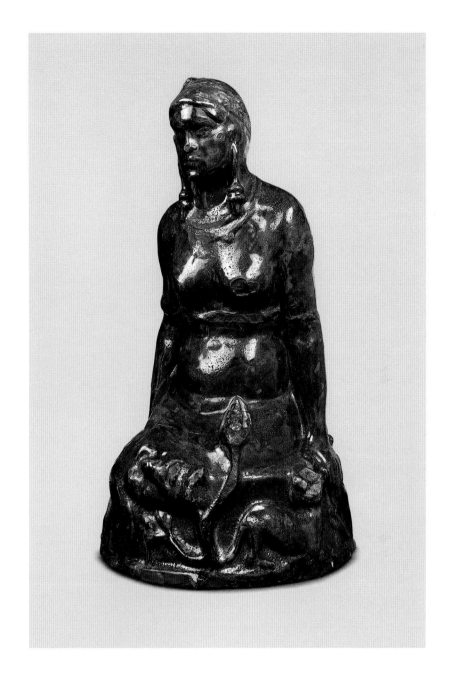

Always keep your eye on the Persians, the Cambodians and to a small extent the Egyptians.
The big mistake is Greek art, no matter how beautiful it is.
Letter to Daniel de Monfreid, from Tahiti, October 1897; Guérin 1978, p. 125

21 Aôut – 1887.

Mon cher Marsouin

Pour répondre à ta lettre absurde il faudrait plaisanter mais je ne suis guère en train. Je sors de la tombe et suis en ce moment à l'état de squelette. Je souffre le martyre depuis un mois dyssenterie maladie de foie et fièvres paludéennes.

Je n'ai plus qu'une chose à faire c'est de rentrer au plus vite en france mais je n'ai pas de quoi payer le bateau ma maladie a épuisé presque toutes nos ressources. Depuis que je suis parti je n'ai pas reçu une seule lettre de Schuffenecker et cependant je lui ai écrit 9 lettres. J'aurais cru après ce que je lui avais écrit qu'il m'aurait envoyé un peu d'argent et je serais parti en même temps que cette lettre. Non je suis condamné ici et naturellement je vais y claquer si je reste !

Laval a des nouvelles de france et c'est dommage j'ai en france une affaire avec de l'argent qui me tirait d'affaire à tout jamais (en Céramique) –

Perds donc l'habitude d'être sur le bord de l'eau regardant quelqu'un se noyer en lui donnant mille conseils. Relis tes lettres c'est toujours ce rôle là que tu joues –

En te crois de l'esprit parceque tu écris à ton père ton ami comme à un serrurier. J'ai reçu ton honorée du Cᵗ.
À propos de commerce Dillies ont écrit en Danemarck

Cat. no. 34. *Letter to Antoine Favre ("le Marsouin"),*
from St. Pierre, Martinique, August 25, 1887
Pen and ink
The Pierpont Morgan Library, New York, Purchased as the
gift of Jack Rudin, in honor of the Morgan Library's Fiftieth
Anniversary, 1974 MA 3272

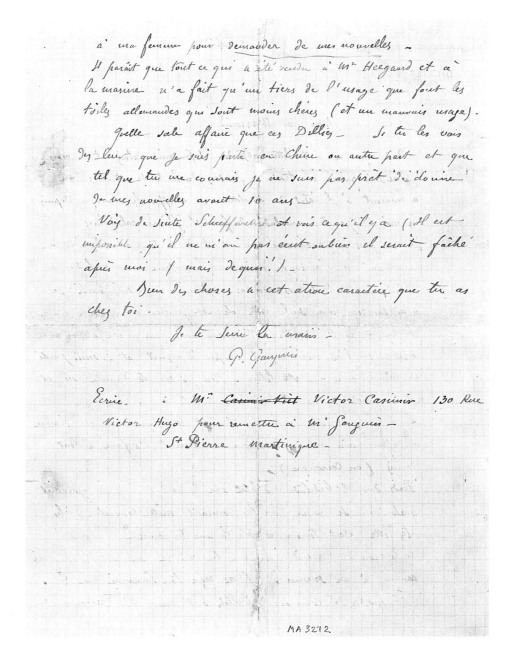

à ma femme pour demander de mes nouvelles –

Il paraît que tout ce qui a été vendu à M^r Heegaard et à
la marine n'a fait qu'un tiers de l'usage que font les
toiles allemandes qui sont moins chères (et un mauvais usage).

Quelle sale affaire que ces Dillies – Si tu les vois
dis leur que je suis parti en Chine ou autre part et que
tel que tu me connais je ne suis pas prêt de donner
de mes nouvelles avant 10 ans –

Vois de suite Schuffenecker et vois ce qu'il y a (il est
impossible qu'il ne m'ai pas écrit oubien il serait faché
après moi – / mais de quoi !) –

Bien des choses à cet atroce caractère que tu as
chez toi.

Je te serre la main –

P. Gauguin

Ecrire : M^r ~~Casimir Vict~~ Victor Casimir 130 Rue
Victor Hugo pour remettre à M^r Gauguin –
St Pierre Martinique –

MA 3272

August 25, 1887 / Dear Marsouin, / To reply to your absurd letter I'd have to make jokes, but I'm hardly up to it. I've just escaped the grave and look like a skeleton at the moment. I've been tormented for a month with dysentery, liver problems, and malarial fever. / There's only one thing for me to do and that's to go home to France as quickly as possible but I don't have the boat fare my illness has drained almost all our resources. Since I've been gone I haven't had a single letter from Schuffenecker and yet I sent him five letters. I'd have thought that after what I wrote him he would've sent me a little money and I could have left at the same time as this letter. No, I'm doomed here and naturally I'll croak if I stay! / Laval has news of France and it's a shame I have some business in France with money that would get me out of trouble forever (in ceramics)— / So drop the habit of standing at water's edge watching someone drown while giving him tons of advice. Reread your letters that's always the part you play in them. . . . / Write to M. Victor Casimir 130 Rue / Victor Hugo / To be forwarded to M. Gauguin / St. Pierre Martinique

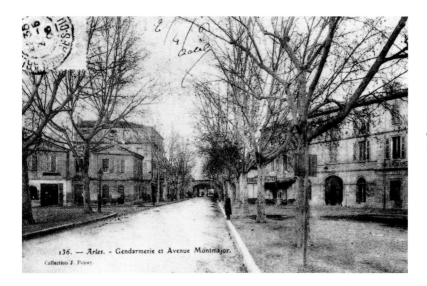

Fig. 31. Gendarmerie and the "Yellow House"
on the Avenue Montmajour, Arles, ca. 1900.
Postcard

Fig. 32. Les Alycamps, Arles, ca. 1890–1900.
Postcard. Photograph courtesy Christie's,
New York

Fig. 33. Washboards along the Roubine du Roi,
Arles, ca. 1900. Postcard

GAUGUIN IN ARLES, 1888

Gauguin met the brothers Vincent and Theo van Gogh late in November of 1887 in Paris, shortly after he returned there from Martinique. Theo, then manager of the gallery Boussod, Valadon et Cie in Montmartre, immediately took an interest in exhibiting Gauguin's work, and soon Vincent and Paul had exchanged mutually admired paintings. Early in 1888 both artists left Paris, Van Gogh to roam the sunny fields and dusty roads of Provence, Gauguin to ponder further the curious backwardness of Brittany.

Unlike Gauguin, who was part of a colony of artists in Pont-Aven, Van Gogh lived and painted in Arles entirely alone. But, with an increasing eagerness to share his activity, Vincent beckoned Gauguin to join him, his request reinforced by his brother Theo's promise to finance the joint venture. The two men (Gauguin aged forty; Van Gogh, thirty-five) spent the nine weeks from October 23 to December 23, 1889, living side by side in four rooms in the Yellow House, painting together, indoors and out, until Vincent's unsettling behavior drove his friend back to Paris.[1]

Van Gogh had hoped that Gauguin would find Arles appealing for the remnants of its ancient Roman past and, as he had Pont-Aven, for its special regional identity. Indeed, the seventeen or so pictures Gauguin painted in Arles focus on local costumes and activities and views of the landscape. But Van Gogh, having already surveyed the area, quickly swept his colleague off to paint with him at his own favorite sites, which must have annoyed Gauguin, who preferred to wander and discover his own motifs, collecting them along the way and by making sketches. It was not his habit to paint in the open air but rather to work in the studio, after his memory had filtered and reconfigured his subject. During his stay he tried, with very little success, to convince Van Gogh of the importance of painting from memory, although Vincent gamely gave it a try, declaring, "Gauguin gives me the courage to imagine things, and certainly things from the imagination take on a more mysterious character."[2] Both temperamentally and in their tastes, the two could hardly have been more different, as Gauguin pointed out: "Vincent and I have little in common, in general, much less in painting. He admires Daumier, Daubigny, Ziem and the great Rousseau, all people for whom I have no taste. On the other hand, he detests Ingres, Raphael, Degas, all of whom I admire. . . . He is a romantic and me, I'm much more disposed toward the primitive."[3]

Although the experience of the Studio of the South ended badly, the weeks he shared with Van Gogh at least confirmed, if not enlightened, Gauguin's estimate of his own artistic strengths and needs. Furthermore, Van Gogh's idea of a Studio of the Tropics helped Gauguin to envision an exotic outpost and himself as the painter in exile who inhabited it. Writing to Schuffenecker from Arles in December 1888, he confided, "Vincent sometimes calls me the man who comes from afar, who will go a long way."[4]

Less than two years after they parted, Gauguin learned of Vincent's death, without surprise. "I am glad you went to his funeral," he told Émile Bernard. "Sad though this death may be, I am not very grieved, for I knew it was coming and I knew how the poor fellow suffered in his struggles with madness. . . . He took with him the consolation of not having been abandoned by his brother and of having been understood by a few artists."[5] Perhaps, as well as anyone, Gauguin knew Van Gogh's demons. When he painted sunflowers he himself had grown in Tahiti in 1899 and again, in 1901, he portrayed their golden heads vividly and with intense feeling, as tributes to Van Gogh's hard-won achievement.

Cat. no. 35. *Human Misery*, 1898–99
Woodcut
The Metropolitan Museum of Art, New York,
The Elisha Whittelsey Collection, The Elisha
Whittelsey Fund, 1952 52.608.1

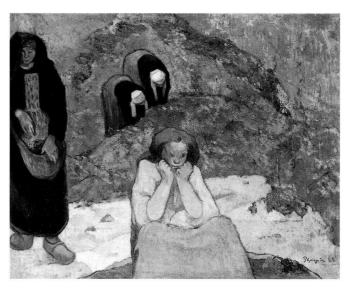

Fig. 34. *The Grape Harvest at Arles (Human Misery)*, 1888. Oil on burlap,
28¾ x 36¾ in. (73 x 93 cm). Ordrupgaard, Copenhagen

Cat. no. 36. *Human Misery*
From the Volpini Suite: *Dessins lithographiques,* 1889
Lithograph on zinc; first edition
The Metropolitan Museum of Art, New York, Rogers Fund, 1922
22.82.2–3

Purple vines forming triangles against an upper area of chrome yellow. On the left, a Breton woman of Le Pouldu in black with a gray apron. Two Breton women bending over in light blue-green dresses with black bodices . . . a beggar-girl with orange-colored hair. . . . It's a study of some vineyards I saw at Arles. I've put some Breton women in it—so much for exactitude. It's the best oil I've done this year. . . .

Letter to Émile Bernard, from Arles, mid-November 1888; Merlhès 1984, no. 179

Cat. no. 37. *Washerwomen*
From the Volpini Suite: *Dessins lithographiques,* 1889
Lithograph on zinc; first edition
The Metropolitan Museum of Art, New York, Rogers Fund, 1922 22.82.2–8

. . . [Théo] van Gogh has just bought 300 francs' worth of pottery from me. So at the end of the month I leave for Arles, where I think I'll stay a long time, since the purpose of my stay there is to make it easier for me to work without worrying about money until he has managed to launch me.

Letter to Émile Schuffenecker, from Quimperlé, October 8, 1888; Guérin 1978, p. 24

Cat. no. 38. *Washerwomen at the Roubine du Roi, Arles,* 1888
Oil on burlap
The Museum of Modern Art, New York, The William S. Paley Collection

. . . Look closely at the Japanese; they draw admirably and yet in them you will see life outdoors and in the sun without shadows. . . . I will move as far away as possible from whatever gives the illusion of a thing, and as shadow is the trompe l'oeil of the sun, I am inclined to do away with it.
Letter to Émile Bernard, from Arles, December 1888; Guérin 1978, pp. 25–26

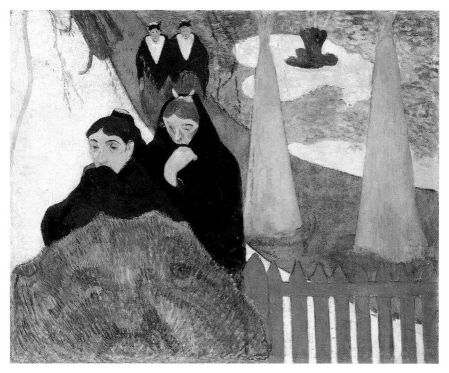

Fig. 35. *Old Women of Arles*, 1888. Oil on canvas, 28¾ x 36¼ in. (73 x 92 cm). The Art Institute of Chicago. Mr. and Mrs. Lewis Larned Coburn Memorial Collection 1934.391

. . . I went to wake Vincent up. The day was given over to settling in, lots of chatter, and strolling about to admire the beauties of Arles and the Arlésiennes (for whom, by the way, I could not work up a great deal of enthusiasm). . . . Several weeks passed before I clearly grasped the sharp flavor of Arles and its environs. We worked steadily nonetheless, especially Vincent. Between the two of us, one a volcano, the other seething, too, but within, a struggle was brewing.

Memoirs, 1902–03, published as *Avant et après*, 1923

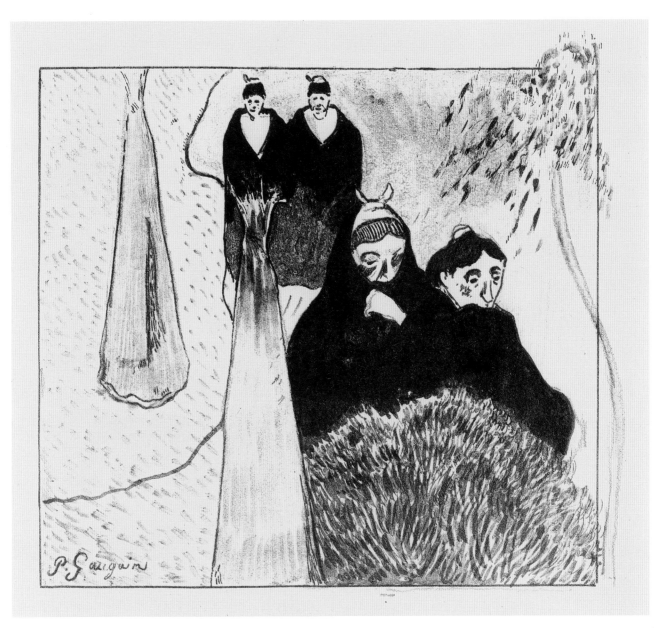

Cat. no. 39. *Old Women of Arles*
From the Volpini Suite: *Dessins lithographiques,* 1889
Lithograph on zinc; first edition
The Metropolitan Museum of Art, New York, Rogers Fund, 1922 22.82.2–10

*It's strange, Vincent sees plenty of Daumier to do here, but I see highly
colored Puvis blended with Japanese. The women here with their elegant
headdresses, their Grecian beauty, and their shawls with pleats like you
see in the early masters, remind one of the processions on Greek urns. . . .
At any rate, here is one source for a beautiful modern style.*
Letter to Émile Bernard, from Arles, late October or
early November 1888; Merlhès 1984, no. 176

499. LE POULDU — La Pointe Pen'Mane aux Grands Sables

Fig. 36. Grands Sables, Le Pouldu, ca. 1890–1900. Postcard. Collection B. Welsh

Fig. 37. Marie Henry's inn, Le Pouldu, ca. 1890. Collection B. Welsh

Fig. 38. Shoreline path near Le Pouldu, 2001

GAUGUIN IN BRITTANY: LE POULDU, 1889

Perched on cliffs at the edge of Brittany, Le Pouldu has a faraway feeling. It has been called Gauguin's "French Tahiti." Unlike Pont-Aven, situated some three miles inland and nestled in fields and woodlands, Le Pouldu abuts the ocean, and its windswept terrain tumbles into the sea.

When Pont-Aven's charming but narrow streets became too crowded for Gauguin at the start of the summer of 1889, he set his sights on the fishing village he had visited earlier, some thirty miles to the east. In late June he moved to the much more desolate Le Pouldu. After a brief stay at the Auberge Destais, he and Paul Sérusier settled into La Buvette de la Plage, built by its innkeeper, Marie Henry, on the road to the beach. Aside from short visits to Pont-Aven and a four-month stay with Schuffenecker in Paris, in early 1890, Gauguin made the inn of Marie Henry his address for the better part of the next year and a half.

Gauguin was soon joined in Le Pouldu by a Dutch painter, Jacob Meyer de Haan, who had been introduced to him by Theo van Gogh. Already established in Holland as an academic painter, Meyer de Haan wished to catch up with the French avant-garde and was willing to pay for Gauguin's tutelage. In the months that followed their meeting, the men painted together in the attic studio of the nearby Villa Mauduit and in Marie Henry's inn, where, with some help from fellow lodgers Sérusier and Charles Filiger, they lavishly decorated the dining room's walls and ceilings with paintings and sculpture.

Today it is possible to visit the inn at Le Pouldu, where reproductions of the now-dispersed decorations give some semblance of the dining room's original madcap splendor. A glimpse of the tiny bedrooms cramped together upstairs evokes the impression of what must have been a close-knit community.

Reflected in Gauguin's work from Le Pouldu is his appreciation for the special features of the local landscape: the wide vistas of pasturelands opening out to the sea, the coastal ravines, white-capped waves, seaweed, and mussel-encrusted black rocks. The bleak scenery seems to have suited the painter's mood and his bitter disappointment at the poor reception of his work in Paris. Complaining to Émile Bernard that he was so discouraged that he could not paint, he wrote, "[I] spend my time dragging my old bones along the beaches of Le Pouldu in the cold North wind."[1]

It was on the windswept sands of Le Pouldu that Gauguin was inspired to plan a voyage to the even more isolated reaches of the island of Tahiti, to which he was evidently attracted as much for its distant location as its exotic nature. Writing to Odilon Redon from Le Pouldu in September 1890, he announced, "My mind is made up, and since I've been in Brittany I've altered my decision somewhat. Even Madagascar is too near the civilized world; I shall go to Tahiti and I hope to end my days there. . . . my art . . . is only a seedling thus far, and out there I hope to cultivate it for my own pleasure in its primitive and savage state. In order to do that I must have peace and quiet."[2]

In the paintings done at Le Pouldu, we find for the first time a marked emphasis on the oriental exoticism that became a potent ingredient of Gauguin's art, as the imported Japanese woodcuts he had encountered in Paris and in the collection of Van Gogh took hold of his imagination, along with impressions of the Javanese and other Far Eastern pavilions at the 1889 Paris Exposition Universelle. Moreover, Gauguin's pupil Meyer de Haan paid his way as a most provocative companion, for the Dutchman's knowledge of Jewish theology and other strains of Eastern religion and philosophy proved spellbinding. The firmer abstraction of Gauguin's imagery and the sometimes inscrutable symbolic content that is encountered in his work from this period are surely the outcome of the artist's exposure to novel sights and stimulating thoughts.

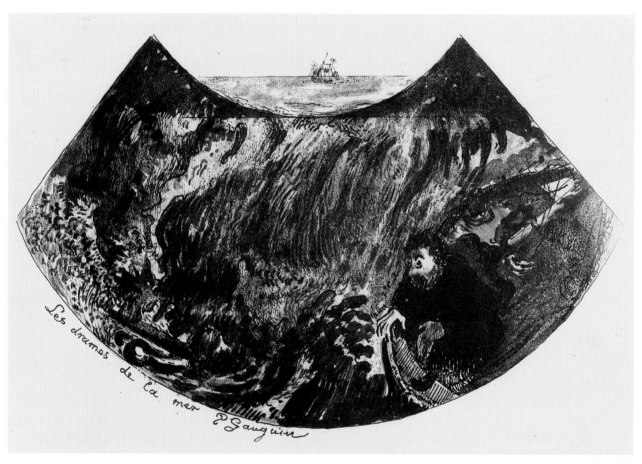

Cat. no. 40. *The Drama of the Sea*
From the Volpini Suite: *Dessins lithographiques,* 1889
Lithograph on zinc; first edition
The Metropolitan Museum of Art, New York,
Rogers Fund, 1922 22.82.2–7

Fig. 39. Sadahide (Japanese, 1807–1873).
The Seaweed Gatherer, ca. 1850. Japanese
fan print, color woodcut. Victoria and Albert
Museum, London

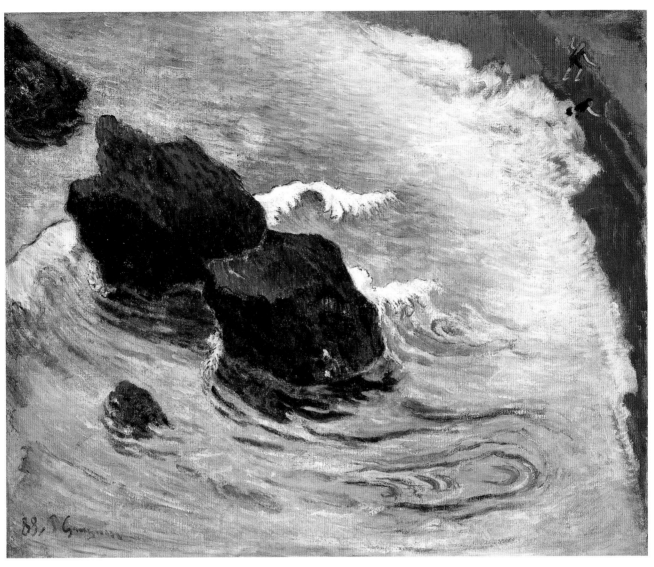

Cat. no. 41. *The Wave*, 1888
Oil on canvas
Private Collection
Photo by Malcolm Varon, N.Y.C. ©2001

It hasn't stopped storming for ten days, the sea is scouring our beach.
Letter to Émile Bernard, from Le Pouldu, 1890; Malingue 1946, no. CVI

. . . A bit of advice, don't copy nature too closely. Art is an abstraction; as you dream amid nature,
extrapolate art from it and concentrate on what you will create as a result.
Letter to Émile Schuffenecker, from Pont-Aven, August 14, 1888; Guérin 1978, p. 22

I am by the seaside in a fishermen's inn near a village that has a hundred and fifty inhabitants; there I live like a peasant, and am known as a savage. And I have worked every day wearing [a] pair of duck trousers (all those I had five years ago are worn out). I spend a franc a day on my food and two sous on tobacco. So I can't be accused of enjoying life.

Letter to Mette, from Le Pouldu, late June 1889; Guérin 1978, p. 27

Cat. no. 42. *The Drama of the Sea, Britanny*
From the Volpini Suite: *Dessins lithographiques,* 1889
Lithograph on zinc; first edition
Watercolor added by hand
Albright-Knox Art Gallery, Buffalo, New York, Gift of ACG
Trust, 1970 P1970:1.24

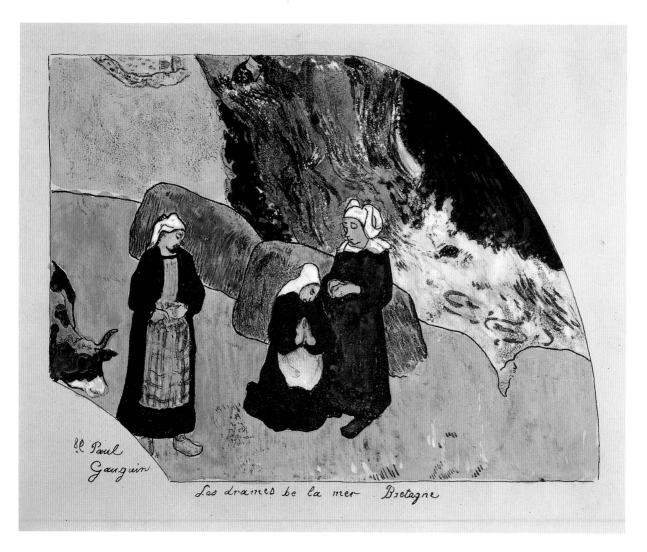

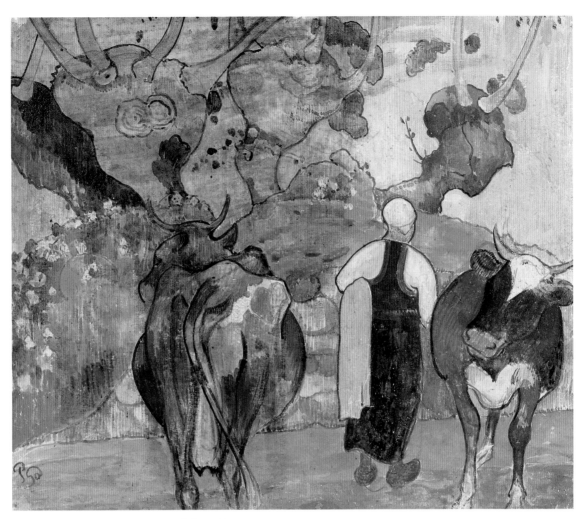

Cat. no. 43. *Peasant Woman and Cows in a
Landscape,* 1889–90
Watercolor and gouache over a white ground
Sarah-Ann and Werner H. Kramarsky

*What I've concentrated on this year is simply peasant children strolling unconcernedly along the shore with
their cows. . . . I'm trying to put into these dreary figures the wildness I see in them, which is in me, too. There
is something medieval looking about the peasants here in Brittany; they don't look as though they suspect for a
moment that Paris exists or that it's 1889. . . . Here everything is as rugged as the Breton language, closed tight
(forever, it seems). Their apparel, too, is little short of symbolic, influenced by the superstitions of Catholicism.
Look at how the bodice forms a cross in back, how they wrap their heads in black headscarves, like nuns. It
makes their faces look almost Asiatic—sallow, triangular, dour. . . . As I look at this every day, I suddenly
sense the struggle to survive, a sadness, a submission to wretched laws [of nature].*

Letter to Vincent van Gogh, from Le Pouldu, ca. December 12–13, 1889;

Cooper 1983, nos. 36.2, 36.3

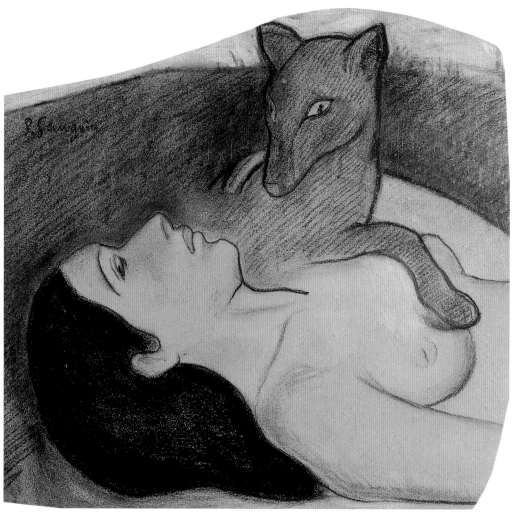

Cat. no. 44. *Girl with a Fox,* ca. 1890–91
Conté crayon, white pastel, and red chalk over graphite
Ms. Marcia Riklis

. . . when all the main joys of existence are beyond my reach and intimate satisfaction is lacking, my isolation and my concentration on myself create a kind of hunger, like an empty stomach; and in the end this isolation is an enticement to happiness.
Letter to Émile Bernard, from Le Pouldu, November 1889; Malingue 1946, no. XCL

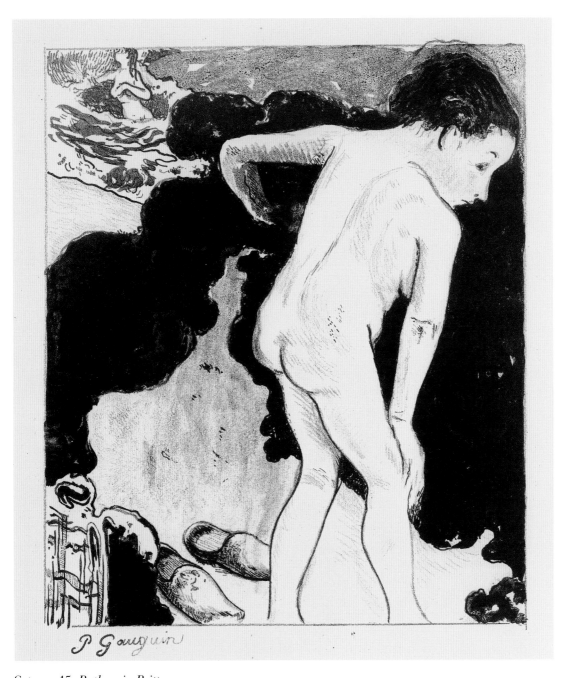

Cat. no. 45. *Bathers in Brittany*
From the Volpini Suite: *Dessins lithographiques*, 1889
Lithograph on zinc; first edition
The Metropolitan Museum of Art, New York, Rogers Fund, 1922 22.82.2–9

I have just done several nudes that you will like. And they're not Degas at all.
The last one, though done by a savage from Peru, is altogether Japanese.
Letter to Émile Schuffenecker, from Pont-Aven, July 8, 1888; Guérin 1978, p. 22

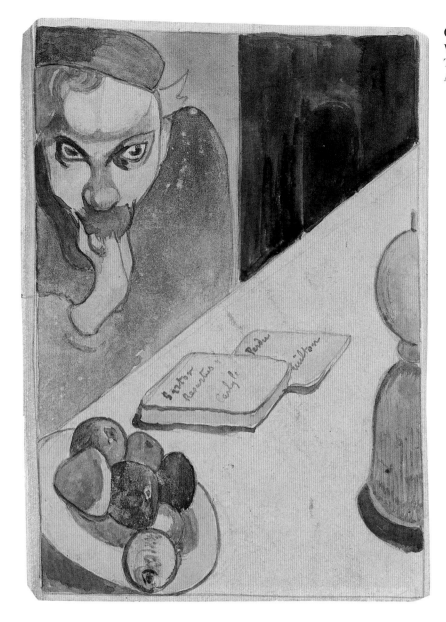

Cat. no. 46. *Jacob Meyer de Haan*, 1889
Watercolor, graphite, and ink
The Museum of Modern Art, New York, Gift of
Arthur G. Altschul 699.76ab

I do not know who could have told you I walked along the beach with my disciples. So far as
disciples are concerned, there is de Haan who goes off to work by himself, and Filiger who
works at the house. As for me I walk about like a savage with long-hair and do nothing. . . .
I made a few arrows and exercise by shooting them on the beach, Buffalo Bill-style. . . .
What's become of Van Gogh? I haven't heard a word about him.
 Letter to Émile Bernard, from Le Pouldu, August 1890; Malingue 1949, no. CX

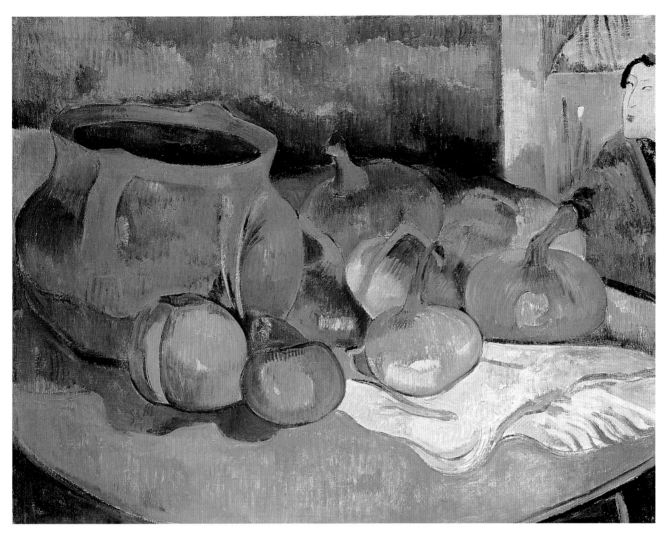

Cat. no. 47. *Still Life with Onions, Beetroot, and a Japanese Print*, 1889
Oil on canvas
Judy and Michael Steinhardt Collection, New York

The entire East—the lofty thoughts inscribed in golden letters in all their art—all of that is worth studying, and I feel I can revitalize myself out there. The West is effete at present, and even a [man with the strength of] Hercules can, like Antaeus, gain new vigor just by touching the ground [of the Orient]. . . .

. . . There's not much light [here, in Le Pouldu] *during the day, so I relax by carving and doing still lifes.*

Letter to Émile Bernard, from Le Pouldu, June 1890; Cachin 1992, p. 144

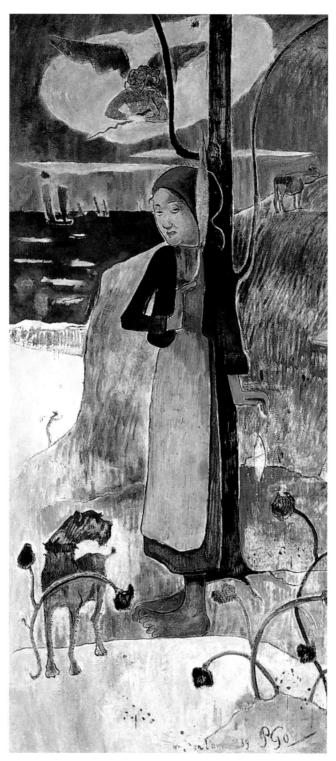

Fig. 40. *The Spinner (Joan of Arc)*, 1889.
Fresco from the inn at Le Pouldu, transferred
to canvas, 45¾ x 23 in. (116 x 58 cm).
Private Collection

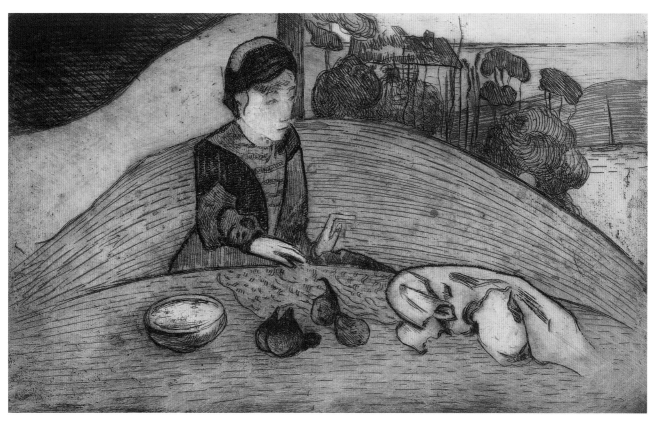

Cat. no. 48. *Woman with Figs,* 1894
Etching, lavis, and soft-ground etching on zinc
The Metropolitan Museum of Art, New York,
The Elisha Whittelsey Collection,
The Elisha Whittelsey Fund, 1967 67.753.6

I only want to do simple, very simple art, and to be able to do that, I have to immerse myself in virgin nature, see no one but savages, live their life, with no other thought in mind but to render, the way a child would, the concepts formed in my brain and to do this with the aid of nothing but the primitive means of art, the only means that are good and true. . . .

Jules Huret, "Paul Gauguin devant ses tableaux,"
L'écho de Paris, February 23, 1891; Guérin 1978, p. 48

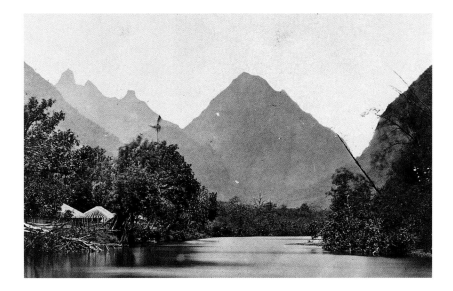

Fig. 41. Tahiti: Interior of the island, ca. 1880–90. Photograph by Courret Brothers. Private Collection

Fig. 42. A woman washing, Tahiti. Postcard. Photograph by Maxime Bopp du Pont (1890–1966). The Photograph Study Collection, Department of the Arts of Africa, Oceania, and the Americas, The Metropolitan Museum of Art, New York

Fig. 43. Quai de Commerce, Papeete, Tahiti, 1897. Photograph by Henri Lemasson. Research Library, Getty Research Institute, Los Angeles 93.R.92

GAUGUIN IN TAHITI: 1891–93, 1895–1901

When Gauguin set sail for the South Pacific in April of 1891, he did so believing that exile in the tropics might very well bring about what he most desired: a reversal of his fortunes and a recognition of his genius. In at least one respect he was correct, for, although he mostly remained destitute to the end of his days, his artistic fame was indeed secured as the result of his sojourns in Tahiti: the first lasting two years, from 1891 to 1893, and the second, six years, from 1895 to 1901.

In view of the ever-increasing distance Gauguin was putting between himself and Paris by traveling to paint in Brittany, Provence, and Martinique, his departure for Polynesia might seem to have been the logical next step. While he was in Arles with Van Gogh, he wrote to Émile Bernard of more distant prospects, "I agree a little bit with Vincent, the future belongs to painters who depict the tropics, which have not yet been painted, and we need some new motifs for the stupid buying public."[1] Surely the displays of native peoples and goods from French colonies exhibited at the Exposition Universelle in Paris in 1889 excited the sailor-painter's wanderlust; soon he could envision a Studio of the Tropics such as Van Gogh had suggested, shared with Bernard, Schuffenecker, and Meyer de Haan in either Java, Tonkin (North Vietnam), or Madagascar. In June 1890 he wrote enthusiastically to Bernard, "With the money I'll have, I can buy a native house like those you saw at the Exposition Universelle. Made of wood and dirt, with a thatched roof, near the city, but off in the countryside, that costs almost nothing, and I will enlarge it by cutting down wood to make a comfortable abode for us."[2]

Gauguin's sights had become more focused by the time he wrote to Redon in September: "Even Madagascar is too near to the civilized world. . . . I shall go to Tahiti and I hope to end my days there. I judge that my art, which you like, is only a seedling thus far, and out there I hope to cultivate it for my own pleasure in its primitive and savage state."[3] Meanwhile, to his wife, who had been charged with the care of their five children in Copenhagen, he waxed poetic about his own prospects: "in the silence of Tahiti's beautiful tropical nights, I will hear the soft, murmurous music of my heart, in perfect harmony with the mysterious beings that inhabit my surroundings."[4]

The Tahiti that Gauguin encountered upon his arrival in the port town of Papeete in June 1891 was, however, far from what he had expected, for the structure of its native culture was dilapidated, if not altogether collapsed. Since its discovery by Europeans in 1767, nearly every aspect of the island and its community had been eroded by the influx of foreigners. During the so-called Bibles-and-muskets phase, traders and whalers depleted the island of natural resources, while delivering the corrupting forces of alcohol and guns. And when the London Missionary Society made Tahiti its first field of operation, in 1795, it launched the campaign that successfully undermined existing customs and beliefs.[5] Gauguin assessed the damage and wrote disappointedly to his wife, "The land of Tahiti is becoming completely French and little by little, all the ancient ways of doing things will disappear. Our missionaries have already imported a lot of hypocrisy . . . while sweeping away a part of the poetry."[6]

Gauguin's own image of Tahiti was most likely formed by literature in which the natural beauty of the islands and its people were extolled by adventurers who had dropped anchor in its harbor and were enchantingly welcomed. One of these, the French captain Louis-Antoine de Bougainville, who arrived in 1767, named it New Cythera after the island of Venus's birth: "Nature has placed it [Tahiti] in the most beautiful climate in the Universe, embellished with the most joyous aspects, enriched with all her gifts, covered with inhabitants that are handsome, tall, and strong . . . perhaps the happiest society that exists on the globe. . . . These people breathe only repose and the pleasures of the senses. Venus is the goddess one feels ever-present."[7] Reinforcing early favorable reports was the

subsequent import to Europe of a genuine Tahitian native, Orau, who excited not only great interest but also soulful comparisons between the inherently wise, unschooled savage and his civilized counterparts, the latter judged sadly deficient by Diderot and then Rousseau. The seductive appeal of sensual, peaceful, plentiful Tahiti was broadcast still further by the mythic mutiny on the *Bounty* in 1789, with its sailors jumping ship to join the *bons sauvages*.

By the mid-nineteenth century there was an international group of writers who took to the high seas in order to create adventure stories about the still-remote and inaccessible South Pacific, among them Herman Melville, Robert Louis Stevenson (who stopped in Tahiti in 1888), and the Frenchman Julien Viaud (Pierre Loti). It is certain that Gauguin read Viaud's popular novel *Le mariage de Loti* (1880), an operatic tale of romance between a European traveler and a Tahitian vahine; indeed, Gauguin's largely fictional journal of life in Tahiti, *Noa Noa*, and perhaps his actual experiences, might be confused with those of Loti.

It is fascinating that Gauguin seems to have so completely accepted the fantasies of paradise spun in the existing wealth of enchanting tales about Tahiti and its neighboring islands. After an unsteady landing in the port of Papeete, the center of the island's commerce and French military community, he found his way along the narrow coast to remote stations where he managed to settle in among the natives, to study their unusual faces and customary postures, the abundant flora and fauna, and something of the local language. In his paintings he made only ironic reference to the European presence in the islands, which was revealed in the women's flesh-concealing "missionary" dresses and in their pareus, fashioned from English-manufactured cloths. Moreover, Gauguin generally steered clear of familiar landmarks, such as Point Venus, the jagged crown of volcanic Mount Roniu, the Grotto of Maraa (although in *Noa Noa* he bragged of bravely swimming there), and the imposing outlines of the island of Moorea that faced his huts along the western shore. He had come to Tahiti to paint the past, not the present, to portray symbols, rather than specifics.

Gauguin surely must have been disappointed to find very little remaining of Tahiti's culture, religion, or indigenous arts, especially since his travel there had

been approved and, in part, subsidized under arrangements similar to a government-sponsored *mission scientifique*. He gained some knowledge of native rituals from books such as Jacques-Antoine Moerenhout's *Voyages aux îles du Grand Océan* (1837), which was lent to him by a local plantation owner, Auguste Goupil, early in 1892. His attentive reading of the text informed at least a dozen programmatic paintings from his first Tahitian sojourn and were the basis of *L'ancien culte mahorie*, his illustrated guide to foreign aspects of his art. But, on the whole, Gauguin seems to have had few inhibitions about embellishing his works with any exotic motif he found at hand, regardless of its origins. His "Tahitian" pictures are thus punctuated with imagery from the Cook Islands and the Marquesas, New Zealand, Southeast Asia, Egypt, and Japan.

It is perhaps Gauguin's self-conscious straining after the exotic that distinguishes the wood carvings and paintings he produced during and just after his first Tahitian stay from the elegiac creations of his second. Discouraged by the unappreciative response to his art in Paris after he returned there in 1893, Gauguin sailed back to Tahiti in 1895, resigned to the solitude of his mission and of his life. The novelty of its exoticism worn off, Tahiti, to Gauguin, was no longer foreign, but *his*. Henceforth, he would set aside his study of its particular mysteries to explore questions that were his own. Thus, fantastic look-at-me concoctions were supplanted by serenely monumental scenes vaguely suggesting the faraway in time and place; now, without the litany—only the chant.

Although one could not guess it from his pictures, Gauguin's last six years in Tahiti were made miserable by poverty and illness. Frequently, he was bedridden or hospitalized, and late in 1897, in the midst of creating the majestic *Where Do We Come From? What Are We? Where Are We Going?*, he evidently attempted suicide. That spring he had learned of the death of his adored daughter Aline, and in August, with a bitter letter to his wife, Mette, their unbelievably enduring correspondence finally came to an end. Meanwhile, as he had during his previous island stay, he strove to maintain a Tahitian-style family with a young vahine.

Gauguin's paintings appear as the calm center of his personal maelstrom. The Arcadia they represent stood in sharp contrast to the ruined paradise he found all about

him. The job he held for most of 1898 as a draftsman for the Public Works Department in Papeete helped to make ends meet but brought him in disturbing proximity to the corruption in Tahiti's tangled affairs of church and state. His disgust with colonial politics erupted soon afterward in essays published in the newspaper *Les guêpes* (The wasps) (of which he later became editor) and in his own illustrated broadsheet, *Le sourire* (The smile).

It was probably the contractual arrangement Gauguin secured with the art dealer Ambroise Vollard early in 1900 that gave him a means of escape from the hornets' nest he had stirred up in Tahiti. The promise of three hundred francs a month for the production of twenty to twenty-four paintings a year gave him the financial security to flee yet again to a much more remote and far less "civilized" island.

From a Tahitian
Sketchbook, ca. 1891

Cat. no. 49. *Taoa*
From a Tahitian sketchbook,
probably 1891
Pen and ink over graphite
Mrs. Alex Lewyt

Cat. no. 50. *Fare*
From a Tahitian sketchbook,
probably 1891
Pen and ink over graphite
Mrs. Alex Lewyt

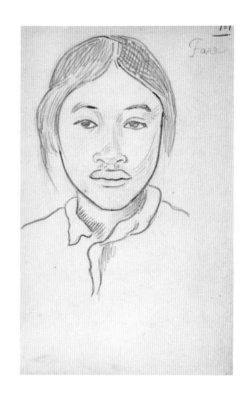

Cat. no. 51. *Woman with a Shawl*
From a Tahitian sketchbook,
probably 1891
Graphite, black chalk, and
watercolor
Mrs. Alex Lewyt

Cat. no. 52. *Tetua*
From a Tahitian sketchbook,
probably 1891
Pen and ink over graphite
Mrs. Alex Lewyt

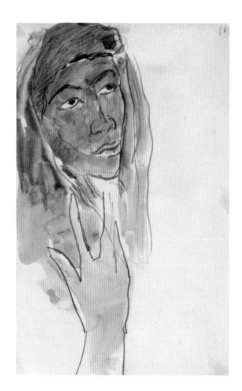

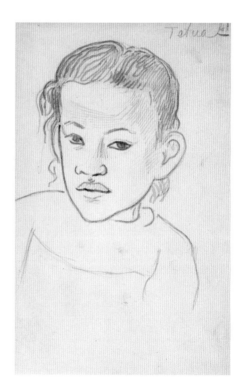

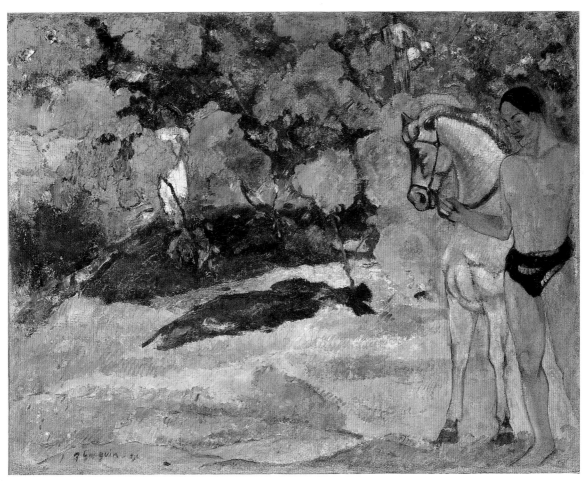

Cat. no. 53. *In the Vanilla Grove, Man and Horse*, 1891
Oil on burlap
Solomon R. Guggenheim Museum, New York, Thannhauser Collection,
Gift, Justin K. Thannhauser, 1978 78.2514.15

I am working hard and earnestly. I can't tell if it's good, for I'm doing a lot and at the same time it amounts to nothing. Not one painting as yet, but a great deal of research that can lead to something, many notes that will be of use to me for a long time, I hope. . . .

Letter to Paul Sérusier, from Tahiti, November 1891; Guérin 1978, p. 54

On the ground, beneath tufts of broad pumpkin leaves, I spied a little brown head with calm eyes. A small child was examining me; he ran away, frightened, when my eyes met his. . . . For them too I was the savage.

Noa Noa, 1893; Guérin 1978, p. 82

I don't know why ~~my~~ the government has accorded me this mission—probably to appear to be protecting an artist. . . .
First sentence of Gauguin's first ms. of *Noa Noa*, 1893, Research Library, Getty Research Institute, Los Angeles

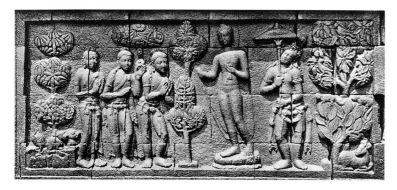

Fig. 44. *The Tathagata Meets an Ajiwaka Monk on the Benares Road.* Relief from the Temple of Borobudur, Java, 775–842

Gauguin owned photographs of this relief and one other from Borobudur, which he kept in his traveling portfolio of pictures from the time of their purchase in 1886 or 1887 until his death in the Marquesas in 1903.

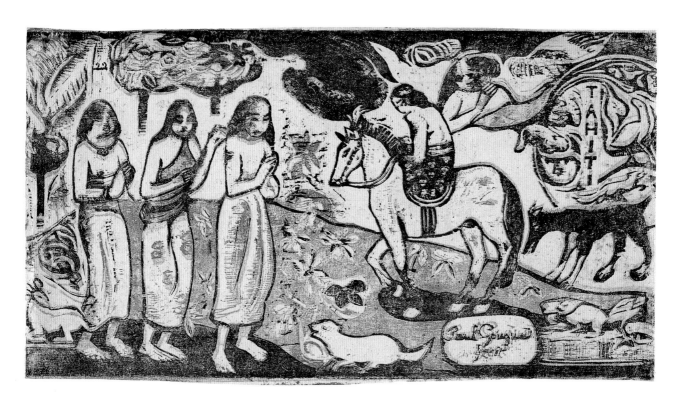

Cat. no. 54. *Tahiti (Change of Residence)*, 1898–99
Woodcut, printed in color
Brooklyn Museum of Art, Museum Collection Fund 37.152

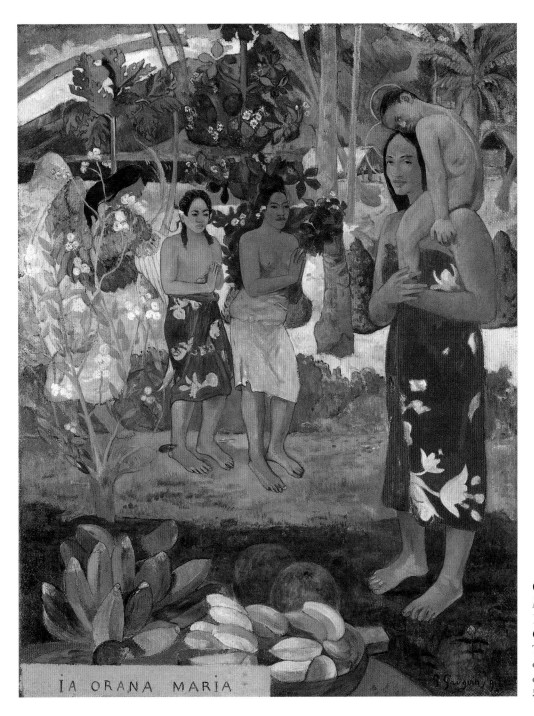

IA ORANA MARIA

Cat. no. 55. *Ia Orana Maria (Hail Mary),* 1891
Oil on canvas
The Metropolitan Museum of Art, New York, Bequest of Sam A. Lewisohn, 1951
51.112.2

I have . . . made a painting, size 50 canvas. An angel with yellow wings points out Mary and Jesus, both Tahitians, to two Tahitian women, nudes wrapped in pareus, *a sort of cotton cloth printed with flowers that can be draped as one likes from the waist. [There is] a very somber, mountainous background and flowering trees, [also] a dark violet path and an emerald green foreground, with bananas on the left.—I'm rather happy with it.*

Letter to Daniel de Monfreid, from Tahiti, March 11, 1892; Joly-Segalen 1950, no. III

Cat. no. 56. *Ia Orana Maria*
(Hail Mary), 1895
Lithograph on zinc; published in *L'épreuve*,
March 1895
The Metropolitan Museum of Art, New York,
The Elisha Whittelsey Collection, The Elisha
Whittlesey Fund, 1962 62.501.1

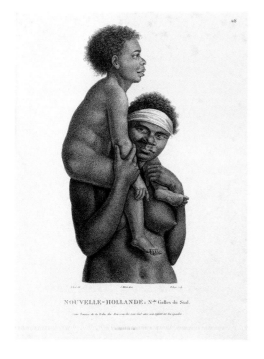

Fig. 45. *Mother Carrying a Child on Her Shoulder, New Zealand.* Lithograph
in François Péron and Louis de Freyeinet, V*oyage de découvertes aux Terres
Australes* . . . (Paris, 1824). Library, American Museum of Natural History,
New York

It is not known whether or not Gauguin was acquainted with this
illustration. If it did not prompt him to introduce the unusual pose
of mother and child in *Ia Orana Maria*, it at least presents evidence
that natives in the South Pacific carried children on their shoulders.

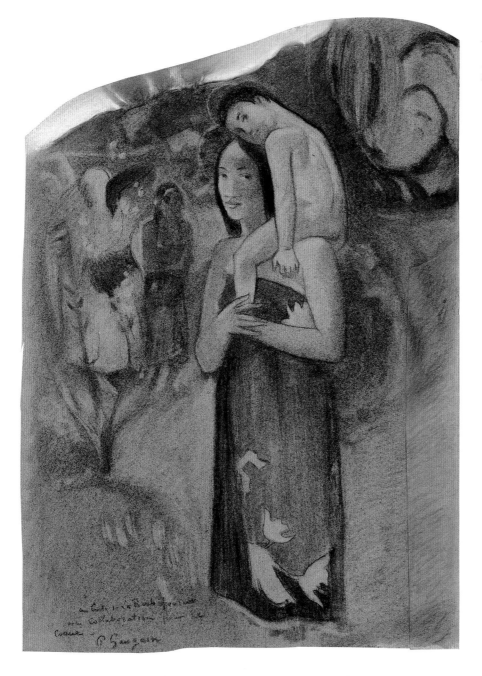

Cat. no. 57. *Ia Orana Maria (Hail Mary)*, ca. 1893–95
Fabricated charcoal, red chalk, and white pastel
The Metropolitan Museum of Art, New York, Bequest of Loula D. Lasker, New York City, 1961 61.145.2

This drawing is dedicated to Comte Antoine de La Rochefoucauld, a Neo-Impressionist painter, poet, and patron of the arts who sponsored the Rosicrucian movement and financed the journal *Le coeur illustré*, to which Gauguin submitted drawings for illustrations. The comte purchased Gauguin's paintings *Woman Sewing* (W 358) in 1891 and *The Loss of Virginity* (W 412) in 1895.

Here, everyone looks on a child as nature's greatest blessing and people vie with one another to adopt one. That's how savage the Maoris are. This kind of savagery I adopt.

Memoirs, 1902–3, published as *Avant et après*, 1923;

Guérin 1978, p. 272

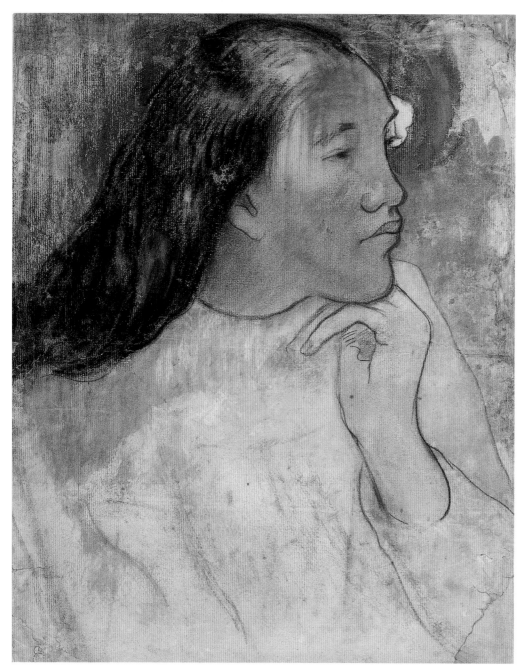

Cat. no. 58. *A Tahitian Woman with a Flower in Her Hair*, ca. 1891–92
Charcoal, pastel, and wash
The Metropolitan Museum of Art, New York, Bequest of Miss Adelaide Milton de Groot
(1876–1967), 1967 67.187.13

In order to understand the secret in a Tahitian face, all the charm of a Maori smile, I had been wanting for a long
time to do the portrait of a neighboring woman of pure Tahitian race. One day, when she had been bold enough to
come into my hut to look at some pictures and photographs of paintings, I asked her if I could do it. . . . She had a
flower at her ear which listened to her perfume. And the majesty and uplifted lines of her forehead recalled these lines
by Poe: "There is no exquisite beauty without some strangeness in the proportion."

<div align="right">

Noa Noa, 1893; Guérin 1978, p. 83

</div>

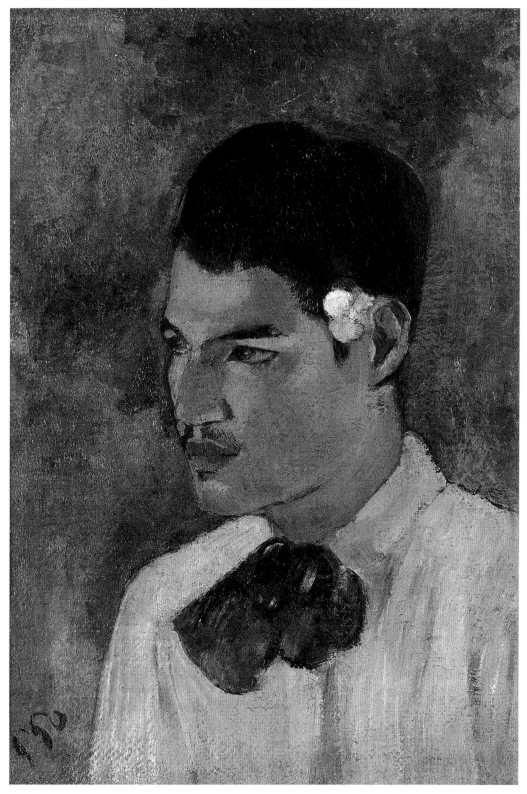

Cat. no. 59. *Young Man with a Flower*, 1891
Oil on canvas
Collection I. Mavrommatis Family

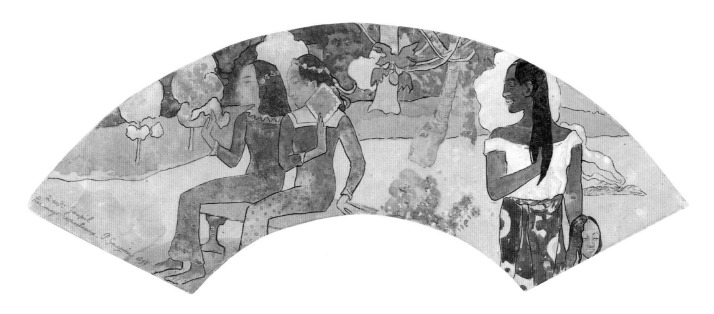

Cat. no. 60. *Fan Design with Motifs from Ta Matete*
(The Market), 1892
Watercolor, gouache, pen and ink, and graphite
The Whitehead Collection, courtesy Achim Moeller Fine Art,
New York

You will always find sustenance and vital strength in the primitive arts. . . . When I studied the
Egyptians, I always found in my brain a healthy element.
 "Diverses choses," 1896–98, in *Noa Noa*, Musée du Louvre, Paris; Guérin 1978, p. 130

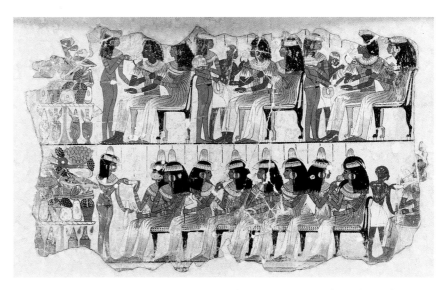

Fig. 46. Egyptian, 18th Dynasty, ca. 1400 B.C. (detail). Wall painting from the tomb of Nebamun,
Thebes. Trustees of the British Museum, London

A photograph of this Egyptian tomb painting was found among Gauguin's
possessions at the time of his death.

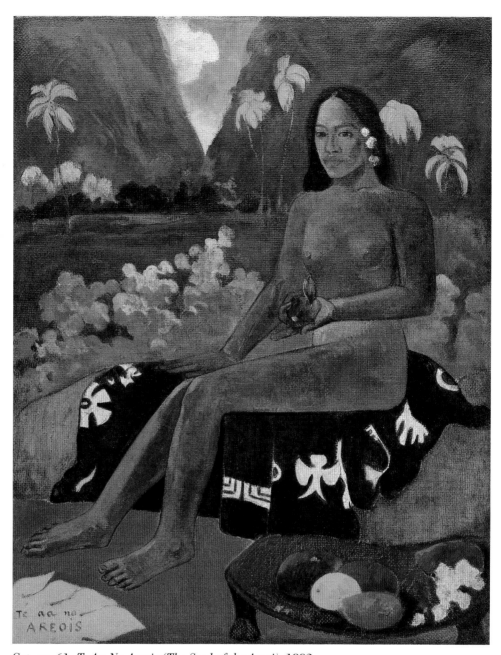

Cat. no. 61. *Te Aa No Areois (The Seed of the Areoi)*, 1892
Oil on burlap
The Museum of Modern Art, New York, The William S. Paley Collection

. . . one could recall the periodic feasts of the Ariois; They said that the seeds of the ora tree had been brought to them from the moon by a white pigeon.

L'ancien culte mahorie, 1892; Guérin 1978, p. 59

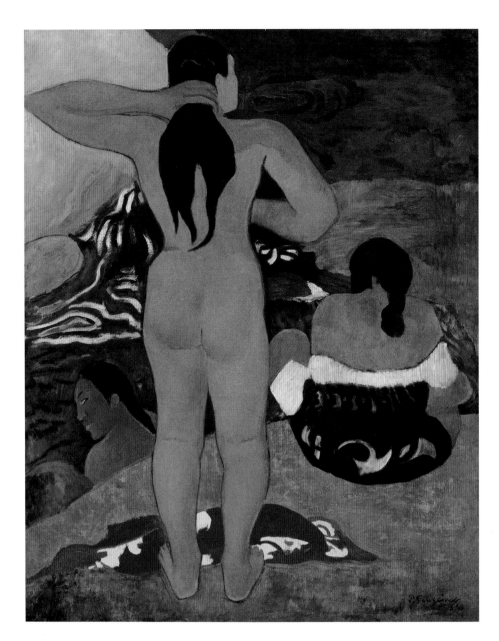

Cat. no. 62. *Tahitian Women Bathing*, 1892
Oil on paper laid down on canvas
The Metropolitan Museum of Art,
New York, Robert Lehman
Collection, 1975 1975.1.179

The thing that distinguishes the Polynesian woman from all others, and which often causes one to
mistake her for a man, is the way her body is proportioned. A Diana the Huntress with broad shoulders
and narrow hips. . . . The legs of Polynesian women, from hip to foot, form lovely straight lines. Their
thighs are nicely fleshed out but not wide, which makes them look very full and spares them that sepa-
ration which has caused [the legs of] some of our European women to be likened to a pair of tongs.

Memoirs, 1902–3, published as Avant et après, *1923*

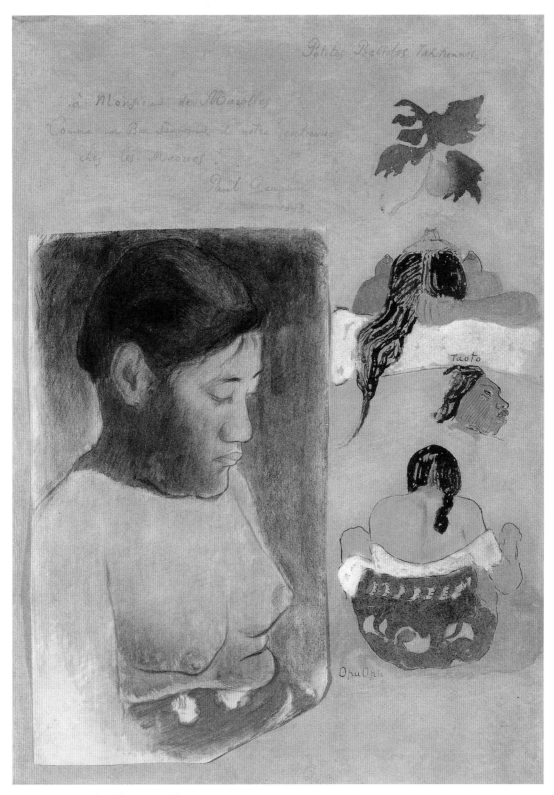

Cat. no. 63. *Little Tahitian Trinkets*, 1892
Pastel, watercolor, compressed charcoal, gouache, and ink over graphite
Private Collection

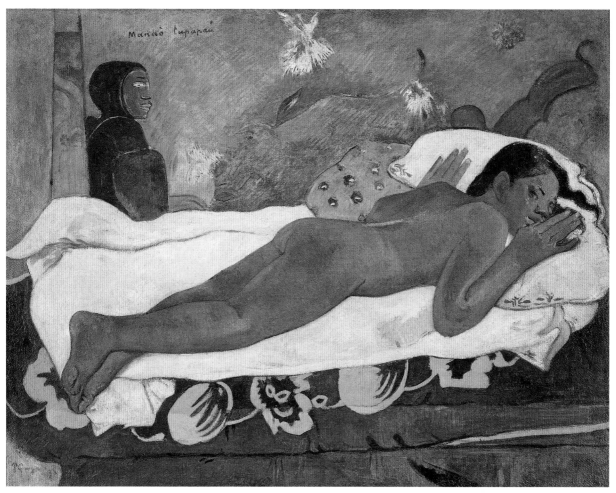

Cat. no. 64. *Manao Tupapau (Spirit of the Dead Watching)*,
1892
Oil on burlap mounted on canvas
Albright-Knox Art Gallery, Buffalo, New York, A. Conger Goodyear
Collection, 1965 1965:1

*She was never willing to accept the notion that shooting stars, which are frequently seen in this
country and cross the sky slowly and full of melancholy, are not* tupapaüs.

One day I had to go to Papeete; . . . I had promised to return that very evening. . . .

*It was one in the morning by the time I arrived. . . . The lamp had gone out and when I
came home the bedroom was dark. I felt a sort of fear, . . . I struck some matches and on the
bed I saw [what I pictured in my painting* Manao] Tupapaü.

Noa Noa, late 1893; Guérin 1978, pp. 94–95

Cat. no. 65. *Te Po (The Night)*
From the series *Noa Noa (Fragrance)*, 1893–94
Woodcut printed in color
The Metropolitan Museum of Art, New York, Harris Brisbane Dick Fund, 1936 36.6.12

The title Manao Tupapau
*("Thought or Belief and the
Specter") can have two meanings:
either she is thinking of the specter
or the specter is thinking of her. . . .
The literary theme: the soul of the
living woman united with the spirit
of the dead. The opposites of night
and day. . . . otherwise it is simply
a nude from the South Seas.*

"Cahier pour Aline," Tahiti,
begun December 1892;
Bibliothèque d'Art
et d'Archéologie, Paris

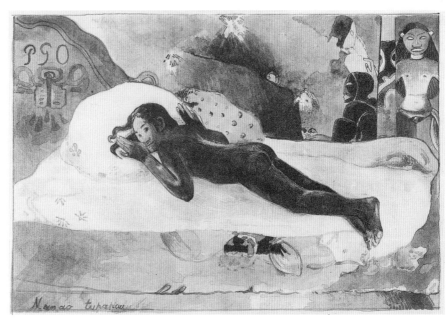

Cat. no. 66. *Manao Tupapau (Spirit of the Dead Watching)*
Lithograph on zinc; published in *L'éstampe originale*, April–June 1894
The Metropolitan Museum of Art, New York, Rogers Fund, 1922 22.82.1–53

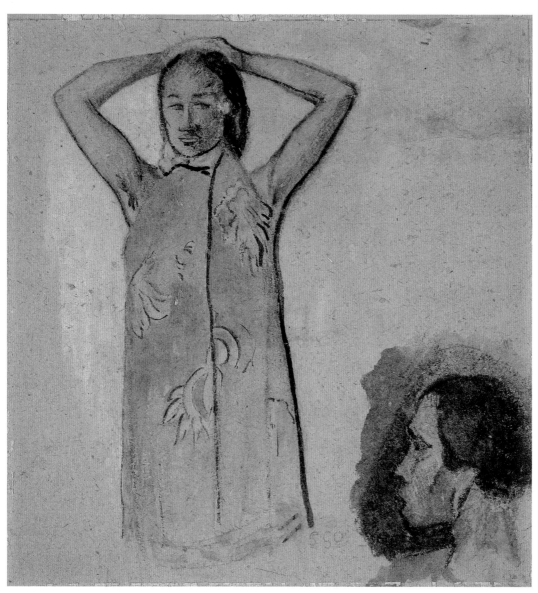

Cat. no. 67. *Tahitian Girl in a Pink Pareu*, 1894
Gouache, watercolor, and ink
The Museum of Modern Art, New York, The William S. Paley Collection,
SPC 12.90

The few girls of Mataiéa who do not live with a tané *look at you so frankly—dignity without any fear—that
I was really intimidated.*

Noa Noa, 1893; Guérin 1978, p. 80

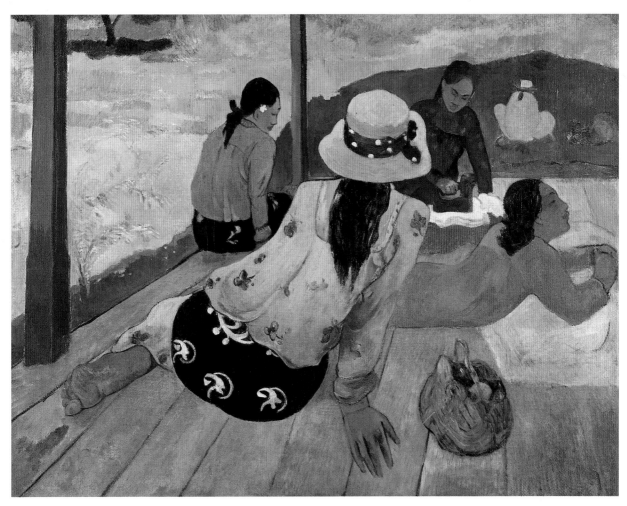

Cat. no. 68. *The Siesta,* probably 1891–92
Oil on canvas
The Metropolitan Museum of Art, New York, The Walter H. and Leonore Annenberg Collection,
Partial Gift of Walter H. and Leonore Annenberg, 1993 1993.400.3

Tipping his hat to Impressionism, Gauguin updated the theme of the fête champêtre. His Tahitian
porch scene recalls Degas's rehearsal halls and milliners' shops, and perhaps also the geisha
houses pictured in ukiyo-e woodcuts.

*. . . Any of the women can make her own dress, plait her hat, bedeck it with ribbons in a way that outdoes
any milliner in Paris, and arrange bouquets with as much taste as on the Boulevard de la Madeleine. Their
beautiful bodies, without any whale bone to deform them, move with sinuous grace under their lace and
muslin chemises. . . . Their feet, on the contrary, which are wide and sturdy, and wear no laced boots, offend
us but only at first, for later it is the sight of laced boots that would offend us.*

Memoirs, 1902–3, published as *Avant et après,* 1923; Guérin 1978, p. 281

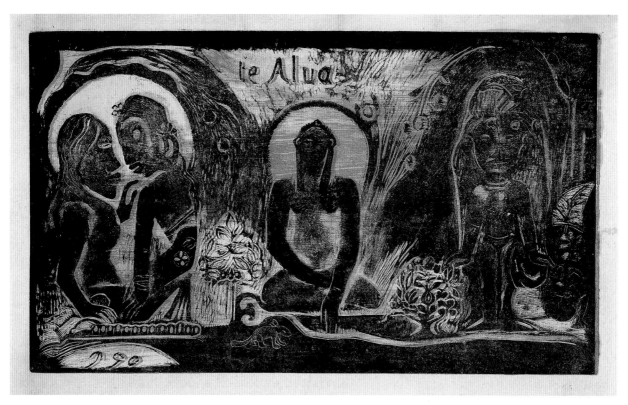

Cat. no. 69. *Te Atua (The God)*
From the series *Noa Noa (Fragrance)*, 1893–94
Woodcut, printed in color by the artist and Louis Roy
The Museum of Modern Art, New York, Gift of Abby Aldrich Rockefeller, 1940

*What a religion the ancient Oceanian religion is. What a marvel! My brain is bursting with it
and all it suggests to me will certainly frighten people.*
Letter to Paul Sérusier, from Tahiti, March 25, 1892; Guérin 1978, p. 57

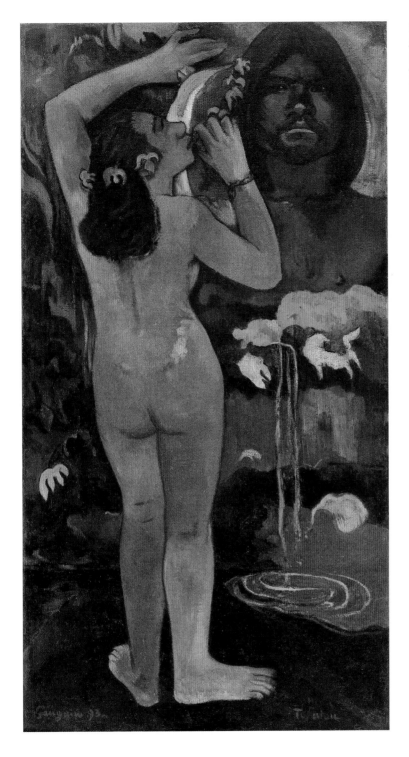

Cat. no. 70. *Hina Tefatou (The Moon and the Earth)*, 1893
Oil on burlap
The Museum of Modern Art, New York,
Lillie P. Bliss Collection, 1934

In his guide to the ancient beliefs of the Tahitians, which he based on J. A. Moerenhout's *Voyages aux îles du Grand Océan* (1837), Gauguin related this dialogue regarding man's fate:

Hina [goddess of air and the moon] said to Fatu [her son, god of the earth]: "Bring man back to life or resuscitate him after his death." Fatu replied: "No, I will not bring him back to life. The earth will die; the plants will die . . . the earth will come to an end . . . never to be reborn." Hina replied: "Do as you wish; for my part I will bring the moon back to life. And that which belongs to Hina will continue to exist; [while] that which belongs to Fatu perishes. . . ."
L'ancien culte mahorie, 1892; Washington–Chicago–Paris 1988–89, p. 254

Cat. no. 71. *Noa Noa (Fragrance)*,
1893–94
Carved fruitwood (commercial composite
woodblock) with traces of zinc white
and ink
The Metropolitan Museum of Art, New
York, Harris Brisbane Dick Fund, 1937
37.97

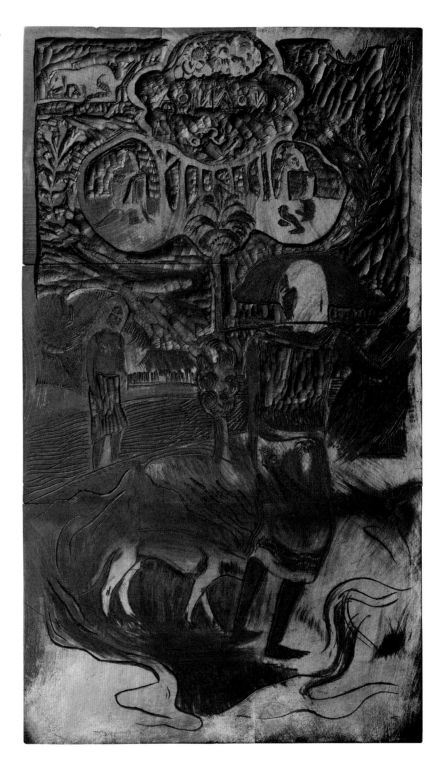

*. . . The Tahitian noa noa makes everything fragrant. I no longer
feel the passing of days and hours, I am unaware of Good and Evil;
everything is beautiful, everything is good.*

Noa Noa, 1893; Guérin 1978, p. 94

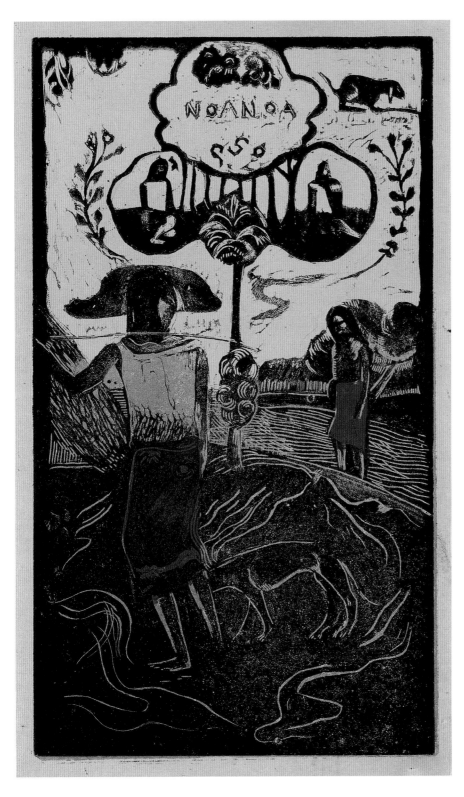

. . . Noa Noa—*a Tahitian word meaning "fragrant." In other words,*
[my] book will be about what Tahiti exhales.

 Interview with Eugène Tardieu, May 13, 1895; Cachin 1992, p. 171

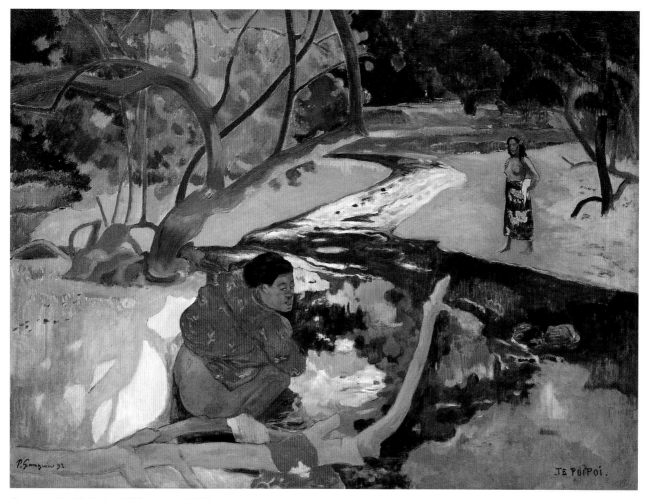

Cat. no. 73. *Te Poipoi (Morning)*, 1892
Oil on canvas
From the collection of Joan Whitney Payson

*I began to work: notes and sketches of every sort. But the landscape with its pure, intense
colors, dazzled and blinded me. Previously always in doubt, I searched from noon until
two o'clock. . . . It was so simple, however, to paint what I saw, to put a red or a blue on my
canvas without so much calculation! Golden forms in the streams enchanted me; why did
I hesitate to make all of that gold and all of that sunny joy flow on my canvas? Old European
habits, the limitations to expression enforced by degenerate races!*

Noa Noa, 1893–94, Musée du Louvre, Paris, ms. 43

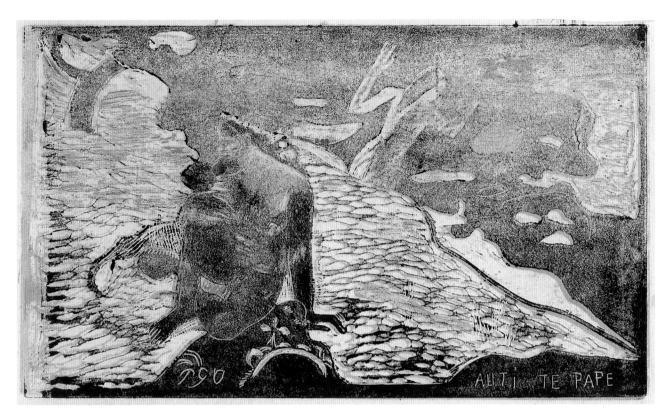

Cat. no. 74. *Auti Te Pape (The Fresh Water
Is in Motion)*
From the series *Noa Noa (Fragrance)*, 1893–94
Woodcut printed in color
The Metropolitan Museum of Art, New York, Harris Brisbane
Dick Fund, 1936 36.6.2

On the road back, . . . the vahines *took the arm of their* tanés *again . . . their broad bare feet
stepped heavily in the dust along the way. When they came near the river of Fataua, everyone
dispersed. Here and there some of the women, hidden by stones, squatted in the water, their skirts
lifted to their waists, cleansing their hips soiled by the dust of the road, refreshing the joints that
had become irritated by the walk and the heat.*

Noa Noa, 1893; Guérin 1978, p. 78

101

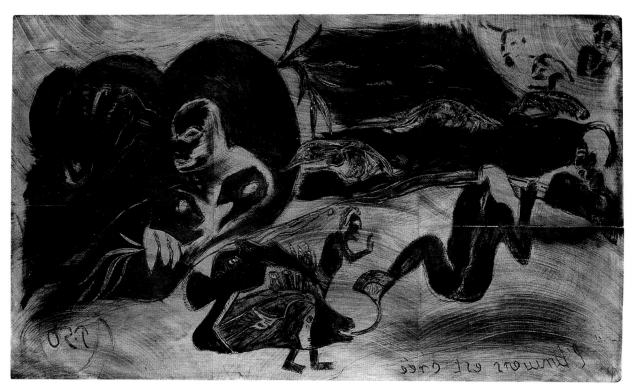

Cat. no. 75. *The Universe Is Created*
From the series *Noa Noa (Fragrance)*, 1893–94
Carved commercial composite woodblock
Memorial Art Gallery of the University of Rochester, Gift of
Dr. and Mrs. James H. Lockhart Jr. 77.147.1

Around the island the infinitely tiny creatures have built a gigantic barrier: the waves that batter this wall do not bring it down, but flood it with phosphorescent spray. Vaguely I watched these scrolls and curls edged with green lace, but my thoughts were far away, unaware of time: the notion of time fades into space on such nights.

"Sous deux latitudes," *Essais d'art libre* 5 (May 1894); Guérin 1978, p. 101

I do not see why it is said that Odilon Redon paints monsters. They are imaginary beings. He is a dreamer, an imaginative spirit. . . .

Nature has mysterious infinities, and imaginative power. It is always varying the productions it offers to us. The artist himself is one of nature's means and, in my opinion, Odilon Redon is one of those it has chosen for this continuation of creation. In his work, dreams become reality because of the believability he gives them. All of his plants, his embryonic and essentially human creatures have lived with us. . . .

Article on Huysmans and Redon, first published in
Les nouvelles littéraires, May 7, 1953; Guérin 1978, p. 39

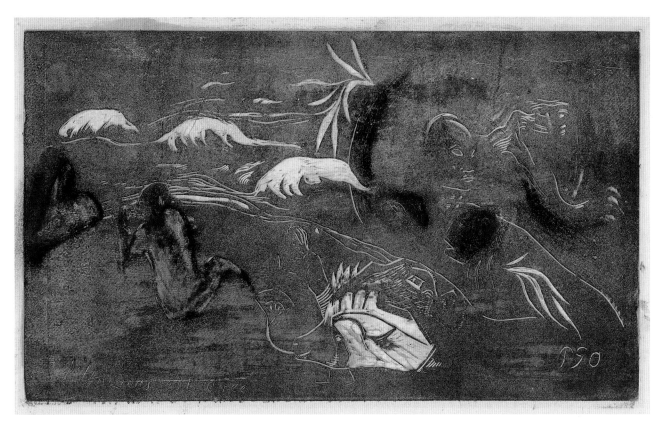

Cat. no. 76. *The Universe Is Created*
From the series *Noa Noa (Fragrance)*, 1893–94
Woodcut printed in color
The Metropolitan Museum of Art, New York,
Harris Brisbane Dick Fund, 1936 36.6.6

Cat. no. 77. *The Universe Is
Created*
From the series *Noa Noa (Fragrance)*,
1893–94
Woodcut printed in color by Louis Roy
Memorial Art Gallery of the University
of Rochester, Gift of Dr. and Mrs.
James H. Lockhart, Jr. 77.147.2

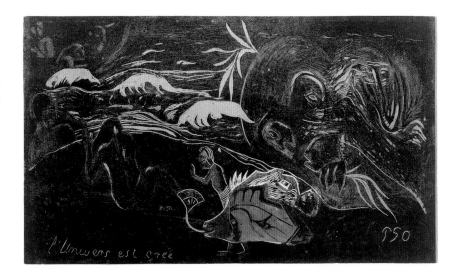

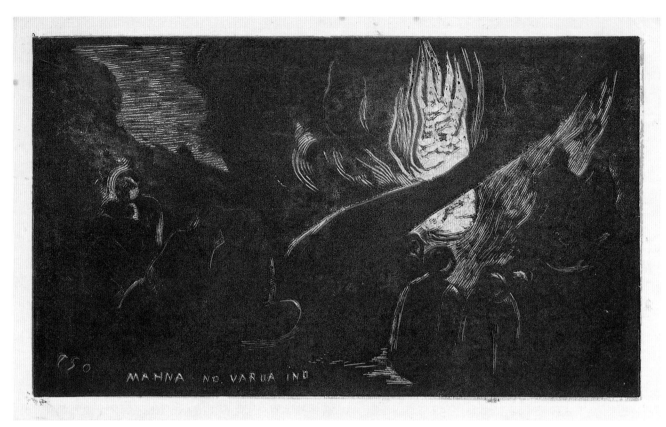

Cat. no. 78. *Mahna No Varua Ino (Day of the Evil Spirit)*
From the series *Noa Noa (Fragrance)*, 1893–94
Woodcut printed in color
The Metropolitan Museum of Art, New York, Harris Brisbane Dick Fund, 1936 36.6.3

May the day come (soon perhaps) when I'll flee to the woods on an island in Oceania, there to live on ecstasy, calm, and art. With a new family by my side, far from this European scramble for money. There, in Tahiti, in the silence of the beautiful tropical nights, I will be able to listen to the soft murmuring music of the movements of my heart in amorous harmony with the mysterious beings around me. Free at last, without financial worries and able to love, sing, and die. . . .

Letter to Mette, from Paris, [February 1890]; Guérin 1978, p. 40

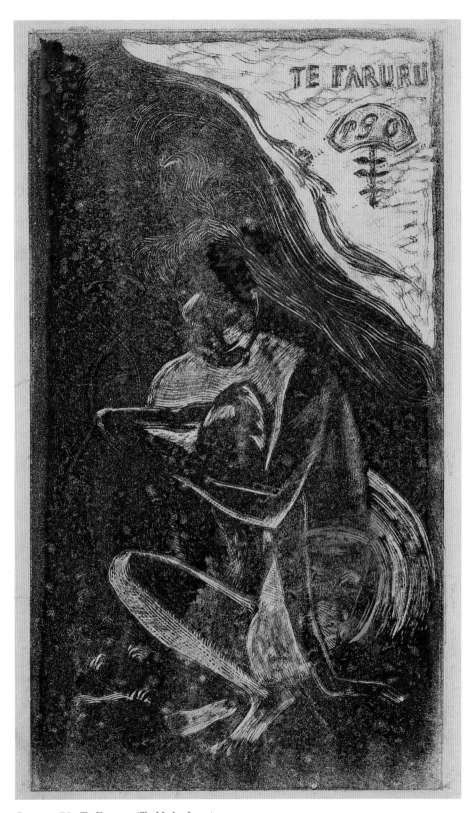

Cat. no. 79. *Te Faruru (To Make Love)*
From the series *Noa Noa (Fragrance)*, 1893–94
Woodcut printed in color
The Metropolitan Museum of Art, New York, Harris Brisbane Dick Fund, 1936 36.6.8

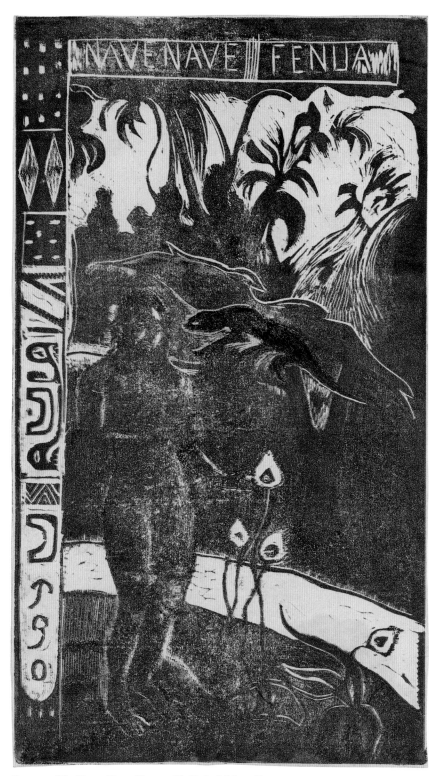

Cat. no. 80. *Nave Nave Fenua (Delightful Land)*
From the series *Noa Noa (Fragrance)*, 1893–94
Woodcut printed in color
The Metropolitan Museum of Art, New York, Rogers Fund,
1922 22.26.11

Cat. no. 81. *Nave Nave Fenua (Delightful Land)*
From the series *Noa Noa (Fragrance)*, 1893–94
Woodcut printed in color
The Metropolitan Museum of Art, New York, Harris Brisbane
Dick Fund, 1936 36.6.5

Cat. no. 82. *Nave Nave Fenua (Delightful Land)*
From the series *Noa Noa (Fragrance)*, 1893–94
Woodcut printed in color
The Metropolitan Museum of Art, New York, Harris Brisbane
Dick Fund, 1936 36.6.4

My Eve is almost animal. That is why she is chaste for all her nakedness.
But all the Venuses in the Salon are indecent and disgracefully lewd.
Interview with Eugène Tardieu, May 17, 1895; Cachin 1982, p. 171

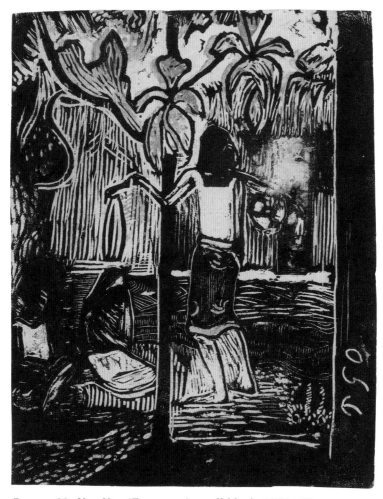

Cat. no. 83. *Noa Noa (Fragrance);* small block, 1894–95
Woodcut printed in color
The Metropolitan Museum of Art, New York, Harris Brisbane Dick Fund, 1936 36.6.1

I am writing you in the evening. This silence at night in Tahiti is even stranger than the other things. It can be found only here, with not even a birdcall to disturb it. Here and there, a large dry leaf falls but does not give an impression of noise. It's more like a rustling in the mind. The natives often go about at night, but barefoot and silent. Always this silence.

Letter to Mette, from Tahiti, July [1891]; Guérin 1978, p. 52

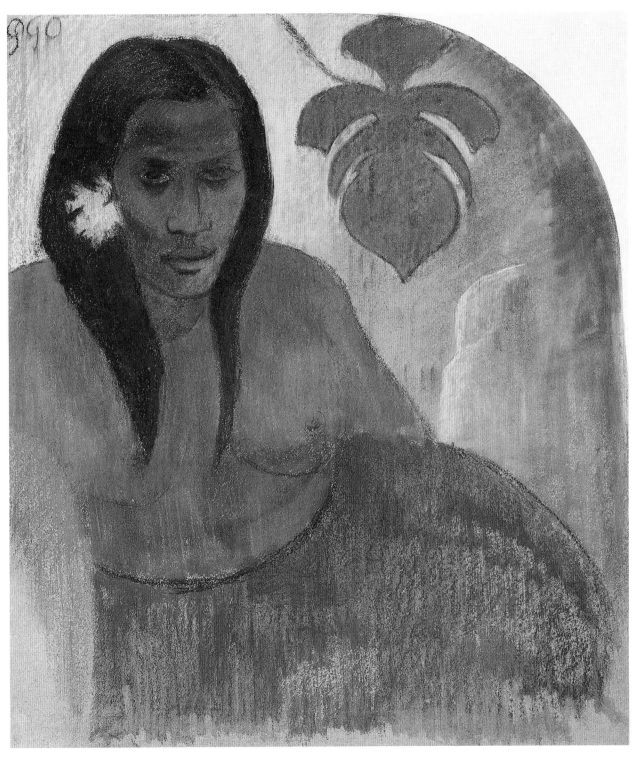

Cat. no. 84. *Tahitian Woman*, ca. 1893–94
Pastel and charcoal
Brooklyn Museum of Art, Museum Collection Fund 21.125

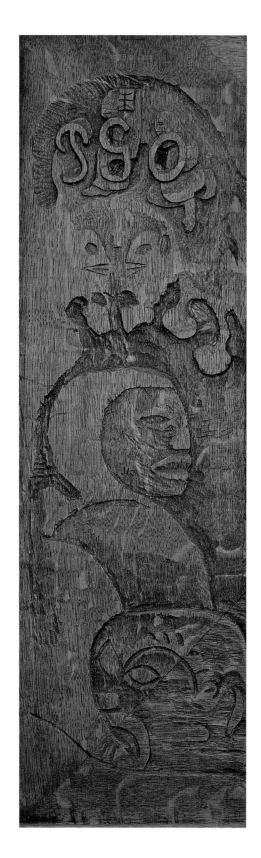

Cat. no. 85. *The Profile of a Tupapau (Spirit)*
From the *Pape Moe (Mysterious Water)* relief ensemble, 1894
Carved oak
Mr. and Mrs. Herbert D. Schimmel

Whether it is stained glass, or furniture, or ceramics, etc . . . these are basically where my talents lie, much more so than in painting, per se.
Letter to Daniel de Monfreid, from Tahiti,
August 1892; Malingue 1946, no. CXXXI

I dare not tell you not to abandon painting since I am thinking of abandoning it myself so as to live in the woods and carve imaginary beings on the trees. . . .
Letter to Émile Schuffenecker,
from Pont-Aven, July 26, 1894;
Guérin 1978, p. 103

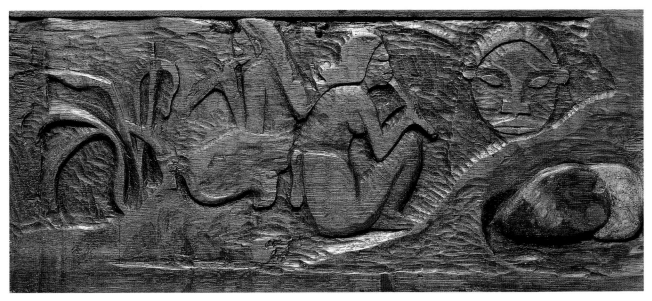

Cat. no. 86. *Hina's Head and Two Vivo Players*
From the *Pape Moe (Mysterious Water)* relief ensemble, 1894
Carved oak
Private Collection

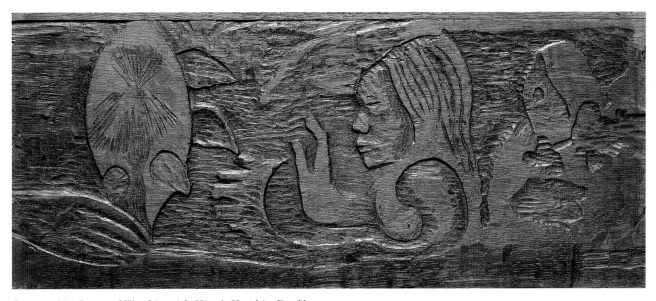

Cat. no. 87. *Scene of Worship with Hina's Head in Profile*
From the *Pape Moe (Mysterious Water)* relief ensemble, 1894
Carved oak, partly polychromed
Private Collection

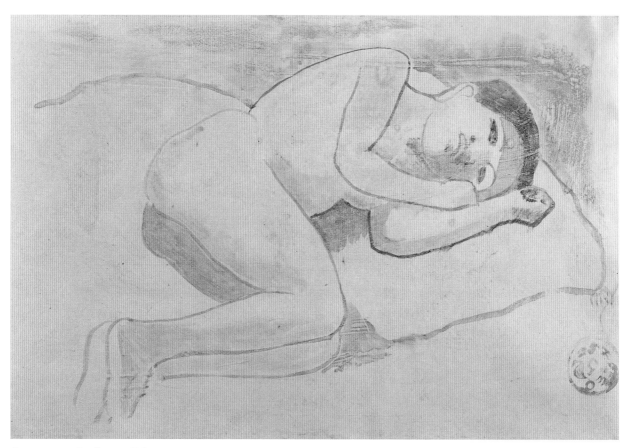

Cat. no. 88. *Reclining Tahitian*, 1894
Watercolor transfer, with additions in watercolor
Private Collection

Silence of a Tahitian night. Only the beating of my heart could be heard. Seen from my bed, by the moonlight that filtered through them, the lines of reeds some distance from my hut looked like a musical instrument. . . . Above me the great lofty roof of pandanus leaves, with lizards living in them. In my sleep I could picture the space above my head, the heavenly vault, not a stifling prison. My hut was space, freedom.

Noa Noa, 1893; Guérin 1978, p. 81

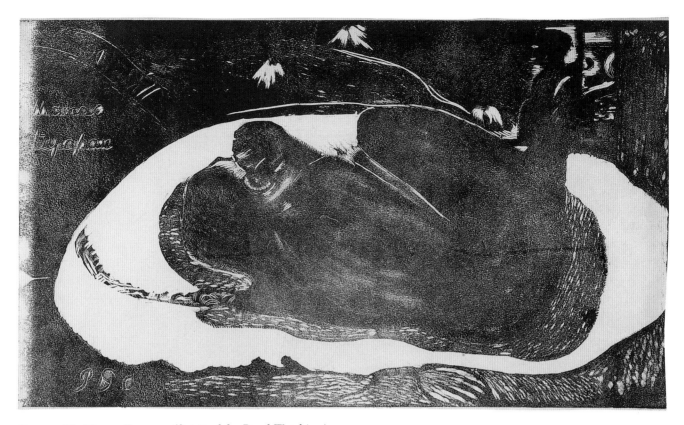

Cat. no. 89. *Manao Tupapau (Spirit of the Dead Watching)*
From the series *Noa Noa (Fragrance)*, 1893–94
Woodcut
The Metropolitan Museum of Art, New York, Harris Brisbane Dick Fund, 1936 36.6.10

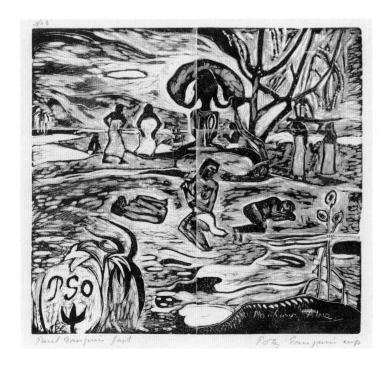

Cat. no. 90. *Mahana Atua (The Day of God)*, 1894–95
Woodcut; posthumous impression
The Metropolitan Museum of Art, New York, Rogers Fund, 1921
21.38.1

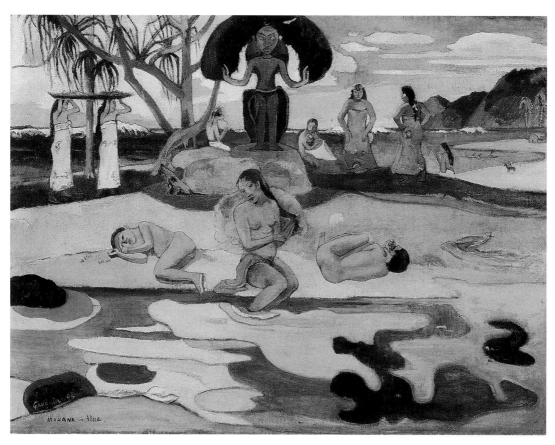

Fig. 47. *Mahana No Atua (Day of the God)*, 1894.
Oil on canvas, 26⅝ x 35⅝ in. (68.3 x 91.5 cm).
The Art Institute of Chicago, Helen Birch Barlett
Memorial Collection 1926.198

Gauguin entrusted the letter at right and the painting *Three Tahitian Women* (cat. no. 94) to a doctor who was sailing home to France from Tahiti, in hopes that they might be sold to raise funds for the artist. Dr. Nolet apparently kept the items himself, for they remained with his descendants until their purchase by a French art dealer.

Cat. no. 91. *Illustrated Letter to an Unknown Collector*, ca. 1896
Pen and ink
Mrs. Alex Lewyt

To the unknown collector of my works Greetings— / May he excuse the barbarism of this little picture; certain dispositions of my spirit are probably the cause. / I recommend a modest frame and if possible a sheet of glass which, while [the picture] ages, will preserve its freshness, and prevent the alterations always produced by the stuffy atmosphere of an apartment. / Paul Gauguin

Cat. no. 92. *Oviri (Savage)*, 1894
Watercolor monotype, heightened with gouache
Private Collection

Speaking of sculptures, I would like the very few I have done not to be scattered. . . . The large pottery figure [Oviri] which has not found a buyer . . . I would like to have it to put on my tomb in Tahiti, and before that, as the ornament of my garden. Which means that I would like you to send it to me, carefully packed. . . .

Letter to Daniel de Monfreid, from Tahiti, October 1900; Guérin 1978, p. 210

Cat. no. 93a. *Head of a Tahitian Woman* (recto),
1896
Pastel
Private Collection

I have just received your letter with its many requests, many propositions, . . . I have no old
drawings here, since I have left everything with Chaudet who takes care of my affairs. As to
new ones!!! I have not yet found . . . the trick to making drawings which sell. But should I be
in the right disposition, I shall send you some.

Letter to Ambroise Vollard, from Tahiti, April 1897; Rewald 1959, p. 62

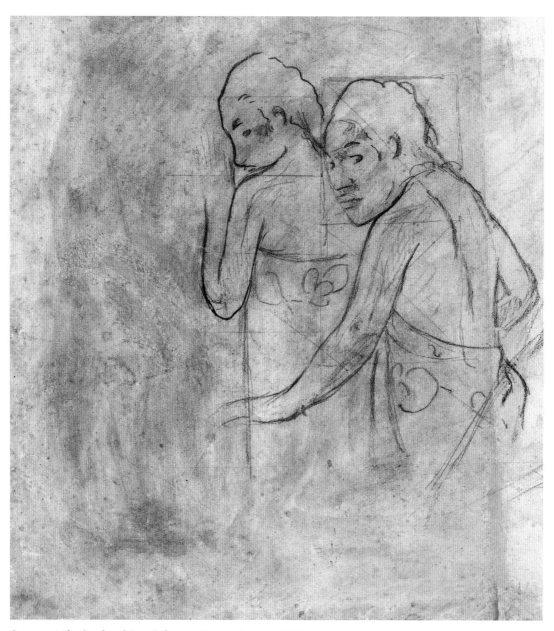

Cat. no. 93b. *Study of Two Tahitian Women* (verso), 1896
Black chalk
Private Collection

Cat. no. 94. *Three Tahitian Women,* 1896
Oil on wood
The Metropolitan Museum of Art, New York, The Walter H. and Leonore Annenberg
Collection, Partial Gift of Walter H. and Leonore Annenberg, 1997 1997.60.3

. . . As I wanted to suggest a luxuriant and untamed type of nature . . . I was obliged to give my figures a suitable setting.

. . .

It is indeed the out-of-door life—yet intimate *at the same time, in the thickets and the shady streams, these women whispering in an immense palace decorated by nature itself, with all the riches that Tahiti has to offer. This is the reason behind all these fabulous colors, this subdued and silent glow.*

"Diverses choses," 1896–98, in *Noa Noa,* Musée du Louvre, Paris; Guérin 1978, p. 137

Fig. 48. Paul Cézanne (French, 1839–1906). *Still Life with Apples in a Compote*, 1879–80. Oil on canvas, 18¼ x 21¾ in. (46 x 54.9 cm). Private Collection. Photo by Malcolm Varon, N.Y.C., © 2001

Gauguin spent holidays during the summer of 1891 painting with Pissarro and Cézanne, whose works he began collecting in the 1870s. Of all the paintings in his collection, he regretted most parting with this Cézanne still life, which he kept until 1897.

Look at Cézanne, the misunderstood: an essentially mystical, Oriental temperament. . . .
He is partial to forms that exude the mystery and tranquility of a recumbent man dreaming.
His somber colors are in keeping with the Oriental frame of mind. A man of the Midi, he spends
entire days on mountaintops reading Virgil and gazing at the sky. Thus, his horizons are very
high, his blues very intense, his reds stunningly vibrant. . . .
Letter to Émile Schuffenecker, from Copenhagen, January 14, 1885; Malingue 1946, no. XI

Cat. no. 95. *Still Life with Teapot and Fruit*, 1896
Oil on canvas
The Metropolitan Museum of Art, New York, The Walter H. and Leonore Annenberg
Collection, Partial Gift of Walter H. and Leonore Annenberg, 1997 1997.391.2

*Everything I do springs from my wild imagination. And when I am tired of painting human figures
(my favorite subject), I begin a still life, which I finish, by the way, without a model.*

. . . I had a collection of all *the Impressionists that I bought at very low prices. . . . It includes
twelve Cézannes.*

Letter to Ambroise Vollard, from Tahiti, January 1900; Guérin 1978, pp. 204–5

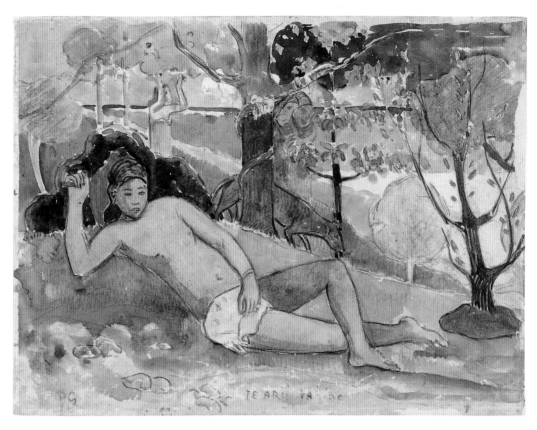

Cat. no. 96. *Te Arii Vahine (The Queen of Beauty)*, ca. 1896–97
Watercolor, gouache, and pen and ink over graphite
Thaw Collection, The Pierpont Morgan Library, New York

I have just finished a canvas of 1.30 by 1 meter [now in the Pushkin State Museum of Fine Arts, Moscow] *that I believe to be much better than anything I've done previously: a naked queen, reclining on a green rug, a female servant gathering fruit, two old men, near the big tree, discussing the tree of science; a shore in the background: this light trembling sketch only gives you a vague idea. I think that I have never made anything of such deep sonorous colors. The trees are in blossom, the dog is on guard, two doves at the right are cooing.*

<div align="right">Letter to Daniel de Monfreid, from Tahiti, April 1896; Joly-Segalen 1950, no. XXI</div>

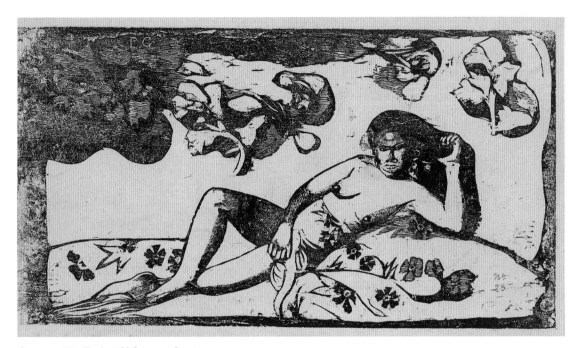

Cat. no. 97. *Te Arii Vahine—Opoi*
(The Queen of Beauty—Tired), 1898
Woodcut
The Metropolitan Museum of Art, New York,
Harris Brisbane Dick Fund, 1926 26.47

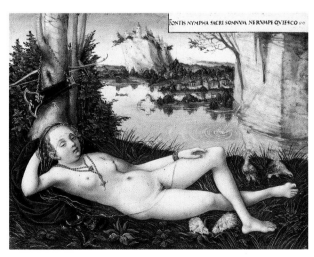

Fig. 49. Lucas Cranach the Younger (German, 1515–1586). *Nymph of the Spring*. Oil on wood, 6 x 8 in. (15.2 x 20.3 cm). The Metropolitan Museum of Art, New York, Robert Lehman Collection, 1975 1975.1.136

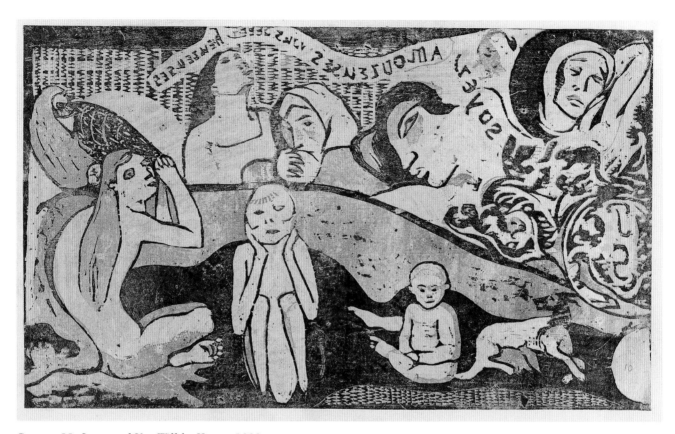

Cat. no. 98. *Love, and You Will be Happy*, 1898
Woodcut
The Honorable Samuel J. and Mrs. Ethel LeFrak / S-R Art Investors, LLC

*. . . woman, who is after all our mother, our daughter, our sister, has the right to
earn her living.*

Has the right to love whomever she chooses.

Has the right to dispose of her body, of her beauty.

*Has the right to give birth to a child and to bring him up—without having to go
through a priest and a notary public.*

*Has the right to be respected just as much as the woman who sells herself only in
wedlock (as commanded by the Church) and consequently has the right to spit in
the face of anyone who oppresses her.*

An essay, ca. 1902; Guérin 1978, p. 178

Cat. no. 99. *Letter to Daniel de Monfreid, from Papeete, Tahiti, November 1898*
Pen and ink
The Pierpont Morgan Library, New York, Gift of John Rewald, 1986 MA 4360

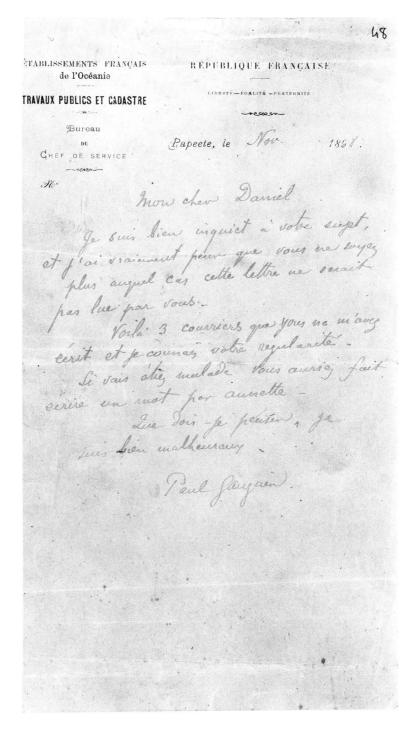

Nov. 1898 / Dear Daniel, / I'm very worried about you, and am very afraid you're no longer alive, in which case this letter won't be read by you. / There have been three mail deliveries since you wrote me last and I know how regular you are. / If you were sick you'd have had Annette send word. / What should I think, I'm very unhappy. / Paul Gauguin
[Letterhead: French Company of Oceania, Public Works and Cadastre, Office of the Department Manager, Papeete, French Republic, Liberty–Equality–Fraternity]

Cat. no. 100. *Women, Animals, and Foliage,* 1898
Woodcut
The Honorable Samuel J. and Mrs. Ethel LeFrak / S-R Art Investors, LLC

Next month I am sending, by someone who is traveling to France, about 475 woodcuts—25 to 30 numbered prints have been made from each block, and the blocks then destroyed. . . . They should be profitable to a dealer, I think, because there are so few prints of each. I am asking 2500 francs for the lot, or else 4000 francs if sold by the piece. Half the money at once and the balance in three months.

Letter to Ambroise Vollard, from Tahiti, January 1900; Malingue 1949, no. CLXXIII

(misattributed as to Emmanuel Bibesco)

Cat. no. 101. *Eve*, 1898–99
Woodcut
The Metropolitan Museum of Art, New York,
Harris Brisbane Dick Fund, 1936 36.7.4

Women want to be free. That is their right. And it is certainly not men who stand in their way.
The day a woman's honor is no longer located below the navel, she will be free.
"Cahier pour Aline," Tahiti, begun December 1892; Bibliothèque d'Art et d'Archéologie, Paris

Cat. no. 102. *Tahitian Carrying Bananas,* 1898–99
Woodcut
The Metropolitan Museum of Art, New York, Harris Brisbane Dick
Fund, 1930 30.66

*Food can certainly be found—in the trees, in the mountains, in the sea, but you have to know how
to climb up a tall tree, how to go into the mountains and come back bearing heavy burdens, how to
catch fish. . . . So there I was, I, the civilized man, for the time being far inferior to the savage . . . on
an empty stomach, . . .*

<div align="right">

Noa Noa, late 1893; Guérin 1978, p. 81

</div>

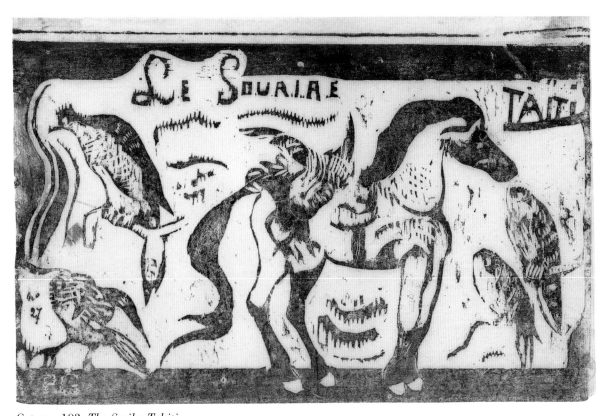

Cat. no. 103. *The Smile: Tahiti*
Published in *Le sourire*, December 1899
Woodcut
The Metropolitan Museum of Art, New York,
Harris Brisbane Dick Fund, 1936 36.11.9

I think man is inclined to playfulness at certain times, and childish things are far from detracting from serious work; they imbue it with gentleness, gaiety, and naïveté. . . . As for myself, my art goes way back, further than the horses on the Parthenon—all the way to the dear old wooden horsie of my childhood.

"Diverses choses," 1896–98, in *Noa Noa*, Musée du Louvre, Paris; Guérin 1978, p. 127

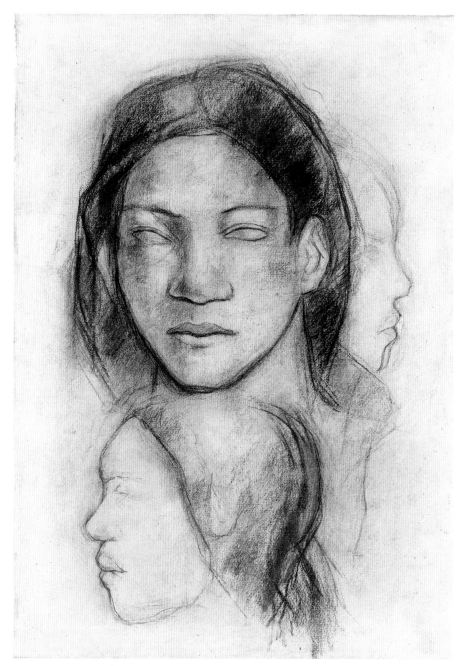

Cat. no. 104. *Tahitian Faces (Frontal View and Profiles)*, ca. 1899
Charcoal
The Metropolitan Museum of Art, New York, Purchase, The Annenberg Foundation Gift, 1996
1996.418

. . . I have never been able to do a drawing properly, never learned how to handle a stump and a piece of dough. I always feel that something is missing: color.

 Before me, the face of a Tahitian woman. The blank paper bothers me.

<div align="center">. . .</div>

. . . A critic who comes to my house sees my paintings and, breathing hard, asks to see my drawings. My drawings! Not on your life. They are my letters, my secrets.

<div align="right">Memoirs, 1902–3, published as Avant et après, 1923; Guérin 1978, pp. 267, 268</div>

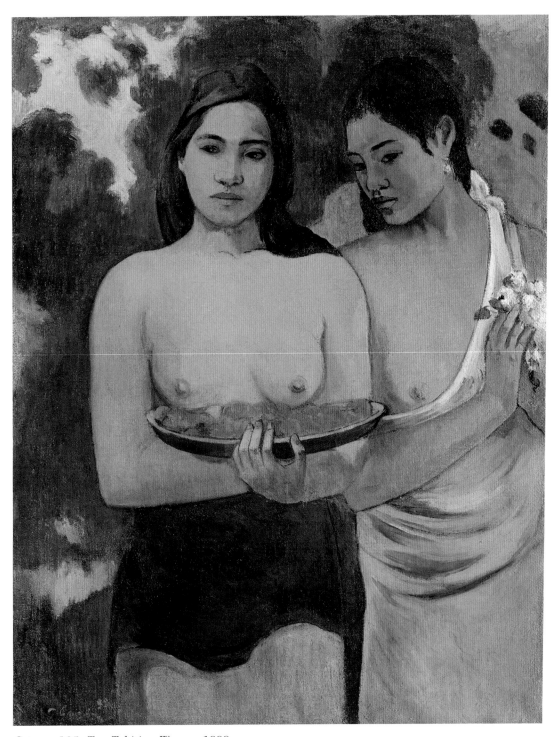

Cat. no. 105. *Two Tahitian Women*, 1899
Oil on canvas
The Metropolitan Museum of Art, New York, Gift of William Church Osborn, 1949 49.58.1

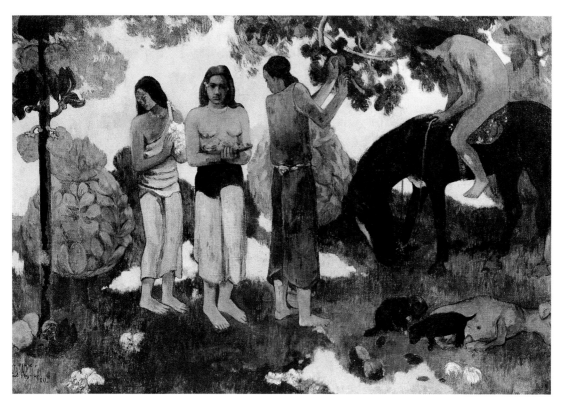

Fig. 50. *Rupe Rupe (Luxury)*, 1899. Oil on canvas, 50½ x 78¾ in. (128 x 200 cm). The Pushkin State Museum of Fine Arts, Moscow

Here, near my hut, in total silence, I muse on violent harmonies amid the intoxicating fragrances of nature. . . . The fragrance of a bygone joy I breathe in the here and now. Animal figures, as rigid as statues; something indescribably ancient, august, religious in the rhythm of their pose, in their singular immobility. In dreaming eyes, the blurred surface of an unfathomable riddle.

Then night comes on—all is at rest. My eyes close, to *see without comprehending the dream in the infinite space before me, and I can sense the plaintive progression of my hopes.*
Letter to André Fontainas, from Tahiti, March 1899; Malingue 1946, no. CLXX

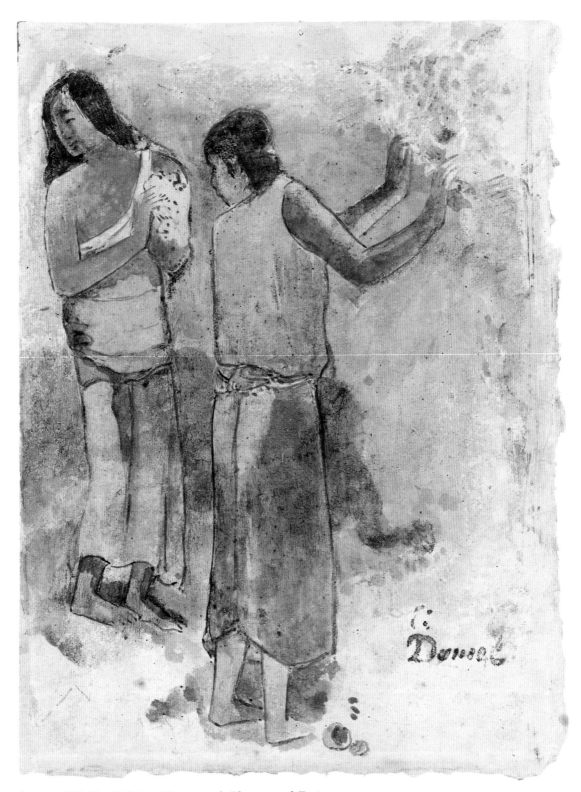

Cat. no. 106. *Two Tahitian Women with Flowers and Fruit,*
ca. 1899
Watercolor monotype with additions in watercolor and gouache
Mr. and Mrs. Richard M. Thune

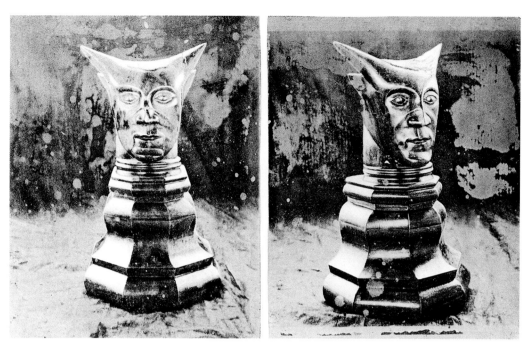

Fig. 51. Jules Agostini. Two views of the *Head with Horns*, carved by Gauguin before January 1898. Photograph pasted by Gauguin on page 56 of the *Noa Noa* manuscript. Musée du Louvre, Paris

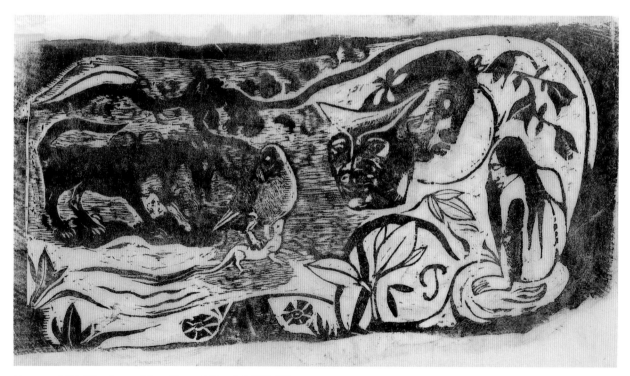

Cat. no. 107. *Woodcut with a Horned Head*, 1898–99
Woodcut
The Metropolitan Museum of Art, New York, Harris Brisbane Dick
Fund, 1936 36.7.3

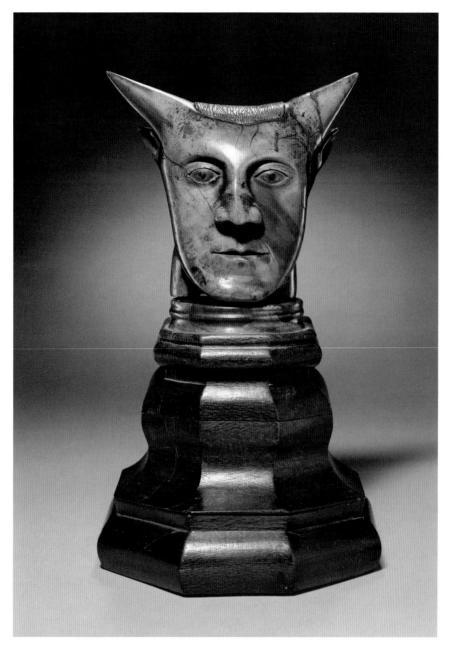

Cat. no. 108. *Head with Horns,* ca. 1895–97
Carved wood, mounted on a pedestal
Private Collection

You were mistaken in telling me one day that I was wrong to say that I am a savage. The fact is that I am a savage. And civilized people sense this. In my work there is nothing that can surprise or disconcert, except the fact that I am a savage, in spite of myself. That's also why my work is inimitable.

Letter to Charles Morice, from Hiva Oa, April 1903; Malingue 1946, no. CLXXXI

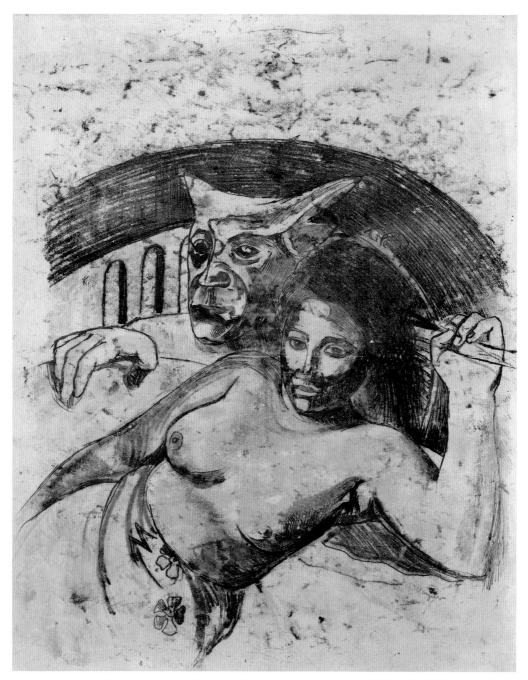

Cat. no. 109a. *Polynesian Beauty and Evil Spirit* (recto), ca. 1900
Transferred drawing in black ink and *essence*
Private Collection

*Right now I have a series of experimental drawings that I am pretty pleased with and I am
sending you a very small example; it's like an impression and yet it isn't. I use heavy ink
instead of pencil, that's all. . . .*

. . .

*. . . no one wants my painting because it is different from other people's—peculiar, crazy
public that demands the greatest possible degree of originality on the painter's part yet won't
accept him unless his work resembles that of the others!*

Letter to Ambroise Vollard, from Tahiti, January 1900; Guérin 1978, pp. 204, 205

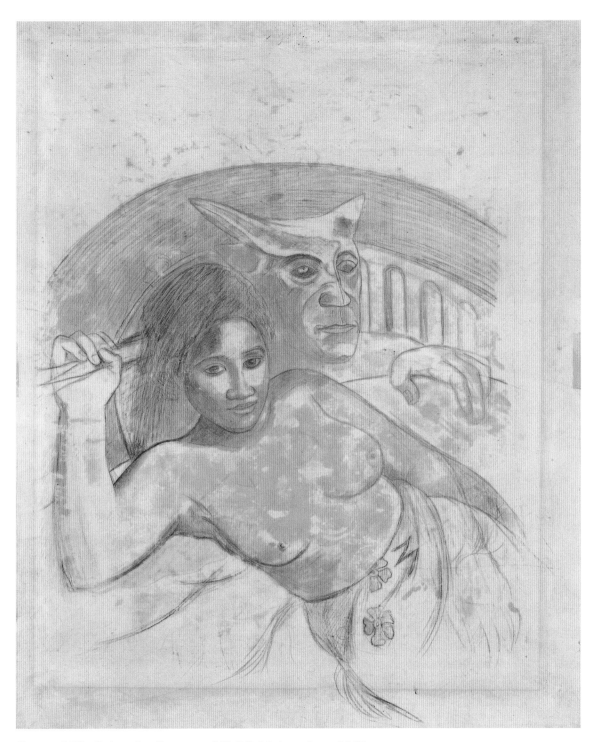

Cat. no. 109b. *Polynesian Beauty and Evil Spirit* (verso), ca. 1900
Drawing in fabricated black crayon, graphite, and blue wax crayon

Fig. 52. Mt. Temetiu and the bay at Atuona, Hiva Oa, Marquesas Islands

Fig. 53. Bronze cast of Gauguin's *Oviri (Savage),* mounted on his grave site, as the artist requested, Atuona, Hiva Oa, Marquesas Islands

Fig. 54. Ipona, *meae* (sacred site), at Puamau, Hiva Oa, with Takaii, the largest tiki in the Marquesas

GAUGUIN IN THE MARQUESAS: HIVA OA, 1901–3

Gauguin's attraction to the Marquesas was no doubt due to their remote situation and fabled, savage state. The twenty or so islands of the group, which rise sharply out of the Pacific midway between Australia and South America, are the most isolated points of land on earth. In other words, they are farther away from anywhere than is any other place. Oral tradition has it that they were born of the copulation of ocean and sky.

One wonders if Gauguin realized that the islands had been named by Spanish sailors in 1595, after the viceroy of Peru, land of his family and early childhood. Until the early nineteenth century there were few foreign visitors to the Marquesas, and then the sandalwood trade and whaling brought ships from around the world. Just a year before the French annexed the archipelago in 1842, a whaler deserter, Herman Melville, was temporarily held captive there by the tribe after which he named his book *Typee* (1846). The Pacific's most celebrated literary beachcomber, Robert Louis Stevenson, also preceded Gauguin to the islands.

A history of violence that included cannibalism and rebellion against foreigners shaped the reputation of the Marquesas and probably, so far as Gauguin was concerned, increased their allure. He had been in Tahiti for less than a year when he voiced a desire to move to the islands, which he imagined would be less expensive and less civilized than his current stopping place, yet still capable of revealing the origins and essence of Polynesian culture. The arts of the outer islands had evidently been introduced to him before he set off for the archipelago, for there survives a copy of a Marquesan ear ornament that he drew during the first part of his Tahitian stay, and motifs from Marquesan carvings appear in his ironwood sculpture *Idol with a Shell*, made in Tahiti, and in his woodcut *Nave Nave Fenua (Delightful Land)*, (see cat. nos. 80–82). done later in Paris. His contemporaneous sketches of Marquesan sculpture, carved bowls, war clubs, and also tattoos were probably copied from photographs, illustrations, or both.[1] Gauguin's application for a vacant civil service post in the islands was refused in February 1892, but a letter he wrote to his wife the following summer still held out hope that he would be able to move there. Not until his request for repatriation was granted in early November of that year did Gauguin change direction and prepare to head back to France.[2]

Apparently reminded of his former disillusionment with Tahiti, Gauguin announced almost immediately upon his return to the South Pacific in September 1895, that he intended to leave straightaway for the Marquesas.[3] But it was not until six years later that he finally stepped aboard *Le croix de sud* on a weeklong sailing trip over 750 miles that would deliver him to his last outpost. "In the Marquesas, where . . . there are . . . completely new and wilder elements with entirely new and primitive sources of inspiration, I shall do fine things," he optimistically wrote. "My imagination was beginning to go cold . . . and, also, the public was getting too used to Tahiti, [which] will become comprehensible and charming. My paintings of Brittany are now like so much rosewater because of Tahiti; Tahiti will become so much eau de cologne after the Marquesas."[4]

In fact, the frequent bouts of illness exacerbated by chronic syphilis that Gauguin had suffered in recent years had taken their toll. He needed a quieter, simpler life. "I am laid low these days, defeated by poverty and especially the disease of a premature old age. Shall I have some respite to finish my work? . . . I am making one last effort by moving . . . to . . . a still almost cannibalistic island in the Marquesas. . . . There, I feel, completely uncivilized surroundings and total solitude will revive in me, before I die, a last spark of enthusiasm which will rekindle my imagination and bring my talent to its conclusion."[5]

In many ways the islands where Gauguin made his new home were in no better shape than he was. Contact with outsiders had not been healthy for the Marquesans,

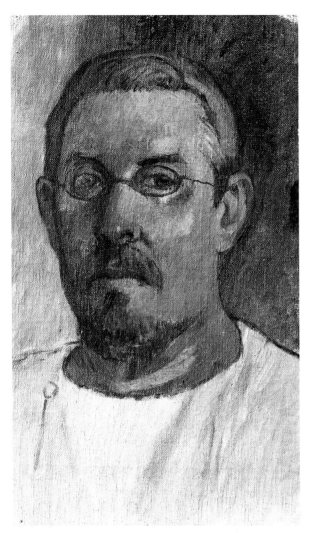

Fig. 55. *Self-Portrait*, 1903. Oil on canvas, 16¼ x 9½ in. (41.5 x 24 cm). Kunstmuseum Basel 1943

whose population had fallen catastrophically from an estimated peak of eighty thousand to fewer than three thousand people at the time the artist arrived. It was feared that the natives were in danger of extinction, and even the Catholic and Protestant missionaries, who both maintained a forceful presence, seemed powerless to save them. One imagines, nonetheless, Gauguin's deep contentment in settling on the sultry, fertile island of Hiva Oa with its lofty, volcanic peaks and lush valleys. Not since his time in Britanny had he seen such harshly magnificent terrain. The wild, dramatic vistas, often veiled in clouds and mist, were sublime. Like the dizzying mountainscapes of Chinese scrolls, although perhaps too dreamy, they were not to be subject to Gauguin's art.

Hampered by difficulty in walking, Gauguin got around with the help of a horse and cart, but he probably spent most of his time right in the tiny village of Atuona, where he built his house on stilts. Around his front door he installed wooden reliefs carved with nude women, animals, and the salacious name for his abode, Maison du Jouir (House of Pleasure), designed to irritate the local clergy. Despite the severity of his illnesses, he made the most of his final eighteen months, with a productive burst of painting, sculpting, drawing, and writing.

His Marquesan paintings have a wistful, searching quality. They are generally simpler and more rapidly done than works carried out in Tahiti; two oils of women are based on photographs, perhaps evidence that the artist could not always find models when and where they were needed. The island's tribe of horses inspired brilliantly colored processions of riders on the beach at sunset, when the black volcanic sands glowed pink. As he had always done, Gauguin gave rein to memory and imagination, without reference to landmarks, although he once slipped into a picture the image of the tall white cross that stood on the hill overlooking Atuona, where eventually he was buried.

Often unable to stand at his easel, Gauguin as an alternative to painting sometimes turned to writing down his ruminations on life and religion: *L'esprit moderne et le catholicisme* (Modern thought and Catholicism); the conclusion of his essay on the nature of art (published in 1951 as *Racontars de Rapin* [A dauber's gossip]); and his memoirs, which he introduced as "scattered notes, unconnected, like dreams, like life" and entitled *Avant et après* (Before and after), in reference to his break with European life. In Atuona, he found his third young Polynesian "wife," Vaeohoa, and fathered his fourth Polynesian child.

Aside from these creative activities, Gauguin enjoyed challenging colonial authority at every turn, representing the natives' grievances, refusing to pay his taxes, and encouraging others likewise to ignore regulations, such as those that required the local children to attend the church-run schools. At times he became so discouraged that he considered returning to France or making a new beginning in Spain. But to any such suggestion of a homecoming, his old friend Daniel de Monfreid was decidedly negative, warning the artist that by his exile Gauguin was "enjoying the immunity of the great departed" and had

already "passed into the *history of art*."[6] After a cyclone hit the Marquesas in January 1903 and when, a short time later, he was found guilty of defamation, fined, and sentenced to a month in prison, Gauguin's resistance gave out. He had pasted his reproduction of Dürer's *Knight, Death, and the Devil* into his memoirs and arranged for its posting to Paris, when he died on May 8.

A bronze cast of the ceramic statue *Oviri* that he had asked be placed on his grave in Atuona was finally installed there in 1973. His own brief self-assessment might have served as his epitaph: "I feel that where art is concerned I am right . . . and even if my works do not endure, there will always be the memory of an artist who set painting free"[7]

Artists have lost all their savagery, all their instincts, one might say their imagination, and so they have wandered down every kind of path in order to find the productive elements they hadn't the strength to create; as a result, they . . . feel frightened, lost as it were, when they are alone. That is why solitude is not to be recommended to everyone, for you have to be strong in order to bear it and act alone. Everything I learned from other people merely stood in my way. Thus I can say: no one taught me anything. On the other hand, it is true that I know so little! But I prefer that little, which is of my own creation. And who knows whether that little, when put to use by others, will not become something big? . . .
Letter to Charles Morice, from Atuona, Hiva Oa, Marquesas Islands,
April 1903; Guérin 1978, p. 294

. . . I always had a fondness for running away; in Orléans, when I was nine years old, I took it into my head to run away into the forest . . . with a handkerchief filled with sand on the end of a stick I carried over my shoulder.

I had seen a picture which appealed to me, showing a vagabond with his stick and his bundle over his shoulder. Watch out for pictures. . . .
Memoirs, 1902–3, published as *Avant et après*, 1923; Guérin 1978, p. 233

Fig. 56. Jules Agostini or Henri Lemasson. *Two Women*, ca. 1894.
Papeete Museum, O'Reilly Collection

. . . no Maori woman could appear badly dressed and ridiculous, even if she wanted to; she has
the innate sense of decorative beauty that I admire in Marquesan art now that I have studied it.
<div align="right">

Memoirs, 1902–3, published as *Avant et après*, 1923; Guérin 1978, p. 281

</div>

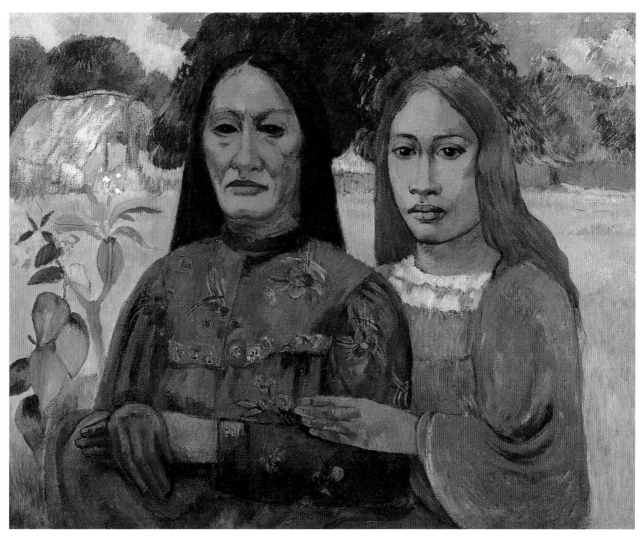

Cat. no. 110. *Two Women*, ca. 1901–2
Oil on canvas
The Metropolitan Museum of Art, New York, The Walter H. and Leonore Annenberg
Collection, Partial Gift of Walter H. and Leonore Annenberg, 1997 1997.391.3

*My life in the Marquesas is that of a recluse living far from the road, disabled and working
away at my art, speaking not one word of the Marquesan language, and only very rarely
seeing a few Europeans who come by to say hello. Often it's true, the women come to see me for
a minute, but because they're curious about the photographs and drawings hung on the walls
and especially because they want to try to play my harmonium.*
 Letter to the lieutenant of the Gendarmerie, from Hiva Oa, late April 1903; Guérin 1978, p. 293

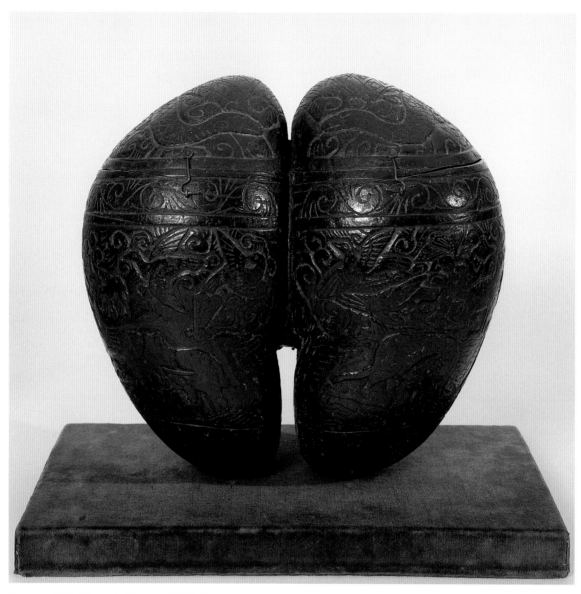

Cat. no. 111. *Coco de Mer*, ca. 1901–3
Carved double coconut
Albright-Knox Art Gallery, Buffalo, New York,
A. Conger Goodyear Fund, 1964 1964:3

The Marquesans especially have an extraordinary sense of decoration. Give a Marquesan an
object of any geometric shape, even hump-backed, rounded geometry, and he will manage to
make everything harmonious without leaving any shocking and disparate empty place.
 Memoirs, 1902–3, published as *Avant et après*, 1923; Guérin 1978, p. 280

Cat. no. 112. *Te Fare Amu (House for Eating)*, ca. 1901–2
Carved wood relief, painted
The Henry and Rose Pearlman Foundation, Inc.

*. . . I have been good sometimes; I do not
pride myself on it. I have often been wicked;
I do not repent of it.*

 Memoirs, 1902–3, published as *Avant et
 après*, 1923; Guérin 1978, p. 268

Cat. no. 113. *Three Polynesians and
a Peacock*, ca. 1902
Transferred drawing in gouache
Private Collection

Cat. no. 114. *Marquesan Landscape with a Horse,* 1901
Oil on canvas
Private Collection

Think of the musical role color will henceforth play in modern painting. Color, which is vibration just as music is, is able to attain what is most universal yet at the same time most elusive in nature: its inner force.
Letter to André Fontainas, from Tahiti, March 1899; Malingue 1946, no. CLXX

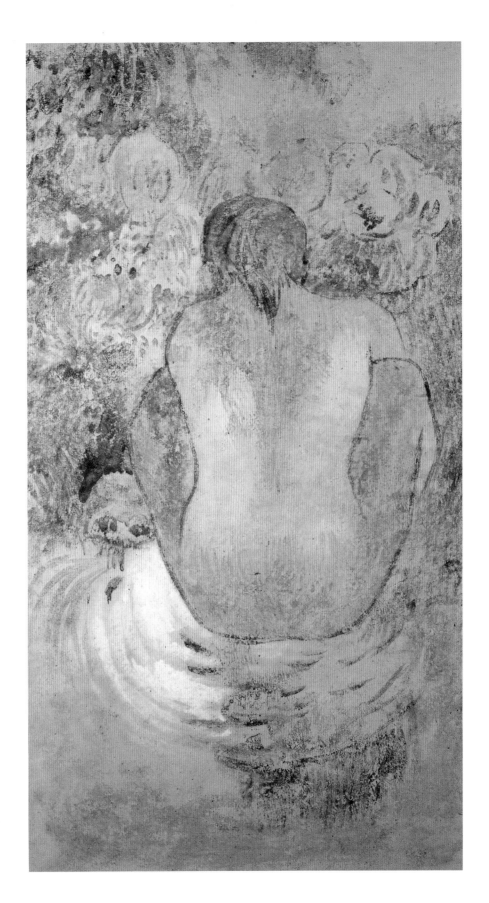

Cat. no. 115. *Crouching Nude Woman, Seen from the Back,* ca. 1902
Watercolor monotype with additions in gouache
Thaw Collection, The Pierpont Morgan Library, New York

February 1903

Mr. Brault

As soon as I arrived in the Marquesas, I wrote the governor that, having only one legal means
*of protesting, I will not pay my taxes twenty-four francs and allocations so long as our custom
fees are not included in our budget—*

*My property has been seized to pay that debt and here are the objects listed—A horse, a
brand-new carriage, a hunting rifle and . . . four statues sculpted out of rosewood—*

*Let me mention that not only do I still have a lot of other valuable personal property in my
house but also that the objects seized represent ten times the value of what is owed—*

How, then, to explain the seizure of my sculptures if not as the malicious desire *to try to
depreciate them by putting them up for sale on an* unestablished *art market. I also thought
that what constituted* my livelihood paintings and sculptures could not be seized especially

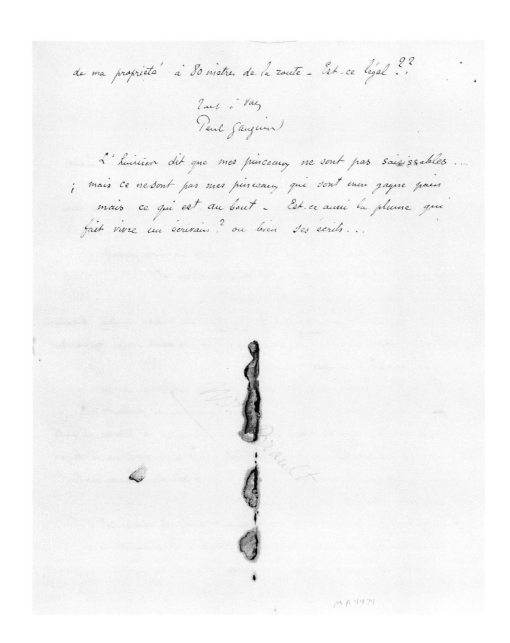

when *there are other valuables nearby sufficient to cover the debt.*

I wish you'd tell me the exact regulations *on seizure and if there might not be any way for me to file a complaint with the administration—*

In addition to the notices displayed on trees next to the fence along the street, a notice was put up on my property, eighty meters from the road—Is that legal??

All the best, Paul Gauguin

P.S. The process server says my paintbrushes can't be seized but it's not my paintbrushes that are my livelihood but what's at the end of them. Is it also the pen that provides for the writer? Or rather the writings . . .

FROM THE BEGINNING: COLLECTING AND EXHIBITING GAUGUIN IN NEW YORK

SUSAN ALYSON STEIN

> *My painting arouses a lot of discussion and I must say that Americans rather like it.*
> *That's some hope for the future.*
>> Gauguin, letter to his wife, Mette, from Pont-Aven, ca. July 25, 1886;
>> Merhlès 1984, no. CVII; Guérin 1978, p. 16

Little did Gauguin know how prophetic his words were. There was good reason, as the present exhibition amply demonstrates, for him to be optimistic about his future success in America. Yet that success was hardly imminent in 1886, when American painters working in Pont-Aven bolstered his spirits. Indeed, it was not until a quarter of a century later—after Gauguin's place in the history of art as one of the "great dead" had been assured—that his genius came to be appreciated by collectors on this side of the Atlantic. This essay looks at a subject that has never been studied: how Gauguin, whose works are so richly represented in New York today, became known and appreciated by an ever widening public.

> *A time will come when people will think I am a myth, or rather something the*
> *newspapers have made up; and they will say: "Where are those paintings?"*
>> Gauguin, letter to Daniel de Monfreid, from Tahiti, October 1897;
>> Guérin 1978, p. 125

PRELUDE TO THE ARMORY SHOW

Gauguin's talent and his temperament, his initiatives and his exploits, and his indomitable presence on the Paris art scene as well as his mythic absence from it had made him a legendary figure in his own time. His fame quickly grew in the years immediately after his death. Posthumous tributes held in Paris in 1903 and 1906 and elsewhere in Europe shortly thereafter revealed the full magnitude of his vision for the emergent Fauves, Cubists, and Expressionists, while collectors from Germany and Russia, rivaling his earliest admirers in France and Scandinavia, carried off his works in great numbers.

Gauguin soon came to interest the close-knit New York art world, as reports filtered back from travelers abroad and from expatriate American artists and intellectuals in Paris. Many Americans were introduced to Gauguin's work at the famous rue de Fleurus apartment of the pacesetting patrons of modern art Gertrude and Leo Stein (fig. 57), who in late 1904, well

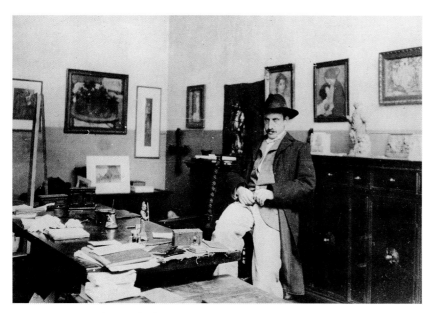

Fig. 57. Leo Stein in his rue de Fleurus apartment, Paris, ca. 1906. Gauguin's *Sunflowers* (W 602) is the second painting from the left. Photograph, The Baltimore Museum of Art, The Cone Archives

in advance of their compatriots, acquired two of his paintings.[1] "Monet is not the only one," wrote American painter Morgan Russell to his colleague Andrew Dasburg, apropos his visit to the Steins in 1908, "wait till you get acquainted with Gauguin, Cézanne, and the younger men, Matisse, etc."[2] Intimates of the Stein circle included Chicago heiress Emily Crane Chadbourne, who owned at least seven Gauguin drawings by 1910[3]—four of which she lent to the Armory Show of 1913—and the brilliant critic and coorganizer of that exhibition, Walter Pach, who returned to New York from a two-year sojourn in Paris an admirer of Gauguin's work. "I wish to know more of this true artist, who has the spiritually enlarging vision," he confided to painter Arthur B. Davies, with whom he would orchestrate the Armory Show.[4]

There were ample opportunities to see Gauguin's work in Europe at any of a number of group and solo exhibitions held in forty-six venues in fifteen different cities during the period 1903 to 1912. Paintings were also regularly on display at the galleries of the dealers Ambroise Vollard and Eugène Druet in Paris—it was at Druet's, for example, that Bryson Burroughs, curator of the Metropolitan Museum, admired a Brittany landscape in 1909.[5] Word of Gauguin's art reached New York, through letters and conversation, a few brief notices in the press, and, in the case of Metropolitan officials, through the first of Burroughs's two ill-fated proposals that the Museum acquire one of his paintings.

Fuller assessments of Gauguin's work appeared in books newly translated into English. These ranged from the two-page-long and halfhearted musings of French critic Camille Mauclair's *French Impressionists* of 1903 to the more inspired *Modern Art* of 1908 by the German art historian Julius Meier-Graefe. In a collection of essays, *Promenades of an Impressionist,* published in 1910, James Gibbons Huneker, critic for the *New York Sun,* became the first American writer to devote a chapter-length study to him. Huneker brought both his experience, which dated back to a visit to the 1893 Gauguin exhibition at the Galerie Durand-Ruel in Paris, and his spirited perceptions to the task of describing a "bold initiator . . . who shipwrecked himself in his efforts to fully express his art."[6]

Gauguin's reputation as a "bold initiator" grew by the winter of 1910–11, owing to the sensation caused by the landmark exhibition *Manet and the Post-Impressionists,* held that season at the Grafton Galleries in London. Widespread coverage by the New York dailies of

this controversial event stimulated a keen interest in the works of Gauguin and other artists, who had become known as the "Post-Impressionists" as soon as the show's organizer, Roger Fry, coined the term. No doubt some of the exhibition's noteworthiness, if not cachet, in New York stemmed from the fact that Fry, the new bête noir of the art world, was well known to New Yorkers as a curator of the Metropolitan Museum from 1906 to 1907.[7] Quite a buzz was created: sundry details were reported by the press of bewildered viewers and of train stations plastered with posters of "a Tahitian native woman . . . from the brush of Gauguin,"[8] and lengthy debates enlivened the pages of American journals. All of a sudden the Post-Impressionists—for whom photographer Alfred Stieglitz had long tried to gain recognition through his gallery 291—became topical, engaging the attention of a wide circle of readers and writers alike. From Stieglitz's perspective all the talk about Post-Impressionism was idle chatter. He complained, "People talk about it and critics write about it, who have seen nothing at all."[9] The leading question became "When are Americans to have a fair chance to judge of these painters?"[10] The Armory Show was, in effect, the response.

I exhibit my works . . . and they cause a real sensation but people are very reluctant to buy them. When that will come I can't say, but what I can say is that today I am one of the artists who astonish people the most. . . .
Gauguin, letter to Mette, from Le Pouldu, late June 1889; Guérin 1978, p. 27

My exhibition did not actually achieve the result that was expected of it. . . . Never mind. The main thing is that my show was a very great success, artistically speaking—it even aroused fury and jealousy. The press treated me in a way it had never yet treated anyone, that is, reasonably and with praise. For the moment, many people consider me the greatest modern painter.
Gauguin, letter to Mette, from Paris, December 1893; Guérin 1978, p. 73

THE ARMORY SHOW

An event that has remained unrivaled in terms of its ambition and impact, the *International Exhibition of Modern Art* (figs. 58, 59), popularly known as the Armory Show, provided the American public (which had more or less ignored all the "isms" that followed in the wake of Impressionism) with a large-scale crash course in modernism. Comprising sixteen hundred works of the late nineteenth and early twentieth centuries, it was displayed at the Sixty-ninth Regiment Armory in New York from February 17 to March 15, 1913. Smaller versions subsequently traveled to Chicago and Boston. The enterprise was undertaken as America's answer to major shows of modern art that had recently taken place in Europe. Indeed, the principal organizers of the event, artists Davies, Pach, and Walt Kuhn, drew upon the lessons of, as well as many of the loans featured in, the Post-Impressionist show held at the Grafton Galleries in London, and the 1912 Sonderbund exhibition in Cologne. The enthusiasm of Kuhn's initial reaction to the Sonderbund exhibition—"great show! Van Gogh and Gauguin great! Cézanne

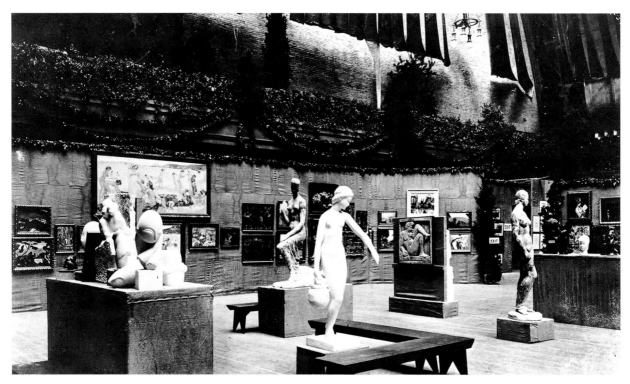

Fig. 58. Installation view, Armory Show, New York, 1913. Photograph by Walter Pach, courtesy of The Museum of Modern Art, New York

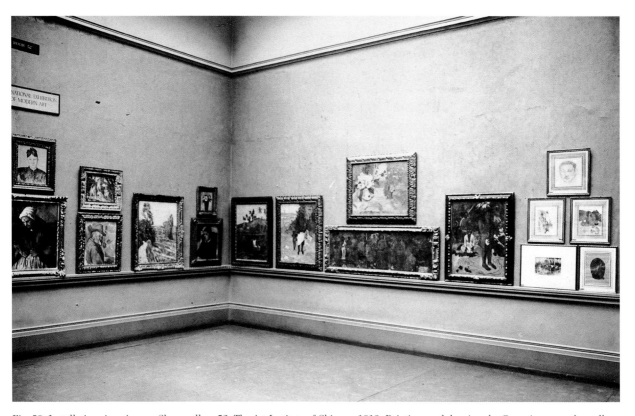

Fig. 59. Installation view, Armory Show, gallery 52, The Art Institute of Chicago, 1913. Paintings and drawings by Gauguin are on the wall at right, left to right: *Under the Palm Trees* (W 444); *Bathers* (fig. 60); top, *Still Life with Japanese Print* (W 375), bottom, *Fa Iheihe* (W 569); *Parau Na Te Varua Ino* (fig. 61); top, *Head of a Tahitian Man;* center, *Pape Moe, Two Tahitian Women in a Landscape;* bottom, unidentified landscape, *Tahitian Child*. Photograph. © 2002 The Art Institute of Chicago. All rights reserved.

154

didn't hit me so hard"—was surpassed by that of his excited comments of some weeks later, as plans for the New York project were taking shape: "Our show is going to be fully as good as the one at Cologne, and that's going some. We already have a better Cézanne and Gauguin collection than Cologne, only in Van G[ogh]'s they beat us."[11]

The Armory Show has been described aptly as "both a culmination and a beginning."[12] This phrase can be applied to the new plateau reached in the appreciation of Gauguin's art in America that was ushered in by the event. The exhibition drew together and encouraged a loose fraternity of admirers who would include the first New York collectors of his work. Appropriately enough, it was John Quinn, affectionately dubbed "the man from New York," who led the way: on the eve of the Armory Show, for which he was legal counsel and a guiding force, he acquired Gauguin's glorious *Bathers* of 1902 (fig. 60).[13]

A brilliant financial attorney who was passionately interested in contemporary Irish literature, Quinn was forty-one when he decided to collect modern art. Almost immediately, inspired by recent European exhibitions and spurred on by his friends critic Huneker and English painter Augustus John, he set out to acquire works by the hallowed trinity of modern masters. In 1912 he bought from the Galerie Vollard the Gauguin *Bathers* along with paintings by Cézanne and Van Gogh. These purchases effectively launched his decade-long patronage of modern art and may be seen as a declaration of ambition. Quinn went on to amass an unparalleled collection of some two thousand works by 151 painters and sculptors that represented the leading avant-garde movements of the first years of the twentieth century.[14]

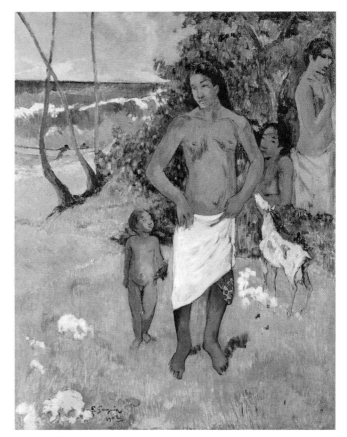

Fig. 60. Paul Gauguin. *Bathers*, 1902. Oil on canvas, 36¼ x 28¾ in. (92.1 x 73 cm). The Wynn Collection, Las Vegas

The "three great dead moderns,"[15] Cézanne, Gauguin, and Van Gogh, were given center stage at the armory, but they did not steal the show. This distinction went to the newer, more startling works of the Cubists, Futurists, and Dadaists, most famously Marcel Duchamp's *Nude Descending a Staircase*. The context may have been imperfect insofar as Gauguin was partially eclipsed by so many competing and exciting modernists. However, the impressive group of Gauguin loans, prominently installed and well publicized, commanded attention. Those among the seventy thousand visitors who stopped in Gallery R were introduced to some of Gauguin's greatest achievements as a painter, owing largely to the pictures contributed by the dealers Vollard (who lent four) and Druet (who lent three as well as a wood carving). Three canvases of 1888–89, including *Still Life with Japanese*

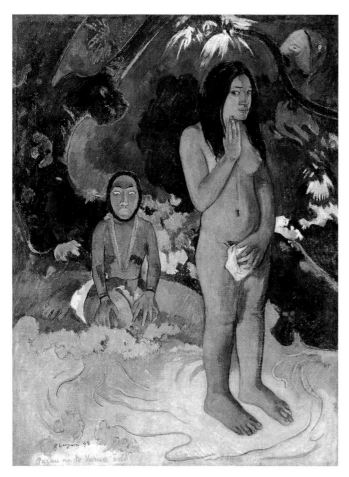

Fig. 61. Paul Gauguin. *Parau Na Te Varua Ino (Words of the Devil)*, 1892. Oil on canvas, 36 x 27 in. (91.7 x 68.5 cm). National Gallery of Art, Washington, Gift of the W. Averill Harriman Foundation in memory of Marie N. Harriman

Print (Tehran Museum of Contemporary Art, W 375) and the equally striking atelier scene the *Schuffenecker Family* (Musée d'Orsay, Paris, W 313), images compelling for their salty wit and inventive *japoniste* design, admirably conveyed the originality of the work he produced in France.[16] A series of paintings traced the evolution of Gauguin's genius as it unfolded during his first and second sojourns in the South Seas. These works drew the most critical attention. They ranged in date and sensibility from the lyrical *Under the Palm Trees* of 1891 (private collection, W 444) and the provocative *Parau Na Te Varua Ino (Words of the Devil)* of 1892 (fig. 61) to the elaborate *Fa Iheihe (Tahitian Pastorale)* of 1898 (Tate Gallery, London, W 569), with its frieze of intertwined bathers and flora, and the limpid Cézannesque *Bathers* of 1902 lent by Quinn.[17] Another Tahitian landscape was lent by Mrs. Alexander Tison (née Annie H. Stevens). Wife of a New York attorney, she was probably a friend of Quinn or Davies, whose works she acquired.[18] Yet like so many of the early collectors of Gauguin's art in New York, she has gone unrecorded in the literature.

A sense of Gauguin's accomplishments in other media was afforded by a wood carving of uncertain merit that came from Druet, four drawings lent by Chadbourne, including the powerful *Head of a Tahitian* executed in black and red chalk (fig. 85a), and a series of prints from the so-called Volpini Suite of 1889.[19] Extracts from the artist's *Noa Noa* were translated by Kuhn and published in a pamphlet sold at the armory. (This colorful narrative account of Gauguin's first stay in Tahiti was, however, banned as "lewd material" in Chicago and removed from sale.)[20]

Though in New York the response to Gauguin's art was mixed and commentary often paraded a fair share of disparaging terms—composing a litany that includes "unskilled," "petulant," "dispiriting," "false," "morbid," "crude," "unbalanced, undisciplined and self-absorbed"[21]—it was in Chicago that his work met a whole new vocabulary of invective, fueled by the moral outrage of a high-school art instructor, a certain W. C. Strauss. "Nasty, obscene, indecent, immoral, lewd and demoralizing were a few of the adjectives [he] used" to describe Gauguin's work, as the Chicago press was quick to report.[22] Gauguin's *Parau Na Te Varua Ino* had the dubious distinction—shared with Seurat's memorable *Models* of 1888

(Barnes Foundation, Merion, Pennsylvania) and with *Loverene* by the now-forgotten New York artist Charlotte Meltzer—of being singled out as one of the three worst offenders. "They are not merely nudes," it was contended, "they are naked pictures, the products of demoralized minds."[23]

Gauguin's work may have sparked no comparable controversy in New York, but it was not free from debate here: the issue, however, was Gauguin's virtuosity rather than his lack of virtuousness. Inveterate academicians contended that he had limited or no talent, and the modernist camp embraced and defended the liberties and excesses of his style. Yet most critics, unwilling to dismiss Gauguin as a charlatan or madman or to herald him as the "Paint God of the twentieth century,"[24] took a stand between the two extremes. Few writers failed to mention the originality of his color, his ambition (whether perceived as fully or only partly manifest), and the crudeness of his technique (whether considered a fault stemming from deficient skill or understood as deliberately realized for its expressive potential). Several critics questioned the sincerity of his expression. James Britton found "it impossible to believe Gauguin sincere. There is so much art in his pattern, and in his dispiriting color."[25] Academic artist Kenyon Cox found Gauguin's work "honest enough" but the product of a "decorator tainted with insanity."[26] Wary of the extent to which Gauguin's celebrity was a function of his artistic innovation or merely of the "glamour cast over his product" by his exotic adventures and picturesque personality, a certain skepticism held sway.[27] In the end, all voices contributed to spirited banter that may have questioned the deservedness of Gauguin's reputation but ultimately did not challenge the simple fact that he was recognized as one of the titans or prophets of modern art. A sense of his importance was already in place even if, as Huneker put it, Gauguin remained "too new, too startling, too original . . . for the majority."[28]

Gauguin's established reputation in Europe did not guarantee his immediate acceptance or a ready clientele in America. His paintings proved a hard sell: culture shock on the part of the many and sticker shock on the part of the enlightened few seem to have kept interest at bay during the run of the show. The eight loans from Vollard and Druet, priced between $4,000 and $8,000, with one tagged as high as $40,000—formidable sums by provincial standards—returned to France unsold.[29] Several would be acquired by American collectors a decade or more later, after enough time had elapsed for them to digest the Armory Show's all-at-once introduction to modern art.

Many of Gauguin's prints (priced at $6 apiece and $27 for a set) did sell, however, and offer a telling gauge of interest from a diverse group. Quinn—called the beneficiary of the show as the lender and buyer of the largest number of works on display—set the pace, acquiring two sets of the Volpini Suite lithographs and a single print from the series for his mistress, Dorothy Coates. Other prints were purchased by Davies; Pach; American artist Allen Tucker; Mary Rumsey (née Harriman), the wife of Beaux Arts sculptor Charles C. Rumsey, daughter of the railroad tycoon E. H. Harriman, and sister of W. Averill Harriman, later the owner of *Parau Na Te Varua Ino;* and Arthur Spingarn, lawyer, cofounder of the NAACP, and amateur of African-American literature. The roster of buyers also includes a trio of illustrious patrons of modern art in America: Walter C. Arensberg, who chose *Design for a Plate* (see cat. no. 23);

Katherine S. Dreier, who bought *Joys of Brittany* (see cat. no. 17); and Lillie P. Bliss, who purchased the *Grasshoppers and the Ants* (see cat. no. 27) and *Martinique Pastorals* (see cat. no. 30). Quinn, Bliss, and Davies went on to collect other works by Gauguin.[30]

Each of these individuals, whether a well-known avant-garde collector, the civil-rights activist Spingarn, or the socially prominent gallery owner Rumsey—who helped found the Junior League, and later held a post in Roosevelt's administration—was an advocate of progressive tendencies in art and/or society. It would be largely among such enlightened intellectuals, many of whom were independent women or foreign born, whose aesthetic tastes ranged outside conventional, genteel culture, that Gauguin and modern artists in general found their earliest American collectors: from Leo Stein in Paris, Albert C. Barnes in Philadelphia, Claribel and Etta Cone in Baltimore, to Quinn, Bliss, Josef Stransky, and Adolph Lewisohn in New York.[31]

When all is said and done, the best way of selling is by keeping quiet, while working on the art dealers.

> Gauguin, letter to Daniel de Monfreid, from Tahiti, February 14, 1897; Guérin 1978, p. 124

I have always said . . . that a dealer could make a great deal of money out of my work. Because, first, I am fifty-one years old and have one of the best artistic reputations in France and other countries, and, having begun to paint very late in life, my pictures are very few in number. . . . So from the standpoint of a dealer it is only a matter of good will and patience.

> Gauguin, letter to Ambroise Vollard, from Tahiti, January 1900; Rewald 1986b, p. 191

IN THE SHADOW OF WAR

After Gauguin's historic debut at the armory, he became almost invisible on the New York art scene. That this changed after World War I owed as much to the resolution of conflict abroad as to the resolute efforts of a few individuals at home. Gauguin found a devoted following among the first champions of modern art in New York. Quinn remained a faithful collector and advocate. Despite his resolve "to buy only the work of living men," he made the occasional exception for Gauguin, acquiring two more pieces by him in 1914 and 1920, and throughout the decade he spearheaded efforts to secure commercial and museum venues for Gauguin's art.[32] Quinn and a coterie of his collector-friends, among them Arensberg, Rumsey, Agnes and Eugene Meyer, and Paul Haviland, provided financial backing and continuing patronage to start-up galleries that featured Gauguin's work.[33] Davies remained a vital presence as adviser to Bliss and through his own relatively modest Gauguin acquisitions (of prints and a painting), as did Pach by means of his efforts as an organizer of exhibitions and adviser to Quinn. These activities helped to advance Gauguin's reputation but were, of course, part of a larger campaign to advance the cause of modernism.

Ultimately it was through the initiative of resourceful dealers—both newly established in New York, such as Bourgeois Galleries and the Modern Gallery, and older firms, including M. Knoedler and Co. and Frederick Keppel and Co. (which began quietly displaying Gauguin's paintings and prints by 1916 and 1921, respectively)—that the artist's works gained entry into prominent collections. Indeed, virtually all the Gauguins acquired by New York collectors immediately after the war were purchased from local dealers, most notably Stephan Bourgeois, Marius de Zayas, and Knoedler.

The Paris-based dealer Stephan Bourgeois, whose family had been in the trade for three generations, moved to New York in 1910. He opened the gallery bearing his name in 1914, confident that "it was only a question of time" before the great French masters "received the attention which is due them" in the United States. After the Armory Show, to which he lent paintings by Cézanne and Van Gogh that found no buyers, Bourgeois confessed his surprise and disappointment at the "lack of public interest" in the "giants" of modern art but also his faith that "what is not understood today, will be tomorrow." He sensed that the tide would turn "some day as it did in Germany" and that eventually "Americans will begin to form interesting collections of modern art."[34] Bourgeois was directly involved in the formation of one of the most interesting of all such collections, as adviser to the great New York collector, financier, and philanthropist Adolph Lewisohn—who acquired four major Gauguin paintings between 1919 and 1928.

An equally decisive role was played by the Mexican-born caricaturist and critic Marius de Zayas. In 1915 he established the Modern Gallery as a commercial offshoot of Stieglitz's 291, for "the sale of paintings of the most advanced character of the Modern Art Movement, Negro Sculpture, pre-conquest Mexican Art, Photography." De Zayas—a Gauguin enthusiast from the start—had hoped to inaugurate a series of exhibitions devoted to the development of modern art "with the work of Gauguin who first introduced into European contemporary art the exotic element." The plans fell through because "Gauguin's paintings of Tahiti were not available . . . at the time."[35] Vollard probably had been unwilling to cooperate;[36] he was notoriously difficult to begin with—"one had to invoke and propitiate the spirits of Machiavelli and others to help perform the miracle of getting him to sell";[37] and, after all, none of the paintings he had lent to the Armory Show had sold. It seems that if Vollard was reluctant to collaborate he was not alone. "In general the dealers are not over anxious to send paintings to America," De Zayas complained in 1919. "You have a better and quicker market in Switzerland, Holland and Scandinavia."[38] Though initially thwarted in his efforts to bring Gauguin's art to New York, De Zayas ultimately prevailed. Not only did he succeed over the next few years in securing a dozen or so of Gauguin's paintings and various drawings, which immediately found their way into New York collections, but, in 1920, he also organized the first one-man show of the artist's works in America.

De Zayas, like Bourgeois and Knoedler, availed himself of new opportunities. Between 1918 and 1919, as a consequence of estate and private sales, the marketplace was enriched by Gauguins that had belonged to some of his closest associates, including the ever-supportive Edgar Degas, the publisher and dealer Michel Manzi, and the Breton innkeeper Marie Henry.

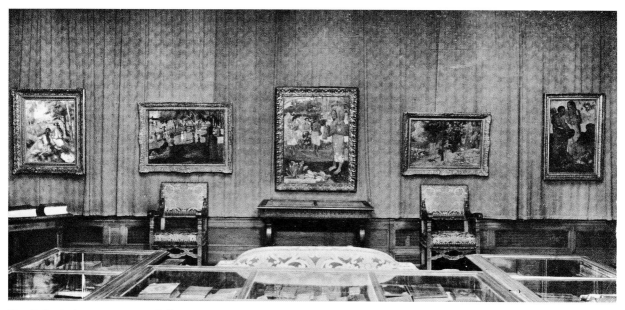

Fig. 62. Lewisohn apartment, 881 Fifth Avenue, New York, ca. 1939. Center to right: *Ia Orana Maria* (cat. no. 55); *Bathers* (W 572); *Maternity* (W 582)

While New York collectors may not have had the gumption to bid for them at auction or to ferret them out of galleries in Paris, they came to own such important paintings by Gauguin as Degas's *Hina Tefatou (The Moon and the Earth)* (cat. no. 70), Manzi's *Ia Orana Maria* (cat. no. 55), and Marie Henry's *Caribbean Woman* (fig. 63)—which were acquired by Bliss, Adolph Lewisohn, and Quinn, respectively—thanks to the savvy purchases that local dealers made abroad and introduced to them at home.

Of the older firms, Knoedler, it seems, was the first to take a gamble on Gauguin, who was represented by a "Head of a Man" in the gallery's January 1916 *Exhibition of Paintings by Contemporary French Artists.* It was one of the rare times his work was featured during the war, but an even more notable occasion came in 1919, when his *Ia Orana Maria* was on display in a back room at Knoedler. As critic Hamilton Easter Field reported to readers of *Arts and Decoration,* the picture "dominated the gallery with its splendor. . . . Some may feel a shock to see the Madonna and Child represented in this way; to me it was a new revelation of the brotherhood of man."[39] By the time Field's piece was published, on December 15, *Ia Orana Maria* was probably no longer on view, having been purchased with keen "excitement" by Adolph Lewisohn. Twenty years later his son Sam, who bequeathed the painting to the Metropolitan Museum in 1951, described the thrill of buying the family's first Gauguin (three more would be acquired soon thereafter) and the not-always-enlightened response of visitors who saw it at their Fifth Avenue apartment (fig. 62). He recalled, "The feature of the painting that worried most of our friends was the size of the feet of the natives depicted. There were long arguments whether Tahitians actually had large feet, and the highly decorated aesthetics, the Sabbath calm of the painting, were largely ignored."[40] With this purchase, postwar collecting of Gauguin's art by New Yorkers had begun in earnest.

How right you are about the notoriety to be gained from the press! A clear conscience first of all, and the esteem of a few people, the aristocrats who understand: beyond that, there is nothing.

Gauguin, letter to Daniel de Monfreid, from Hiva Oa, November 1901; Guérin 1978, p. 211

AN "AWAKENED AND NOT ALWAYS ENLIGHTENED INTEREST IN GAUGUIN"

In the years after the Armory Show, Gauguin's reputation had advanced at a slow but steady pace through the efforts of a dedicated few who set the stage for further growth. But real momentum—which indeed catapulted Gauguin to instant fame, or what one critic called the "unfortunate position of a 'matinée idol'"—resulted from the publication of a best-selling novel in 1919.[41] W. Somerset Maugham's *Moon and Sixpence* achieved for Gauguin what Irving Stone accomplished for Van Gogh when his *Lust for Life* hit bookstores (1935) and movie theaters later (1956). "It was an entirely new section of the community that Mr. Maugham awakened to an interest in art."[42]

The phenomenon was widely commented upon by art critics with a mix of bemused awe, cynicism, and scorn. A writer for *The Touchstone* offered one of the more evenhanded accounts: "Today the artistic and literary world of America are remembering Gauguin, not because his work has suddenly been appreciated or because an exhibition of his paintings has been brought to America or because he is better understood and admired. Our awakened and not always enlightened interest in Gauguin has come almost entirely from Somerset Maugham's book 'The Moon and Sixpence,' in which he writes most cleverly and dramatically of the life of a bourgeois Englishman who had made no impression upon his generation or even his family until one day he ran away to France, where he painted violently and furiously without peace or happiness or joy, without clothes or food enough, without a single expression or association that seemed reasonable or normal except the chance to paint."[43]

Critic Henry McBride, with perspective that came from being a veteran admirer of Gauguin's art, brought his canny insight and good humor to the topic. "To those who had vainly talked Gauguin into deaf ears at the time when the colourful canvases hanging in Vollard's shop with 1200-franc price-labels on the best of them were the whole of the story, the easy credit that Gauguin obtained last year with a public that had come to believe him as great an artist as he was ruffian, thanks to Mr. Maugham's novel making the villainy if not the art comprehensible, was not the least of the season's surprises; particularly as this public heretofore has loved only virtuous artists."[44] McBride appreciated the fact that the book, whatever its literary or art historical value, had succeeded in making Gauguin's art accessible to a large public. In a similar vein, a reporter for the *New York Herald* remarked: "It doesn't matter how the public is brought around to the right attitude so long as it is brought around. All the sober exhortations in the world could not have done so quickly what has been accomplished by a cheap and sensational novel."[45] Not all Gauguin enthusiasts were so charitable. Frederick O'Brien (aptly described by one of his contemporaries as a "leading figure in the Tahitian

cult")[46] resented the success of the exploitative British novelist, who had depicted in "hideous tones the general trend of Gauguin's life, and in watery and false colors sketch[ed] the incidents of his residence in Tahiti."[47]

The relationship between fact and fiction became a subject of debate among many writers. Some saw close parallels between the real artist and Maugham's character Strickland. The critic for *Arts and Decoration,* for example, felt there were "striking similarities" between the two and elaborated: "In this composite portrait of the eccentric and unpleasant genius . . . Maugham has undoubtedly put no small part of Gauguin. But . . . this novel is significant because it is so tinctured with the ironic tragedy of all of modern art, of every great artist, struggling against the weight of misunderstanding and Philistinism. . . . Mr. Maugham has with rare insight refrained from softening the brutal aspects of his portrait, at the same time insisting that greatness in art—true greatness—does not necessarily make the 'genius' a kind-hearted father and husband."[48] Another, typically, found "a tremendous difference between Gauguin and Strickland" and wrote that it was the disparity in artistic personality that set the two apart: "I cannot see Gauguin's art as crude or clumsy; I can only see it as immeasurably understanding and sympathetic and loving."[49]

The debate about—and seemingly endless fascination with—the true nature of Gauguin was stimulated, and for some resolved, by the publication in 1919 of Gauguin's letters to Daniel de Monfreid and Charles Morice's biography of the artist. "Gauguin's letters come at the right time to 'prove' the truth of Mr. Maugham's novel," one writer commented. "Reading these letters, one finds no taint of virtue, no glimmer of unselfishness, no flash of kindness, no sudden outburst of wit or intelligence. He lived outside the world of morality and he was no less a stranger to intellectual activity. Like Somerset Maugham's Strickland, he wanted only to paint."[50] A different view of the letters came from the pen of the lofty Royal Cortissoz of the *New York Tribune.* Though he had read the Morice book (pronouncing it "the best literary memorial to the artist which exists") and the Maugham novel (which he thoroughly dismissed) and even the more obscure publications of O'Brien, Cortissoz deigned to comment only on the letters—which he did at considerable length. Summing up his impression of the letters and the sense of Gauguin he gathered from them, Cortissoz wrote: "I behold . . . a painter of modest talent, who from egotism and whim strayed into a strange land, got into a pickle there, and paid a grievous penalty," concluding: "It is doubtful if Gauguin's celebrity . . . will ultimately survive in any serious measure, leaving him more than an interesting minor type. . . . In the long run the letters will be useful in bringing about a proper appraisal. . . . They are compiled, of course, to advance the man's repute. Among readers unbitten by the Gauguin mania they will not altogether do this. To be hard as a stone is not to be really admirable. The letters expose only too vividly a gross and selfish nature. Yet here and there a likable trait peeps out."[51]

Old prejudices died hard, but new interest in Gauguin had awakened on a wide front. Through his own words and those of a novelist, the artist had captured the imagination of the American public and critical attention even from the most unlikely quarters.

While much was written about Gauguin's life and persona, considerably less ink was

spilled on the subject of the artist's first one-man show in America, *Paintings by Gauguin*, held at the De Zayas Gallery in April 1920.[52] The two-week-long exhibition of some thirty works generated only a few short notices in the papers and has since their publication gone unrecorded. Reporters who covered the event did so in light of the recent fanfare. Thus, the *American Art News* critic noted: "The display will doubtless attract unusual attention from the fact that Somerset Maugham, the English author, is thought to have modelled the chief and repulsive character of his widely read and sensational novel 'The Moon and Sixpence' after Gauguin and the artist's life in Tahiti." The same writer also remarked, however, that those "who visit the display with the hope of seeing the works of Gauguin's Tahitian period will be disappointed, as those shown are of his earlier, and by some thought his best and climacteric period."[53] Or, as the *New York Herald* reviewer stated plainly, "The collection now on view in the De Zayas Galleries is almost exclusively of the Brittany period."[54] More specifically, the collection was almost certainly that of Breton innkeeper Marie Henry, which had been featured a year earlier in *Paul Gauguin: Exposition d'oeuvres inconnues* at the Galerie Barbazanges in Paris, having been secured en bloc for exhibition and sale by the dealer.[55]

No catalogue of the De Zayas show has come to light, nor has documentation in the form of gallery records or letters exchanged between De Zayas and Barbazanges regarding the works included. The contemporary reviews, at present, provide the only concrete information about the content of an exhibition that was appraised as a largely shrewd venture by the few critics who noticed it; one, in fact, wrote, "Gauguin has now become as powerful a bait as any art dealer cares to use to attract visitors to his galleries,"[56] while another pointed out that it was of limited appeal since "the little Gauguins have nothing to do with romantic histories . . . that recently [have] swarmed about" the artist.[57] Yet chances are that the timing of the exhibition, though fortuitous, had less to do with Gauguin's new box-office appeal or De Zayas's shrewdness than with the dealer's long-standing desire to have a show of the artist's work and his ability to seize a perfect opportunity once it came along. De Zayas, as noted, had wanted to mount a Gauguin exhibition five years earlier but found no works available. Now, however, there was a group of *oeuvres inconnues*—or unknown Gauguins—with Barbazanges: a ready-made show. Indeed, all the pictures mentioned by title or described in brief in the reviews of the "some 32 examples of the much discussed art of Paul Gauguin . . . shown at the De Zayas Gallery"[58] are listed among the thirty-three works in the 1919 Barbazanges exhibition catalogue. This introduces the intriguing possibility that De Zayas may have borrowed the entire group that debuted at Barbazanges rather than just a portion of it. As such, it would be interesting to know more about the content of the original show. What other pieces could have been sent to New York? The Barbazanges catalogue, typically for its time a no-frills affair—essentially a checklist with a single illustration—does not allow us to solve the riddle altogether, nor does the literature, which provides only a spotty account of the loans.

Nevertheless, the identity of at least a dozen of the works shown by De Zayas can be established with relative certainty. Not all of them are presently attributed to Gauguin. Ironically, New Yorkers whose sense of the artist's personality had come from a novel that

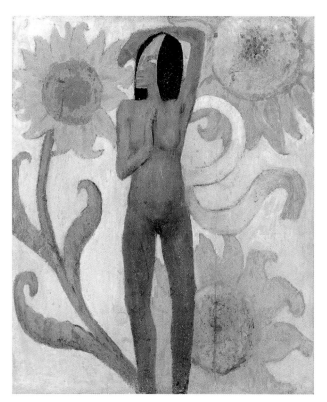

Fig. 63. Paul Gauguin, *Caribbean Woman*, 1889. Oil on wood, 25¼ x 21¼ in. (64.1 x 54 cm). Private Collection. Photograph courtesy of The Art Institute of Chicago

borrowed incidents but few of the inner realities of his life gained from the De Zayas show a somewhat distorted sense of his work from "this decade of the eighties when Brittany and Martinique were struggling for control of Gauguin's talent."[59] Imperfect as the selection may have been, there were notable highlights.

There can be little doubt of the presence in the De Zayas show of Gauguin's striking *Self-Portrait with Halo* (National Gallery of Art, Washington, W 323), reproduced as the frontispiece to the Barbazanges catalogue, for it unfailingly captured reviewers' attention. "The head of Gauguin himself, Saturnine, Parisian, without a hint of the exotic strain supposed to run in his blood," was called "a commanding performance" by the critic for the *New York Times*.[60] Other works, which, like this self-portrait, were known to have adorned Marie Henry's dining room in Le Pouldu, were also noted, from the great *Portrait of Meyer de Haan* (private collection, W 317) to the "frieze of 'Breton Dancers,'" now attributed to Paul Sérusier (private collection), which formed the fireplace lintel.[61] Among the "little Gauguins" remarked upon were charming gouaches that once hung side by side on the dining-room wall: *Kelp Gatherers* (fig. 89) and *Peasant Woman and Cows in a Landscape* (cat. no. 43) with its "horned cattle repeating in their tall horns the design of the great bolo tree sprouting with young shoots."[62] It is not clear whether De Zayas borrowed sculptures from Barbazanges, for example, the *Statuette of a Martinique Woman* (cat. no. 32), which once sat on the mantel at Le Pouldu.[63]

Compelling evidence regarding the presence of other works in the De Zayas show comes from what we know about their provenances. Several pictures long held by Marie Henry and first brought to light at Barbazanges turned up in New York collections in the early 1920s. One can be tied directly to De Zayas: on April 21, four days after the show closed, he sold Quinn the stylized oil on panel *Caribbean Woman* (fig. 63).[64] Moreover, their mutual friend Davies owned Gauguin's spoof on Neo-Impressionist technique, *Still Life "Ripipoint"* (private collection, W 376), until 1926.[65] And surely it is no coincidence that three years after the New York show *Bonjour Monsieur Gauguin* (Armand Hammer Museum of Art, Los Angeles, W 321) and a landscape, *View of Pont-Aven near Lézavan* (private collection, W 370), were auctioned from the prestigious collection of the New York jeweler Meyer Goodfriend.[66] For these and other works the De Zayas exhibition serves as the missing link in otherwise inscrutable provenance entries, explaining how the pictures came to belong to New York collectors so soon after they emerged on the Paris market and, in certain instances, their presence in American

hands today. The lineage of various works, including those owned by Quinn, Davies, and Goodfriend, can be traced to second-generation collectors in this country—Chester Dale, A. Conger Goodyear, and Armand Hammer—and, in turn, to successive American owners who acquired them through purchase or, in the case of the Hammer Museum's *Bonjour Monsieur Gauguin*, through donation.

In art, there are only two types of people: revolutionaries and plagiarists. And, in the end, doesn't the revolutionary's work become official, once the State takes it over?
Gauguin in *Le soir*, April 23, 1895; Guérin 1978, p. 107

"IN THE COMPANY OF THE CANONIZED IMMORTALS"

In 1920—which was destined to be a year of firsts in the history of Gauguin's coming-of-age in New York—the Metropolitan Museum celebrated its fiftieth anniversary with an exhibition of works from its own holdings and from private collections. It proved a telling gauge of the advances made in taste and collecting since the Armory Show. "Take the men of the modern school of painting as they are represented on this notable occasion!" exclaimed one viewer. "Barely seven years ago Cézanne, Van Gogh, Gauguin and Redon were less than so many names—rather shadows of names to the majority of New Yorkers who were interested in the fine arts. Today their works are in the company of the canonized immortals."[67] Gauguin was represented—for the first time on the walls of the Metropolitan—by two paintings recently acquired by Adolph Lewisohn, *Ia Orana Maria* (cat. no. 55) and the *Bathers* (National Gallery of Art, Washington, W 572). After years of resistance, some barriers had broken down at the venerable institution, which extended "hospitality to the post impressionists," whose "pictures had found their way into the houses of persons who were to prove themselves real friends and benefactors of the Metropolitan."[68] By the following year, at the instigation of some of these friends and future donors, the Museum prominently featured Gauguin's pictures in its *Loan Exhibition of Impressionist and Post-Impressionist Paintings* and, in an accompanying show devoted to works on paper, debuted its first Gauguin acquisitions: a suite of *Noa Noa* woodcuts (see cat. no. 90).

In 1921 a new plateau was reached in the recognition of Gauguin's genius with the official sanction of his art by museums. That year Gauguin was represented on the walls of three New York museums; more significantly, two of these institutions added his works to their permanent collections. The Museum of French Art (which existed from 1912 to 1939) led the way, showing two Gauguin watercolors lent by De Zayas in its spring *Loan Exhibition of Works by Cézanne, Redon, Degas, Rodin, Gauguin, Derain, and Others*.[69] On its heels came the Brooklyn Museum's more ambitious show *Paintings by Modern French Masters Representing the Post Impressionists and Their Predecessors*, which also opened in March. The exhibition of more than 220 works was anchored by 136 pictures from the collection of Paris-based dealer

Dikran Kelekian, including a single superb Gauguin, *Maternity* (private collection, W 582), along with two Van Goghs and rich concentrations of works by Cézanne, Matisse, Derain, Picasso, and others. In addition to the Kelekian holdings—some of which, the Gauguin, for example, were withdrawn for the Metropolitan Museum's exhibition, and all of which were auctioned off a year later—there were forty other loans, among them a vibrant Gauguin pastel, *Tahitian Woman* (cat. no. 84) from the Swiss dealer Gustav Bollag.[70] The balance was made up of works from the Brooklyn Museum's collection, which, after the close of the show, would include the Gauguin pastel.

The Brooklyn exhibition was hailed as a "miracle" by Stieglitz. He saw it as a triumph, albeit a long time in coming, observing that "Museums of Greater New York were so backward in their official recognition of the 'New'" that it had been "more than thirteen years since '291' in its little room on Fifth Avenue introduced the 'revolutionists' to the United States." But now "Officialdom of Greater New York was finally awake," he proclaimed, taking no small delight, at the Metropolitan's expense, in adding that "Brooklyn was stealing a march on its big neighbor in Manhattan." Yet he did not disguise an "idiosyncrasy" of his taste, namely, that he had never been much of a fan of Gauguin, admitting that the artist "always seems to irritate me."[71] Though Stieglitz's remarks were aired in *The Brooklyn Museum Quarterly*, this last declaration seems not to have dissuaded the museum from purchasing its first Gauguin. The acquisition of this pastel, an utterly original and quite abstract conception, in which a Tahitian woman is set against an intense acid yellow background and disposed as a counterpoint to a breadfruit leaf, was a bold move. In regard to this purchase it can truly be said that Brooklyn "stole the march" on its Manhattan neighbor. (The Metropolitan's collection of Gauguins began more timidly, with prints, and it was not until forty years later that the institution acquired its first drawing by the artist [cat. no. 57].)

The Brooklyn show did not, however, steal any of the thunder from the Metropolitan's own foray into modern art or, for that matter, from the famous storm of controversy that dissipated just as quickly as it erupted at the end of the four-month run of the Museum's display *Impressionist and Post-Impressionist Paintings* (fig. 64). This well-received and well-attended exhibition of 128 works—in which Gauguin was handsomely represented by ten fine pictures—became for a ten-day period, just before its close, a succès de scandale.[72] In a pamphlet given considerable play in the press, an anonymous writer waged a vehement protest against the display of "art crimes on the splendid walls of the Metropolitan Museum."[73] Few paintings were free from one charge or another: Gauguin's *Farm in Brittany* (cat. no. 18), *Ia Orana Maria* (cat. no. 55), and *Hina Tefatou* (cat. no. 70) were three of the fourteen works called "simply pathological in conception, drawing, perspective and color."[74] Ironically, the attack had the effect of sparking interest in the show from "outside the usual art columns and art publications" and filling the Metropolitan's skylit galleries to capacity.[75]

Notoriety endowed by the press once again propelled Gauguin's steady rise to fame. However, as it had in the past, the "esteem of a few people" and the "aristocrats who understand" nurtured and encouraged his reputation.[76] Indeed, the initial impetus for the Metropolitan's show had been

Fig. 64. Installation view, *Loan Exhibition of Impressionist and Post-Impressionist Paintings*, The Metropolitan Museum of Art, New York, 1921. Paintings by Gauguin are on the far wall, top, fourth from left to right: *Caribbean Woman* (fig. 63); *Te Burao* (W 486); *Farm in Brittany* (cat. no. 18); *Bathers* (fig. 60); *Young Man with a Flower* (cat. no. 59); bottom, fourth from left to right, *Maternity* (W 582); *In the Vanilla Grove, Man and Horse* (cat. no. 53); *Ia Orana Maria* (cat. no. 55); *Bathers* (W 572); *Hina Tefatou* (cat. no. 70). Archives, The Metropolitan Museum of Art, New York

a letter cosigned by Quinn, Davies, Bliss, Agnes Meyer, and Gertrude Whitney that urged the Museum to hold "a special exhibition illustrative of the best in modern French art."[77]

Curator Bryson Burroughs admirably rose to the challenge, providing, as one critic put it, the "best basis for an estimate of Post-Impressionism that the country has yet had."[78] The impressive selection of paintings, limited to loans from private collections, placed a premium on quality and on criteria that looked back to the Grafton Galleries show mounted by Burroughs's predecessor Roger Fry and ahead to Alfred H. Barr's inaugural exhibition at the Museum of Modern Art, *Cézanne, Gauguin, Seurat, Van Gogh*, held in 1929. "The battle cry of the enthusiasts," wrote Burroughs in advance of the show, "is the name of Cézanne and practically all of his pictures which are available will be exhibited, as will also be the case with Gauguin, Van Gogh and Seurat."[79] Burroughs secured twenty-four Cézannes, ten Gauguins, seven Van Goghs, but only two Seurats. Once the show opened, the Museum's *Bulletin* highlighted aspects of it that were of particular interest: "important groups of pictures from the minds and hands of three artists who have within a few years attained what now appears to be a final and established place among the immortals: Van Gogh, Gauguin, Cézanne." Distinguishing "the majestic calm of Gauguin's colorful conceptions" from Van Gogh's "opposite temperamental expression," the article described the ten paintings by Gauguin in brief: "mostly Tahitian subjects, but also a panel painted in the American tropics and a Brittany landscape."[80]

The panel was Quinn's latest Gauguin purchase, *Caribbean Woman*, which was joined by his earliest, the *Bathers* of Armory Show fame, on the Museum's walls. The Brittany

landscape (cat. no. 18) was lent by Josef Stransky, conductor of the New York Philharmonic Orchestra from 1911 to 1923, who would retire "at the height of his musical career to devote himself entirely to the fine arts. His hobby became his profession and his profession his hobby."[81] A passionate *amateur-marchand*, Stransky bought as avidly as he sold. As a result, his notable holdings—which numbered as many as five Gauguins[82]—came to be distributed among many collectors, including Adolph Lewisohn, who acquired the *Farm in Brittany*, his fourth Gauguin, by 1928. Lewisohn, who was lending his *Ia Orana Maria* and *Bathers* to the Metropolitan for the second time, bought Kelekian's loan, *Maternity*, when it was sold at auction in January 1922.[83] Bliss lent *Young Man with a Flower* (cat. no. 59), which had once belonged to Henri Matisse (who bought it from Vollard, in 1899, when he could ill afford to do so); soon after the exhibition she would buy a painting lent to it by De Zayas that had originally belonged to Degas, *Hina Tefatou*. In 1931 Bliss bequeathed both paintings to the fledgling Museum of Modern Art (which deaccessioned the portrait ten years later). De Zayas's two other loans also found their way into museum collections. *Te Burao (Hibiscus Tree)*, sold at auction in 1923 to Joseph Winterbotham, became the first painting by Gauguin to enter the holdings of the Art Institute of Chicago (1923.308 [W486]).[84] (It was the second to come to an American museum: the Worcester Art Museum had purchased a painting as well as a pastel in 1921.[85]) And De Zayas's *In the Vanilla Grove, Man and Horse* (cat. no. 53), after changing hands several times, was acquired in 1942 by the German-born dealer Justin K. Thannhauser, who had recently moved to New York and would bequeath it to the Guggenheim Museum in 1978.[86] These pioneering collectors, whether their acquisitions were dispersed at sale or donated to institutions, established a tradition carried on by successive generations of Gauguin's admirers. More than eighty years after the Metropolitan's show, all but one of the Gauguin paintings included in it have remained in the United States if not in New York collections.

Gauguin's graphic work, like his paintings, had continued to attract interest in the years after the Armory Show, as attested by the rotating selection of eleven prints that curator William M. Ivins Jr. featured in the presentation of modern French-school works on paper that complemented the *Loan Exhibition of Impressionist and Post-Impressionist Paintings*. Davies, who bought one of the Volpini Suite lithographs from the Armory Show, lent three from the series; a certain Frank V. Chappell lent two hand-colored lithographs of Breton and Tahitian subjects; and Anna Pellew, who donated a Goya etching to the Museum the following year, lent a colored impression of *Design for a Plate* (see cat. nos. 23, 25).[87] The subsequent provenances of these works are difficult to trace—not so, however, with the rest of the prints shown in 1921, for they remain part of the Metropolitan Museum's collection.

It was Ivins who in 1921 acquired the first Gauguins to enter the Metropolitan's collection: a suite of ten woodcuts posthumously published by Gauguin's son Pola. Purchased from Frederick Keppel and Co., New York's oldest print firm, this edition of prints, mostly from the *Noa Noa* series (see cat. no. 90), was not a terribly grand start perhaps, but it was a prescient one. Over the next fifteen years Ivins succeeded in forming an impressive,

Fig. 65. Installation view, *Cézanne, Gauguin, Seurat, Van Gogh*, The Museum of Modern Art, New York, 1929, at the museum's first location, the twelfth floor of the Heckscher Building, 730 Fifth Avenue. Gauguin's *Manao Tupapau* (cat. no. 64), flanked by Van Gogh portraits, is second from the left. Photograph © 2002 The Museum of Modern Art, New York

quite comprehensive, collection of Gauguin's graphic production, drawing on the resources of dealers at home and abroad.[88]

By the early 1920s Gauguin's art had engaged the imaginations of the many and had secured a place reserved for the few: namely, on the walls of museums. This was true not only in New York but also beyond state and even national borders: the recalcitrant French Réunion des Museés Nationaux finally acquired its first Gauguin in 1923. Indeed, the 1920s can be called the "museum age" for Gauguin. The decade began with the Metropolitan showing two paintings by him and ended with the opening of the Museum of Modern Art, which in its inaugural show of late 1929, *Cézanne, Gauguin, Seurat, Van Gogh*, guaranteed him a permanent and preeminent place as one of the "four great ancestors of modern art" (fig. 65).[89]

In that show Gauguin—appearing "in a completeness never hitherto matched in an American exhibition"—was represented by twenty paintings and one drawing.[90] Nine works were from New York collections. Some, for example Bliss's *Hina Tefatou* and Lewisohn's *Bathers*, were familiar to the museumgoing public, but most had recently been acquired by their lenders, among them Stransky's "simply gorgeous"[91] *Reverie* (Nelson-Atkins Museum of Art, Kansas City, Missouri, W 424), which was making its first appearance in New York. Three of the finest paintings, including *Manao Tupapau (Spirit of the Dead Watching)* (cat. no. 64), were lent anonymously by the Buffalo-born industrialist and first president of the Museum of Modern Art, A. Conger Goodyear, one of the great Gauguin collectors of his generation.[92] By

this date Goodyear owned five works by Gauguin. We might say that the torch had been passed from one generation of Gauguin's admirers to the next: Goodyear's collection, in fact, originated with purchases from the Quinn estate sales of 1926–27, from which he acquired the *Bathers* and a wooden mask.[93]

The circle of New York private collectors of Gauguin's art, as indicated by new names among such lenders as James W. Barney and Dr. and Mrs. F. H. Hirschland, as well as dealers involved with his work, for example Paul Rosenberg, who lent the *Yellow Christ* (cat. no. 22), had widened and would expand significantly over the next few years. In 1931 the list of public institutions that owned works by Gauguin came to include the Museum of Modern Art—thanks to bequest of two paintings and fourteen prints (the first two acquired at the Armory Show) by cofounder and first vice-president of the institution, Lillie P. Bliss.[94]

The deaths of Quinn in 1924, Davies in 1928, Bliss in 1931, Stransky in 1936, and Adolph Lewisohn in 1938 marked the end of one era. Yet the new collectors who emerged—including Goodyear, Adelaide Milton de Groot (cat. nos. 13, 58), and Joseph M. May (cat. no. 1)—ensured the seamless continuation of the tradition established by the pioneers. William S. Paley, trustee and later president of the Museum of Modern Art—who bought his first Gauguin in 1936, *Te Aa No Areois (The Seed of the Areoi)* (cat. no. 61) and his last in 1958, *Washerwomen at the Roubine de Roi, Arles* (cat. no. 38)—extended this tradition still further.[95]

From the very beginning until now my work (as one can see) forms one indivisible whole, with all the gradations due to the education of an artist. . . . I am convinced that truth becomes manifest not through controversy, but in the work one has produced.
Gauguin, letter to André Fontainas, from Marquesas Islands,
September 1902; Rewald 1986b, pp. 206–7

IN FULL GLORY

The year 1936 was a watershed for Gauguin's coming-of-age in New York. His genius was celebrated in three monographic shows held that spring, beginning with the first retrospective of his work in America, organized by the Wildenstein Galleries (fig. 66).[96] The event was enthusiastically received by the press. Never before had Gauguin been seen with such "magnificent completeness," observed Alfred M. Frankfurter, the bright young reviewer for *Art News*, who acclaimed it as "the first American one man show of a painter richly deserving and long awaiting this honor."[97] (Even seasoned critics, not to mention all future scholars, overlooked the obscure first one-man show at De Zayas in 1920.) A quarter of the loans that made up the forty-nine-work Wildenstein survey were drawn from New York collections, a distinguished group that included Adolph Lewisohn's *Ia Orana Maria*, the Museum of Modern Art's new acquisitions (cat. nos. 59, 70), four paintings from Stransky, one from Goodyear, and pictures from a half-dozen other new owners, including composer George Gershwin and William

Church Osborn, longtime Metropolitan Museum trustee and its future president. The majestic *Two Tahitian Women* (cat. no. 105), acquired by Osborn six years earlier (and donated to the Metropolitan in 1949), came from the estate of Gauguin's most devoted French patron, Gustave Fayet, in whose collection this great painting had pride of place. Fayet's formidable holdings numbered some sixty works, many of them now represented in New York collections (for example, cat. nos. 10, 22, 38, 67, 85–87, 109, 110) in large measure through the Wildenstein Galleries. In the six decades that succeeded the groundbreaking retrospective of 1936 no other firm played a more active or dominant role in promoting Gauguin's art in this country, by means of sales and exhibitions.

A week after the close of the Wildenstein retrospective, in late April 1936, "the name of Gauguin and the *chef d'oeuvre* of his last Tahitian period" remained topical as a new one-man, one-work show opened at the Marie Harriman Gallery.[98] The monumental *Where Do We Come From? What Are We? Where Are We Going?* of 1898 was featured at the gallery for two weeks before it left to take its permanent place on the walls of the Museum of Fine Arts, Boston, as that institution's first Gauguin painting. No sooner had this show closed than the next, devoted to "Gauguin's highly decorative prints in black and white and in color" opened at the Keppel galleries.[99] From the Keppel exhibition the Metropolitan Museum acquired a dozen color woodcuts (cat. nos. 65, 74, 76, 78, 79, 81–83, 89), the clou of its print collection, which—a decade and a half in the making—was now virtually complete. Three years later, the Museum received its first painting by Gauguin, *Tahitian Landscape* (cat. no. 119), the authenticity of which has been questioned (see essay by Charlotte Hale, pp. 190–94).

Fig. 66. Installation view, *Paul Gauguin 1848–1903: A Retrospective Loan Exhibition*, Wildenstein and Co., New York, 1936. Left to right: *Te Raau Rahi* (W 439); *Two Tahitian Women* (cat. no. 105); *In the Vanilla Grove, Man and Horse* (cat. no. 53). Photograph courtesy of the Wildenstein Archives

After 1936 Gauguin became ever more visible on the New York art scene as a consequence of exhibitions, the growth of museum holdings by purchase and gift, and the spirited buying of his works by private collectors, especially during the boom decade after World War II. In fact, he had become so popular by 1959 that when the Metropolitan Museum announced that year that "it would present a major exhibition of the works of Gauguin," critic Emily Genauer protested: "Only three years ago the Wildenstein Galleries staged a huge Gauguin show . . . seven years before that the same gallery presented another major Gauguin survey. Besides, there are always Gauguin paintings around. What could one more exhibition . . . tell us about his art that we don't already know? What more . . . can a critic say about either the work or the life of this most tragic, colorful, written-about of all painters?" Yet she, like so many other writers on Gauguin, found something much more positive to say, as her "boredom with the too often exhibited post impressionists" succumbed to the power of his artistic expression. "His color remains vibrant . . . his pictorial structure stands up . . . and his message . . . seems more poignant than ever in this time when all men dream of escape to a land of peace and harmony and know, as Gauguin died finding out, that there is none."[100]

Today, more than forty years later, Gauguin's art has withstood the test of time, and his message is no less timely than it was in 1959, when the last major show of his works was held

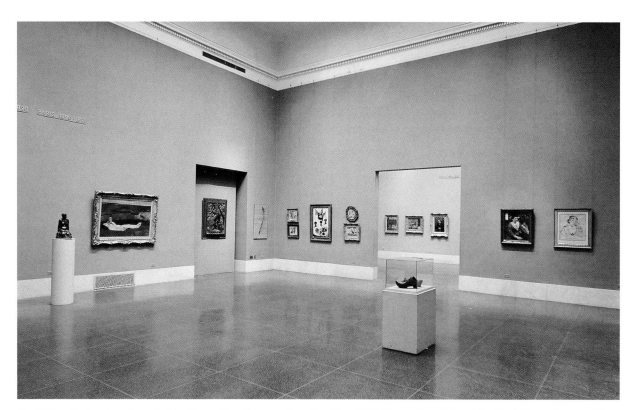

Fig. 67. Installation view, *Gauguin*, The Metropolitan Museum of Art, New York, 1959. Front gallery, left to right: *Black Woman* (cat. no. 33); *The Loss of Virginity* (W 412); *Be in Love and You Will Be Happy* (G 76); *Walking Stick* (cat. no. 13); top, *Peasant Woman and Cows in a Landscape* (cat. no. 43); bottom, *Nirvana: Portrait of Meyer de Haan* (W 320); *Still Life with Three Puppies* (cat. no. 16); top, *Follies of Love* (R 24); bottom, *Still Life with Apples* (not in W); in case, *Wooden Shoes* (G 81); *Portrait of a Woman, with Still Life by Cézanne* (W 387); *L'Arlésienne (Mme Ginoux)* (R 15); rear gallery, left to right: *Skaters at Frederiksberg Park* (W 148); *Flowers in a Basket* (W 182); *Portrait of a Seated Man* (cat. no. 5). Archives, The Metropolitan Museum of Art, New York

in New York. That exhibition, *Gauguin*, coorganized by the Art Institute of Chicago and the Metropolitan Museum (fig. 67),[101] revealed the full extent to which his artistic genius commanded the attention of a nation of collectors from coast to coast and from Manhattan to Buffalo. The retrospective's two hundred works were drawn almost exclusively from public and private American collections, with half of the eighty lenders hailing from New York. The present exhibition features some sixty of those loans; many are still in the same New York collections, a few have changed hands, and the rest have been donated to museums, their former owners continuing a tradition of beneficence almost as old as the tradition of collecting Gauguin's art. Works that were then recent acquisitions—Robert Lehman's *Tahitian Women Bathing* (cat. no. 62), Mr. and Mrs. Walter H. Annenberg's *Two Women* (cat. no. 110), William S. Paley's *Washerwomen at the Roubine du Roi, Arles* (cat. no. 38), Harry F. Guggenheim's *Black Woman* (cat. no. 33), Mr. and Mrs. Henry Root Stern's *Jugs in "Chaplet" Stoneware* (cat. no. 24), and Mr. and Mrs. Eugene V. Thaw's *Crouching Nude Woman* (cat. no. 115)—are now, thanks to the generosity of their lenders, part of the rich cultural heritage of New York's public institutions. Other Gauguins that had been in private hands since the mid-1930s, such as Adelaide Milton de Groot's *Walking Stick* (cat. no. 13) and *Tahitian Woman with a Flower in Her Hair* (cat. no. 58), Joseph M. May's bust *Emil Gauguin* (cat. no. 1), and Loula D. Lasker's drawing after *Ia Orana Maria* (cat. no. 57), would, within the decade after the 1959 retrospective, become part of the holdings of the Metropolitan Museum.

Within the last decade these holdings have grown significantly with the addition of four exceptional paintings from the collection initiated in the 1950s by Walter H. Annenberg, publisher, philanthropist, and ambassador, and his wife, Leonore. In the present exhibition Mr. and Mrs. Annenberg's gifts to the Museum of *Two Women*, along with *Siesta* (cat. no. 68), *Three Tahitian Women* (cat. no. 94), and *Still Life with Teapot and Fruit* (cat. no. 95), join an aggregate of paintings, drawings, sculptures, and prints assembled over a period of eighty years that bear witness to an ongoing history of appreciation that assured Gauguin's renown. The public debut, in the present show, of works acquired at the dawn of the twenty-first century— for one, the captivating *Artist's Portfolio* (cat. no. 26)—reminds us of the prescient remark Gauguin made in 1886 apropos the friendly encouragement he had received from his first American admirers: "That's some hope for the future."[102]

GAUGUIN'S PAINTINGS IN THE METROPOLITAN MUSEUM OF ART: RECENT REVELATIONS THROUGH TECHNICAL EXAMINATION

CHARLOTTE HALE

How does an institution such as The Metropolitan Museum of Art go about finding out all it can about the works in its collection? Connoisseurship and art historical sleuthing are at the heart of establishing the status of an object, but direct technical examination can provide information about its materials and creation that cannot be obtained in any other way. The current exhibition presented the opportunity to pursue a technical study of Paul Gauguin's paintings in the Metropolitan Museum's collection that would investigate the genesis of these works and address issues of authorship and authenticity. Gauguin's paintings were not subject to in-depth technical study until the early 1980s. Studies undertaken since that time, some of which are ongoing, have brought to light much about the artist's materials and techniques, and our research is indebted to a number of them.[1] While valuable material was obtained for every picture we looked at, the most interesting and unexpected information was yielded by four paintings, each of which is in a rather different category in terms of its attribution. *Tahitian Women Bathing* (cat. no. 62) is catalogued as a work by Gauguin, but the extent of his contribution has been questioned. *Still Life* (cat. no. 117), a painting once thought to be by Gauguin, clearly is not, and whether it is the work of a follower or an outright forgery is open to debate. Generally accepted as genuine until about 1982, *Captain Swaton* (cat. no. 118) was passed off as a Gauguin by the man who painted it, Lieutenant Jénot, a marine officer who befriended the artist during his first stay in Tahiti. *Tahitian Landscape* (cat. no. 119) was deattributed a generation ago, but this study presents evidence that suggests that this decision was premature. These four paintings are the focus of the present essay. [2]

TAHITIAN WOMEN BATHING

Tahitian Women Bathing (cat. no. 62; fig. 68), painted in the course of Gauguin's first sojourn in Tahiti, from June 1891 to June 1893, is one of the Metropolitan Museum's most popular pictures. Although the painting is frequently requested for loan and extensively reproduced, how much, if any, of it is by Gauguin has been the subject of some attention. In his review of

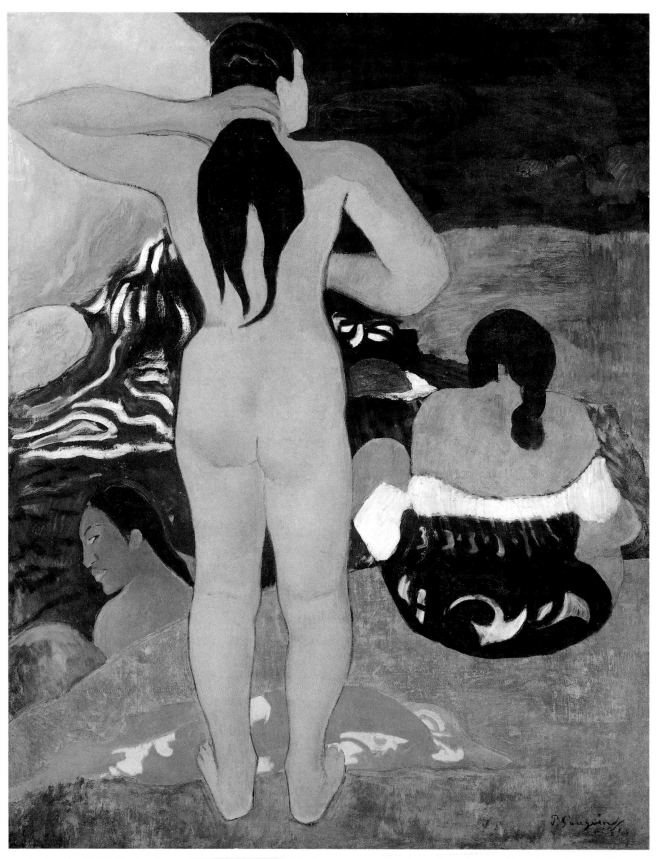

Fig. 68. *Tahitian Women Bathing*, 1892 (cat. no. 62). Oil on paper laid down on canvas. The Metropolitan Museum of Art, New York, Robert Lehman Collection, 1975 1975.1.179

the monographic Gauguin exhibition held at the Metropolitan Museum and at the Art Institute of Chicago in 1959, John Richardson wrote in the *Burlington Magazine* that the picture "might well prove under investigation not to be entirely by Gauguin's hand. Some such idea may have occurred to the compiler of the catalogue who wrote that 'the lack of modeling, and the flat color areas are unique in Gauguin's work'. The provenance (if correct)—Ambroise Vollard, Alphonse Kann—would be reassuring, but in the messy pentimenti and in the awkward handling of the top left-hand corner and the seated woman seen from the back one senses the inexpert hand of someone familiar with Matisse's style of 1906–7. Admittedly, Gauguin was often a clumsy painter but seldom as clumsy as this."[3] Richard Field, in his study of the paintings of Gauguin's first stay in the South Seas, called it "a parody of Gauguin."[4]

The appearance of *Tahitian Women Bathing* is indeed disconcerting. It is a large-format work, vividly—even garishly—colored, with an oddly flat surface exaggerated by the presence of a glossy varnish. Certain passages, particularly the left arm and hand of the standing woman, and the yellowish green paint in the upper left, are crudely carried out. It is not generally understood that the picture is executed in oil on paper. This accounts for its smooth surface, which contrasts with the range of canvas weaves, some of them extremely coarse, that we associate with Gauguin's paintings.[5] That the paper support was lined onto canvas, mounted on a stretcher, and varnished explains why it has been taken as an oil on canvas. The painting entered the Museum in 1975 as part of the Robert Lehman Collection. In 1981 it was examined by John M. Brealey, then Sherman Fairchild Chairman of Paintings Conservation, who concluded that Gauguin had begun the picture but had abandoned it at an early stage, and that substantial areas had subsequently been overpainted.[6]

During the latest examination of the *Tahitian Women Bathing* we used X-radiography to examine the painting's structure and condition and infrared reflectography (IRR) to penetrate the visible paint layers to see the underdrawing. With these tools and with the benefit of the recent technical studies of Gauguin's paintings, we were able to come to a new understanding of what the picture is and why it looks the way it does. An exceptionally interesting painting in the context of Gauguin's oeuvre, it is one of only two known mature works on paper carried out in oil on paper by the artist.[7] The other, the *Meal* or the *Bananas*, 1891 (Musée d'Orsay, Paris, W 427), is close in date to the present example but very different technically: it was painted on a paper support mounted on canvas by the artist, who subsequently used what appears to have been a decorator's comb to apply a ground that simulated the texture of a coarse canvas before the application of the paint layers.[8] The *Meal* is a carefully planned and finished painting and a very successful one. In these respects it stands in contrast to *Tahitian Women Bathing*, which could be described as a working document, for the reasons outlined below.

IRR demonstrates that *Tahitian Women Bathing* started as a sheet of working drawings comprising a cartoon (a full-scale working drawing) and a preparatory study, the latter partially squared for transfer (figs. 69, 70). Though Gauguin liked to present himself as an artist

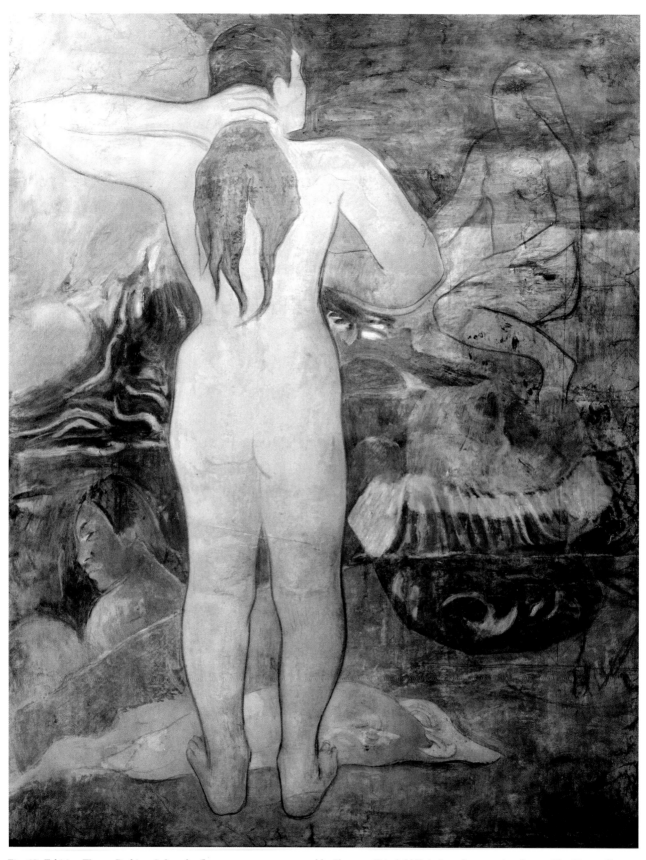

Fig. 69. *Tahitian Women Bathing*. Infrared reflectogram computer assembly. Sherman Fairchild Paintings Conservation Center, The Metropolitan Museum of Art, New York

Fig. 70. *Tahitian Women Bathing* (detail). Infrared reflectogram computer assembly. Sherman Fairchild Paintings Conservation Center, The Metropolitan Museum of Art, New York

who worked spontaneously,[9] he took considerable pains to prepare his paintings; this is a dichotomy apparent throughout his oeuvre. Under the influence of Camille Pissarro in the early 1880s, he developed a procedure that began with rapid notational sketches made in the field (Gauguin called them "*documents*"), sometimes with color notations, that formed the basis of more elaborate working drawings using posed models in the studio. He then carefully transferred these drawings to his canvas by means of various traditional techniques, namely, squaring, pouncing, and tracing.[10] On the prepared canvas he went over the drawing with dilute dark, generally Prussian, blue outlines, which he painted up to and only occasionally crossed. Contours were often redefined with dark blue in the final stages of painting. It is the presence of Prussian blue, a pigment that shows up very clearly under IRR, that allows a clear reading of the underdrawing in *Tahitian Women Bathing* and certain of Gauguin's other pictures.

179

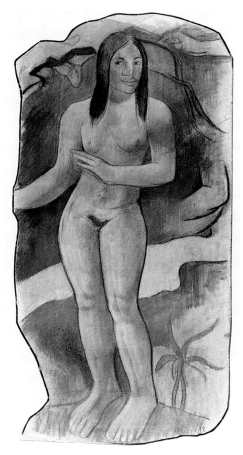

Fig. 71a. Reworked study for *Nave Nave Fenua (Delightful Land)* (recto), 1882, reworked about 1884. Charcoal and pastel, 36¼ x 21½ in. (92 x 55 cm). Des Moines Art Center Permanent Collections, Gift of John and Elizabeth Cowles 1948.76

Fig. 71b. Reworked study for *Nave Nave Fenua* (verso), showing prick marks for pouncing

In its scale, composition, and technique the underdrawing of the main figure in the present work recalls the drawings for two monumental standing nudes from 1892, the reworked study for *Nave Nave Fenua (Delightful Land)*, recto, 1882, reworked about 1884 (Des Moines Art Center; see fig. 71a) and the reworked study for *Parau Na Te Varua Ino (Words of the Devil)*, 1892 (Kupferstichkabinett, Öffentliche Kunstsammlung Basel), both full-scale cartoons that were pricked for transfer.[11] The parallels suggest that Gauguin would have used the standing figure in *Tahitian Women Bathing* as a cartoon for transfer to canvas for painting. Instead he chose to apply paint to the drawing itself.

IRR reveals not only the underdrawing of our picture but also a transfer grid on the mid-right side of the painting, extending from the bottom of the seated figure to a little above the green bank and from the right edge to the right elbow of the standing figure. Gauguin used transfer grids frequently; his preparatory drawing for the crouching woman in *Nafea Faaipoipo (When Will You Marry?)*, 1892 (Rudolf Staechelin Family Foundation, Aresheim, Switzerland, W 454), for example, has a similar grid that, like the grid in the Museum's picture, includes diagonals.[12] There is also a grid over the drawing on the verso

of the Des Moines cartoon for *Nave Nave Fenua* (see fig. 71b). In *Tahitian Women Bathing* the grid relates to an early underdrawing of a seated, crouching, or kneeling figure, of which we can image only one foot, visible just below and to the right of the seated woman; the rest of this underdrawing is obscured by the overlying paint. A little higher up, a beautifully drawn kneeling nude was discovered, which recalls a crouching figure in a sketchbook Gauguin used between 1891 and 1893,[13] as well the crouching woman in the painting *Nafea Faaipoipo*. This newly discovered nude was both drawn and painted; surrounding her were white ripples in the water that can be seen in the X-radiograph. At some point Gauguin made a significant change in the composition by painting out the kneeling figure and the ripples and adding the seated woman seen from behind who now occupies the space to the right of the standing nude.[14] Because oil paint becomes slightly transparent over time, we can see with the unaided eye that the seated figure was painted over the green banks and blue water. There is a colored drawing of a woman that corresponds to the drawing of the seated woman on the sheet called *Little Tahitian Trinkets* (cat. no. 63). The right arm of the blocky figure in the drawing extends beyond the contour of the body. In the painting Gauguin oriented the stripes on the top of the pareu to echo the ripples in the water beneath them.

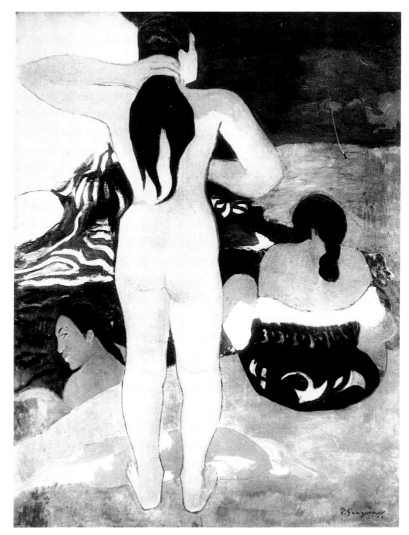

Fig. 72. *Tahitian Women Bathing*. Photograph by Eugène Druet. Vizzavona Archives, Bibliothèque Nationale, Paris

Although Gauguin reworked a number of drawings with pastel to make them into more finished, salable pieces,[15] *Tahitian Women Bathing* is his only known preparatory drawing on paper that evolved into an oil painting. Furthermore, he commonly adjusted the contours of his forms as he progressed and sometimes made minor compositional changes, but because he planned his paintings carefully, he rarely made major alterations of the kind seen in *Tahitian Women Bathing*.[16] The pentimenti in this picture show that he developed it over a period of time (long enough for the lower layers of paint to dry before he continued work). But the painting was left unfinished, as revealed by

various details. Lack of articulation in the lost profile of the standing woman, for example, is not characteristic.[17]

We are informed by the account of Lieutenant Jénot that Gauguin brought some rolls of canvas with him when he traveled from France to Tahiti.[18] In August 1892 the artist wrote to Daniel de Monfreid that he had been out of canvas for the last month and could not afford to buy any more.[19] Did the picture evolve as it did because Gauguin was running low on canvas? Were there other works that fall into a similarly hybrid category but which have been misidentified or lost?

The paper support was found to be a single sheet of low-grade wood-pulp wove paper that would have come off a roll. Similar types of smooth-surfaced paper appear to have been used for a number of Gauguin's woodblock prints in the collection of the Metropolitan Museum.[20] As an unmounted work on paper of large scale, *Tahitian Women Bathing* would have been inherently very fragile. Moreover, the poor condition of the paper support— there are numerous tears and creases—attests to its having been roughly handled. Early in the work's existence, possibly on the order of Vollard, the dealer with whom it was deposited in the early part of the twentieth century, it was lined onto canvas and mounted on a stretcher. At the same time, to mask the damages and to make the piece appear more finished, sections of the picture, including much of the standing figure and the top left corner, were quite extensively and rather crudely overpainted. We know that this intervention took place before 1909 on the evidence of a large-format photograph made by the dealer Eugène Druet (fig. 72), which was reproduced in a 1909 publication[21] and shows the picture in substantially the same state we see today. We can deduce that the sharp and awkwardly painted left elbow of the standing nude is the work of a more recent restorer, as the original paint trails off in this area.

The painting was probably varnished as part of the early restoration, to make it look more like a traditional oil painting on canvas and therefore more attractive to buyers with traditional taste. Gauguin intended his paintings to have matte surfaces, in accordance with the avant-garde aesthetic that rejected academic notions of illusion and finish associated with the oil medium in favor of surfaces that emulated the dry appearance of fresco and tempera.[22] To this end he generally employed absorbent grounds and advocated using no coating other than wax for the protection of his surfaces. He also recommended the display of his paintings behind glass for their safeguarding (see cat. no. 91).[23] Given the presence of a thick, glossy varnish on *Tahitian Women Bathing*, it is ironic that Gauguin wrote to Monfreid that he should make sure that Vollard applied wax rather than "this dirty disgusting varnish which picture dealers use and which is so common."[24]

There is no doubt that *Tahitian Women Bathing* is a painting by Paul Gauguin, albeit one compromised by early damage and intervention. Once we are aware of its condition, we can fully appreciate the great quality of the parts of the picture that are least changed, particularly the two subsidiary figures, the pink rock, and the patterned cloth in the foreground.

Still Life (cat. no. 117; fig. 73), signed and dated *P.Gauguin 91* and catalogued by the Metropolitan Museum as "Style of Paul Gauguin" since 1979, is in a very different category. Indeed, with hindsight it is hard to believe that this picture was ever seriously considered to be by the artist. But it changed hands as an autograph work three times, passing from Amédée Schuffenecker in Paris to Durand-Ruel in 1926, first in Paris and then in New York, to the collection of Adelaide Milton de Groot in New York in 1937, and then by her bequest to The Metropolitan Museum of Art in 1967. It has hung in a number of exhibitions as genuine and has been reproduced as such in Gauguin literature.[25] The painting was officially downgraded by the Museum in 1979, after its authenticity had been questioned by a number of scholars within and outside the institution, among them Douglas Cooper and John Rewald.[26] Cooper dubbed it "a bad pastiche" and opined that it was painted by Émile Schuffenecker, the artist, collector, sometime friend of Gauguin and the brother of Amédée. Émile's name has been linked with questionable practices ranging from retouching the work of other artists to forgery.[27] Recently scholars have considered whether it might be the work of a follower of Gauguin in Pont-Aven or Le Pouldu, proposing Paul Sérusier, Jan Verkade, and Meyer de Haan as possible authors.[28] What is its connection with Paul Gauguin? Is it an *hommage* by a pupil or follower? Is it a pastiche, and if so, is it contemporary or later? The examination of this strange little painting, not exhibited publicly since 1971, uncovered some surprises.

In its composition the painting echoes still lifes by Gauguin that show a strong influence of works of the same genre by Paul Cézanne. Gauguin described some of that master's pictures as "marvels of an essentially pure art."[29] He owned five Cézannes, including *Bowl, Glass, Knife, Apples, and Grapes*, ca. 1880 (private collection).[30] He incorporated elements of this picture in a number of his own paintings and portrayed it in the background of *Portrait of a Woman, with Still Life by Cézanne*, 1890 (Art Institute of Chicago, W 387).[31] *Bowl, Glass, Knife, Apples, and Grapes* shows fruit arranged on a white cloth on a table and a blue-green patterned background—features that are echoed in the Metropolitan Museum's little *Still Life*. Gauguin's Cézannesque still lifes, such as the Metropolitan Museum's *Still Life with Teapot and Fruit*, 1896 (cat. no. 95), are measured and beautifully orchestrated compositions that show an intuitive understanding of the master. By conspicuous contrast, the composition of the small canvas under discussion here is awkward: the green vase is like nothing in either artist's work, nor is the dahlia, which is ugly and poorly placed, and the white cloth is stiff and wooden. The palette is bland compared with Gauguin's invariably lovely color harmonies, and the execution is extremely poor.

Gauguin's method in such pictures as the *Still Life with Teapot and Fruit* typically involved a painted dark blue outline underdrawing set down first, followed by paint layers built up slowly and thinly within the initial contours, and final reinstatement of some contours with dark blue. The X-radiograph of the *Still Life with Teapot and Fruit* (fig. 74) very clearly shows the outlined, cloisonné effect that results from this procedure and conveys as well a convincing

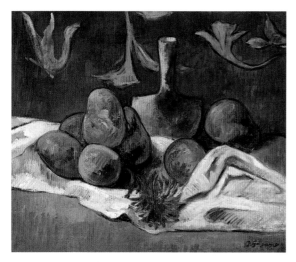

Fig. 73. Style of Paul Gauguin (French, late 19th century). *Still Life* (cat. no. 117). Oil on canvas. The Metropolitan Museum of Art, New York, Bequest of Miss Adelaide Milton de Groot (1876–1967), 1967 67.187.69

Fig. 74. *Still Life with Teapot and Fruit*, 1896 (cat. no. 95). Oil on canvas, The Metropolitan Museum of Art, New York. Partial Gift of Walter H. and Leonore Annenberg, 1997 1997.391.2. X-radiograph. Sherman Fairchild Paintings Conservation Center, The Metropolitan Museum of Art, New York

sense of space and three-dimensionality that the artist had in mind to express when he conceived the work. The cloisonné effect is commonly seen in X-radiographs of Gauguin's paintings.[32] The X-radiograph of the Museum's small *Still Life* (fig. 75) shows none of these features. It lacks contrast, appearing soft and amorphous. The paint is pastose, applied broadly and rapidly with no apparent system, producing a messy and chaotic effect that stands in marked contrast to Gauguin's generally finer paint strokes, controlled buildup, and smooth surfaces. (Gauguin once wrote, "I detest messing with brushwork.")[33] In this respect we should note in particular the rather heavy-handed hatched paint strokes in the background, foreground, and white cloth: while Gauguin used hatched strokes derived from Cézanne, in his work they are part of an organized approach, and the individual strokes of paint are never so

Fig. 75. Style of Paul Gauguin. *Still Life* (cat. no. 117). X-radiograph. Sherman Fairchild Paintings Conservation Center, The Metropolitan Museum of Art, New York

Fig. 76. Paul Cézanne. *Peaches and Pears*, ca. 1890. Oil on canvas, 14¾ x 17¼ in. (37.5 x 43.8 cm). The Barnes Foundation, Merion, Pennsylvania BF 577, Gallery IX

184

coarsely or thickly laid on as here. The blue outlines were added wet-in-wet at the end of the painting process in imitation of the artist's style, and the signature is blatantly false. The stylistic and technical crudeness of this painting rule out the possibility that it is a work by Gauguin.

To further illuminate Gauguin's usual procedures, a few more remarks about *Still Life with Teapot and Fruit* are in order here. As has been noted, the decorative motifs on the far wall in this picture are taken from a piece of paper printed or stenciled with flower patterns with which Gauguin wrapped his collection of *Le sourire*.[34] The X-radiograph of the painting shows that he originally painted the flower on the left with four petals, as it appears on his wrapper for *Le sourire*, and that in the course of developing the composition he added another petal over the blue background. Such borrowings and adjustments are characteristic of his method.

The X-radiograph shows that the genesis of the *Still Life* was surprising and complex in nature. Beneath this composition is another one, a faithful copy of a work by Cézanne, *Peaches and Pears* in the Barnes Foundation (fig. 76). The Cézanne, which is close in size to the Museum's *Still Life*,[35] depicts a plant, five peaches in a dish, and two pears on a white rumpled cloth set at the end of a table. As demonstrated by the X-radiograph, the copy of the Barnes painting was at some time reworked to incorporate a wide-mouthed pitcher positioned over the plant. (The impasted strokes of the rim and handle of the pitcher can be discerned on the surface of the painting in a raking light.) Subsequently, the picture was completely repainted in imitation of Gauguin's style. The "Cézanne" still life was transformed into a "Gauguin" still life. The multihued peaches and pears were elongated, rotated, or otherwise morphed into mangoes and repainted red and green accordingly. The dish was removed so that the fruit sits directly on the cloth, and the front of the table was eliminated. A strange, spade-shaped vase replaced the plant and the pitcher, and a red dahlia was added in the center foreground. The background was decorated with vaguely vegetal and birdlike forms that crudely mimic similar motifs in the backgrounds of a number of Gauguin's still lifes and genre paintings from 1880 to 1888, among them the *Vase of Peonies II* (fig. 77).[36]

If the *Still Life* is demonstrably not by Gauguin, who could have painted it? Though the provenance of the picture cannot be traced further back than 1926, the pigments in all layers were found to be consistent with a palette of the late nineteenth century.[37] Thus it is reasonable to look at other members of Gauguin's circle in Brittany as possible authors. Gauguin exhorted his followers in Pont-Aven, "Let's do a Cézanne,"[38] and it is in this context that we might view the Cézannesque aspect of the present work and the copy of the Cézanne under it. There are still lifes by Meyer de Haan, Émile Bernard, Wladislaw Slewinski, Paul Sérusier, Roderic O'Conor, and Gustave Loiseau,

Fig. 77. *Vase of Peonies II*, 1884. Oil on canvas, 18 x 21¾ in. (46 x 55 cm). Location unknown

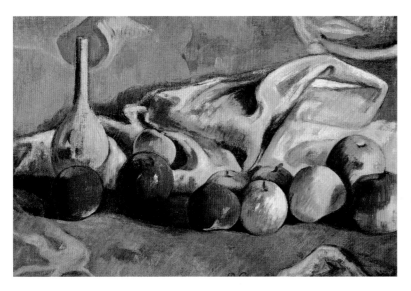

Fig. 78. *Still Life with Apples*, 1890. Oil on canvas, 12¾ x 18¼ in. (32.2 x 46.3 cm). Courtesy of Christie's Images, New York

among others in the Pont-Aven group, that show an indebtedness to Cézanne as well as the strong stylistic influence of Gauguin that mark the Metropolitan Museum's *Still Life*.[39] However, though a number of scholars have suggested that our picture could be by a member of the Brittany circle, there are, in the opinion of this author, stylistic and technical disparities that distance it from the various painters who have been proposed. There is a confident sloppiness in the composition and execution that is at odds with the striving, variously successful efforts of Gauguin's followers.

The painting closest to the *Still Life* in terms of composition (though not technique) is *Still Life with Apples* (fig. 78), which was sold at Christie's, London, on June 25, 2001.[40] This work has in common with the Museum's little canvas an oddly formed green vase, a rather wooden white cloth—elements of the folds at the right are very similar—and, in background as well as its lower left foreground, virtually identical vegetal and birdlike forms. Whoever painted the Metropolitan Museum's *Still Life* must surely have seen this work. In our picture the transformation of the "Cézanne" still life seen in the X-radiograph and the appropriation from other paintings of the decorative motifs in the background smack of pastiche.

The copy of the Barnes Foundation Cézanne under the surface of the *Still Life* is harder to explain. (Here it should be borne in mind that a copy of a painting by an artist and a work inspired by that artist are very different entities.) Some members of Gauguin's circle painted copies or variants of his pictures, and Gauguin himself copied a Cézanne landscape he owned, executing it in the form of a fan.[41] Study of *Peaches and Pears* and its copy allows us to come to at least some conclusions about them. For one, we can assume that the copyist had direct access to the model because he followed it so faithfully. Furthermore, close inspection of the Barnes painting shows that at some point its format was enlarged by additions on the right side and the top. In the process the white cloth on the right was extended in a rather unconvincing manner.[42] It is clear from the X-radiograph of the Metropolitan Museum's *Still Life* that it is a copy of the Barnes painting produced after the additions were made.

Where, exactly when, by whom, and with what intention the copy of the Cézanne and the Cézannesque "Gauguin" *Still Life* were painted have not yet been established. The earliest documentation of the work that we know of shows that it was with Amédée Schuffenecker in 1926. The connection with the Schuffenecker brothers certainly bears further investigation.[43] While it has slight artistic merit, the little *Still Life* is of considerable didactic interest in the context of Gauguin scholarship.

Captain Swaton (cat. no. 118; fig. 79) is a striking bust-length portrait—something of a swagger portrait, painted contre-jour—of a French marine officer stationed in Papeete, who became Gauguin's neighbor and friend during the artist's first Tahitian sojourn. It was generally accepted as a painting by Gauguin when it entered the Metropolitan's collection by bequest in 1982. However, based on information from Cooper, who was working on a revised edition of the Gauguin catalogue raisonné at the time of the bequest,[44] the Museum attributed the picture to Paulin Jénot. A second lieutenant in the French marines stationed in Tahiti and a mutual friend of Swaton and Gauguin, Jénot was given painting lessons by the artist.[45] Cooper described an interview of 1980 he had conducted with Jénot's son, in which the latter reported that in the 1930s he had sold *Captain Swaton* and three other pictures painted by his father as Gauguins; he explained that he had done so because his father told him that "the idea for each of them came from Gauguin." Our study of *Captain Swaton* aimed to investigate the attribution to Jénot from a technical viewpoint.

Lieutenant Jénot is known as the author of a manuscript that is the only firsthand account of Gauguin's life in Tahiti. The text, which exists in several different drafts, has been pored over and cited widely by Gauguin scholars; one version was published in the *Gazette des beaux-arts* in 1956.[46] In it Jénot describes how he first encountered Gauguin one morning in June 1891 as he disembarked the vessel *La Durance* out of Nouméa, New Caledonia, together

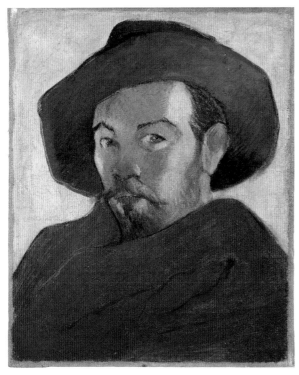

Fig. 79. Attributed to Paulin Jénot (French, active by 1886, died after 1930). *Captain Swaton* (cat. no. 118). Oil on canvas. The Metropolitan Museum of Art, New York, Gift of Raymonde Paul, in memory of her brother, C. Michael Paul, 1982 1982.179.12

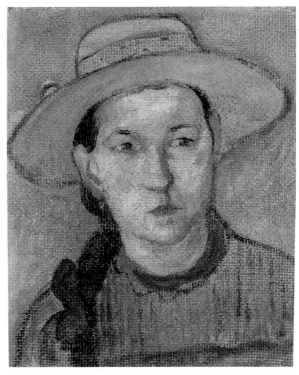

Fig. 80. Here attributed to Paulin Jénot (French, active by 1886, died after 1930). *Young Creole Girl.* Oil on canvas, 14¼ x 11¾ in. (36 x 30 cm). Musée d'Art Moderne de Troyes, Donation Pierre et Denise Lévy

with Swaton, Jénot's new captain. Jénot, who had arrived in Papeete six months earlier, relates also that he introduced the newcomers to the island and helped them get settled. And he tells how, despite a considerable difference in age, Gauguin and he became friends. Jénot assisted the artist in navigating local affairs and finding out about local customs, attempted—with limited success—to teach him Maori, and sought models and even prospective buyers for his pictures. Some of the most arresting passages in the manuscript describe Gauguin going about his work. Jénot recounts, for example, how Gauguin prepared and painted canvases and carved wooden sculpture at the lieutenant's cabin, which was more isolated and peaceful than the artist's own. Jénot himself apparently had artistic training, for, according to his son's report to Cooper, he had won a grand prix at the École des Beaux-Arts in Nancy about 1886. The lieutenant was clearly drawn to Gauguin as an artist, and Gauguin appears to have responded to him as a friend and pupil of sorts. Jénot writes: "We had long conversations and discussions chiefly about his way of drawing, which I found unacceptable in every way, and about his way of painting to which I made many objections. In this way I received from him some important lessons on art and in this way he opened up to me memories of Martinique, Pont-Aven and his beginnings."[47]

He also explains that

Once he was settled, Gauguin began to paint some small pieces, landscapes, studies of figures and nudes. But he didn't undertake any large canvases in Papeete. He used only his eye and his hand to discover the Tahiti he wanted to understand and define in order to express himself. This is how he did the portraits I own of the children of his neighbor, Cap^{ne} Swaton and Teuraheimata à Potoru.

He had brought with him from France enough materials to work for at least a few months, counting on restocking as work progressed, according to his needs. Together with a certain number of couleurs fines, *he brought a large assortment of tubes of decorators' colors from the firm of Lefranc et Cie. Additionally he brought some rolls of canvas, of which one was a coarse hemp, which he used for the portraits of children that I spoke of above, and the others were finer, like the one that was used for the portrait of Cap. Swaton. Along with these canvases he had caseine,* colle forte *and* blanc d'Espagne *with which he made his ground.*[48]

Thus it was Jénot who was responsible for the attribution to Gauguin of *Captain Swaton* and the three other paintings mentioned by his son. (The four portraits were used as illustrations identified as Gauguins for Jénot's account when it was published, in 1956.)

Captain Swaton to a certain extent relates stylistically and technically to Gauguin's paintings from his first Tahitian stay but does not look like a work by the artist himself. The painting has appeal conferred by its stylish composition and the bold gaze of the sitter; however, that very gaze gives it a stagy quality not seen in Gauguin's portraits, whose sitters generally confront the viewer indirectly and with some degree of reticence. The technique is superficially similar to Gauguin's: the artist employed Gauguin's materials and followed his general method, yet the hand is clearly different.

The canvas is a medium-weight cotton twill that is certainly finer than the hemp (probably meaning jute) Jénot mentions. It is the very same canvas Gauguin used for *Te Bureo (Hibiscus Tree)*, 1892 (Art Institute of Chicago, W 486).[49] Like the majority of paintings by Gauguin, *Captain Swaton* has a white ground. From the early 1880s the artist generally preferred to make up and apply his own absorbent grounds using chalk and glue, a technique Jénot describes in his account. The ground here is artist-applied barium sulfate. Barium sulfate had been used as an extender for commercial grounds since 1820.[50] Artist-applied barium sulfate grounds have been identified recently in a number of paintings by Gauguin and Van Gogh that date from October to December 1888, when they were together in Arles and seem to have been experimenting with the material.[51] Van Gogh did not continue to use self-applied barium grounds. Until now they had not been identified in paintings associated with Gauguin after the Arles period, though the number of grounds in his work that have been analyzed is fairly limited as yet.[52] Barium sulfate was identified as the principal component of the ground of the Metropolitan Museum's *Two Tahitian Women* (cat. no. 105), along with smaller amounts of lead white and chalk.

The contoured underdrawing of *Captain Swaton* attempts to echo that seen in Gauguin's autograph paintings; the composition was underdrawn in dark blue and black paint, with fine lines for the features and thick for the coat and hat. As in Gauguin's pictures, the paint layers are applied up to these lines without crossing them, and some contours are reinstated in final touches. However, their handling is at odds with Gauguin's fluid, elegant outlines: they are either tentative or overstated here. The large fields of unmodulated color recall similar areas in Gauguin's paintings, but the brushwork is haphazard by comparison. While the flesh paint is thinly applied as it is in Gauguin's work, it is treated superficially, without the systematic approach the master used to model forms that are at once spatially convincing and decorative. Certain touches—wet-in-wet dabs of paint in the eyes and hatched striations made in wet paint in the eyebrows, mustache, and right temple—are not characteristic of Gauguin's technique.[53]

The stylistic and technical evidence presents *Captain Swaton* as a picture not by Gauguin's hand but painted with his materials and under his guidance. Together with this evidence, the provenance, the information in Jénot's manuscript, and the testimony of Jénot's son affirm the attribution to Lieutenant Jénot, though there are no documented works by him and he is not listed in any dictionaries of artists. Of the four small portraits mentioned in Jénot's text and used to illustrate it, two, the present work and a *Young Creole Girl* (fig. 80) are in public collections, whereas two are in private hands and available to this author only in photographs.[54] All are unsigned and undated. The *Young Creole Girl* is in the Musée d'Art Moderne, Troyes, and was examined there. It is—as noted by Jénot—on a coarse canvas similar to the supports used for Gauguin's *Ia Orana Maria (Hail Mary)* (cat. no. 55) and the *Siesta*, both works from the master's first Tahitian sojourn.[55] The composition, style, and handling of *Young Creole Girl* are very close indeed to those of *Captain Swaton*. Given their shared provenance and documentation and as far as is possible to say on the basis of comparing photographs of the two other portraits, it appears that all four works are by the same hand.

TAHITIAN LANDSCAPE

Tahitian Landscape (cat. no. 119; fig. 81), donated to the Metropolitan Museum in 1939, was the first painting by Gauguin to enter the collection. It was for many years exhibited and reproduced as autograph—notably in the 1959 monographic Gauguin exhibition at the Metropolitan Museum and the Art Institute of Chicago and in the Wildenstein catalogue raisonné of 1964.[56] However, the picture was deattributed by the Museum forty years after it came to the institution. A number of prominent Gauguin scholars either questioned the painting or rejected its attribution to the artist.[57] Cooper intended to omit it from the new edition of the catalogue raisonné. He considered passages weak and atypical, the palette uncharacteristic, and the signature spurious; he also believed the provenance to be problematic.

Our goal in the present study was to reexamine this controversial work in light of the technical studies of Gauguin's paintings that have been conducted in the last twenty years or so.[58] *Tahitian Landscape* is an unassuming picture, diminutive in scale.[59] The composition appears random, the mood detached. The handling is unresolved and awkward even for a work of this famously uneven painter. Certain technical features are somewhat unusual: the use of black in addition to dark blue for various details and contours and for the signature; the presence of areas of low impasto. Our first reaction was that the painting was indeed likely to be a pastiche, but this was soon tempered by the technical evidence that came forward as we proceeded.

The canvas is a medium-weight linen that was stretched and prepared by the artist with an extremely thin and unevenly applied ground made of chalk and glue.[60] Gauguin describes using this type of absorbent ground, and it has been identified on a number of his pictures.[61] Many avant-garde painters of the last quarter of the nineteenth century favored *toiles absorbantes*—which had been available commercially since at least 1839—for

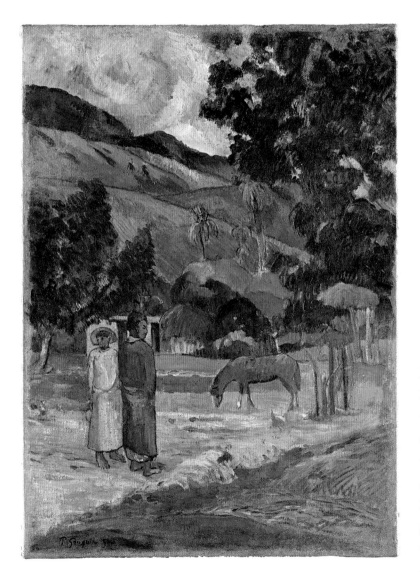

Fig. 81. Attributed to Paul Gauguin. *Tahitian Landscape*, probably 1892 (cat. no. 119). Oil on canvas. The Metropolitan Museum of Art, New York, Anonymous Gift, 1939 39.182

the fresh, matte surface they provided by absorbing some of the oil medium in the overlying paints.[62] Control of all stages of the creation of a painting was essential to Gauguin. Though he sometimes used commercially prepared canvases, particularly in the early years, during the first Tahitian stay he regularly prepared his own canvases.[63] His self-grounded supports are marked by strong cusping (local arc-shaped distortions of threads at the edges of the picture caused by the tacks that were used to stretch the canvas) on all sides and by knife applications that do not reach the edges of the canvas, or do so only irregularly, as is the case with *Tahitian Landscape*.[64]

The underdrawing of *Tahitian Landscape* that was imaged using IRR shows some painted contours similar to those observed in Gauguin's undisputed work, for example, *Tahitian Women Bathing*.[65] The X-radiograph (fig. 82) reveals the familiar cloisonné effect arising from the application of X-ray-opaque paint within the boundaries of an initial painted underdraw-

ing composed of a material that is X-ray-transparent. The pigments were analyzed and found to be consistent with Gauguin's palette as we know it from his requests for paints from Paris and from the technical examination of a number of his pictures.[66] *Tahitian Landscape* displays another feature present in many of Gauguin's works: the ragged and uneven application of paint at the picture's edges, exposing areas of bare canvas. In the present case these ragged edges were masked by heavy old overpaint, applied—as it not infrequently was on Impressionist canvases—to make the picture look more finished and thus more salable. The removal of this overpaint and an inappropriate, thick, and degraded varnish in the recent cleaning has uncovered a painting much more convincing as a work by Gauguin than in its previous state.

The signature and date in the bottom left corner are original.

Fig. 82. Attributed to Paul Gauguin. *Tahitian Landscape*. X-radiograph. Sherman Fairchild Paintings Conservation Center, The Metropolitan Museum of Art, New York

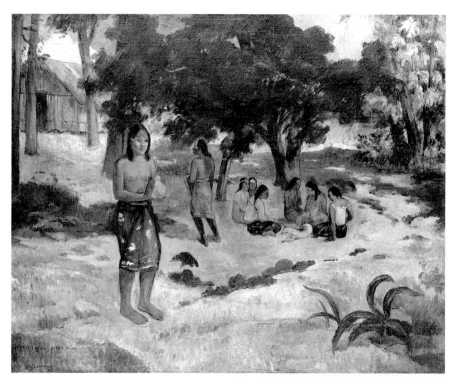

Fig. 83. *Parau Parau (Whispered Words)*, 1892. Oil on canvas, 30 x 22 in. (76 x 56 cm). Yale University Art Gallery, New Haven, John Hay Whitney, B.A. 1926, M.A. (Hon.) 1956, Collection

The date has generally been read as "91," but wear and the overlying degraded varnish rendered these numerals barely legible. Recent cleaning of the painting reveals with greater clarity that the date should be read as "92."[67]

A number of landscapes with small figures from the first Tahitian sojourn share close stylistic and technical parallels with *Tahitian Landscape*. Among them are two works, both signed and dated 1892, *Landscape with Figures* (Ny Carlsberg Glyptotek, Copenhagen, W 480) and *Parau Parau (Whispered Words)* (Yale University Art Gallery, New Haven, W 472) (fig. 83). In their casual compositions all three reflect the Tahitian images of the contemporary photographer Charles Spitz (see fig. 84).[68] (We know that Gauguin owned and took imagery from a large collection of photographs and was himself interested in photography.)[69]

The detached introspection of the protagonists in *Tahitian Landscape* —despite their proximity, they engage neither with each other nor with the viewer—is characteristic of most of Gauguin's paintings that include figures. Here the figures are depersonalized by means of the schematic treatment of the faces—in the Copenhagen painting and others the faces are left completely blank. These devices contribute to the rather melancholy and unsentimental quality of the pictures. The schematization of the facial features in the Yale work and in the *Tahitian Landscape*, indicated in black paint in each, is especially close.

The three pictures are similar in other respects as well—though the Copenhagen example is more elaborate in composition and sustained in execution and the Yale painting has more variegated brushwork—both are grander in scale than the *Tahitian Landscape. Parau Parau* is particularly close to the Metropolitan Museum's landscape: the palette and the handling of paint are very much alike, and both show abundant black contours and a black signature as well as localized areas of impasto made up of the same kind of strokes.[70] All three have areas of short, diagonal parallel hatching as final accents. Red accents are a ubiquitous element of Gauguin's landscapes beginning with his early Impressionist works, and all three of these pictures have red outlines defining some branches, and they show small dabs of red in the foliage. Moreover, all have the very fluid, calligraphic contour strokes in dark blue, blue-black, or

192

black seen in many of Gauguin's paintings. Toes are described with the same short, parallel notational lines in the woman in *Tahitian Landscape,* in the kneeling nude that was painted out of the Museum's *Tahitian Women Bathing* (cat. no. 62; fig. 68), and in the figure to the right of the angel in the underdrawing of *Ia Orana Maria* (cat. no. 55) as well as in one of the drawings noted below (fig. 85b). Minor details in *Tahitian Landscape* appear in other paintings of the first Tahitian sojourn. These include the dab of red used for

Fig. 84. Copse at Punaavia. Photograph, ca. 1890–95, probably by Charles Spitz, from *Autour du monde,* Paris, 1895

the man's mouth, the heart-shaped hibiscus (?) leaf floating on the ground below the horse, the schematized, cartoonlike features of the animal, and the clearly demarcated bright patch of light on its hind quarters.[71]

Three drawings related to *Tahitian Landscape* are helpful in establishing the status of the painting. Two are in Dorival's edition of the *Carnet de Tahiti.*[72] Both show horses grazing;

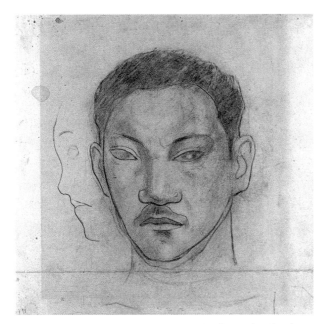

Fig. 85a. *Head of a Tahitian,* ca. 1891–93. Graphite with red and black chalk, 13¾ x 14½ in. (35 x 37 cm). The Art Institute of Chicago, Gift of Mrs. Emily Crane Chadbourne 1922.4794

Fig. 85b. *Two Standing Figures,* 1891–93 (verso of *Head of a Tahitian*). Charcoal. The Art Institute of Chicago, Gift of Mrs. Emily Crane Chadbourne 1922.4794

one, though reversed, is very close to the horse in the painting, even in terms of the summary treatment of the fall of light; the other is not as similar, though it is the page Dorival associates with the canvas.[73] The third is a drawing of two figures on the verso of the very beautiful *Head of a Tahitian* in the Art Institute of Chicago (figs. 85a, 85b).[74] The painted figures are without doubt based on this careful studio drawing. However, there are differences. The figures in the sheet, which look like separate studies, have been moved closer together in the final work; the man in the drawing wears a cap, but he is hatless in the painting; his facial features are coarsened and his expression is neutralized in the landscape.[75] (Gauguin often changed the facial expressions of his figures when he transformed his preparatory sketches into paintings.) Furthermore, in the drawing the man's right arm hangs convincingly and there is even a second study of the hand adjacent to the figure, while in the canvas the arm is very weakly executed and the hand poorly articulated.

Based on the technical and stylistic evidence cited here, there is a good case to be made for restoring *Tahitian Landscape* to Gauguin's oeuvre. It is unlikely that either a pasticheur or an imitator would have had access to the drawing on the verso of the Chicago *Head of a Tahitian* (which, in fact, may have been hidden, as the work shows evidence of having been pasted down onto a backing), or that such a person would have been sophisticated enough to adjust the model in subtle ways when making the painting. Moreover, as has been noted, the choices of materials and technique—the type of support, ground, underdrawing, and pigments and the individual brushstrokes—are consistent with Gauguin's practice, as evidenced by both the picture surface and the X-radiograph.

The stylistic analysis that rejected the painting on the basis of weaknesses must be reexamined in the light of the technical findings. In the two years prior to his first Tahitian voyage, working in what he called the "savage" and "primitive" surroundings of the less remote Brittany, Gauguin had with great success synthesized the stimuli of his environment with a new pictorial language.[76] In Tahiti the process of adjustment to his new setting was complex intellectually, emotionally, and artistically. When he left France for Tahiti, Gauguin had anticipated that he would find artistic and economic freedom in an unspoiled island paradise. But his letters home show him dismayed at the degree of Europeanization he encountered along with the bureaucracy that affected his daily life, deeply disillusioned by the loss of native culture—particularly of the Maori religion—that he wanted to draw on, and always anxious about money. The first Tahitian sojourn was a period of intense creative activity, growth, and prolific output, which, not surprisingly in these circumstances, is extremely uneven.[77] It is in this context that the shortcomings of *Tahitian Landscape* can be understood. And it is also in this context that the painting's noncommittal mood, its very awkwardness, and the ambiguity of its space (which Field deftly describes as an "expressive variable" for the artist)[78] place it more squarely with Gauguin's oeuvre than with that of any imitator.

A NOTE ON *IA ORANA MARIA*

In this discussion of revelations gained through technical investigation of Gauguin's work, it is appropriate to include a note about one of the masterpieces of the first Tahitian stay, the Metropolitan Museum's *Ia Orana Maria* (cat. no. 55). It has been suggested that Gauguin began this composition in a horizontal format (rotated ninety degrees from its present orientation), as it appeared in a sketch the artist included in a letter to his friend Monfreid in which he describes the painting.[79] Our recent technical examination of the picture, however, has produced no evidence to support this theory. Furthermore, it is evident from the X-radiograph, infrared reflectography, and surface examination that the cartouche for the inscription, which is featured in the sketch, was added on top of the still life, which originally extended to the bottom of the painting. Gauguin must have made the sketch after the fact, as indicated by the date on the letter, March 11, 1892, and the date marked on the painting, *91*.

You know that though others have honored me by attributing a system to me, I have never had one, and could not condemn myself to it if I had. I paint as I please, bright today, dark tomorrow. The artist must be free or he is not an artist.

"But you have a technique?" they say.

No, I have not, or rather I have one but it is a vagabond sort of thing, and very elastic. It is a technique that changes constantly, according to the mood I am in, and I use it to express my thought, without bothering as to whether it truthfully expresses nature.[80]

Gauguin liked to present himself to the world as complex and impenetrable. His painting materials and technique were in fact largely unexceptional in the context of the contemporary avant-garde. Yet the wide range of his work in terms of medium, handling, and quality has inspired the multifaceted investigations of the handful of paintings described here and continues to give rise to as many new questions as answers.

GAUGUIN'S WORKS ON PAPER: OBSERVATIONS ON MATERIALS AND TECHNIQUES

MARJORIE SHELLEY

R ejecting what he saw as the corruption of European society[1] and despising bourgeois values, hypocrites, bureaucrats, and academicians, Gauguin lived a myth that was sustained by his desire to create an entirely original art. He achieved his stated goal—a "mystical and symbolic art"[2] that evoked a deep emotional response—by employing exotic imagery and surfaces whose matte optical qualities, simplified forms and brushwork, textured substrates, and purity of color summoned up a primitive beauty. Despite his search for an elemental simplicity in his life and work, and his retreat to Brittany, Martinique, and the South Seas to find it, neither his drawing materials nor his techniques were derived from naive sources. Both were firmly rooted in traditional and contemporary European practices.

There are no precise records regarding what drawing materials Gauguin purchased while he was in France or elsewhere. It is known, however, that he relied on friends and art dealers to send him much of what he needed from Paris.[3] His prolific correspondence, replete with references to his oil paintings, makes little mention of graphic media or tools. In part this is probably because he would have been able to buy his basic supplies (plain paper, pens, inks, and graphite pencils) from tobacconists or stationers wherever he worked. As for materials that were not readily accessible, the published correspondence from his Tahitian years gives some indication of these but leaves many questions as to exactly what drawing supplies he was sent and what he bought.[4] Letters exchanged with his artist friends Daniel de Monfreid and Georges Chaudet and the dealer Ambroise Vollard refer to his receipt of Ingres paper, watercolors, and Japanese paper, request sable brushes for drawing, and mention a new printing technique, shortages of paper, and twenty-three drawings irreparably damaged by rats.[5] Such accounts are never as detailed as Gauguin's remarks regarding his tube paints, canvases, and paintings in progress. Yet even these cursory comments indicate that he was as particular about his drawing materials as he was about those for painting and that his choice of media was as studied and methodical as his technique.[6]

Gauguin had no formal training as a draftsman. Apart from his months with Camille Pissarro—whose influence is seen in the pale colors, broken Impressionist brushstrokes, and simplified forms of such works as *Design for a Fan: Breton Shepherd Boy* (cat. no. 15)—he seems to have learned the practices of drawing, printing, and transferring by examination of the works of others, trial and error, reading, and discussions with a wide circle of fellow

artists. Although many art manuals were available at the time, it cannot be assumed that he turned to such sources for practical information.[7] Gauguin's writings focus on painting, but because he did not erect boundaries between media (using many comparable techniques in his drawings and paintings), his words can also be used to interpret his works on paper. What is evident from his letters and his art is that, in spite of his arrogance, he was always receptive to new ideas. Seurat's dots and Van Gogh's plein-air painting as well as homemade paints, color theory, and various printing techniques all caught his interest at one time or another, although he ultimately rejected most of them.

Gauguin's life as a professional artist was beset by recurrent financial hardship. Notwithstanding his critical acclaim he had few sales, and from as early as 1888 until his death he was repeatedly in need of paints and money. Drawing clearly offered him a means of artistic expression that was cheaper and quicker than painting, for its materials required no preparation, were uncomplicated to use, and needed no drying time (issues that were repeatedly of concern to him in his paintings). Yet, beyond these practical considerations, Gauguin regarded his drawings as instruments of thought that were seminal to his artistic production, and he utilized a wide range of graphic materials in making them.

Despite legends to the contrary, Gauguin did not utilize exotic materials for his works on paper, nor is there firm documentary or analytical evidence that he fabricated his own graphic media; although he mixed or prepared them as he saw fit, he acquired them ready-made. The materials he employed were conventional, and except for watercolor, which had been in widespread use throughout the century, most of them had become popular only in the 1860s and 1870s. These included various drawing materials such as Conté crayons, compressed charcoal, wax crayons, natural charcoal, and pastel as well as gouache and *peinture à l'essence*, a matte, drained oil paint mixed with turpentine. He also made use of an equally varied range of white and colored European and Asian papers. The present discussion of how Gauguin employed these materials centers on a small but representative group of drawings and offers an overview, based on technical examination, of his careful working processes. When his practices are viewed in a historical context, his innovative use of media, especially pastels and printed drawings, becomes obvious but so, too, does his awareness of traditional techniques. This study also sheds some light on his deliberate choices in pairing media with particular types of paper, his consistent rejection of tactile effects, and the fluid technical boundaries of his drawings.

Since it is generally not possible to remove sample material from works on paper and because mountings often obscure the structure of the support, many limitations are imposed in this type of investigation. Most of the works included in this study were examined under high-powered magnification and, when possible, with transmitted and ultraviolet light and infrared reflectography. In the case of a few drawings, pigment analysis was carried out by Raman laser microscopy and X-ray fluorescence; for a small number of gum samples, FTIR (Fourier Transform Infrared Spectroscopy) was used (see Table at end of chapter).

TRANSFERRING TECHNIQUES

Drawing was fundamental to Gauguin's artistic process, forming the basis of his work in every other medium and imparting a distinct correspondence among them. Throughout his life he continually turned to his sketchbooks, filled with summary studies in graphite, ink, crayon, and watercolor, as well as to his extensive collection of photographs, postcards, and reproductions of old master paintings and ancient sculpture. Using these motifs as sources of ideas, he would either select one subject and entirely rework it or reassemble parts of several images into a definitive composition in oil, ceramic, sculpture, woodcut, or lithography; alternatively, he would embellish a studio drawing with watercolor or pastel to make it more salable. Realizing the importance of these drawings to his creative process, Gauguin referred to them as his secrets: "A critic who comes to my house sees my paintings and, breathing hard, asks to see my drawings. My drawings! Not on your life. They are my letters, my secrets. The public man, the private man. You want to know who I am: are my works not enough for you? Even right now, as I write, I show only what I want to show."[8]

The close guard Gauguin kept on these works was surely not meant to conceal the drawings themselves but rather to hide the fact that he transposed them from one medium to the next. To reveal his technique would in effect diminish his originality, and hence his stature as an avant-garde artist, for his meticulous methods were actually based on the much-despised practice of copying.[9] The reuse and multiplying of images were, however, entrenched in nineteenth-century artistic activities. This was an era that celebrated pictorial reproduction, manifested in the *répétitions* and replicas of Salon paintings; the burgeoning of lithography, steel engraving, and photographic and photomechanical techniques; the instruction in transferring techniques offered in artists' manuals; and the products sold by colormen, which included tracing papers and cloths and copying pens and pencils. Copying also constituted the core curriculum of the Academy.

Claiming disdain for these imitative practices, which had been vociferously challenged by Manet and the Impressionists, Gauguin maintained that it was better to paint from memory than from nature[10] (a position that reflected both nineteenth-century concepts of originality and imitation and his own antagonism toward the Academy). He wrote in his journals that "it is only the sign painter who should copy the work of others. If you reproduce what another has done you are nothing but a maker of patchwork, you blunt your sensibility and immobilize your colouring."[11] However, at some point in his workshop practices, "memory" was obviously put aside and Gauguin turned to the methods prescribed by academic tradition expressly for copying and duplicating,[12] using them to reproduce images from his personal sources, to transfer motifs and change their scale, and to vary their placement.

One such method was pouncing, in which a drawing is pricked along its contours, and charcoal powder is dusted over the punctures onto an underlying support or interleaf to give an exact-size transfer, as in *Parau Na Te Varua Ino* (Kupferstichkabinett, Öffentliche Kunstsammlung Basel). Far more common in his work was squaring, in which a composition is

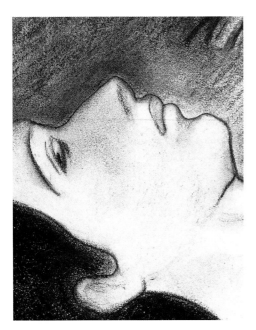

Fig. 86. *Girl with a Fox*, ca. 1890–91 (cat. no. 44, detail). Conté crayon, white pastel, and red chalk over graphite. Ms. Marcia Riklis

enlarged, decreased, or transferred on the same scale through the use of a grid. Such devices were generally employed to transfer motifs from a drawing to a painting—as Gauguin did when he transposed the seated figure from *Martinique Women with Mangoes* (cat. no. 29), executed in fabricated black crayon and developed in pastel and watercolor, to the oil painting *Among the Mangoes, Martinique* (fig. 30).[13] Another practice was the use of reference lines, a device essential to academic artists but also popular among members of the avant-garde such as Degas and Puvis de Chavannes, both of whom were greatly admired by Gauguin. These are horizontal and vertical axes by means of which "the individual features of a face, head or figure" are oriented to simplify it and eliminate detail, enabling it to be copied.[14] Although usually obscured in finished drawings by thick layers of media, in *Girl with a Fox* (fig. 86) the fine horizontal graphite line intersecting the girl's profile is evidence of this practice. It was used to transfer the drawing, later worked up in Conté, to the related painting, the *Loss of Virginity* (The Chrysler Museum of Art, Norfolk, Virginia, W 412).

Gauguin also traced his designs and made monotypes and counterproofs—all well-known techniques for multiplying images—in order to work them up in pastel and other media.[15] Under magnification, the diffuse, flat texture of the red-chalk profile in *Tahitian Woman with a Flower in Her Hair* (cat. no. 58) suggests that it was produced by dampening and pressure, and therefore impressed from another surface.[16] Gauguin has carefully traced the outline in compressed charcoal above the red chalk (the slip of his hand is visible where the contour extends upward at the mouth); he then enhanced the drawing with broad areas of color.

These processes provide visual evidence of Gauguin's working methods and signify the importance to him of drawing, both as a creative and a mechanical or duplicating process. Yet the means he used to transfer his precise, simplified contours and to construct his independent drawings often remain enigmatic. Because of their transparency, watercolors such as *Te Arii Vahine (The Queen of Beauty)* (cat. no. 96) may reveal an underlying drawing, but these are frequently not detected in pastels and in charcoal and Conté drawings. Underdrawings in red chalk, such as that presumably used in *Ia Orana Maria* (cat. no. 57), are transparent under infrared light; those in graphite, Conté, or charcoal, as in *Tahitian Faces* (cat. no. 104), are difficult to differentiate from the final layer if that too is executed in a medium containing carbon. Gauguin did make revisions when transferring his drawings, as in the adjustment in the scale of *Martinique Women with Mangoes*. However, the changes that are usually revealed through examination with infrared or transmitted light, such as those in the contours of the large portrait in *Little Tahitian Trinkets* (cat. no. 63), are invariably minor and indicate that his ideas were generally well established before he began the deliberate process of developing his compositions.[17]

DRAWING MATERIALS: CONTÉ, CHARCOAL, WAX CRAYON, AND PASTEL

Gauguin's receptivity to traditional practices is also evidenced in his use of popular contemporary drawing materials, including many types of fabricated black crayons and pastels and an array of papers made especially for artists. Despite the periodic poverty of his supplies, he does not seem to have made random choices in this respect but rather to have purposely selected papers and media suited to each other or to have modified them to accord with his expressive purposes. One of his few recorded comments about his drawing materials relates to this issue. In 1899 Vollard sent him Ingres paper (the generic name for a popular type of white or toned laid drawing paper with a slightly rough surface) along with the following request:

Dear Mr. Gauguin,

You will receive, at approximately the same time as this letter, two parcels containing about sixty sheets of Ingres paper and some watercolours. I am sending these in the hope that you will be good enough to make me some sketches in washed pencil with watercolour, covering the entire paper—something like the drawings you made in Brittany some time ago and colored with pastels. I will buy all you make at a rate of 30 francs each.[18]

Gauguin responded bitterly:

I fear that your Ingres paper will not be of much use to me. I am very exacting in the matter of paper; moreover your requirement that the entire paper must be covered intimidates me so that I can scarcely begin. Now an artist (if you consider me such, and not a machine to produce on order) can only do what he feels, and what does size matter! I love experimenting; but if this picture must be a watercolor or a pastel, well I lose all interest in it.[19]

Vollard failed to understand what Gauguin was aware of—that this type of paper would absorb and dull watercolor and that its ribbed pattern would be visible in the finished composition. Papers with such textures, as well as lightly sized colored wove papers, had therefore never been favored for watercolor but rather for direct media—those materials worked without an intermediary brush or pen, including charcoal, Conté, and pastel. Several factors were responsible for the popularity of these media in the second half of the nineteenth century: the drawing reforms of the École des Beaux-Arts, which in response to demands for spontaneity and individuality rejected the linearity of the graphite pencil for the expansive tones of charcoal; the exhibitions of the Fusainistes, Salon artists such as Adolphe Appian, Auguste Allongé, and Jean-François Millet who gave charcoal drawing a fresh prominence; and the new, draftsmanlike manner of applying pastel as opposed to the earlier practice of "painting" in dry color. In turn, as these media increasingly became appreciated, so did the physical properties of the specialized papers made for them. Their irregular, fibrous surfaces produced a broken, open line when particles of the friable media were stroked across them, and their colors lent a chromatic component to the newly desirable, sketchlike "unfinished" works.

Like so many artists of the time, Gauguin often worked in these media on such supports.

His technical range is particularly apparent in his drawings in black media, that is, charcoal, compressed charcoal, Conté, and wax crayon. Some of these, such as *Tahitian Faces* (cat. no. 104), reflect his employment of traditional practices for tonal modulation, while others, *Ia Orana Maria* (cat. no. 57), for instance, reveal how he transformed these methods to serve his expressive purposes. However, in their emphasis on decorative line and flat surfaces rather than chiaroscuro or illusion, all attest to Gauguin's defiance of convention.

Identifying exactly which black media Gauguin employed in each of his drawings is often difficult. All these media are composed of carbon, completely or in part, and contain little or no binder, and thus their particle morphology—the shape, size, degree of reflection, and distribution of the powder when the crayon is stroked across a sheet of paper—must be used as the basis of differentiation. In addition, the variations in texture and hardness possible in one type of fabricated medium often appear in other types as well. The fact that these materials differ in their degree of blackness and in their ability to produce a broad or more sharply defined line, to be readily blended, and to be modified by the texture of the substrate must have accounted for Gauguin's choice of one or another crayon and also determined his artistic approach to a particular drawing.

One example of his approach is *A Woman Sewing and Other Figure Studies* (cat. no. 3), which was executed in black crayon bound with wax. Such crayons (including those made for lithography) were in popular demand in the late nineteenth century because they were cheap and tenacious and required no more than plain wove paper. Though they were used by many Pont-Aven artists for highly worked drawings, Gauguin employed them mostly for his sketchbook studies. Their compact structure made them unsuited for tonal gradation; Gauguin thus relied on firm contours and strong hatched lines to render the volume and modeling of these images. *A Woman Sewing*, however, is drawn on pink, Ingres-type laid paper (once far brighter), a support identical to that which Van Gogh used in several graphite studies made in Arles.[20] But Gauguin has treated the sheet much as he would a page from a sketchbook, disregarding its color and texture and using it simply as a surface for quick renderings of an image.

Although there is no interrelationship of media and support in *Woman Sewing*, this is usually not the case in Gauguin's more highly developed compositions in black direct media, which often employ red chalk or touches of white pastel. While never as complex as the *noirs* of Redon (a major exponent of such materials whose work was familiar to Gauguin), these drawings reflect the artist's sensitivity to the different textural and tonal properties of these crayons and to their interactions with the surface and color of the support. In both the *Portrait of Annette Belfils* (cat. no. 7) and *Girl with a Fox* (cat. no. 44), for instance, he applied the Conté in broad masses. In the former, his vigorous sweeps with the side of the crayon produce dark passages lightly broken by the projecting pattern of laid and chain lines. In the latter, however, the smooth paper allowed him to distribute the Conté uniformly: thus, the forms contrast more sharply with the surrounding exposed support and they are even more simplified, the latter effect intended to parallel the Symbolist content of the composition.[21]

Conté, made of fired graphite and clay, was especially popular in the last decades of the century, being valued for its rich depth of tone. Conversely, natural charcoal, which produces

shades of gray but never black, is tonally limited. Thus, in order to build up gradations of light and dark, Gauguin employed veil-like layers of it in *Tahitian Faces* (cat. no. 104). The medium's relative lack of density and the fact that it cannot be heavily pressed into the paper without crumbling also accounted for the more linear structure and the light hand he used for this composition. The broken texture and luminosity of the sheet—the same laid paper used in the Belfils portrait—thus became an active element in the composition, comparable to the textured canvases in his paintings.[22]

Ia Orana Maria (cat. no. 57) is executed in compressed charcoal (pulverized natural charcoal that is compressed and fired, yielding a crayon that is softer and darker than natural charcoal) and red chalk on wove paper (fig. 87). In this composition Gauguin again exploited the particular expressive possibilities of his materials. He produced a delicately textured matte effect by manipulating the paper and the media and achieved a decorative presentation by dramatically cutting the support and applying a band of white pastel and strips of rose-colored paper to two edges. Employing common techniques, he rubbed the surface of the paper until delicate wisps of fibers, evoking the texture of felt or tapa cloth, appeared. This method is similar to one traditionally used to work up a nap on paper that would loosely secure pastel or charcoal powder but be obscured by the medium

Fig. 87. *Ia Orana Maria (Hail Mary)*, ca. 1893–95 (cat. no. 57). Photomicrograph showing manipulation of charcoal layer to produce highlights. Sherman Fairchild Center for Works on Paper and Photograph Conservation, The Metropolitan Museum of Art, New York

upon completion of the work. As opposed to the consistently thick, opaque layering of conventional charcoal work, Gauguin applied the red and black crayons not only in firm, direct strokes but also by stumping (rubbing and blending) in a thin, diffuse film—a technique that partially reveals the surface of the support and confers an atmospheric, ambiguous quality. Lastly, his precise and purposeful wipes of the media with his fingers, India rubber, or bread crumbs (an effect reminiscent of the *retroussage* inking he used for the *Noa Noa* woodcuts) served to lift the powder from the sheet and produce gradations of tone, subtle texture, and flickers of light—reductive techniques that were a mainstay of the Fusainistes.

PASTEL

The widespread enthusiasm for pastel during Gauguin's time, especially among the avant-garde, was in part inspired by the matte surface and opacity of the medium, qualities that evoked the finish associated with primitive art and early Italian frescoes. Such optical effects, fundamental to the modern aesthetic,[23] resulted from the diffuse reflection of light from the medium's irregular, weakly bound particles. From his earliest years as a Sunday painter,

Gauguin was attracted to this readily manipulated material, and he continually experimented with it until about 1899. His accomplishments in pastel probed to be among the most innovative of his graphic efforts. By 1886 his monumental style had emerged, its development becoming evident in the full-scale pastel studies for *Four Breton Women* (Bayerische Staatsgemäldesammlungen, Munich). These early drawings are rendered in a direct, simplified manner: a uniformly thin layer of stroked crayon in the modern, draftsmanlike technique that conveys spontaneity by revealing the color and striated texture of the paper.

Gauguin's later pastels, far more complex in execution, are characterized by the frequent incorporation of brushwork. *Tahitian Woman* (cat. no. 84) combines broad, vertical strokes of pastel, built up in thick layers of vibrant color applied with the side of the crayon, and vigorous, transparent stroked washes in the lower part of the sheet. A yellowed, gumlike substance, visible in the small voids of the paper, and discrete areas of craquelure around the face indicate the use of a fixative. While generally applied after completion of a pastel to stabilize the powder, such substances were occasionally used before drawing to coat the paper or at intermediary stages of work to act as barriers between colors and thus allow the friable medium to be thickly built up. Degas often employed the latter practice, and Gauguin may have observed it in his work. Gauguin's letters reveal, however, that he had also seen and admired Maurice Quentin de La Tour's pastels and would have recognized a similar technique in the earlier artist's *"préparations."*[24]

In La Tour's portrait studies the head is surrounded by a halo of fixative, applied to stabilize the preliminary layers of pastel without impairing the evanescent qualities of the final touches. Gauguin seems to have devised a comparable procedure in constructing *Tahitian Woman*, but he began with a preparatory drawing in brushwork, which he left partially visible. The dark, compact paintlike texture of the face and the craquelure both suggest that he then applied multiple layers of pastel, interspersing them with fixative; however, by saturating the powder, he reduced the scattering of surface light. Undoubtedly the risk that the thick pastel layer would be dislodged by any movement of the paper must have provoked Gauguin to use a fixative. Yet this potential risk of damage probably also accounts for his mounting *Tahitian Woman* to its rigid millboard backing, a strip of which remains visible along the left edge. Finally, the powdery texture of the pastel surrounding the face indicates that the uppermost layers were not fixed. It would appear that here Gauguin, like his vanguard circle with their contempt of varnishes, avoided coating the final surface in order to achieve the most light-reflective effect. As in the drawing *Ia Orana Maria* (cat. no. 57), the artist enhanced the decorative quality with a spandrel and lower border cut from bright yellow paper—material similar to the distinctive, brilliant chrome yellow supports he used for the so-called Volpini Suite lithographs.[25]

Gauguin's treatment of *Tahitian Woman* is very different from that of his later, more economically applied pastels, such as *A Tahitian Woman with a Flower in Her Hair* (cat. no. 58). In this work, rendered in a limited palette, he covered much of the white laid paper with broad areas of black and pink pastel. Rather than applying a fixative at a preliminary or intermediary phase, he instead brushed a wash solution over all but the darkest areas of color. Although this wash cannot be precisely identified without chemical analysis, its uniform flow and the

lack of pigment accumulation at the end of the brushstrokes suggest that it was made with a mixture of water and a solvent such as alcohol.[26] This innovative method of modifying the pastel transformed the powdery alizarin pink background into a paintlike substance and the red-chalk flesh tones into transparent washes, as well as rendering the medium more cohesive. But what was perhaps equally important to Gauguin was that it obscured the pattern of the paper by dissolving and spreading the powder from the surface of the laid lines into the hollows between them. Unlike Degas, who had used water and steam to enhance the working properties of the medium, turning it into paste and thick washes, Gauguin seems to have striven to minimize surface effects and to create flatter color areas in his pastels. The same approach was employed in the large portrait in *Little Tahitian Trinkets* (fig. 88), which is executed on a smooth wove paper. After applying richly colored strokes of blue and green pastel[27] to the background and soft browns and reds to the skin, Gauguin carefully brushed over them with a solvent wash in order to diminish the individual marks of his hand. Rather than stumping the powder, a technique that had been rejected by vanguard artists because it tended to flatten and thus optically dull color, he transformed it into a broadly painted field with a tonal luminosity comparable to that of the adjacent watercolor vignettes on the underlying sheet.

It was undoubtedly Gauguin's aesthetic concern with maintaining the matte effect of his pastels that led him to experiment with the washes evident in the previously discussed compositions. However, on a very practical level, he would have been aware that friable media (including the black "chalks" as well as pastel) were readily subject to abrasion and were thus often fixed to keep their surfaces intact. Fixatives, nonetheless, presented a problem. Like varnishes, they darkened colors by filling the voids between their loosely held particles, thus compromising their characteristic light-diffusing appearance. The disfiguring results had led artists to continually experiment with various types of transparent materials, ranging from traditional ones, including isinglass, to modern casein solutions such as those Gauguin may have learned about from Pissarro,[28] in hopes of preserving the optical and tactile qualities of these media.

In theory, the use of any surface consolidant would have been antithetical to Gauguin, but evidence of his experimentation with them was detected in a few works in this study. *Ia Orana Maria* and *Tahitian Faces* each revealed a barely perceptible amount of a gum resin in the form of tiny droplets, suggesting application by the common technique of quickly releasing a loaded bristle brush or a

Fig. 88. *Little Tahitian Trinkets*, 1892 (cat. no. 63). Photomicrograph showing pastel with washes of solvent and water. Sherman Fairchild Center for Works on Paper and Photograph Conservation, The Metropolitan Museum of Art, New York

simple tube atomizer.[29] *Annette Belfils* has a hard, transparent surface film, which was identified as egg white.[30] Although not recorded for use with drawing materials, this substance is described in many nineteenth-century painting manuals as a temporary retouching varnish. Van Gogh used it in place of glossy coatings to saturate dark oil colors painted on absorbent grounds that had become matte.[31] His example and a desire to protect the surface of this portrait, or perhaps even tonally enrich it, may have inspired Gauguin to use egg white, which has given a slightly grayish cast to this usually dense black medium. That these materials are present on each of the drawings in such minimal amounts almost certainly indicates that it was Gauguin who applied them: he would have been resolute in his insistence that the inherent matte qualities of the media be preserved.[32]

There were no comparable means of preserving the color of paper, and sadly, owing to exposure to light and inherently fugitive dyes, the once-vivid wove supports of *Tahitian Woman* and *Ia Orana Maria*, evidenced in each by the remaining red and blue fibers, have faded. This dynamic element would have been visible at the lower edge and in the small areas of reserve in *Tahitian Woman*, and throughout the more thinly applied charcoal composition. It would have combined with the contoured shapes of these sheets and the brightly colored paper additions to impart a vibrancy and a sculptural presence. Many other works on paper by Gauguin similarly unite a flat decorative surface with three-dimensionality implied by cutting—a means of presentation comparable to the artist's painted and carved wooden reliefs, such as *Soyez Mystérieuses* (Musée d'Orsay, Paris). Among these are *Girl with a Fox* (cat. no. 44) and the *Ta Matete* fan (cat. no. 60); the latter is partially folded in multiple sections, as if to transform it into a functional object.[33]

GOUACHE

Gauguin's use of absorbent grounds and coarse fabric was fundamental to the subtle textural effects and brilliant colors that he sought in his oil paintings.[34] Of all his works on paper substrates, those in gouache, an opaque medium having a high proportion of pigment to water and gum binder, most closely approach this sensibility. The interrelationship of their physical characteristics—high-keyed palettes, light-diffusing matte surfaces, and rough, porous supports—was central to the chromatic and optical theories of the Impressionists and Neo-Impressionists. Even more than pastel, gouache implied modernism, and Gauguin's use of it on a variety of paper-based materials testifies both to the importance of this medium in his graphic oeuvre and to his employment of it to achieve the effects he desired in his oils.

Evidence of this relationship is seen in *Jugs in "Chaplet" Stoneware* (cat. no. 24), in which the palette of muted earth tones was produced by mixing watercolor with white gouache. The impact of the heightened colors on the white paper corresponds to the enhanced brightness produced when oils are applied to a chalk ground on canvas. Highly esteemed by the avant-garde, this *peinture claire* effect—perceived in painting as light reflected from the preparation and suffusing the composition with a pale tonality—is similarly conveyed in the drawing. That this

was Gauguin's intent, and that he placed great importance on the aesthetic role of the support, is conveyed by his explicit reference in *Avant et après:* "Let the background of your paper lighten your colours and supply the white, but never leave it absolutely bare."[35] Like his canvases with their thin layers of paint, the gouache in the still life, which is given greater definition by the charcoal outlines, is very fluid and has been wicked into the fibrous surface of the Japanese paper, a material in great demand by vanguard European artists. Gauguin's appreciation of this paper and its absorbent, fibrous texture—properties he also utilized in creating varied surface effects in his monotypes—was reflected in the pleasure he expressed upon receiving a supply of it from Vollard.[36]

The matte quality of the medium of the *Jugs*, which has understandably been mistaken for pastel, is produced by the reflection of surface light from the thin layer of minimally bound pigment and the fibrous white support. In the *Artist's Portfolio, Pont-Aven* (cat. no. 26), Gauguin achieved a similar frescolike effect but with different materials. This object, constructed of a hinged leather cover and a millboard interior (typically used in letterpress work), was transformed by the artist into a folder for his drawings, which he decoratively embellished with inscriptions, an emblem, aniline-dyed silk ribbons, and shoe buttons.[37] The millboard's raw surface, dull opaque and rough texture, and ability to absorb water from paint, leaving behind pure color, must have made it attractive for the primitive effects he sought.[38] In this work the gouache is less fluid than in the *Jugs;* its thicker consistency allows for the well-defined, drier brushwork needed to depict the sinuous color bands describing the flow of water and other motifs of rustic Breton life. Differing from his more precisely finished gouaches, the *Portfolio* has a personal quality that is conveyed by the spontaneity of the painting and the broad areas of reserve.

The palette of the Pont-Aven *Portfolio* is characteristic of the vibrant hues found in Gauguin's work in water-based media. Analysis of many of the pigments in this composition and in the monotype *Two Tahitian Women with Flowers and Fruit* (cat. no. 106) reveals few differences from the colors the artist used in Brittany and in the South Seas. It also demonstrates that they are similar to those of his oils: cadmium yellow and red-orange; bright semiopaque vermilion; *vert véronèse* (emerald green); opaque zinc white (the customary white for watercolor because it did not blacken); and ultramarine (probably the less costly artificial or French ultramarine).[39] There are no earth colors. Although Gauguin mostly employed pure color, as prescribed by Symbolist doctrine, he also mixed pigments to enlarge his range: ultramarine was found in the purples, zinc white in the lighter tints (including the green and mauve in the *Portfolio*), and a compound brown in the monotype.[40] The presence of another mixture, vermilion and cadmium red-orange, in both works raises the question of whether this combination was intended by Gauguin or was an adulterated or impure color like many encountered at the time.[41]

Gauguin's stated preference for surfaces painted thinly with subtle strokes of color, as opposed to "the accidents of impasto" and "messing with brushwork" that he saw in Van Gogh's oil paintings, is apparent in *Peasant Woman and Cows in a Landscape* (cat. no. 43) and *Kelp Gatherers* (fig. 89).[42] Executed between 1889 and 1890 as part of a decorative ensemble for Marie Henry's inn at Le Pouldu, these works were conceived and constructed in the manner of

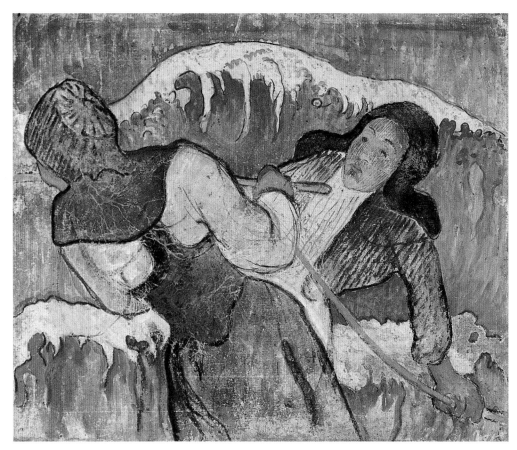

Fig. 89. *Kelp Gatherers*, 1889–90. Gouache and watercolor on prepared ground applied to millboard, 11 x 12⅝ in. (27.9 x 32.1 cm). Private Collection, courtesy of Sotheby's, New York

oil paintings.[43] Like the *Portfolio,* they are on millboard, a material comparable to the rough but supple paper applied to canvas that in 1888 Gauguin had advised Bernard to use because it gripped the color and gave good results.[44] Indeed, the texture and absorbency of this material, along with its rigidity, had made it popular for plein-air oil painting throughout the nineteenth century; the Pont-Aven painters were attracted to it in the 1880s, as many Post-Impressionists, including Pissarro and Seurat, were later. Gauguin's choice of millboard for Le Pouldu must also have been inspired by its tactile resemblance to the surfaces of the murals and other compositions in the inn, which were painted on the same material or directly on the plaster walls.[45] Yet it was undoubtedly his experience with brittle, absorbent chalk preparations applied to coarse canvas that led him to coat the two panels with a similar thin ground.[46] Such preparations served here to absorb moisture from the gouache and water-color, substituted for white paint in the exposed areas, and provided an underlying luminosity. Furthermore, by obscuring the dulling effect of the muted gray cardboard, they allowed Gauguin to apply the paints thinly, as he customarily did with his oils.[47]

Despite the apparent similarities of the two Le Pouldu compositions, examination reveals that Gauguin experimented with diverse techniques in them, as in his canvas paintings. Whereas the *Landscape* is executed in paints of varying opacity, *Kelp Gatherers* is painted in a

Fig. 90. *Kelp Gatherers*, 1889–90. Photomicrograph showing fibrous surface of millboard. Sherman Fairchild Center for Works on Paper and Photograph Conservation, The Metropolitan Museum of Art, New York

gouache of more uniform consistency, of which the blue is notable for the greater coarseness and heterogeneity of its pigment particles. The crudeness of this pigment mixture raises the possibility that it was not commercially produced, even though Gauguin had previously stated that he did not like the oil paints that he and Van Gogh had made in an effort to save money.[48] It may be that Gauguin periodically drew upon this prior experience, using raw pigment or scraped pastel and gum to make his colors.[49] Another notable difference between the two gouaches is Gauguin's choice of the unusually rough side of the millboard panel for *Kelp Gatherers*.[50] Its fibrous network, integrated into the hood of the figure on the left, is made visible by the spare application of paint (fig. 90), whereas the support of the *Landscape* is uniformly smooth and planar. The two panels are further differentiated by the brushwork. The diffuse green and blue strokes at the upper and lower edges of *Kelp Gatherers* indicate the use of a relatively fluid paint and porous ground. Conversely, the *Landscape*, painted in both heavily gummed paint and transparent washes, implies a less absorbent preparation. Such variations in materials parallel Gauguin's experiments on canvas.[51]

WATERCOLOR AND MONOTYPES

The smooth, regular surfaces of the wove papers that Gauguin customarily used for his watercolors, including *Jacob Meyer de Haan* (cat. no. 46), *Little Tahitian Trinkets* (cat. no. 63), and *Te Arii Vahine* (cat. no. 96), are markedly different from the richly textured supports he employed for his other graphic media. His preference for a particular type of paper suited to the requirements of a given medium—which the artist had clearly expressed in his correspondence with Vollard—is made evident when his watercolors are compared with his monotypes, which employ related materials (mostly combinations of watercolor and thin layers of gouache). For the monotypes, which were subject to dampening and pressure during printing,

Gauguin generally employed unsized, absorbent supports, such as the coarse brown wove paper embedded with bits of wood and straw of *Tahitian Girl in a Pink Pareu* (cat. no. 67) and the partially crushed and fibrous Japanese paper of *Two Tahitian Women with Flowers and Fruit* (cat. no. 106).

The textural differences in the paper types used for the two techniques are manifested in the effects these materials convey: in the printed works the rough- and matte-surfaced papers evoke a symbolic, primitive quality; in the watercolors, rendered with the simplest of means in both the paint layer and support, these qualities are evoked by the imagery alone. Although a broad range of textured watercolor papers was actively marketed at the end of the nineteenth century and many of these were comparable to rough-weave canvases,[52] Gauguin seems not to have been attracted to them. The nonporous, gelatin-sized papers he generally used for this medium enabled him to produce a meticulously painted flat surface, comparable to that of his gouaches and pastels, without disruptions in his brushwork.

Because of its saturated tonal qualities, watercolor was never held in high esteem as an avant-garde medium. Gauguin nonetheless continually used this painting material for his intimate sketches, presentations to friends, and independent studies, as well as for the fully worked compositions that Vollard ordered. Optically, watercolor is very different from gouache: its jewel-like luminosity derives from light penetrating through its imperceptibly thin, transparent layers and being reflected back to the viewer from the underlying support. To optimize this effect, Gauguin applied the medium sparingly to white or off-white paper, producing a luminescence analogous to that created by the white priming in his oil paintings. This light-evoking effect was, in fact, acknowledged by him in *Avant et après* as a necessary element in drawing.[53] Although the monotypes often incorporate passages of watercolor, their visual effect is usually closer to that of the artist's gouache compositions. In these works, in which the opaque paint is impressed into the paper, the frescolike reflectance is enhanced by rough particles partially embedded in the surface. Incrustations of dry crystalline pigment from coarse-grained paint and pastel are present in *Tahitian Girl in a Pink Pareu* and *Oviri* (cat. no. 92), while thick deposits of pigment and gum binder—undoubtedly accidents from the printing process—are visible on the surface of *Two Tahitian Women with Flowers and Fruit* and are present on other monotypes that Gauguin made beginning in 1902.[54] Unlike these materials that yield compressed yet dense surfaces, watercolor cannot be thickly applied without its appearance being substantially altered. Yet its lack of tactility must have had sustained appeal for Gauguin, for he constantly strove to produce this effect in his other media.

Being a fluid paint, watercolor also differs in its application from gouache. For the meticulous brushwork filling the flat color fields of *Meyer de Haan* and the carefully rendered vignettes in *Little Tahitian Trinkets*, Gauguin needed full control of his materials and could not rely on accident, as he believed Van Gogh did. But in his monotypes, chance effects and their consequent alterations in his original conception inevitably occurred. In these printed drawings the separation of the matrix and counterproof papers could cause random striations (*Two Tahitian Women with Flowers and Fruit* [fig. 91]) or a reticulated effect in the paint layer

on smoother, less absorbent wove paper (*Crouching Nude Woman Seen from the Back* [cat. no. 115]). These effects varied according to the viscosity of the media, the amount of binder, and the degree of dampness and pressure utilized in their production.

The precision of the watercolors, which were not subject to such variables, also resulted from the paints' being applied with a minimum amount of water and to dry paper. Gauguin's method—at great variance to the popular late-nineteenth-century watercolor practice that relied on fluid washes applied to wet paper—allowed him to carefully regulate the flow of his paints. In *Meyer de Haan* this is evident in the uniform brushwork and layering of color in the background passages, the absence of diffuse edges or blurred strokes surrounding the forms, and the well-defined area of exposed white paper delineating the book. Gauguin's meticulous execu-

Fig. 91. *Two Tahitian Women with Flowers and Fruit*, ca. 1899 (cat. no. 106). Monotype. Photomicrograph showing printed watercolor. Sherman Fairchild Center for Works on Paper and Photograph Conservation, The Metropolitan Museum of Art, New York

tion seems also to have been made possible by his use of tube paints, which are moist and more pastelike in consistency than pan color and can therefore be used with little or no water to work up a wash. A small, thickened dab of saturated dark blue paint in the background of this portrait (similarly evident in the skirt in *Peasant Woman and Cows in a Landscape* [cat. no. 43]) indicates that Gauguin was equipped with at least some of these more concentrated colors.

Although Gauguin's experiments in this medium included watercolors executed in a fluid, washlike manner,[55] more typically, as in *Meyer de Haan*, he was exacting. In addition to compartmentalizing his forms in ink, crayon, charcoal, or graphite outlines (a cloisonnist method he employed throughout his oeuvre), he also at times blotted his colors. As in monotypes, where the variations in brushwork are minimized by pressing, blotting watercolor with cloth or paper produced thin, uniformly textured flat areas, such as the blue pareu of the seated figure in *Little Tahitian Trinkets*, the same motif that he used in the oil *Tahitian Woman Bathing* (cat. no. 62). A similar precision is evident in *Te Arii Vahine* (cat. no. 96), based on the painting of the same title (Pushkin State Museum of Fine Arts, Moscow, W 542), which, like many other Gauguin works, depended on photographs for its imagery.[56] In this highly finished drawing Gauguin rejected the complex manipulations commonly employed to enhance the expressive or representational potential of watercolor, including glazing, scraping, and masking. Instead, following a loosely rendered underdrawing in black fabricated crayon, he developed the composition using very direct means. With broad, elongated strokes and fields of vivid color, he juxtaposed the white voids of wove paper (the background contours), opaque gouache (the foliage), semiopaque color (the red fan), pure transparent washes (the blue foreground), and layered strokes (the reclining queen). He thus orchestrated this record of his painting into a tapestry of color.

LATER MATERIALS AND TECHNIQUES

The same reliance on mechanical methods of transferring that Gauguin utilized through much of his career characterizes his later work. Starting about 1898–99, however, he devised other means and used other materials for his artistic purposes. Although his miserable circumstances during his later years in Tahiti (including poor health, debt, and lack of supplies) reduced his output of paintings and drawings for long periods, his production of prints increased at this time. Whereas he was completely dependent on canvas and paints being sent to him, he now seems to have turned to graphic materials that he could procure locally—pencils, wax crayon, printing ink, and paper—or prepare himself from supplies at hand, such as thinned oil paint. Putting aside pastels and charcoal, Gauguin returned to woodcuts, monotypes, and his new "invention," which he called printed drawings, or *"dessins"*; these works would dominate his late graphic oeuvre. Always transforming drawing materials to meet his own aims, Gauguin seems to have adapted certain aspects of letterpress technology, or mechanical copying—technology based on the duplication of documents—to the production of unique works of art. To him, the concept of reproducibility had been inherent in the methods he had long used to transfer motifs from one medium to another. It now generated ideas for multiplying his images cheaply and without the encumbrances of equipment, a desire that has been described as motivating many of his innovative practices.[57]

Gauguin's experiences working in the Bourse as a salesman and later in Tahiti as the publisher of the monthly broadside *Le sourire* and editor of *Les guêpes*, as well as in the Public Works Department in Papeete, would have brought him in contact with the many facets of letterpress copying, a technology that by 1899 was "universally employed."[58] There is evidence that he availed himself of the products of this technology: he used an Edison pen (an electric tool that cut perforated paper stencils) for duplicating the text of *Le sourire*, and he owned the means of printing such texts, a mimeograph machine listed in his personal effects after his death.[59]

Gauguin probably did not employ either of these devices for purposes aside from publishing. Several aspects of his artistic production do indicate, however, that he adapted other materials and concepts associated with copying technology and integrated them with his familiar materials and tools in order to devise a simple yet aesthetically compatible means of duplicating his images. Among these was the process he used for the large printed drawings, such as *Polynesian Beauty and Evil Spirit* (cat. no. 109), that he began to develop about 1900. In a letter to Vollard he alluded to his "experiment" in which he used thick ink instead of pencil.[60] He described it to Daniel de Monfreid as his "discovery," "which in due time, will completely upset current notions of printmaking, especially the making of editions, because of its great economy and beauty."[61] Finally, in March 1902 he summarized his method to the collector Gustave Fayet.[62]

The process entailed placing inked paper below the support on which the drawing was to be executed and then drawing on the top sheet, yielding an inked image on its underside. The drawing—which Gauguin arguably held to be of lesser importance than the inked image—

was, as in *Polynesian Beauty and Evil Spirit* (fig. 92), executed in hard graphite and a deeply impressed stylus, augmented with blue wax crayon during and after the transfer.[63] After the black ink was transferred, color was introduced by replacing the inked paper with a second sheet on which he applied yellow *peinture à l'essence*, a material that he had customarily used for the preliminary stage of his paintings but which in these works assured him even drying and a matte effect.[64] Still faceup, the drawing was then rubbed with a broader implement for modeling the figures. Under magnification a bright yellow pigment from the *essence* is visible on the inked side of *Polynesian Beauty and Evil Spirit*. Initially the color would have been luminous and there would have been no oil seepage on the reverse, but as the oil oxidized each side darkened. The diverse requirements of each of the media composing such examples, the inevitable penetration of the oil, and the potentially damaging incising that was part of the process are likely to be responsible for Gauguin's experimentation with several papers and various media for these works. The paper for *Polynesian Beauty and Evil Spirit* is a machine-made, wove wood-pulp sheet of very modest quality, probably intended for printing, that he would have acquired locally.[65]

Gauguin's highly original method, which has correctly been described as an entirely independent innovation,[66] is based on the manifold copying process. This duplicating system, using carbon paper, was widespread in business, and its preparation was so commonplace that household recipes appeared throughout the century.[67] It differed from monotyping, which entailed overall pressure, and from a technique known as calking, in which chalk was rubbed on the back of a drawing in order to transfer it by incising. In Gauguin's *"dessins"* ink-coated paper was inserted beneath a blank sheet and the top sheet was incised, yielding an image on the underside of the original paper. A variant of this process, also used in manifold copying, employed a double-sided carbon, in which case an impression was produced on an underlying blank sheet as well. Double-sided carbons were valued commercially for giving both a positive and a negative copy from which subsequent impressions could be taken, and this mode of reprography may explain Gauguin's reference to multiplying his images in his letter to Fayet.[68] Perhaps the artist thought his process held the same promise that transfer lithography had fulfilled in allowing drawings to be executed directly on paper rather than on a stone or zinc plate.

Critical to letterpress technology were the exceedingly thin, transparent papers that enabled multiple copies of a document to be pulled simultaneously.[69] Although there is no evidence that Gauguin worked in this manner, it was only beginning in the late 1890s that he employed these particular papers. He used them for many of his monotypes and caricatures executed in watercolor and ink, for the production of the fourteen woodcut mastheads of *Le sourire*, a four-page

Fig. 92. *Polynesian Beauty and Evil Spirit* (recto), ca. 1900 (cat. no. 109a). Printed drawing. Photomicrograph showing black ink and *essence*. Sherman Fairchild Center for Works on Paper and Photograph Conservation, The Metropolitan Museum of Art, New York

Fig. 93. *Noa Noa*, 1893–94, pp. 90–91. Pen and soluble ink on wove paper, each page 12¼ x 9⅛ in. (31 x 23.3 cm); facsimile. The Metropolitan Museum of Art, New York

monthly he circulated from August 1899 to April 1900 in as many as thirty to fifty copies, and for the suite of woodcuts he printed in 1898–99.[70] Such papers had been widely available in Paris since 1868, when Japan opened its doors to trade with foreign countries, and Gauguin would have seen them used in France for fine prints.[71] By the end of the century these "tissues," as they were commonly referred to in the West, were being manufactured worldwide and were ubiquitous for commercial purposes.[72]

Fig. 94. *Four Seated Tahitian Women*, ca. 1896–99. Monotype. Photomicrograph showing *essence* and soluble ink on wove paper. Sherman Fairchild Center for Works on Paper and Photograph Conservation, The Metropolitan Museum of Art, New York

Lacking a supply of Western paper, wanting to pursue his woodblock project, and presumably having seen these common papers used for printing, Gauguin must have responded not only to their lustrous texture and transparency but also to their sharp definition, warm ivory tone, and low cost. These diaphanous papers—both the Japanese and the glazed imitations from Europe—create an unexpected contrast with the bold, archaizing imagery of prints such as *Tahiti (Change of Residence)* (cat. no. 54), which is overlaid on a second impression printed on wove paper, and *Eve* (cat. no. 101), an unmounted sheet. They impart a sense of impalpable delicacy when used as supports for watercolor,

as, for example, in the monotypes and drawings Gauguin pasted into the *Noa Noa* manuscript.

Gauguin's adaptation of letterpress technology is also evident in his use of copying ink. Much as in counterproofing a work of art, the use of transferring ink required that the copy papers be dampened and that the inks be soluble. Duplicate documents would readily be produced when the ink penetrated through the copy paper or was impressed against a sheet of paper.[73] The effect of moisture—of ink bleeding through to the verso of the sheet—can be seen in pages 89 to 92 of the *Noa Noa* manuscript (see fig. 93) on which Gauguin transcribed the text and illustrated it with a drawing in blue ink. These particular types of ink, widely used since their

Fig. 95. *Four Seated Tahitian Women*, from *Noa Noa*, ca. 1896–99, p. 124. Monotype in watercolor and soluble ink on Japanese tissue, 9⅛ x 12¼ in. (23.3 x 31 cm). Cabinet des Dessins, Musée du Louvre, Paris

introduction in the last quarter of the nineteenth century, were made with high-tinctorial aniline inks and formed the basis of much mechanical copying technology.[74]

A similar effect of penetration through the sheet to the verso—the ink's solubility being further confirmed by testing—is evidenced in the blue contours of the monotype *Four Seated Tahitian Women* (fig. 94).[75] This suggests that Gauguin used modern copying ink for the work, which is printed on thin but opaque wove paper. The colored areas were transferred in *essence*, the presence of which is indicated by oil seepage through the sheet and by the slightly reticulated printed surface. The latter effect, similar to that in *Polynesian Beauty and Evil Spirit*, resulted from the "tack," or pulling, of the viscous substance as the matrix and counterproof papers were separated. *Four Seated Tahitian Women* corresponds exactly in image and size to a sheet with the same title mounted on page 124 in the *Noa Noa* manuscript (fig. 95) and rendered in watercolor and brush on a very thin, white "laid" Japan paper, as confirmed by overlaying the two. Its diffuse blue contours are again characteristic of wetted copy ink. It is not known whether the *Noa Noa* image was placed above the monotype and the contours were transferred by the ink's penetrating through the paper, with the brushwork subsequently added, or whether there was a different matrix such as a reversed master image.

It would appear from these examples that even in his late years duplicating and transferring images remained fundamental to Gauguin's art. But, rather than drawing upon the academic methods that he had turned to in earlier years, he now innovatively explored the many dry and damp transfer processes commonly used for document reproduction, employing the various utilitarian papers and media available locally and perhaps making use of the simple tools for pressing that these techniques required, such as his hand, a flat iron, or hinged millboard panels.[76]

TABLE: ANALYSIS OF CERTAIN MATERIALS FOUND IN GAUGUIN'S WORKS ON PAPER EXAMINED FOR THIS STUDY

Silvia A. Centeno

A brief summary of some of the materials identified in six of Gauguin's works on paper examined for the present study is given below. Raman spectroscopy, a nondestructive means of analysis, was used for obtaining the chemical composition of pigments, binders, and fixatives. Raman spectra were recorded in situ using a Renishaw System 1000 spectrometer equipped with a 514nm laser and a fiber-optic probe assembly. Laser powers up to 1 mW were employed, with accumulation times up to 120 seconds. The laser spot size was approximately 5 microns in diameter, using a 20X lens. Spectral resolution was 2cm-1. In a few cases, a tiny sample was removed and its Raman spectra were recorded by focusing the laser beam on a 2-micron-spot size and using a Leica microscope attached to the Raman spectrometer. Laser powers were controlled with neutral density filters.

Fourier Transform Infrared Spectroscopy (FTIR) was carried out on a Bio-Rad FTS 40 equipped with a UMA 500 Microscope. Samples were mounted on a diamond anvil cell, and the spectra were recorded with a 2cm-1 resolution.

X-ray fluorescence analysis (XRF) was used to confirm the identification of pigments made by Raman spectroscopy and to identify the substrates of the lake pigments alizarin and carmine. Analyses were carried out in situ in an open-architecture Jordan Valley spectrometer by Lisa Barrow, Andrew W. Mellon Fellow in Conservation in the Sherman Fairchild Center for Works on Paper and Photograph Conservation at the Metropolitan Museum.

Work	*Analytical Technique Used*	*Spot Location*	*Composition*
Two Tahitian Women with Flowers and Fruit (cat. no. 106)	Raman	Blue on dress	Ultramarine
	Raman	Red apple at bottom	Vermilion with cadmium yellow
	Raman	Red at right side	Vermilion
	Raman	Yellow	Cadmium yellow
	Raman	Yellow sample	Cadmium yellow
	Raman	Green sample	Emerald green
	Raman	Orange-red sample	Red lead
	Raman and FTIR	"Gum" sample no. 1	Gum with a small amount of a protein*
Little Tahitian Trinkets (cat. no. 63)	FTIR and Raman	Black sample	Gum* (most probably tragacanth) and carbon black
Portrait of Annette Belfils (cat. no. 7)	FTIR	"Gum" sample no. 2	Protein with a small amount of a natural resin*

Work	Analytical Technique Used	Spot Location	Composition
Tahitian Faces (cat. no. 104)	FTIR	"Fixative" sample	Gum with a small amount of a protein*
Tahitian Woman with a Flower in Her Hair (cat. no. 58)	Raman	Dark pink	Alizarin
	Raman	Light pink	Red lead and white chalk (calcium carbonate)
Artist's Portfolio, Pont-Aven (cat. no. 26)	Raman	Water in bowl	Ultramarine
	Raman	Red fish	Vermilion. Cadmium yellow was also detected in some spots.
	Raman	Dark orange at left side	Vermilion, cadmium yellow, and cadmium red-orange**
	Raman	Light orange area	Cadmium yellow and cadmium red-orange**
	Raman	Yellow gosling	Cadmium yellow
	Raman	Black lines on river at left side	Carbon black
	Raman	Mauve doorway	Ultramarine and carmine lake***
	Raman	Purple roof	Ultramarine and carmine lake
	Raman	Light green	Copper arsenite green (*vert véronèse?*)
	Raman	Red apple at left side	Carmine lake (major component), cadmium yellow, and vermilion
	Raman	Mauve on apple at left side	Ultramarine and carmine lake
	Raman	White on swans	Zinc white

*For most of the organic materials that artists use as binding media and fixatives, FTIR allows for the determination of the general group the compound belongs to (e.g., gums, proteins, natural resins, oils). However, only in a few cases does the technique allow for a full identification of such substances. Other analytical techniques such as gas chromatography–mass spectrometry (GC/MS) are more suitable for this purpose, although they generally require larger samples.

**The commercial production of cadmium reds may have begun about 1910, although a red-orange cadmium pigment containing selenium was available by 1892 (Gettens and Stout 1966, p. 101).

***Carbon black may be present as well. Raman peaks for carbon black are usually broad and, in this particular case, the pigment's characteristic feature at 1325 cm^{-1} is probably masked by the more intense peak for carmine at ~1319 cm^{-1}.

WORKS IN THE EXHIBITION

1. *Emil Gauguin (Born 1874), the Artist's Son, as a Child*, 1877–78
Marble
17 x 8½ in. (43.2 x 21.6 cm)
The Metropolitan Museum of Art, New York, Gift of Joseph M. May Memorial Association Inc., 1963 63.113
G 2; New York 1946, no. 131; 1956, no. 98; 1959, no. 115

2. *Portrait of a Woman*, ca. 1880
Oil on canvas
13⅛ x 10⅜ in. (33.3 x 26.5 cm)
Hofstra Museum, Hofstra University, Gift of Mr. and Mrs. Alexander Rittmaster
HU64.169
W I 66

3. *A Woman Sewing and Other Figure Studies*, ca. 1880
Fabricated black crayon on formerly pink laid paper
9⅛ x 5⅞ in. (23.2 x 14.9 cm)
Private Collection

4. *Tomatoes and a Pewter Tankard on a Table*, 1883
Oil on canvas
23¾ x 28⅞ in. (60.4 x 73.4 cm)
Signed and dated lower left: *p. Gauguin 83*
Private Collection
W 90; W I 107

5. *Portrait of a Seated Man*, 1884
Oil on canvas
25⅞ x 18⅛ in. (65.7 x 46 cm)
Inscribed upper left: *Rouen/1884*
Signed lower right: *p Gauguin*
Private Collection
W 94; W I 153; New York 1956, no. 1; 1959, no. 2

6. *Vessel in the Shape of a Grotesque Head*, ca. 1887–88
Polychromed stoneware
9⅜ x 11 x 6⅝ in. (23.8 x 28 x 16.8 cm)
Numbered on base: *73*
Private Collection
Not in Gray 1963; see Chicago–Amsterdam 2001–2, p. 86

7. *Portrait of Annette Belfils*, 1890
Conté crayon and red chalk on laid paper (partial watermark: cartouche), mounted on wove paper
13⅝ x 12¼ in. (34.6 x 31.1 cm)
Inscribed in black chalk upper left (margin trimmed): *...sies* [indecipherable]
Malcolm Weiner Collection

8. *Portrait of Stéphane Mallarmé*, 1891
Etching, drypoint, and aquatint on Japanese paper
Plate: 7³⁄₁₆ x 5⅝ in. (18.3 x 14.3 cm)
Paper: 9½ x 5⅝ in. (24.1 x 14.4 cm)
Signed and dated in plate upper center: *91/Pgo*
Lawrence Saphire
M/K 12.II.A
(The Metropolitan Museum owns a later impression of this print: 36.11.10, Harris Brisbane Dick Fund, 1936; M/K 12.II.Bb; New York 1971, no. 2)

9. *Portrait of Louis Roy*, 1893 or earlier
Oil on canvas
16 x 13 in. (40.5 x 32.5 cm)
Inscribed upper right: *Expo./Synthé*
Private Collection
W 317 bis; see also "Notes et échos," *L'art littéraire*, October 1893, p. 44

10. *Self-Portrait with Palette*, ca. 1894
Oil on canvas
21⅝ x 18⅛ in. (55 x 46 cm)
Signed and inscribed upper right: *A Ch. Morice de son/ami PGO*
Private Collection
W 410; New York 1959, no. 56

11. *Calling Card: Paul Gauguin/Artist-Painter*
Engraving on bristol board
2⅜ x 3⅞ in. (6 x 9.8 cm)
Card engraved: *Paul Gauguin/Artiste-Peintre*
Inscribed in graphite at top: *Bien le Bonjour à tous deux –/Donnez de vos nouvelles –*
The Metropolitan Museum of Art, New York, Gift of F. C. Schang, 1983 1983.1011.5

12. *Invitation to the Opening of Gauguin's Exhibition at Galeries Durand-Ruel, Paris, on November 9, 1893*, dated November 3, 1893
Pen and ink
7 x 4¹¹⁄₁₆ in. (17.7 x 12 cm)
The Pierpont Morgan Library, New York, Gift of John Rewald, 1986 MA 4360

13. *Walking Stick with a Female Nude and a Breton Sabot on the Handle*, ca. 1888–92
Boxwood, mother-of-pearl, and iron
L. 36¾ in. (93.3 cm)
The Metropolitan Museum of Art, New York, Bequest of Miss Adelaide Milton de Groot (1876–1967), 1967 67.187.45a,b
G 80; New York 1959, no. 118; 1971, no. 48

14. *Head of a Breton Boy*, 1888
Compressed charcoal, red chalk, pastel, and

white gouache with touches of graphite on formerly blue wove paper
8⅞ x 8⅞ in. (22.5 x 22.5 cm)
Private Collection
R 9; P 17; New York 1959, no. 77

15. *Design for a Fan: Breton Shepherd Boy*, 1888
Gouache over graphite on sized, fine-weave fabric
5½ x 18⅞ in. (14 x 48 cm)
Signed lower left: *P. Gauguin*
Richard Adler
W 257; Zingg 1996, pl. XV

16. *Still Life with Three Puppies*, 1888
Oil on wood
36⅛ x 24⅝ in. (91.8 x 62.6 cm)
Signed and dated lower left: *P.Go 88*
The Museum of Modern Art, New York, Mrs. Simon Guggenheim Fund, 1952
W 293; New York 1956, no. 8; 1959, no. 12

17. *The Joys of Brittany*
From the Volpini Suite: *Dessins lithographiques*, 1889
Lithograph on zinc printed on chrome yellow wove paper; first edition
7¹⁵⁄₁₆ x 9½ in. (20.2 x 24.1 cm)
Signed and inscribed in plate lower left: *Paul Gauguin/Joies de Bretagne*
The Metropolitan Museum of Art, New York, Rogers Fund, 1922 22.82.2–11
M/K 7.A.b; New York 1959, nos. 128–38 (2); 1971, no. 4

18. *A Farm in Brittany*, probably 1894
Oil on canvas
28½ x 35⅝ in. (72.4 x 90.5 cm)
Signed lower left: *P.Gauguin*
The Metropolitan Museum of Art, New York, Bequest of Margaret Seligman Lewisohn, in memory of her husband, Sam A. Lewisohn, 1954 54.143.2
W 526; New York 1921, no. 49; 1946, no. 9; 1959, no. 59; 1971, no. 53

19. *Vessel in the Form of the Head of a Breton Girl*, 1886–87
Unglazed stoneware decorated with black slip and gold paint
5½ x 3⅝ x 6½ in. (14 x 9.2 x 16.5 cm)
Signed and numbered on handle: *P GO. 54*
Private Collection
G 39

20. *Breton Women by a Fence*
From the Volpini Suite: *Dessins lithographiques*, 1889

Lithograph on zinc printed on chrome yellow
wove paper; first edition
6⁵⁄₁₆ x 8⁷⁄₁₆ in. (16 x 21.4 cm)
Signed in plate lower left: *P Gauguin*
The Metropolitan Museum of Art, New York,
Rogers Fund, 1922 22.82.2–2
M/K 8.A; New York 1959, nos. 128–38(4);
1971, no. 6

21. *Wayside Shrine in Brittany*, 1898–99
Woodcut on transparent wove tissue paper
5¾ x 9 in. (14.6 x 22.9 cm)
The Metropolitan Museum of Art, New York,
Harris Brisbane Dick Fund, 1936 36.7.2
M/K 50.B; New York 1971, no. 41

22. *The Yellow Christ*, 1889
Oil on canvas
36¼ x 28⅞ in. (92 x 73 cm)
Signed and dated lower right: *PGauguin 89*
Albright-Knox Art Gallery, Buffalo,
New York,
General Purchase Funds, 1946 1946:4
W 327; New York 1929, no. 41; 1956,
no. 14; 1959, no. 16

23. *("Leda") Design for a Plate: Shame on
Those Who Evil Think*
Cover illustration for the Volpini Suite:
Dessins lithographiques, 1889
Lithograph on zinc
Proof impression on wove paper with
additions in watercolor
13 x 10 in. (33 x 25.4 cm)
Brooklyn Museum of Art,
Museum Collection Fund 38.116
M/K 1

24. *Jugs in "Chaplet" Stoneware*, ca. 1887–89
Gouache, watercolor, and charcoal on
Japanese paper
12½ x 16⅜ in. (31.8 x 41.6 cm)
Signed and inscribed lower right:
P Gauguin/Pot en grès Chaplet
Collection of the Frances Lehman Loeb Art
Center, Vassar College; bequest of Sarah
Hamlin Stern, class of 1938, in memory of
her husband, Henry Root Stern, Jr.
1994.2.1
R 23; P 23; New York 1959, no. 79

25. *("Leda") Design for a Plate: Shame on
Those Who Evil Think*
Cover illustration for the Volpini Suite:
Dessins lithographiques, 1889
Lithograph on zinc with additions in water-
color and gouache on chrome yellow wove
paper, mounted on marbled paper applied to
millboard
11¹⁵⁄₁₆ x 10¹⁄₁₆ in. (30.4 x 25.9 cm)
Inscribed in graphite below image: *Dessins
lithographiques/Paul Gauguin*
Inscribed in plate and printed in reverse:
homis [sic] *soit qui mal y pense. PGO / Projet
d'asiet* [sic] *89*
The Metropolitan Museum of Art, New York,
Rogers Fund, 1922 22.82.2–1
M/K 1.A.a; New York 1959, nos. 128–38(1);
1971, no. 3

26. *The Artist's Portfolio, Pont-Aven*, 1894
Two inside covers decorated in watercolor
and gouache over charcoal with graphite on
millboard sewn to leather
Each drawing 16¾ x 10⅜ in. (42.5 x 26.4 cm)
Front cover of leather binding inscribed in
pen and ink: *SUR/CHAMP D'ART/E.F.R./
le 25 Juin 1894 Nous artistes peintres
orgueilleu/sement de haute race dans le
grand livre mystérieux/de la nature né Paul
Gauguin dit PGO né/Eric Forbs Robertson
dit le Celte né Roderic/O'Conor, né Seguin le
Jovial avons décidé/Dé ce jour ce livre
en/terrain neutre de sympatie* [sic] *et d'art
littéraire/pictural et musical, recueillera les
pensées dessins/et signatures de tous ceux qui
de bonne foi/s'associeront à notre oeuvre pour
se retrouver/un jour à la divine source de
toute harmonie/de conforme volonté avons
déposé/ce livre entre les mains de Marie
Jeanne/femme Gloanec, afin qu'il/soit
préservé de tout outrage/En foi de quoi avons
signé/PGO/Eric Forbes-Robertson/ Roderic
O'Conor/Armand Seguin*
The Metropolitan Museum of Art, New York,
Promised Gift of Leon D. and Debra R.
Black, and Purchase, Joseph Pulitzer and
Florence B. Selden Bequests, and 1999
Benefit Fund, 2000 2000.255

27. *The Grasshoppers and the Ants
(A Souvenir of Martinique)*
From the Volpini Suite: *Dessins litho-
graphiques*, 1889
Lithograph on zinc printed on chrome yellow
wove paper; first edition
7¾ x 10¼ in. (19.7 x 26 cm)
Signed and inscribed in plate lower left:
Paul Gauguin /Les Cigales et les fourmis
The Metropolitan Museum of Art, New York,
Rogers Fund, 1922 22.82.2–4
M/K 5.A.b; New York 1959, nos. 128–38(10);
1971, no. 12

28. *Women in the Mango Grove, Martinique*,
1887
Oil on canvas
36⅜ x 28⅜ in. (92.4 x 72 cm)
Signed and dated lower right: *P. Gauguin 87*
Mr. and Mrs. Joe L. Allbritton
W 230; W II 244

29. *Martinique Women with Mangoes*, ca.
1887
Study for the painting *Among the Mangoes,
Martinique*, 1887
Black chalk and pastel with touches of
watercolor on laid paper
Signed lower right: *P. G.*
19 x 25¼ in. (48.5 x 64 cm)
Private Collection
P 20

30. *Martinique Pastorals*
From the Volpini Suite: *Dessins litho-
graphiques*, 1889
Lithograph on zinc printed on chrome yellow
wove paper; first edition
6¹⁵⁄₁₆ x 8¾ in. (17.6 x 22.2 cm)

Signed and inscribed in plate lower left:
Pastorales Martinique. Paul Gauguin
The Metropolitan Museum of Art, New York,
Rogers Fund, 1922 22.82.2–5
M/K 6.A; New York 1959, nos. 128–38(9);
1971, no. 11

31. *Vessel Decorated with Goats and Girls
from Martinique*, ca. 1887–89
Stoneware with color glaze and slip
7⅞ x 4⅜ in. (20 x 11.1 cm)
Robert A. Ellison Jr.
Not in Gray 1963 or Bodelsen 1964

32. *Statuette of a Martinique Woman*,
ca. 1889
Painted terracotta and bronze on a
wood base
7¾ x 4⅜ x 3⅜ in. (19.7 x 11.1 x 8.6 cm)
With base: 9⅛ x 4⅜ in. (23.2 x 11.1 cm)
The Henry and Rose Pearlman
Foundation, Inc.
G 61

33. *The Black Woman (La Femme Noire)*,
1889
Glazed stoneware
H. 19 in. (48.3 cm)
Signed on base behind right hand:
P. Gauguin
Nassau County Division of Museum
Services at the Sands Point Preserve,
Port Washington, New York
G 91; New York 1959, no. 119

34. *Letter to Antoine Favre ("Le Marsouin"),
from St. Pierre, Martinique, August 25,
1887*
Pen and ink on light gray-blue paper
10⅝ x 8⅛ in. (27 x 20.7 cm)
Letterhead engraved: *FABRIQUE
SPÉCIALE/DE/TOILES IMPERMÉABLES
& IMPOURRISSABLES./DILLIES &
Cⁱᵉ/ROUBAIX/P. GAUGUIN, Representant*
The Pierpont Morgan Library, New York,
Purchased as the gift of Jack Rudin, in
honor of the Morgan Library's Fiftieth
Anniversary, 1974 MA 3272
Merlhès 1984, no. 132

35. *Human Misery*, 1898–99
Woodcut on transparent laid tissue paper
Block: 7⅝ x 11¾ in. (19.4 x 29.8 cm)
Paper: 9 x 11⅞ in. (22.9 x 30.2 cm)
Signed and numbered lower left: *PG/n. 14*
The Metropolitan Museum of Art,
The Elisha Whittelsey Collection, The
Elisha Whittelsey Fund, 1952 52.608.1
M/K 49; New York 1971, no. 42

36. *Human Misery*
From the Volpini Suite: *Dessins litho-
graphiques*, 1889
Lithograph on zinc printed in brown ink on
chrome yellow wove paper; first edition
11¹⁄₁₆ x 9 in. (28.1 x 22.9 cm)
Signed in graphite lower right: *Paul Gauguin*
The Metropolitan Museum of Art, New York,
Rogers Fund, 1922 22.82.2–3

M/K 11.A.b; New York 1959, nos. 128–38(5); 1971, no. 7
(The Metropolitan Museum also owns an impression of this print from the second edition: 1984.1203.47, Bequest of Scofield Thayer, 1982; M/K 11.B)

37. *Washerwomen*
From the Volpini Suite: *Dessins lithographiques*, 1889
Lithograph on zinc printed on chrome yellow wove paper; first edition
Image: 8¼ x 10¼ in. (20.8 x 26.1 cm)
Paper: 13½ x 18¾ in. (34.2 x 47.7 cm)
Signed in plate lower right: *P. Gauguin*
The Metropolitan Museum of Art, New York, Rogers Fund, 1922 22.82.2–8
M/K 10.A.b; New York 1959, nos. 128–38(6); 1971, no. 8

38. *Washerwomen at the Roubine du Roi, Arles,* **1888**
Oil on burlap
29⅛ x 36¼ in. (75.9 x 92.1 cm)
Signed and dated lower left: *P. Gauguin 1888*
The Museum of Modern Art, New York, The William S. Paley Collection
W 302; New York 1959, no. 15

39. *Old Women of Arles*
From the Volpini Suite: *Dessins lithographiques*, 1889
Lithograph on zinc printed on chrome yellow wove paper; first edition
7½ x 8¼ in. (19.1 x 21 cm)
Signed in plate lower left: *P. Gauguin*
The Metropolitan Museum of Art, New York, Rogers Fund, 1922 22.82.2–10
M/K 9.A.b; New York 1959, nos. 128–38(11); 1971, no. 13

40. *The Drama of the Sea*
From the Volpini Suite: *Dessins lithographiques*, 1889
Lithograph on zinc printed on chrome yellow wove paper; first edition
6¾ x 10¾ in. (17.1 x 27.3 cm)
Signed and inscribed in plate lower left: *Les drames de la mer PGauguin*
The Metropolitan Museum of Art, New York, Rogers Fund, 1922 22.82.2–7
M/K 3.A; New York 1959, nos. 128–38(7); 1971, no. 10

41. *The Wave,* **1888**
Oil on canvas
23¾ x 28¾ in. (60.3 x 73 cm)
Signed and dated lower left: *88 P. Gauguin*
Private Collection
W 286

42. *The Drama of the Sea, Britanny*
From the Volpini Suite: *Dessins lithographiques*, 1889
Lithograph on zinc printed on chrome yellow wove paper; first edition
Watercolor added by hand
6⅝ x 8³⁄₁₆ in. (16.8 x 20.8 cm)

Signed dated, and inscribed in plate at bottom: *⁸⁹Paul/Gauguin /Les drames de la mer Bretagne*
Albright-Knox Art Gallery, Buffalo, New York, Gift of ACG Trust, 1970 P1970:1.24
M/K 2.A.a
(The Metropolitan Museum owns an impression from the first edition: 22.82.2–6, Rogers Fund, 1922; M/K 2.A.b; New York 1971, no. 9)

43. *Peasant Woman and Cows in a Landscape,* **1889–90**
Watercolor and gouache over a white ground on millboard
10⅜ x 12⁹⁄₁₆ in. (26.4 x 31.9 cm)
Signed lower left: *PGO*
Sarah-Ann and Werner H. Kramarsky
W 343 bis; P 46; New York (De Zayas) 1920; 1959, no. 75

44. *Girl with a Fox,* **ca. 1890–91**
Study for the *Loss of Virginity*
Conté crayon, white pastel, and red chalk over graphite on light brown wove paper
12⁷⁄₁₆ x 13¹⁄₁₆ in. (31.6 x 33.2 cm)
Signed upper left: *P. Gauguin*
Ms. Marcia Riklis
P 49

45. *Bathers in Brittany*
From the Volpini Suite: *Dessins lithographiques*, 1889
Lithograph on zinc printed on chrome yellow wove paper; first edition
9³⁄₁₆ x 7⅞ in. (23.3 x 20 cm)
Signed in plate lower left: *P Gauguin*
The Metropolitan Museum of Art, New York, Rogers Fund, 1922 22.82.2–9
M/K 4.A.b; New York 1959, nos. 128–38(3); 1971, no. 5

46. *Jacob Meyer de Haan,* **1889**
Watercolor, graphite, and ink on coarse-fibered wove paper
6⁷⁄₁₆ x 4½ in. (16.4 x 11.5 cm)
The Museum of Modern Art, New York, Gift of Arthur G. Altschul 699.76ab
P 40

47. *Still Life with Onions, Beetroot, and a Japanese Print,* **1889**
Oil on canvas
16 x 20½ in. (40.6 x 52.1 cm)
Signed top center: *PGO 89*
Judy and Michael Steinhardt Collection, New York
W 380; New York 1959, no. 20

48. *Woman with Figs,* **1894**
Etching, lavis, and soft-ground etching on zinc, printed in green ink
10½ x 17⁷⁄₁₆ in. (26.7 x 44.3 cm)
Inscribed in plate upper left: *Chez Séguin à St. Julien*
The Metropolitan Museum of Art, New York, The Elisha Whittelsey Collection, The Elisha Whittelsey Fund, 1967 67.753.6
M/K 25; New York 1971, no. 1

49. *Taoa*
From a Tahitian sketchbook, probably 1891
Pen and ink over graphite on wove paper
6¹¹⁄₁₆ x 4⁵⁄₁₆ in. (17 x 11 cm)
Mrs. Alex Lewyt
R 34; New York 1956, no. 64; 1959, no. 85

50. *Fare*
From a Tahitian sketchbook, probably 1891
Pen and ink over graphite on wove paper
6¹¹⁄₁₆ x 4⁵⁄₁₆ in. (17 x 11 cm)
Mrs. Alex Lewyt
R 33; P 57; New York 1956, no. 63; 1959, no. 84

51. *Woman with a Shawl*
From a Tahitian sketchbook, probably 1891
Graphite, black chalk, and watercolor on wove paper
6¹¹⁄₁₆ x 4⁵⁄₁₆ in. (17 x 11 cm)
Mrs. Alex Lewyt
New York 1956, no. 66; 1959, no. 86

52. *Tetua*
From a Tahitian sketchbook, probably 1891
Pen and ink over graphite on wove paper
6¹¹⁄₁₆ x 4⁵⁄₁₆ in. (17 x 11 cm)
Mrs. Alex Lewyt
R 32; New York 1956, no. 65; 1959, no. 83

53. *In the Vanilla Grove, Man and Horse,* **1891**
Oil on burlap
28¾ x 36¼ in. (73 x 92 cm)
Signed and dated lower left: *P.Gauguin 91*
Solomon R. Guggenheim Museum, New York, Thannhauser Collection, Gift, Justin K. Thannhauser, 1978 78.2514.15
W 443; New York 1921, no. 51; 1936, no. 18; 1946, no. 21

54. *Tahiti (Change of Residence),* **1898–99**
Woodcut, printed in color on transparent wove tissue paper, mounted on wove paper
6⅜ x 11⅞ in. (16 x 30.1 cm)
Numbered upper left: *no 22*
Brooklyn Museum of Art, Museum Collection Fund 37.152
M/K 54.II.b

55. *Ia Orana Maria (Hail Mary),* **1891**
Oil on canvas
44¾ x 34½ in. (113.7 x 87.6 cm)
Inscribed lower left: *IA ORANA MARIA*
Signed and dated lower right: *P Gauguin 91*
The Metropolitan Museum of Art, New York, Bequest of Sam A. Lewisohn, 1951 51.112.2
W 428; New York 1920; 1921, no. 47; 1936, no. 17; 1946, no. 19; 1956, no. 22; 1959, no. 28

56. *Ia Orana Maria (Hail Mary),* **1894–95**
Lithograph on zinc, printed on imitation Japanese paper; published in *L'épreuve*, March 1895
Image: 10⅛ x 7 in. (25.7 x 17.8 cm)
Paper: 14¼ x 10⅝ in. (36.2 x 27 cm)
The Metropolitan Museum of Art, New York, The Elisha Whittelsey Collection, The Elisha Whittelsey Fund, 1962 62.501.1
M/K 27.B; New York 1971, no. 15

57. *Ia Orana Maria (Hail Mary),*
ca. 1893–95
Fabricated charcoal, red chalk, and white
pastel on formerly blue wove paper,
mounted on millboard with strips of rose-
colored wove paper along two edges
23½ x 14¾ in. (59.7 x 37.5 cm)
Inscribed lower left: *Au Comte de La
Rochefoucauld / notre collaboration pour Le /
Coeur / P. Gauguin*
The Metropolitan Museum of Art, New York,
Bequest of Loula D. Lasker, New York City,
1961 61.145.2
P 59; New York 1959, no. 99

58. *A Tahitian Woman with a Flower in Her
Hair,* ca. 1891–92
Charcoal, pastel, and wash
15⅜ x 11⅞ in. (39 x 30.2 cm)
The Metropolitan Museum of Art, New York,
Bequest of Miss Adelaide Milton de Groot
(1876–1967), 1967 67.187.13
P 68; New York 1959, no. 103; 1971, no. 46

59. *Young Man with a Flower,* 1891
Oil on canvas
18⅛ x 13 in. (46 x 33 cm)
Signed lower left: *PGO*
Collection I. Mavrommatis Family
W 422; New York 1921, no. 53; 1936,
no. 38a; 1956, no. 47; 1959, no. 62

60. *Fan Design with Motifs from Ta Matete
(The Market),* 1892
Watercolor, gouache, pen and ink, and
graphite on folded wove paper
5¹¹⁄₁₆ x 18⅛ in. (14.5 x 46 cm)
Inscribed, signed, and dated lower left:
*à Mde Goupil/hommage respectueux—
P. Gauguin 1892*
The Whitehead Collection, courtesy Achim
Moeller Fine Art, New York
Zingg 1996, pl. XX

61. *Te Aa No Areois (The Seed of the Areoi),*
1892
Oil on burlap
36¼ x 28⅜ in. (92.1 x 72.1 cm)
Signed and dated lower center: *P. Gauguin 92*
Inscribed lower left: *Te aa no/areois*
The Museum of Modern Art, New York,
The William S. Paley Collection
W 451; New York 1946, no. 22

62. *Tahitian Women Bathing,* 1892
Oil on paper laid down on canvas
43¼ x 35¼ in. (109.9 x 89.5 cm)
Signed lower right: *P. Gauguin /.*
The Metropolitan Museum of Art, New York,
Robert Lehman Collection, 1975
1975.1.179
W 462; New York 1956, no. 30; 1959, no. 39

63. *Little Tahitian Trinkets,* 1892
Pastel, watercolor, compressed charcoal,
gouache, and ink on two sheets of wove
papers
17⁵⁄₁₆ x 12¹³⁄₁₆ in. (44 x 32.5 cm), with
collage 11⅞ x 6⅞ in. (30 x 17.5 cm)

Signed, dated, and inscribed in graphite
at top: *Petites Babioles Tahitiennes; à
Monsieur de Marolles/Comme un Bon
Souvenir de notre entrevue/chez les Maories/
Paul Gauguin/1892;* at right: *Taota/
Opu Opu*
Private Collection
P 82

64. *Manao Tupapau (Spirit of the Dead
Watching),* 1892
Oil on burlap mounted on canvas
28½ x 36⅛ in. (72.4 x 92.4 cm)
Signed and dated lower left: *P. Gauguin 92*
Inscribed upper left: *Manaó tupapaú*
Albright-Knox Art Gallery, Buffalo,
New York,
A. Conger Goodyear Collection, 1965
1965:1
W 457; New York 1929, no. 44; 1959,
no. 41

65. *Te Po (The Night),* 1893–94
From the series *Noa Noa (Fragrance)*
Woodcut printed in color on wove paper
Block: 8¼ x 14¼ in. (21 x 36.2 cm)
Paper: 11 x 16½ in. (27.6 x 41.9 cm)
The Metropolitan Museum of Art, New York,
Harris Brisbane Dick Fund, 1936 36.6.12
M/K 21.IV.B; New York 1959, no. 143;
1971, no. 17
(The Metropolitan Museum owns two other
impressions: 36.6.11, Harris Brisbane Dick
Fund, 1936; M/K 21.I; and 21.38.2, Rogers
Fund, 1921; M/K 21.IV.D)

66. *Manao Tupapau (Spirit of the Dead
Watching)*
Lithograph on zinc printed on wove paper
for *L'estampe originale,* Part 6, April–June
1894
7¹⁄₁₆ x 10¹¹⁄₁₆ in. (17.9 x 27.1 cm)
Numbered: *73*
The Metropolitan Museum of Art, New York,
Rogers Fund, 1922 22.82.1–53
M/K 23.B; New York 1959, no. 139; 1971,
no. 14
(The Metropolitan Museum owns a second
impression of this print: 1984.1203.48,
Bequest of Scofield Thayer, 1982;
M/K 23.B)

67. *Tahitian Girl in a Pink Pareu,* 1894
Gouache, watercolor, and ink on coarse-
fibered wove paper
9⅝ x 9¼ in. (24.5 x 23.5 cm)
The Museum of Modern Art, New York,
The William S. Paley Collection SPC 12.90
W 425

68. *The Siesta,* probably 1891–92
Oil on canvas
34¼ x 45⅜ in. (87 x 115.9 cm)
The Metropolitan Museum of Art, New York,
The Walter H. and Leonore Annenberg
Collection, Partial Gift of Walter H. and
Leonore Annenberg, 1993 1993.400.3
W 515; New York 1956, no. 38; 1959, no. 50;
1966, unnumbered

69. *Te Atua (The God)*
From the series *Noa Noa (Fragrance),*
1893–94
Woodcut, printed in color by the artist and
Louis Roy
Image: 8 x 13⅞ in. (20.3 x 35.2 cm)
Paper: 9½ x 14¹³⁄₁₆ in. (24.2 x 37.6 cm)
The Museum of Modern Art, New York,
Gift of Abby Aldrich Rockefeller, 1940
M/K 17.III.B

70. *Hina Tefatou (The Moon and the Earth),*
1893
Oil on burlap
45 x 24½ in. (114.3 x 62.2 cm)
Signed and dated lower left: *Gauguin 93*
Inscribed lower right: *Hina Tefatou*
The Museum of Modern Art, New York,
Lillie P. Bliss Collection, 1934
W 499; New York 1921, no. 52; 1929,
no. 45; 1936, no. 281; 1946, no. 24; 1959
no. 52

71. *Noa Noa (Fragrance),* 1893–94
Carved fruitwood (commercial composite
woodblock) with traces of zinc white and ink
13⅞ x 8 x 7/8 in. (35.2 x 20.3 x 2.2 cm)
The Metropolitan Museum of Art, New York,
Harris Brisbane Dick Fund, 1937 37.97
M/K 13; New York 1971, no. 49

72. *Noa Noa (Fragrance)*
From the series *Noa Noa (Fragrance),*
1893–94
Woodcut and stencil printed in color on
wove paper by Louis Roy, spring/summer
1894
Image: 14¹⁄₁₆ x 8⅛ in. (35.7 x 20.7 cm)
Paper: 15½ x 9⅝ in. (39.4 x 24.5 cm)
Inscribed verso: *Fanny Lastblom, 10
Vercingétorix, Paris*
The Museum of Modern Art, New York,
Lillie P. Bliss Collection, 1934
M/K 13.II.D
(The Metropolitan Museum owns a posthu-
mous impression of this print: 21.38.10,
Rogers Fund, 1921; M/K 13.III.E.b)

73. *Te Poipoi (Morning),* 1892
Oil on canvas
26¾ x 36¼ in. (68 x 92 cm)
Signed and dated lower left: *P. Gauguin 92*
Inscribed lower right: *TE POIPOI*
From the collection of Joan Whitney Payson
W 485; New York 1959, no. 47

74. *Auti Te Pape (The Fresh Water Is in
Motion)*
From the series *Noa Noa (Fragrance),*
1893–94
Woodcut printed in color on wove paper
Block: 8⅛ x 14⅛ in. (20.6 x 35.9 cm)
Paper: 10¹³⁄₁₆ x 18½ in. (27.5 x 47 cm)
Inscribed in block lower left: *PGO;*
lower right: *AUTI TE PAPE*
The Metropolitan Museum of Art, New York,
Harris Brisbane Dick Fund, 1936 36.6.2
M/K 16.II.B; New York 1971, no. 33
(The Metropolitan Museum also owns a

posthumous impression of this print: 21.38.6, Rogers Fund, 1921; M/K 16.II.D.b)

75. *The Universe Is Created*
Carved commercial composite woodblock
15¾ x 21¼ in. (20.3 x 35.3 cm)
Incised in block lower right: *l'Univers est créé;*
lower left: *PGO*
Memorial Art Gallery of the University of Rochester, Gift of Dr. and Mrs. James H. Lockhart Jr. 77.147.1
See M/K 18

76. *The Universe Is Created*
From the series *Noa Noa (Fragrance),*
1893–94
Woodcut printed in color on wove paper
Block: 8 x 13⅞ in. (20.3 x 35.2 cm)
Paper: 10 x 18¾ in. (25.4 x 47.6 cm)
Inscribed in block lower left: *l'Univers est créé;* lower right: *PGO*
The Metropolitan Museum of Art, New York, Harris Brisbane Dick Fund, 1936 36.6.6
M/K 18.II.B; New York 1959, no. 153; 1971, no. 25
(The Museum owns two other impressions of this print: 36.6.7, Harris Brisbane Dick Fund, 1936; M/K 18.II.B, and 21.38.8, Rogers Fund, 1921; M/K 18.II.E.b)

77. *The Universe Is Created*
From the series *Noa Noa (Fragrance),*
1893–94
Woodcut; second state; printed in color on heavy Japanese paper by Louis Roy
8 x 13⅞ in. (20.3 x 35.3 cm)
Inscribed in block lower left: *l'Univers est créé;* lower right: *P.GO*
Memorial Art Gallery of the University of Rochester, Gift of Dr. and Mrs. James H. Lockhart Jr. 77.147.2
M/K 18.II.D

78. *Mahna No Varua Ino (Day of the Evil Spirit)*
From the series *Noa Noa (Fragrance),*
1893–94
Woodcut printed in color on Japanese paper
Block: 8 x 14 in. (20.3 x 35.6 cm)
Paper: 11³⁄₁₆ x 18¹⁄₁₆ in. (28.4 x 45.9 cm)
The Metropolitan Museum of Art, New York, Harris Brisbane Dick Fund, 1936 36.6.3
M/K 19.IV.B; New York 1971, no. 31
(The Metropolitan Museum also owns a posthumous impression of this print: 21.38.7, Rogers Fund, 1921; M/K 19.IV.E, New York 1971, no. 32)

79. *Te Faruru (To Make Love)*
From the series *Noa Noa (Fragrance),*
1893–94
Woodcut printed in color on wove paper
Block: 14 x 8 in. (35.4 x 20.3 cm)
Paper: 18¾ x 12½ in. (47.6 x 30.8 cm)
Inscribed and signed in block upper right: *TE FARURU/PGO*
The Metropolitan Museum of Art, New York, Harris Brisbane Dick Fund, 1936 36.6.8
M/K 15.III; New York 1971, no. 22

(The Metropolitan Museum owns a second impression, printed in color: 36.6.9, Harris Brisbane Dick Fund, 1936; M/K 15.II; New York 1971, no. 21)

80. *Nave Nave Fenua (Delightful Land)*
From the series *Noa Noa (Fragrance),*
1893–94
Woodcut printed in color on wove paper, mounted to bristol board faced with blue flecked paper
14 x 8 in. (35.6 x 20.3 cm), trimmed to image
The Metropolitan Museum of Art, New York, Rogers Fund, 1922 22.26.11
M/K 14.III; New York 1971, no. 27

81. *Nave Nave Fenua (Delightful Land)*
From the series *Noa Noa (Fragrance),*
1893–94
Woodcut printed in color on thin wove paper
Block: 13⅞ x 8 in. (35.2 x 20.3 cm)
Paper: 15¾ x 10⅞ in. (40 x 27.5 cm), uneven
The Metropolitan Museum of Art, New York, Harris Brisbane Dick Fund, 1936 36.6.5
M/K 14./IV.B; New York 1971, no. 29

82. *Nave Nave Fenua (Delightful Land)*
From the series *Noa Noa (Fragrance),*
1893–94
Woodcut printed in color on wove paper
Block: 13¾ x 8 in. (34.9 x 20.3 cm)
Paper: 18¾ x 10¹¹⁄₁₆ in. (47.6 x 27.2 cm)
The Metropolitan Museum of Art, New York, Harris Brisbane Dick Fund, 1936 36.6.4
M/K 14.IV.B; New York 1971, no. 28
(The Metropolitan Museum also owns a posthumous impression of this print: 21.38.9, Rogers Fund, 1921; M/K 14.IV.D)

83. *Noa Noa (Fragrance); small block,* 1894–95
Woodcut printed in color on Japanese paper
5¹⁵⁄₁₆ x 4⅝ in. (15.1 x 11.7 cm), trimmed to image
The Metropolitan Museum of Art, New York, Harris Brisbane Dick Fund, 1936 36.6.1
M/K 34.III; New York 1971, no. 36

84. *Tahitian Woman,* ca. 1893–94
Pastel and charcoal on formerly blue wove paper, mounted on chrome yellow wove paper adhered to millboard
22 x 19½ in. (56 x 49.6 cm)
Signed upper left: *PGO*
Brooklyn Museum of Art, Museum Collection Fund 21.125
R 118; W 424 bis; P XI; New York 1921a, no. 120; 1946, no. 42; 1956, no. 70

85. *The Profile of a Tupapau (Spirit)*
From the *Pape Moe (Mysterious Water)* relief ensemble, 1894
Carved oak
23¾ x 7¾ x 2 in. (60.3 x 19.7 x 5.1 cm)
Mr. and Mrs. Herbert D. Schimmel
G 107.I

86. *Hina's Head and Two Vivo Players*
From the *Pape Moe (Mysterious Water)* relief ensemble, 1894
Carved oak
7¾ x 18⅞ x 2 in. (19.7 x 48 x 5.1 cm)
Private Collection
G 107.II

87. *Scene of Worship with Hina's Head in Profile*
From the *Pape Moe (Mysterious Water)* relief ensemble, 1894
Carved oak, partly polychromed
7¾ x 18⅞ x 2 in. (19.7 x 48 x 5.1 cm)
Private Collection
G 107.III

88. *Reclining Tahitian,* 1894
Watercolor transfer, with additions in watercolor on Japanese paper
9⅝ x 15⁹⁄₁₆ in. (24.5 x 39.5 cm)
Signed with woodcut stamp lower right: *PGO*
Private Collection
F 15; New York 1959, no. 189

89. *Manao Tupapau (Spirit of the Dead Watching)*
From the series *Noa Noa (Fragrance),*
1893–94
Woodcut on wove paper
8⅛ x 13¾ in. (20.6 x 34.9 cm), trimmed to image
The Metropolitan Museum of Art, New York, Harris Brisbane Dick Fund, 1936 36.6.10
M/K 20.III; New York 1971, no. 20
(The Metropolitan Museum also owns a posthumous impression of this print: 21.38.4, Rogers Fund, 1921; M/K 20.IV.F)

90. *Mahana Atua (The Day of God),* 1894–95
Woodcut on china paper; posthumous impression
Block: 7³⁄₁₆ x 8 in. (18.3 x 20.3 cm)
Paper: 10⅜ x 17⅛ in. (26.4 x 43.5 cm)
Inscribed in graphite lower left: *Paul Gauguin fait;* lower right: *Pola Gauguin imp.*
The Metropolitan Museum of Art, New York, Rogers Fund, 1921 21.38.1
M/K 31.II.C; New York 1971, no. 35
(The Metropolitan Museum owns the complete posthumous edition of prints from Gauguin's woodblocks published by the artist's son Pola in 1921: 21.38.1–10. The set includes impressions of eight *Noa Noa* woodcuts [see nos. 65, 72, 74, 76, 78, 82, 89], and also *Maruru* [21.38.3, not illustrated] as well as a print of *Le Sourire* [21.38.5, M/K 58]).

91. *Illustrated Letter to an Unknown Collector,* ca. 1896
Pen and ink
10 x 8 in. (25.5 x 20.5 cm)
Mrs. Alex Lewyt
R 98; P 83; New York 1956, no. 68; 1959, no. 113

92. *Oviri (Savage),* 1894
Watercolor monotype, heightened with

gouache on Japanese paper laid down on board
11 x 8¾ in. (28.2 x 22.2 cm)
Signed with woodcut stamp lower left: *PGO*
Private Collection
F 30

93 a. *Head of a Tahitian Woman* (recto), 1896
Pastel
 b. *Study of Two Tahitian Women* (verso), 1896
Black chalk
12¼ x 13⅜ in. (31.1 x 34 cm)
Private Collection
W 549

94. *Three Tahitian Women*, 1896
Oil on wood
9⅝ x 17 in. (24.6 x 43.2 cm)
Signed and dated lower right: *P. Gauguin 96*
The Metropolitan Museum of Art, New York,
The Walter H. and Leonore Annenberg
Collection, Partial Gift of Walter H. and
Leonore Annenberg, 1997 1997.60.3
W 539; New York 1956, no. 46

95. *Still Life with Teapot and Fruit*, 1896
Oil on canvas
18¾ x 26 in. (47.6 x 66 cm)
Signed and dated lower right: *P Gauguin 96*
The Metropolitan Museum of Art, New York,
The Walter H. and Leonore Annenberg
Collection, Partial Gift of Walter H. and
Leonore Annenberg, 1997 1997.391.2
W 554; New York 1956, addendum,
unnumbered

96. *Te Arii Vahine (The Queen of Beauty)*,
ca. 1896–97
Watercolor, gouache, pen and ink over
graphite, and fabricated black crayon on
wove paper
Verso: *Study of head and feet*
Fabricated black crayon
6¹⁵⁄₁₆ x 9¼ in. (17.6 x 23.5 cm)
Signed lower left: *PG*
Inscribed lower center: *TE ARII VAHINE*
Thaw Collection, The Pierpont Morgan
Library, New York
R 100; P 98; New York 1956, no. 69; 1959,
no. 112

97. *Te Arii Vahine—Opoi (The Queen of
Beauty—Tired)*, 1898
Woodcut on transparent wove tissue paper
laid down to bristol board
6⅜ x 11⅞ in. (16 .2 x 30.2 cm)
Numbered lower right: $n^a/23$
The Metropolitan Museum of Art, New York,
Harris Brisbane Dick Fund, 1926 26.47
M/K 44.A; New York 1971, no. 38

98. *Love, and You Will Be Happy (Soyez
amoureuses, vous serez heureuses)*, 1898
Woodcut on transparent wove tissue paper
6⅜ x 10⅞ in. (16.2 x 27.6 cm)
Numbered lower left: $n^a/10$
The Honorable Samuel J. and Mrs. Ethel
LeFrak / S-R Art Investors, LLC
M/K 55.II.b

99. *Letter to Daniel de Monfreid, from
Papeete, Tahiti, November 1898*
Pen and ink
Letterhead imprinted upper left:
*ÉTABLISSEMENTS FRANÇAIS/de
l'Océanie/TRAVAUX PUBLICS ET
CADASTRE/Bureau/DU/Chef de service;*
center: *RÉPUBLIQUE FRANÇAISE/
LIBERTÉ–ÉGALITÉ–FRATERNITÉ*
9¹¹⁄₁₆ x 5⁷⁄₁₆ in. (24.5 x 13.8 cm)
The Pierpont Morgan Library, New York,
Gift of John Rewald, 1986 MA 4360
Not in Malingue 1946

100. *Women, Animals, and Foliage*, 1898
Woodcut on Japanese paper
Block: 6⁷⁄₁₆ x 8⅞ in. (16.3 x 22.5 cm)
Paper: 9 x 11¾ in. (23 x 30 cm)
Numbered lower left: $n^a/20$
The Honorable Samuel J. and Mrs. Ethel
LeFrak / S-R Art Investors, LLC
M/K 43.II.A

101. *Eve*, 1898–99
Woodcut on transparent wove tissue paper
11 x 8¼ in. (27.9 x 20.9 cm), trimmed to image
Numbered lower left: $n^a/25$
The Metropolitan Museum of Art, New York,
Harris Brisbane Dick Fund, 1936 36.7.4
M/K 42.II.b; New York 1971, no. 37

102. *Tahitian Carrying Bananas*, 1898–99
Woodcut on transparent wove tissue paper
6⅜ x 11⁵⁄₁₆ in. (16.2 x 28.7 cm)
Numbered lower left: *6*
The Metropolitan Museum of Art, New York,
Harris Brisbane Dick Fund, 1930 30.66
M/K 46.II; New York 1971, no. 39

103. *The Smile: Tahiti*, 1899
Published in *Le sourire*, December 1899
Woodcut on transparent laid tissue paper
5⅜ x 8⁹⁄₁₆ in. (13.7 x 21.8 cm), trimmed to
image
Inscribed at top: *Le Sourire Taiti*
Signed lower left: *PG*
Numbered in ink lower left: *no. 27*
The Metropolitan Museum of Art, New York,
Harris Brisbane Dick Fund, 1936 36.11.9
M/K 61.C

104. *Tahitian Faces (Frontal View and Profiles)*,
ca. 1899
Charcoal on laid paper
16⅛ x 12¼ in. (41 x 31.1 cm)
The Metropolitan Museum of Art, New York,
Purchase, The Annenberg Foundation Gift,
1996 1996.418
Not in R or D; see Washington–Chicago–
Paris 1988–89, p. 425

105. *Two Tahitian Women*, 1899
Oil on canvas
37 x 28½ in. (94 x 72.4 cm)
Signed and dated lower left: *99/P. Gauguin*
The Metropolitan Museum of Art, New York,
Gift of William Church Osborn, 1949 49.58.1
W 583; New York 1936, no. 41; 1946,
no. 35; 1959, no. 64

106. *Two Tahitian Women with Flowers and
Fruit*, ca. 1899
Watercolor monotype with additions in
watercolor and gouache on Japanese paper
9⅛ x 6⅞ in. (23.3 x 17.3 cm)
Mr. and Mrs. Richard M. Thune
Not in Field 1973

107. *Woodcut with a Horned Head*, 1898–99
Woodcut on transparent laid tissue paper
Block: 5⅝ x 11¼ in. (14.3 x 28.6 cm)
Paper: 6⅞ x 11⅜ in. (17.4 x 28.7 cm)
The Metropolitan Museum of Art, New York,
Harris Brisbane Dick Fund, 1936 36.7.3
M/K 48; New York 1971, no. 40

108. *Head with Horns*, ca. 1895–97
Carved wood, mounted on a pedestal
H. 15½ in. (39.4 cm)
Pedestal: 7⅞ x 9⅞ x 6¾ in. (20 x 25.1 x
17.1 cm)
Private Collection
G A-13; see also Saint-Paul 1997, no. 30

109 a, b. *Polynesian Beauty and Evil Spirit*,
ca. 1900
Recto: Transferred drawing in black ink and
essence on wove paper
Signed in graphite lower right: *P. Gauguin*
Verso: Drawing in fabricated black crayon,
graphite, and blue wax crayon
25¼ x 20⅜ in. (64.1 x 51.6 cm)
Private Collection
F 66

110. *Two Women*, ca. 1901–2
Oil on canvas
29 x 36¼ in. (73.7 x 92.1 cm)
The Metropolitan Museum of Art, New York,
The Walter H. and Leonore Annenberg
Collection, Partial Gift of Walter H. and
Leonore Annenberg, 1997 1997.391.3
W 610; New York 1956, no. 50; 1959, no. 65

111. *Coco de Mer*, ca. 1901–3
Carved double coconut
11 x 12 x 5½ in. (27.9 x 30.5 x 14.0 cm)
Signed and inscribed: *à Mr. Paillard /
P. Gauguin*
Albright-Knox Art Gallery, Buffalo, New York,
A. Conger Goodyear Fund, 1964 1964:3
G 139

112. *Te Fare Amu (House for Eating)*,
ca. 1901–2
Carved wood relief, painted
9¾ x 58⅜ in. (24.8 x 148.3 cm)
Inscribed and signed in carved relief at
center: *TE FARE AMU PGO*
The Henry and Rose Pearlman
Foundation, Inc.
G 122; New York 1959, no. 125

113. *Three Polynesians and a Peacock*, ca. 1902
Transferred drawing in gouache on Japanese
paper
11⁵⁄₁₆ x 8⅜ in. (28.8 x 21.3 cm)
Private Collection
F 137

114. *Marquesan Landscape with a Horse,*
1901
Oil on canvas
37⅜ x 24 in. (94.9 x 61 cm)
Signed and dated lower right: *P. Gauguin 01*
Private Collection
W 599

115. *Crouching Nude Woman, Seen from the*
Back, ca. 1902
Watercolor monotype with additions in
gouache on light brown wove paper
21 x 11⅛ in. (53.2 x 28.3 cm)
Signed upper right: *P. Gauguin*
Thaw Collection, The Pierpont Morgan
Library, New York
R 111; P 106; F 133; New York 1959,
no. 194

116. *Letter to M. Brault, from Atuona, Hiva*
Oa, Marquesas Islands, February 1903
Pen and ink on paper (double-sided)
9¹⁵⁄₁₆ x 7¹⁵⁄₁₆ (25.2 x 20.2 cm)
The Pierpont Morgan Library, New York,
Purchased on the Fellows Fund as the
special gift of Judith Randal and Samuel
R. Rosenthal, 1982 MA 4474

STYLE OF PAUL GAUGUIN (FRENCH, LATE
19TH CENTURY)
117. *Still Life*
Oil on canvas
15⅛ x 18¼ in. (38.4 x 46.4 cm)
Inscribed lower right: *P. Gauguin. 91*
The Metropolitan Museum of Art, New
York, Bequest of Miss Adelaide Milton de
Groot (1876–1967), 1967 67.187.69

ATTRIBUTED TO PAULIN JÉNOT
(French, active by 1886, died after 1930)
118. *Captain Swaton*
Oil on canvas
16⅛ x 13 in. (41 x 33 cm)
The Metropolitan Museum of Art, New York,
Gift of Raymonde Paul, in memory of her
brother, C. Michael Paul, 1982 1982.179.12
W 419

ATTRIBUTED TO PAUL GAUGUIN
119. *Tahitian Landscape, probably 1892*
Oil on canvas
25⅜ x 18⅝ in. (64.5 x 47.3 cm)
Inscribed lower left: *PGauguin–9[2]*
The Metropolitan Museum of Art, New
York, Anonymous Gift, 1939 39.182
W 442; New York 1959, no. 32

NOTES

GAUGUIN'S PORTS OF CALL

INTRODUCTION

(pages 3–11)

For epigraphs, see Huret 1891; and Gauguin to Émile Schuffenecker, from Pont-Aven, August 1888; Merlhès 1984, no. 162.

1. See, for instance, Gauguin, letter to Émile Schuffenecker, from Pont-Aven, July 8, 1888, and his letter to Charles Morice from Atuona in the Marquesas, April 1903; Malingue 1946, nos. LXVI, CLXXXI.
2. Memoirs 1902–3, published as *Avant et après*, 1923; cited in Guérin 1978, p. 230.
3. Pissarro, letter to Gauguin's wife, Mette, from Éragny by Gisors, March 19, 1891; Rostrup 1956, p. 78. Pissarro evidently made this remark to distinguish his own circle from the one that Gauguin had lately adopted.
4. Gauguin, letter to Ambroise Vollard, from Tahiti, January 1900; Rewald 1943, p. 32.
5. "Diverses choses," in *Noa Noa*, Musée du Louvre, Paris, ms. 220–21; Cachin 1992, p. 181.
6. Tardieu 1895.
7. Ibid., as translated in Cachin 1992, pp. 170, 171.
8. Gauguin, letter to André Fontainas, from Tahiti, August 1899; Malingue 1946, no. CLXXII.
9. Quoted in Guérin 1978, p. XXXV.
10. According to memoirs of the British painter Alfred Thornton (1938, p. 13), Gauguin's "rooms at Mlle Henry's inn were adorned with Manet's 'Olympia,' Botticelli's 'Triumph of Venus,' [*sic*], and Fra Angelico's 'Annunciation,' as well as some reproductions of the work of Puvis de Chavannes, and a print or two by Utamaro."
11. Gauguin, letter to Émile Schuffenecker, from Quimperlé, October 8, 1888; Malingue 1946, no. LXXI.
12. "Diverses choses," in *Noa Noa*, Musée du Louvre, Paris, ms. 220–21; cited in Washington–Chicago–Paris 1988–89, p. 393.
13. Gauguin, letter to Émile Schuffenecker, from Quimperlé, October 16, 1888; Merlhès 1984, no. 172.

GAUGUIN IN PARIS AND THE ÎLE DE FRANCE

(pages 13–15)

1. Gauguin, letter to Camille Pissarro, from Paris, July 1881; Malingue 1946, no. CXXVII, and Merlhès 1984, no. 16; quoted in Washington–Chicago–Paris 1988–89, p. 12.

2. Gauguin, letter to Mette, from Paris, late March 1887; Cachin 1992, p. 31.
3. Gauguin, letter to Émile Bernard, from Paris, November 1889; Malingue 1946, no. XCII.
4. An enterprise Gauguin proposed about 1888 involving the private backing of a pool of painters is described in Chicago–Amsterdam 2001–2, p. 113.
5. A bibliography of Gauguin's writings is given in Washington–Chicago–Paris 1988–89, pp. 513–14.
6. Gauguin had been lent a copy of J.-A. Moerenhout's *Voyages aux îles du Grand Océan* (1837) in 1891 or 1892, from which he apparently took copious notes.
7. Malingue 1946, no. CXLV, quoted in Washington–Chicago–Paris 1988–89, p. 292.
8. Thirty-one works by Gauguin in Degas's collection are listed in New York 1997–98, vol. 2, pp. 54–57. See also Cachin 1997.
9. Washington–Chicago–Paris 1988–89, p. 301.

GAUGUIN IN BRITTANY: PONT-AVEN, 1886, 1888–90, 1894

(pages 29–31)

1. June 27 to mid-October 1886; late January or early February to October 21, 1888; mid–late February to mid–late April 1889; early June 1889 to February 7, 1890; early June to November 8, 1890. Evidence of the February–April 1889 trip is now in doubt, according to Welsh-Ovcharov 2001, p. 24.
2. Gauguin, letter to Émile Schuffenecker, from Quimperlé, October 8, 1888; Malingue 1946, no. LXXI.
3. Gauguin, letter to Mette, from Paris, February 1888; Malingue 1946, no. LXI.
4. Gauguin, letter to Émile Schuffenecker, from Pont-Aven, February 1888; Guérin 1978, p. 22.

GAUGUIN IN MARTINIQUE, 1887

(page 45)

1. Gauguin, letter to Mette, from Paris, late March 1887; Merlhès 1984, no. 122.
2. Gauguin, letter to Émile Schuffenecker, from Saint-Pierre, early July 1887; Merlhès 1984, no. 129.

3. Gauguin, letter to Mette, from Saint-Pierre, June 20, 1887; Merlhès 1984, no. 127.
4. Gauguin, letter to Émile Bernard, from Arles, about November 9–12, 1888; Merlhès 1984, no. 178.
5. Gauguin, letter to Charles Morice, end of 1890; Rewald 1938, p. 19.

GAUGUIN IN ARLES, 1888

(page 57)

1. The dynamics of this partnership, its impetus, and its aftermath are examined in Chicago–Amsterdam 2001–2.
2. Vincent van Gogh, letter to his brother, Theo, from Arles, undated, probably November 1888; Van Gogh 2000, no. 562.
3. Gauguin, letter to Émile Bernard, from Arles, December 1888; Malingue 1946, no. LXXVIII.
4. Cited in Alexandre 1930, p. 94.
5. Gauguin, letter to Émile Bernard, from Le Pouldu, August 1890; Guérin 1978, p. 42.

GAUGUIN IN BRITTANY: LE POULDU, 1889

(page 65)

1. Gauguin, letter to Émile Bernard, from Le Pouldu, November 1889; Malingue 1949, no. XCII.
2. Gauguin, letter to Odilon Redon, from Le Pouldu, September 1890; Guérin 1978, pp. 42–43.

GAUGUIN IN TAHITI: 1891–93, 1895–1901

(pages 77–79)

1. Gauguin, letter to Émile Bernard, from Arles, about November 9–12, 1888; Merlhès 1984, no. 178.
2. Gauguin, letter to Émile Bernard, from Le Pouldu, June 1890; Malingue 1946, no. CV.
3. Gauguin, letter to Odilon Redon, from Le Pouldu, September 1890; Malingue 1946, app., p. 331.
4. Gauguin, letter to Mette, from Paris, undated, 1890; Malingue 1946, no. C.
5. See Edmond 1997, chap. 1.

6. Gauguin, letter to Mette, from Tahiti, June 29, 1891; Malingue 1946, no. CXXVI. Date of letter supplied by Douglas Cooper in his annotated volume of Malingue 1946, in the library of the Getty Research Institute, Los Angeles.
7. Bougainville's *Voyage autour du monde*, quoted in Varnedoe 1984, pp. 188–89.

GAUGUIN IN THE MARQUESAS: HIVA OA, 1901–3

(pages 139–40)

1. See Varnedoe 1984, pp. 191–93; Gauguin's *Noa Noa* manuscript in the Musée du Louvre, Paris, includes sketches recording rubbings made from Marquesan objects.
2. See Washington–Chicago–Paris 1988–89, pp. 206, 257, cat. no. 141.
3. Malingue 1946, no. CLX.
4. Gauguin, letter to Daniel de Monfreid, from Tahiti, June 1901; Guérin 1978, p. 210.
5. Gauguin, letter to Charles Morice, from Tahiti, July 1901; Malingue 1946, no. CLXXIV. At first Gauguin intended to settle on the island of Fatuhiva, but he was welcomed so warmly in Hiva Oa that he disembarked there instead.
6. Monfreid's letter of 1902 is quoted in Chicago–Amsterdam 2001–2, p. 353.
7. Gauguin, letter to Daniel de Monfreid, from Hiva Oa, November 1901; Guérin 1978, p. 212.

FROM THE BEGINNING: COLLECTING AND EXHIBITING GAUGUIN IN NEW YORK

(pages 151–73)

1. Leo Stein launched his collection of modern art by selecting, as he put it, "two Gauguins, two Cézanne figure compositions, two Renoirs, and . . . a Maurice Denis [thrown in by Vollard] . . . for good measure." Quoted in Gordon 1970, pp. 25–26, 32 n. 45. For the late 1904 acquisition date, see Mellow 1974, p. 62. The paintings by Gauguin can be identified as *Still Life with Sunflowers* (E. G. Bührle Collection, Zurich, W 602) and *Three Tahitians* (State Hermitage Museum, Saint Petersburg, W 581). Stein's interest in Gauguin's works, though influential, was short lived; by the time other Americans followed his lead it appears that Stein (who lent works to the Armory Show) had disposed of his two paintings, having decided that Gauguin "made an important departure, but he is only second-rate." Quoted in Rewald 1989, p. 74. Stein's ownership of the Gauguin canvases is not recorded in Wildenstein 1964. New York collector Josef Stransky owned the *Sunflowers* by 1931 (see note 82 below).

2. Quoted in Rewald 1986a, pp. 30–31.
3. Mrs. Chadbourne is listed as a lender of seven drawings and watercolors (which are only generically described) in the catalogue for the 1910–11 London exhibition, *Manet and the Post-Impressionists*, nos. 160, 162, 167, 179, 181, 185, 192. For her loans to the Armory Show and their subsequent provenance, see note 19 below.
4. Walter Pach Papers, Reel 4216, frame 817, Archives of American Art, Smithsonian Institution, quoted in Perlman 1998, pp. 211–12.
5. Burroughs's interest in a "Paysage, Bretagne" he had seen at Druet's during his fall 1909 trip to Paris is documented in the Archives, Metropolitan Museum. Details concerning this painting and other Gauguins Burroughs considered and proposed as potential acquisitions by the Museum (none of which were made) will be discussed in a forthcoming article by the present author.
6. Huneker 1910, p. 274.
7. On this subject, see Nathanson 1985, pp. 3–4.
8. "London Letter," November 9, 1910, *American Art News* 9 (November 19, 1910), p. 5.
9. Quoted in Nathanson 1985, p. 8.
10. Charles Fitzgerald, "American Post-Impressionism," New York *Evening Sun*, December 13, 1911, quoted in Nathanson 1985, p. 8.
11. Kuhn in postcards to his wife, September 30 and November 11, 1912, quoted in Rewald 1989, pp. 168, 171.
12. Brown 1963, p. 205.
13. Zilczer in Washington 1978, pp. 18, 23.
14. Ibid., pp. 9, 23–24.
15. Monroe 1913, p. 55.
16. Neither Vollard's loan of no. 176, the *Still Life with Japanese Print* nor the two paintings from Druet, no. 182, the *Schuffenecker Family*, and no. 181, a *Still Life* of 1888, are recorded in Wildenstein 1964. The last loan cannot be identified at present. On the basis of documentation at hand (Wildenstein 1964, Wildenstein 2001, vol. 2), there does not seem to be a candidate that corresponds in subject, date, and ownership. The two 1888 still lifes known to have been handled by Druet (W 287 and W 288) were sold prior to 1913; see Wildenstein 2001, vol. 2, nos. 260 and 312. There is, however, the possibility that Druet lent the *Still Life with Fan* in the Musée d'Orsay, Paris (W 377), whose early provenance is unknown.
17. Only one of these four loans, no. 174, *Under the Palm Trees* (W 444), is cited in Wildenstein 1964. As a result, the presence in the Armory Show of the two other paintings lent by Vollard, no. 173, *Fa Iheihe*, and no. 175, *Parau Na Te Varua Ino*, and of no. 581, Quinn's *Bathers*, has tended to escape notice.
18. Tison lent three paintings by Davies to the Metropolitan Museum's 1930 one-man show of his work. Her husband specialized in international law and spent part of his early career in Japan (*Who's Who in*

America 1912–13, vol. 7, p. 2102). Although her Gauguin loan was listed in the Armory Show catalogue as an oil (no. 1066, *Landscape, Tahiti*), it seems likely that it was a watercolor. The catalogue accounts for only four drawings, nos. 177–80, all lent by Emily Crane Chadbourne, but five are shown in a photograph of the Chicago installation (see fig. 59); the horizontal work second from the right at the bottom is presumably the landscape lent by Mrs. Tison.
19. The wood carving no. 615, "Bois sculpté," 1892, cannot be identified at present; scholarship does not account for a wood piece of this date, whether a carved panel or a sculpture, owned by Druet. Chadbourne gave the four drawings she lent to the Armory Show to The Art Institute of Chicago in 1922. The other drawings are no. 178, *Tahitian Child* (1922.4796); no. 179, *Two Tahitian Women in a Landscape* (1922.4795); no. 180, *Pape Moe (Mysterious Water)* (1922.4797). A study on the verso of no. 177, *Head of a Tahitian Man* (1922.4794) is related to a painting in the Metropolitan's collection (see essay by Charlotte Hale, pp. 193–94). Regarding the lithographs, see note 30 below.
20. Brown 1963, p. 207.
21. Britton 1913, p. 3; Cox 1913, p. 10; "Post-Impressionism Arrived," *The Literary Digest*, March 1, 1913, p. 456; Zug 1913, p. 5.
22. "May Bar Youngsters from Cubists' Show," *Chicago Record-Herald*, March 27, 1913, in Armory Show File, Special Collection, 1 XA 7582, Library, Museum of Modern Art, New York.
23. Ibid.
24. Huneker 1910, p. 273.
25. Britton 1913, p. 3.
26. Cox 1913, p. 10, written apropos an "appalling morning" spent at the Armory.
27. Zug 1913, p. 5.
28. Huneker 1910, p. 274.
29. On this subject, see Brown 1963, pp. 105–6; individual prices are listed on pp. 243–45. Gauguin's *Fa Iheihe* (W 569) did not return to France immediately. After the Armory Show, it was included in San Francisco's *Panama-Pacific International Exhibition* of 1915 (section 34), which traveled to Pittsburgh, Toronto, Detroit, and Toledo in 1916 and to Brooklyn in 1918. On January 22, 1918, as the painting circled its way back to New York, Vollard gave curator Burroughs who had admired *Fa Iheihe* five years earlier at the Armory Show—one last chance to purchase the picture (which he called "La Frise") before it returned to Europe. He reminded Burroughs that "paintings by Gauguin are becoming very rare and I think that this is one of the most beautiful" (Archives, Metropolitan Museum). A year later dealer Joseph Duveen purchased it as a gift for the Tate Gallery, London.
30. Buyers' names, prices, and dates of sale are documented in Brown 1963, pp. 244–45. As Brown notes, it is impossible to determine which Gauguin lithographs were exhibited. Sales records indicate that two sets of an

unspecified number of prints and eleven individual impressions were sold; the identified examples are all from the Volpini Suite lithographs on zinc from the edition printed on "Japan" paper by Vollard. These prints were displayed for sale and order but were not listed in the New York catalogue. The individual example purchased by Dreier is now in the Yale University Art Gallery, New Haven, and the two bought by Bliss are at the Museum of Modern Art, New York. Little is known about the subsequent provenance of the dispersed sets or of the eight other single prints. The Metropolitan Museum acquired a complete set of eleven Volpini Suite lithographs printed on yellow paper in 1922 (see cat. nos. 17, 20, 25, 27, 30, 36, 37, 39, 40, 42, 45).

31. On this subject, see Schapiro 1978, pp. 161–63.

32. John Quinn, letter to W. B. Yeats, April 24, 1915, quoted in Reid 1968, p. 213. Quinn's acquisition of a wood mask from Durand-Ruel and Sons in May 1914 is recorded by Zilczer in Washington 1978, p. 160 (the mask is not catalogued in Gray 1963). Quinn's 1920 purchase is recorded in Reid 1968, p. 471, and see text p. 164. For Quinn's efforts to find venues, see, for example, Quinn 1913; Washington 1978, p. 54, and Reid 1968, p. 392.

33. See Zilczer 1982, pp. 57, 60, 63, and 64–65, for an exhibition organized by Agnes Meyer and De Zayas at the Arden Gallery, *The Evolution of French Art*, April 29–May 24, 1919, which included four prints by Gauguin as nos. 111–14. For the involvement of Agnes Meyer, Haviland, and Arensberg in the Modern Gallery and its successor, the De Zayas Gallery, see Zilczer 1974, p. 4, and Naumann 1980, p. 6.

34. Bourgeois, letter to Walter Pach, June 10, 1913, quoted in Brown 1963, p. 190.

35. De Zayas 1996, p. 95.

36. Rewald (1989, p. 117) says that Vollard was probably unwilling to lend.

37. De Zayas quoted in Rewald 1989, p. 302.

38. De Zayas, letter to Walter Arensberg, February 5, 1919, in which he adds that "Vollard says that his painting by Gauguin we wanted to buy will be sold here [Paris] at 50,000"; De Zayas papers, belonging to Francis Naumann, who was kind enough to allow me to consult this material.

39. Field 1919, p. 109.

40. Lewisohn 1939, p. 154.

41. "Gauguin," *New York Times*, April 11, 1920, section 8, p. 2.

42. McBride 1920.

43. "Gauguin, the Great Painter of Tahiti, as the Hero of 'The Moon and Sixpence,'" *The Touchstone* 6, no. 5 (February 1920), p. 290. The writer notes that "The Touchstone had the rare good fortune to secure a collection of reprints of Gauguin's paintings to illustrate this article through the courtesy of Robert Henri" (ibid., p. 298). *Two Tahitian Women* (cat. no. 105) was among the works reproduced.

44. McBride 1920.

45. "Brittany Pictures by Paul Gauguin," *New York Herald*, April 11, 1920.

46. Cortissoz 1925, p. 305.

47. O'Brien 1920, p. 225.

48. "Artists in Fact and Fiction," *Arts and Decoration*, September 1919, p. 223.

49. "Gauguin, the Great Painter of Tahiti, as the Hero of 'The Moon and Sixpence,'" *The Touchstone* 6, no. 5 (February 1920), p. 297.

50. "Artists in Fact and Fiction," *Arts and Decoration*, September 1919, p. 223.

51. Cortissoz 1925, pp. 305, 311–13 [originally published in the *New York Tribune*, 1921].

52. *Paintings by Gauguin*, De Zayas Gallery, April 5–17, 1920; listed in De Zayas 1996, p. 155.

53. "Works by Gauguin at De Zayas' Gallery," *American Art News*, April 10, 1920, p. 3.

54. "Brittany Pictures by Paul Gauguin," *New York Herald*, April 11, 1920.

55. *Paul Gauguin: Exposition d'oeuvres inconnues*, Galerie Barbazanges, Paris, October 10–30, 1919.

56. "Brittany Pictures by Paul Gauguin," *New York Herald*, April 11, 1920.

57. "Gauguin," *New York Times*, April 11, 1920, sec. 8, p. 2.

58. "Works by Gauguin at De Zayas' Gallery," *American Art News*, April 10, 1920, p. 3.

59. "Gauguin," *New York Times*, April 11, 1920, sec. 8, p. 2.

60. Ibid.

61. "Brittany Pictures by Paul Gauguin," *New York Herald*, April 11, 1920.

62. "Gauguin," *New York Times*, April 11, 1920, sec. 8, p. 2.

63. The works referred to are listed in the catalogue to the Galerie Barbazanges exhibition (Paris 1919) as: no. 1, *Portrait de Gauguin par lui-même* [W 323]; no. 3, *Le soir à la lampe. Portrait de Meyer de Haan* [W 317]; no. 12, *Danse Breton* [not in Wildenstein; see Hartford 2001, p. 67, fig. 95]; no. 19, *Les Pêcheurs de Goëmon* [W 392]; no. 8, *La Gardeuse de vaches* [W 343 bis]; no. 28, *Negresse de la Martinque* [G 61].

 Other works mentioned by title in the short review "Works by Gauguin at the De Zayas' Gallery," *American Art News*, April 10, 1920, p. 3, are also found in the Barbazanges catalogue: "Nude on the Beach" (no. 4, *Les Baigneuses* [W 400]); "Chapel of St. Maudet" (no. 17, *L'Église de Saint-Maudet* [not in Wildenstein; Malingue 1959, pp. 36, 38, describes a gouache of this title (38 x 29 cm) from the Marie Henry collection sold at Hôtel Drouot, Paris, March 16, 1959, lot 107, pl. 3; "Beach at Belle-Angenany" (no. 18, *La Plage de Belle-Angenany* [W 371]).

64. Quinn's purchase is recorded in Reid 1968, p. 471. The painting was shown at Barbazanges as no. 5. In addition, a small gouache on millboard portrait (17 x 13 cm) (Edward McCormick Blair collection) included in the Barbazanges exhibition as no. 15, *Portrait de Jeune Femme, Présumé la mere du peintre "Flora Tristan,"* is inscribed on the reverse: *M. de Zayas, 549 Fifth Ave – New York*. Peter Zegers kindly

brought the inscription to my attention. While this picture was undoubtedly handled by De Zayas, it is not known to whom it was sold. The portrait is not recorded in Wildenstein 1964 but is documented among the works once owned by Marie Henry in Malingue 1959, p. 38, no. 23, ill. p. 37. De Zayas himself owned another work that had belonged to Marie Henry, *Adam and Eve (Paradise Lost)* (Yale University Art Gallery, New Haven [W 390]); this painting does not appear in the Barbazanges catalogue, though it may well have been exhibited *hors catalogue* in Paris and subsequently included in the De Zayas show. Three years later he sold it at auction; De Zayas sale 1923, lot 82. De Zayas's ownership of this work is not indicated in Wildenstein 1964 or in the recent literature, where it has sometimes been attributed to Sérusier (see Hartford 2001, p. 150, no. 11).

65. *Still Life "Ripipoint"* was included in the Davies exhibition and sale held at the Feragil Galleries, New York, in February 1926 as no. 19. It had been shown at the Galerie Barbazanges as no. 13.

66. Goodfriend sale 1923, lots 107 and 91, respectively. These works were listed in the Barbazanges catalogue (Paris 1919) as nos. 2 and 7.

67. "French Art of the Great Show," *New York Evening Telegram*, May 10, 1920, quoted in Rewald 1989, p. 317.

68. Ibid.

69. The exhibition ran from March 16 through April 3. The Gauguin watercolors were listed in the catalogue as no. 20, "Mother and Child," and no. 21, "Study."

70. The exhibition was held from March 26 through the summer. These works were listed in the catalogue as no. 119, "Natives of Tahiti," and no. 120, "Head of a Young Girl (pastel)."

71. Alfred Stieglitz, letter to the Brooklyn Museum's director, William Henry Fox, June 21, 1921, published under the title "Regarding the Modern French Masters Exhibition," in *The Brooklyn Museum Quarterly* 8 (1921), p. 108.

72. For an excellent discussion of the exhibition, particularly the controversy at its conclusion, and for a complete checklist of the loans, see Rabinow 2000.

73. The quote is from the pamphlet sent out by "A Committee of Citizens and Supporters of the Museum" and titled *Protest against the Present Exhibition of Degenerate "Modernistic" Works in the Metropolitan Museum of Art*, excerpted at length in Rewald 1989, p. 330. Rewald (ibid., p. 331) identifies the anonymous author as R. W. Ruckstull. Rabinow (2000, pp. 5–6) attributes authorship to Charles Vezin.

74. Quoted in Rewald 1989, p. 330.

75. M. Lincoln Schuster, "New York Overtones: Impressions of Impressionism: Ku Klux Art Fulminations," *Boston Evening Transcript*, September 10, 1921, magazine section, p. 3, quoted in Rabinow 2000, p. 7.

76. Gauguin, letter to Daniel de Monfreid, from Hiva Oa, November 1901; Guérin 1978, p. 211 (cited on p. 141 in text).

77. Letter of January 26, 1921, addressed to Robert de Forest; Archives, Metropolitan Museum (L7806).

78. "Museum Opens Its Modernist Show," *American Art News*, May 7, 1921, p. 5.

79. Burroughs 1921, p. 70.

80. Weyhe 1921, p. 95.

81. Dale 1931, p. 87.

82. See Flint 1931, pp. 87–88, which documents Stransky's ownership of a pastel, *Crouching Tahitian Woman* (R 47) and four paintings: *Self-Portrait with Idol*, W 415; *Faaturuma (Reverie)*, W 424; *Bathers at Tahiti*, W 564; and *Still Life with Sunflowers*, formerly Collection Leo Stein, W 602 (see fig. 57).

83. Kelekian sale 1922, lot 152, purchased by the Bourgeois Galleries (per annotated sale catalogue) for Adolph Lewisohn.

84. De Zayas sale 1923, lot 83.

85. In 1921, three years after it was sold from Degas's estate, the Worcester Art Museum purchased Gauguin's painting *Te Faaturuma (Sulking)* (W 440) from the John Levy Gallery, New York. That same year Worcester also acquired an 1884 pastel, *Head of a Woman* (W 98), which is described and illustrated in the *Bulletin of the Worcester Art Museum* 13 (July 1921), pp. 2–3.

86. The ten paintings by Gauguin in the Metropolitan Museum's exhibition were listed in the catalogue as nos. 46–55. Bliss, Kelekian, and De Zayas lent anonymously.

87. The works included in this show (May 17–September 15, 1921) are recorded in a "List of Exhibitions" ledger in the Department of Drawings and Prints, Metropolitan Museum. Those lent by Davies were described as lithographs depicting "Two Breton women by haystacks," "Two Breton Women by a Fence," and "Goat in the Foreground" (see cat. nos. 17, 20, 30). A hand-colored version of the last print was lent by Frank V. Chappell, along with a "Tahitian scene" also described as "colored by hand."

88. For the subsequent development of the Museum's collection of Gauguin's prints as well as paintings, drawings, and sculptures, see "A Note on the History of the Metropolitan Museum's Collection of Works by Paul Gauguin," following note 102 below.

89. *Cézanne, Gauguin, Seurat, Van Gogh* was held from November 7 to December 7, 1929; see Goodyear 1943, p. 19. Goodyear noted that "the opening exhibition realized our fondest expectations. For the preview on November 7, 'the entire town turned out.' . . . On the walls were one hundred and one examples of the work of the four great ancestors of modern art, many of them never before seen in this country. Included were the pick of the Bliss, Dale and Lewisohn collections, outstanding examples from London, Paris, Amsterdam and Berlin, such famous canvases as . . . Gauguin's *Spirit of the Dead Watching*."

90. Cortissoz 1929, p. 10. The Gauguin loans are listed in New York 1929, pp. 38–42, as nos. 35–54a.

91. Jewell (1929) wrote: "The Gauguins are fewer (twenty) [than the Cézannes], but they are equally representative and some of them are simply gorgeous—the 'Reverie,' for one, from Mr. Stransky's collection. . . . A glorious design; one of the best Gauguins this writer has seen. . . . It is gratifying to see how well Gauguin holds his own. The tendency to esteem him [as] merely decorative, in a limiting sense of the term, can hardly gain momentum, confronted with examples so various and so wisely chosen as those at hand."

92. In addition to no. 44, *Manao Tupapau*—the only Gauguin favored with a full-page description in New York 1929—Goodyear lent no. 47, *Poèmes barbares* (Fogg Art Museum, Cambridge, Massachusetts, W 547) and no. 51, *Te Tiai Na Oe Ite Rata* (private collection, W 587). They were listed as "Private Collection, New York." In 1959 *Te Tiai Na Oe Ite Rata* made headlines when it was sold at auction (Sotheby's, London, November 25, 1959) by A. Conger Goodyear's son, George F. Goodyear, for a record-setting price of $364,000.

93. See Zilczer in Washington 1978, p. 160.

94. See New York 1934, pp. 50–51, nos. 37, 38, and pp. 76–80, nos. 77–90.

95. Rubin and Armstrong 1992, pp. 153–56.

96. New York 1936.

97. Frankfurter 1936a, p. 5.

98. Frankfurter 1936b, p. 5.

99. Cary 1936.

100. Genauer 1959, p. 8.

101. The exhibition opened at the Art Institute of Chicago, where it ran from February 12 to March 29, 1959, and was shown at the Metropolitan Museum from April 23 to May 31, 1959.

102. Gauguin, letter to Mette, from Pont-Aven, ca. July 25, 1886; Guérin 1978, p. 17. See epigraph, p. 151.

A Note on the History of the Metropolitan Museum's Collection of Works by Paul Gauguin

The Museum owns sixty-three Gauguin paintings, drawings, sculptures, and prints. Featured together for the first time in their entirety in the present exhibition, these holdings represent an aggregate of purchases and donations made over an eighty-year period. The collection was initiated in 1921 with a suite of ten woodcuts (see cat. no. 90) acquired by curator William M. Ivins Jr. from Frederick Keppel and Co., New York. The following year Ivins bought a color woodcut, *Nave Nave Fenua (Delightful Land)* (cat. no. 80) from the New York dealer E. Weyhe and from the Parisian vendor Maurice Le Garrec the first edition of Gauguin's 1889 portfolio of eleven lithographs on zinc printed on yellow paper—the so-called Volpini Suite (cat. nos. 17, 20, 25, 27, 30, 36, 37, 39, 40, 45; see cat. no. 42). Between 1926 and 1936 Ivins purchased a number of additional prints, notably five second-voyage woodcuts, two from Maurice Gobin in Paris (cat. nos. 97, 102) and three from the Park Avenue dealer J. Goriany (cat. nos. 21, 101, 107). In 1936, when the Keppel galleries moved to Fifty-seventh Street and inaugurated its new premises with an exhibition devoted to Gauguin prints, Ivins seized the opportunity to buy a dozen color woodcuts (see cat. nos. 65, 75, 76, 78, 79, 81–83, 89). On the heels of this windfall acquisition, he bought two more prints from J. Goriany (cat. no. 103; see cat. no. 8) and, in 1937 a woodblock for *Noa Noa* (cat. no. 71). It is to Ivins's keen eye and vision that the Museum owes the lion's share of its prints by Gauguin. Subsequent additions were few: purchases in 1952 (cat. no. 35), 1962 (cat. no. 56), and 1967 (cat. no. 48); impressions of lithographs bequeathed in 1982 (see cat. nos. 36, 66); and a gift of an inscribed calling card in 1983 (cat. no. 11).

In contrast, for its collection of paintings by Gauguin, the Museum is indebted entirely to the generosity of donors. While curators had considered and proposed various acquisitions of paintings as early as 1909, in the end none were made. Initiated with an anonymous gift in 1939 (cat. no. 119), the paintings collection took shape during the period 1949 to 1954 with the addition of three major canvases—one from William Church Osborn (cat. no. 105) and two from the Lewisohn family (cat. nos. 18, 55); another well-known painting (cat. no. 62) joined the collection with the gift of the Robert Lehman Collection in 1975. Notwithstanding these gains, there have been some losses over the years: two pictures donated between 1967 and 1982 have since been deattributed (cat. nos. 117, 118); and Joanne Toor Cummings's partial-interest gift to the Museum in 1984, *Still Life with Sunflowers* (W 604), was not fully realized at the time of her death in 1995, and the painting was sold from her estate. Within the last decade, however, the paintings collection has rebounded: it has grown considerably in importance and doubled in size, thanks to the gifts of four superb Gauguins from Walter H. and Leonore Annenberg (cat. nos. 68, 94, 95, 110).

During the 1960s the Museum received its first Gauguin drawings (cat. nos. 57, 58) and its only sculptures (cat. nos. 1, 13). Two recent acquisitions, of a drawing in 1996 (cat. no. 104) and the artist's portfolio in 2000 (cat. no. 26), have significantly enhanced the Metropolitan's holdings.

GAUGUIN'S PAINTINGS IN THE METROPOLITAN MUSEUM OF ART: RECENT REVELATIONS THROUGH TECHNICAL EXAMINATION

(pages 175–95)

1. Hale 1983; Couëssin 1991; Christensen 1993; Jirat-Wasiutyński and Newton 2000 (with further bibliography by the authors listed, pp. 272, 275); Kornhauser 2001; Lister, Peres, and Fiedler 2001. Also essential have been X-radiographic examinations of Gauguin's paintings in the Ny Carlsberg Glyptotek, Copenhagen, and Ordrupgaard Museum, Copenhagen, undertaken by Anne Birgitte Fonsmark, Director, Ordrupgaard Museum, and Henrik Bjerre, Chief Conservator, Statens Museum for Kunst, Copenhagen. I thank them for generously allowing me access to this material.

2. This research benefited greatly from profitable discussions with colleagues—both conservators and art historians—at the Metropolitan Museum and elsewhere. I thank the following for their help: Mark Aronson, Henrik Bjerre, Barbara Buckley, Aviva Burnstock, Carol Christensen, Inge Fiedler, Richard Field, Claire Frèches, Patricia Sherwin Garland, Ella Hendriks, Stephen Kornhauser, Vojtěch Jirat-Wasiutyński, Kristin Hoermann Lister, Travers Newton, Roy Perry, Anne Roquebert, Elizabeth Steele, Harriet Stratis, Louis van Tilborgh, Bogomila Welsh-Ovcharov, and Frank Zuccari. I extend special gratitude to Colta Ives and Susan Alyson Stein and to Laurence Kanter, Marjorie Shelley, Yana Van Dyck, and Mark T. Wypyski at the Metropolitan, as well as my colleagues in Paintings Conservation: Maryan W. Ainsworth, Lucy Belloli, George Bisacca, Silvia Centeno, Dorothy Mahon, Hubert von Sonnenburg, and Alison Gilchrest, who made the infrared reflectogram assemblies.

3. Richardson 1959.

4. Field 1977, pp. 341–42. Field ends his entry by noting that there is a "slim possibility" that the painting was begun by Gauguin and completed by another hand.

5. For information on the different types of canvas used by Gauguin, see Christensen 1993, pp. 64–70. See also Lister, Peres, and Fiedler 2001, pp. 354–57.

6. Departmental files, Sherman Fairchild Paintings Conservation Center, Metropolitan Museum.

7. There are two early works on paper catalogued in Wildenstein 1964 and 2001 (W I 8 and 26). The attribution of an unfinished oil on paper, *Tahitians*, ca. 1891 (Tate Gallery of Modern Art, London, W 516), is questioned by this author.

8. I am grateful to Anne Roquebert at the Musée du Louvre, Paris, and Claire Frèches at the Musée d'Orsay, Paris, for allowing me access to the technical material on the *Meal* at the Laboratoire du Louvre. Mme Roquebert also kindly furnished information from the Fiche santé / Peinture, Restauration, CZRMF at Versailles. The only other known paintings with a combed ground texture are all oil on wood: *Self-Portrait with Halo* (National Gallery of Art, Washington, W 323), *Portrait of Meyer de Haan* (private collection, W 317), (see Christensen 1993, p. 70), and *Female Nude with Sunflowers*, 1889 (private collection). All were decorations for the inn of Marie Henry at Le Pouldu. We should note that when Gauguin executed *Three Tahitian Women*, 1896 (cat. no. 94), on a wooden support that was originally a door from a piece of painted furniture, he worked on the rough exterior that appears to have been scraped down before he applied his own ground, rather than on the smooth interior of the door: departmental files, Sherman Fairchild Paintings Conservation Center, Metropolitan Museum. See also Joseph Rishel's entry on the painting in Philadelphia and other cities 1989–91, p. 94.

9. See, for example, Gauguin's letter to Jens Ferdinand Willumsen on p. 195 of this essay. See also Christensen 1993, pp. 63–64.

10. For discussion of Gauguin's use of preparatory drawings, see Jirat-Wasiutyński and Newton 2000, pp. 65–88, 181–84 (for pouncing specifically). Squaring was a very common transfer method, advantageous because it allows the artist to enlarge or reduce the size of an image. In pouncing the artist pricks little holes in the outline of a drawing, places the drawing on top of the painting surface, and then "pounces" charcoal in a bag through the holes to produce a dotted line on the picture surface. This technique was described, in the late trecento, by Cennino Cennini in his *Libro dell'arte* (1954, p. 87). The one-to-one relationship of many of Gauguin's preparatory drawings to their corresponding paintings strongly suggests that he used tracing, as identified for the portrait of Mme Ginoux for the *Night Café* (Pushkin State Museum, Moscow, W 305) in Chicago–Amsterdam 2001–2, p. 233. See also Jirat-Wasiutyński and Newton 2000, pp. 71, 121–22, 239 n. 14. For more information on the use of tracing by Gauguin, the reader is referred to Lister 2001, pp. 65–67, 83.

11. The final paintings are *Te Nave Nave Fenua (Delightful Land)*, 1892 (Ohara Museum of Art, Kurashiki, Japan, W 454) and *Parau Na Te Varua Ino (Words of the Devil)*, 1892 (National Gallery of Art, Washington, W 458).

12. For the drawing, *Crouching Tahitian Woman*, 1892 (Art Institute of Chicago), see Pickvance 1970, pl. 12.

13. Dorival 1954, sketchbook, leaf 71r.

14. The kneeling nude on the far bank may originally have been placed on the near bank where the seated figure viewed from the back now appears. The possibility is suggested by the presence of the lone foot seen in the underdrawing in the area of the near shore, which is larger than the nude's foot and is angled similarly to it.

15. For example, *Woman Bather in Brittany*, 1886–87 (Art Institute of Chicago) and the reworked study for *Te Nave Nave Fenua* noted in the text above. For more on this topic, see Jirat-Wasiutyński and Newton 2000, pp. 148–49.

16. Typical adjustments of contour were made in *Tahitian Women Bathing* in the right arm of the standing woman and in her hair as it spreads out on her back. A more significant but still subtle change was effected in *Haystacks*, 1889 (Courtauld Institute Galleries, London, W 352), where a rather naturalistic figure seen in the underdrawing is stylized in the painting; see Bruce-Gardner, Hedley, and Villers 1987, pp. 32–33. A number of compositional changes can be observed in the *Siesta* (cat. no. 68), a painting that is not signed or dated and appears to be unfinished. These include the replacement of the small dog in the lower right foreground with a basket and modification of the contour of the recumbent woman in red (departmental files, Sherman Fairchild Paintings Conservation Center, Metropolitan Museum); see Rishel's entry on the painting in Philadelphia and other cities 1989–91, pp. 90, 183–85. In addition, analysis indicates that the *Siesta* is painted over another composition. Christensen (1993, pp. 73, 97 n. 66) cites at least six other examples of Gauguin reusing canvases.

17. Compare, for example, the modeling of the lost profile of the woman on the right in *Fatata te Miti (Near the Sea)*, 1892 (National Gallery of Art, Washington, W 463).

18. Jénot (1891–93) 1956, p. 120.

19. Gauguin, letter to Daniel de Monfried, from Tahiti, August 1892; Malingue 1946, no. CXXXII. Field (1977, p. 364) dates this letter to October 1892.

20. The support was more fully identified as wood pulp–paper made from hardwood with a high lignin content. This was an inexpensive, widely available type of paper that was produced in Europe and America. Such paper ages poorly, tending to become acidic, brittle, and brown. I thank Silvia Centeno, Associate Research Chemist in the Sherman Fairchild Center for Works on Paper and Photographs Conservation and the Sherman Fairchild Paintings Conservation Center, Metropolitan Museum, and Yana Van Dyck, Conservation Assistant, in the former department, for carrying out this analysis. I am grateful to Marjorie Shelley, Sherman Fairchild Conservator in Charge of the Center for Works on Paper and Photographs Conservation, for sharing her expertise on Gauguin's materials.

21. Leblond 1909, p. 225.

22. For studies of matte painting, the reader is referred to Jirat-Wasiutyński and Newton 1998 and Callen 1994.

23. For the use of wax, see Christensen 1993, pp. 92–93. For his thoughts on the use of glass, see Gauguin to an unknown collector, a letter that originally accompanied *Three Tahitian Women*, 1896 (cat. no. 91): "To the unknown collector of my works Greetings— / May he excuse the barbarism of this little picture;

certain dispositions of my spirit are probably the cause. I recommend a modest frame and if possible a sheet of glass which, while [the picture] ages, will preserve its freshness, and prevent the alterations always produced by the stuffy atmosphere of an apartment. Paul Gauguin." In his advocacy of glass, Gauguin was surely influenced by Pissarro, who exhibited paintings behind glass in the Impressionist exhibitions of 1881 and 1882: see Jirat-Wasiutyński and Newton 1998, p. 236.

24. Gauguin, letter to Daniel de Monfreid, from Tahiti, February 25, 1901; Joly-Segalen 1950, no. 72.

25. For example, New York 1932, no. 8; Malingue 1948, no. 161; New York 1958, no. 9; Munich 1960, no. 49; Paris 1960, no. 79; and Jaworska 1972, p. 36.

26. Douglas Cooper, letter, January 2, 1979; John Rewald, letter, March 15, 1979; both in the archives, Department of European Paintings, Metropolitan Museum.

27. For a discussion of the Schuffenecker brothers and the linkage to forgeries, see Grossvogel 2000, pp. L–LII, and Van Tilborgh and Hendriks 2001, pp. 28–31.

28. I have obtained information about the attribution of this painting from the archives, Department of European Paintings, Metropolitan Museum, and have enjoyed discussions on the subject with a number of colleagues from the Metropolitan Museum and elsewhere, who are cited in note 2 above.

29. Gauguin, letter to Camille Pissarro from Paris, ca. July 10, 1884; Merlhès 1984, no. 49.

30. For the five paintings, see Bodelsen 1970, p. 602. For *Still Life with Apples in a Compote*, see Venturi 1936, vol. 2, no. 341.

31. See Rishel's comments in Philadelphia and other cities 1989–91, pp. 93, 185–86.

32. The cloisonné-like effect is usually seen where the ground material does not feature significantly in the X-radiograph, as is the case with chalk and glue grounds.

33. Gauguin, letter to Émile Bernard, from Arles, second half of November 1888; Merlhès 1984, no. 182.

34. See Brettell's entry on the painting in Washington–Chicago–Paris 1988–89, pp. 402–3.

35. At 38.4 x 46.4 cm, the Metropolitan Museum's *Still Life* can be considered a standard size no. 8 (portrait) canvas that measures 46 x 38 cm, cited in an 1889 list of merchandise from the color merchant Lefranc et Cie, reproduced in Callen 2000, p. 15. The Barnes picture measures 37.5 x 43.7 cm.

36. The reader is referred to images, some of which are in color, and entries in the new edition of the catalogue raisonné, Wildenstein 2001. *To Make a Bouquet*, 1880 (W I 62), is the first painting in which the bird appears; *Clovis Asleep*, 1884 (W I 151) has the bird; *Vase of Peonies II*, 1884 (W I 146), and *Flowers and Bird* (*Tambourine*), 1886 (W I 147), show the bird and the vegetal form; *Still Life*, probably ca. 1886 (W I 218), has the vegetal form; *Still Life with Ceramic*

Cup, 1888 (W II 263), presents a vegetal form and a vaguely birdlike form.

37. The pigments were identified using scanning electron microscopy–energy dispersive spectroanalysis. I am grateful to Mark T. Wypyski, Associate Research Chemist in the Department of Objects Conservation, Metropolitan Museum, for undertaking this analysis.

38. Chassé 1921, p. 72.

39. See, for example, illustrations in Jaworska 1972, pp. 101 (Meyer de Haan), 36 (Bernard), 117 (Slewinski), 136 (Sérusier), 224 (O'Conor), 201 (Loiseau). For other Cézannesque paintings by Meyer de Haan, see Hartford 2001, pp. 37, 66, 77.

40. Reproduced in Malingue 1943, p. 77. *Still Life with Apples* is not included in Wildenstein's catalogue raisonné of 1964, but according to the Christie's sale catalogue it will appear in the new edition being prepared by Daniel Wildenstein with the collaboration of Douglas Cooper. The painting was examined by the author at Christie's in June 2001. The correspondence between the Metropolitan Museum's *Still Life* and the *Still Life with Apples* is discussed by Field (1977, pp. 348–49). I thank Bogomila Welsh-Ovcharov for providing a good color illustration of *Still Life with Apples*.

41. For example, Gauguin's *Still Life with Onions, Beetroot, and a Japanese Print*, 1889 (cat. no. 47) and a copy of it attributed to Meyer de Haan, *Still Life with Onions*, 1889 (Ny Carlsberg Glyptotek, Copenhagen). See Toronto–Amsterdam 1981, pp. 355–56. See also Welsh-Ovcharov 2001, p. 34. Gauguin's fan, *Fan, Landscape after Cézanne*, 1885 (Ny Carlsberg Glyptotek, Copenhagen, W 147), copies Cézanne's *Mountain, L'Estaque*, 1882 (National Museums and Galleries of Wales, Cardiff).

42. I offer many thanks to Barbara Buckley, Conservator at the Barnes Foundation, Merion, Pennsylvania, for facilitating this examination. *Peaches and Pears* appears in its current format in early photographs, for example photo no. 371 from the Vollard Archives, which is reproduced in Rewald 1996, p. 453, no. 730. This photograph has a cross through it, perhaps suggesting that Vollard questioned the authenticity of the painting; it may, however, merely indicate that the image was overexposed, as Anne Distel has suggested (personal communication to Susan Alyson Stein).

43. Material concerning Schuffenecker's collection was not available to us for the present study. We await the next volume of Grossvogel's catalogue raisonné for this information.

44. See Wildenstein forthcoming.

45. Douglas Cooper, letter, January 1, 1982; archives, Department of European Paintings, Metropolitan Museum.

46. Jénot (1891–93) 1956.

47. Ibid, p. 124. Translations of this text are by the author.

48. Ibid. p. 120.

49. The weave count of both canvases is sixteen

(eight-paired) threads vertically and twelve to thirteen single threads horizontally per square centimeter. Both canvases have a blue thread running close to a selvage on one side. I am very grateful to Kristin Hoermann Lister of the Art Institute of Chicago for this information. Fiber analysis of the support of *Captain Swaton* was conducted by Yana Van Dyck.

50. See Lister, Peres, and Fiedler 2001, p. 368, n. 27. See also London 1990–91, p. 48.

51. See Lister, Peres, and Fiedler 2001, pp. 358–60. I thank Ella Hendriks, Van Gogh Museum, Amsterdam, for sharing information on Van Gogh's grounds.

52. At the Metropolitan Museum the grounds for paintings in the collection were analyzed by Silvia Centeno using micro-Raman spectroscopy. Elemental mapping of samples was undertaken by Mark T. Wypyski; see note 37 above. See also Christensen 1993, p. 103. Lithapone, a mixture of barium sulfate and zinc sulfide, has recently been identified as the material used for the ground of *Te Rerioa (Dream)*, 1897 (Courtauld Institute Galleries, London, W 557); Aviva Burnstock, Courtauld Institute of Art, personal communication. Lithapone was found to be a minor component in the lead-white ground of the Museum's *Siesta*.

53. Gauguin used an implement (probably the wooden end of a brush) to inscribe into wet paint in some pictures (for example, in the left contour of the skirt of the middle figure in *Three Tahitian Women* (cat. no. 94), and around the little horseman in the background of *Te Rerioa (Dream)*, 1897 (Courtauld Institute Galleries, London, W 557); however, his purpose was not to add texture, as in the case of *Captain Swaton*, but to define contour.

54. See Wildenstein 1964, pp. 161–62, nos. 416–19.

55. I am grateful to Gabriel Harnist for facilitating my viewing of this painting. The *Siesta* is not signed or dated, and opinions on its date differ. This author dates it, on technical and stylistic grounds, to Gauguin's first Tahitian sojourn. See Christensen 1993, pp. 67–68. The support of *Ia Orana Maria* has been identified as jute by Yana Van Dyck.

56. Malingue 1948, no. 175; Wildenstein 1964, p. 175, no. 442, as *Cheval au Pastorage*.

57. It was questioned by Philippe Brame and rejected by John Rewald and Douglas Cooper; archives, Department of European Paintings, Metropolitan Museum.

58. See note 1 above.

59. At 64.7 x 47.5 cm the format is close to what Lefranc et Cie listed in 1889 as a standard size (*paysage*) no. 15 canvas that measures 65 x 48.5 cm; see Callen 2000, p. 15.

60. The weave count of this canvas is 11 x 9 threads per square cm. Fiber analysis was conducted by Yana Van Dyck.

61. In September 1899 Gauguin wrote to Daniel de Monfreid from Tahiti, "for ten years as you know I have painted on absorbent canvas and have been able to control as I wish the effects of the colors and their stablility" (author's

translation); Joly-Segalen 1950, no. 58. See also Christensen 1993, pp. 70–73, and app. 3, p. 103.

62. For a discussion of the use of absorbent grounds by Post-Impressionist painters, in particular Gauguin, see Jirat-Wasiutyński and Newton 1998. For a history of absorbent grounds, see Callen 2000, pp. 52–57.

63. The earliest known self-grounded canvas is *Flowers, Still Life, or the Painter's Home, Rue Carcel*, 1881 (Nasjonalgalleriet, Oslo, W 50, W I 76), see Jirat-Wasiutyński and Newton 1998, pp. 237, 238 n. 28, citing Richard Newman's 1998 report on Gauguin samples at the Museum of Fine Arts, Boston.

64. See Christensen 1993, p. 71.

65. For other examples, see ibid., p. 75, and Jirat-Wasiutyński and Newton 2000, pp. 71–74; see also the comment on *Haystacks* in note 16 above.

66. The pigments analyzed were lead white, cadmium yellow, chrome yellow, cadmium orange, vermilion, an unidentified crimson lake, cobalt blue, ultramarine, emerald green, and a finely divided carbon black. See note 37 above. For pigment analysis of paintings by Gauguin, see Christensen 1993, pp. 88–89, and app. 2, p. 102, app. 3, p. 103.

67. The numerals are closely comparable to those inscribed on the *Landscape with Figures*, 1892 (Ny Carlsberg Glyptotek, Copenhagen, W 480).

68. Gauguin access to and relationship with the work of colonial photographers is explored in Childs 2001.

69. Ibid.

70. I thank Mark Aronson and Patricia Garland for facilitating the examination of *Parau Parau* in the Conservation Studio of the Yale University Art Gallery. Black paint was identified by visual means only. Contours in black and black and blue mixtures in a number of other paintings by Gauguin in the collection of the Art Institute of Chicago have been investigated both visually and with pigment analysis. I am grateful to Inge Fiedler, Kristin Hoermann Lister, and Frank Zuccari in the Conservation Department of the Art Institute for sharing this information. Two paint samples from *Tahitian Landscape* that incorporate black were analyzed and found to be mixtures of a finely divided carbon black and cobalt blue. Since black does not appear in any of Gauguin's written orders for paints, he probably was able to purchase it locally.

71. The dab of a mouth is seen in *Parau Parau*; the leaf in two pictures at the Art Institute of Chicago, *Te Raau Rahi (Big Tree)*, 1892 (W 439), and *Te Bureo (Hibiscus Tree)*, 1892 (W 486), both illustrated in Chicago–Amsterdam 2001–2, p. 338; and the light on the horse in the *Black Pigs*, 1891 (Szépművészeti Múzeum, Budapest, W 446). The schematic features of the horse are like those of the sleeping dog in *Te Raau Rahi*.

72. See Dorival 1954, text vol., pp. 23–34, sketchbook, leaves 39r, 63r.

73. For other paintings in which Gauguin reversed his preparatory drawings, see Wildenstein 2001, p. 337.

74. This was one of the first works by Gauguin to enter a United States collection. It was bought by Mrs. Emily Crane Chadbourne of Chicago and was exhibited at the Armory Show in 1913. I am grateful to Douglas Druick and Harriet Stratis at the Art Institute of Chicago for facilitating my study of this drawing. Stratis kindly shared valuable insights regarding the technique and condition of the work.

75. Very similar minor changes in the translation of figures from drawing to painting are seen, to give one example, in Gauguin's *Near the Huts*. See Wildenstein 2001, pp. 334–35.

76. Gauguin, letter to Émile Schuffenecker, from Pont-Aven, 1888: "I love Brittany. There I find the savage, the primitive. When my clogs resound on the granite, I hear the same dull, heavy, powerful tone that I seek in painting." Merlhès 1989, no. 141.

77. For an incisive examination of the paintings of the first stay in Tahiti, see Field 1977, passim.

78. Ibid., p. 206.

79. See Charles Stuckey's catalogue entry for the painting in Washington–Chicago–Paris 1988–89, pp. 243–44.

80. Gauguin, letter to the Danish painter Jens Ferdinand Willumsen, from Pont-Aven, 1890; *Les marges* (Paris), March 15, 1918.

GAUGUIN'S WORKS ON PAPER: OBSERVATIONS ON MATERIALS AND TECHNIQUES

(pages 197–215)

1. Gauguin, letter to Émile Bernard, from Le Pouldu, 1890; Malingue 1946, no. CVI.

2. Ibid., no. CIX.

3. Painting materials available outside Paris were generally of lesser quality (see Constantin 2001), which probably accounted for the supplies Gauguin requested from friends while in Brittany, as noted in letters to Bernard referring to oil paints, from Arles, late November 1888 (Merlhès 1984, no. 182); to Bernard again, thanking him for colors, from Arles, December 1888 (Malingue 1946, no. LXXVIII); and to Émile Schuffenecker, from Pont Aven, in June 1890 (ibid., no. CIV).

4. Gauguin's letters to Daniel de Monfreid indicate that some painting supplies were available in Tahiti: August 1892 (Malingue 1946, no. CXXXII) and December 1892 (Joly-Segalen 1950, no. 9).

5. For mentions of Ingres paper, watercolors, and Japanese paper, see letters of 1899, 1900, and March 1902 (Rewald 1943, pp. 30–31, 32–35, 50–51, respectively). For brushes, see Gauguin, letter to Daniel de Monfreid, from Tahiti, January 27, 1900 (Joly-Segalen 1950, no. 61), but the letter does not specify if these are for oil or watercolor. Concerning paper shortage, see Gauguin, letter to Ambroise

Vollard, from La Dominique, April 1903, "It is now more than eight months since you advised me of the shipment of canvases, paper, *totin* glue and flower seed" (Rewald 1943, pp. 63–64). And Gauguin, letter to Vollard, from Tahiti, August 1901, "just before I went to the hospital I put in a box 23 very careful drawings which would have pleased you very much. When I unpacked them I found them all in a thousand fragments, ruined by a family of rats" (ibid., pp. 47–48). References in his late correspondence to his papers and shipments of woodcuts and drawings are outlined in Field 1973, pp. 19–20, 50 n. 45.

6. Gauguin, letter to Daniel de Monfreid, from Tahiti, October 1900, expresses his concern about the canvases sent to him (Joly-Segalen 1950, no. 68), and another to Ambroise Vollard, from Tahiti, January 1900, complains about the wrong paper (Guérin 1978, pp. 204–5).

7. He would have learned some rudiments of technique from his early training with Marguerite Arosa in 1871, his time at the Atelier Colarossi in the 1870s, and his summers with Pissarro at Pontoise and Osny in 1881 and 1883. Among the many art manuals then in circulation that he may have seen was one published by his colorman, F. A. A. Goupil-Fresquet, *Manuel complet et simplifié de la peinture à l'huile* (1877); another was Charles Blanc, *Grammaire des arts du dessin, architecture, sculpture, peinture* (1867).

8. Memoirs, 1902–3, published as *Avant et après*, 1923; Guérin 1978, p. 268.

9. On the debate between originality and imitation, see Schiff 1984, pp. 70–98.

10. Brooks 1997, p. 27. "I am satisfied to inspect what is in me rather than nature," Gauguin, letter to Daniel de Monfreid, from Tahiti, November 7, 1891; Joly-Segalen 1950, no. 2.

11. Brooks 1997, p. 27. Gauguin's conflicted attitude regarding the practice of copying is evident in the many references in *Avant et après* to tracing, cartoons, silhouettes, and changes in size and shape between the model and the copy: "He traces a drawing, then he traces this tracing" (ibid., p. 29); "to trace the outline of a painted figure results in a drawing totally different in effect" and "the cartoons of Puvis de Chavannes, affirmed . . . that he did not know how to draw" (ibid., p. 88). Despite his efforts at precision he claimed that it "often destroys a dream, takes all the life out of fable" (ibid., p. 26).

12. These methods were in common use and were described in painting manuals such as Goupil-Fresquet 1877 and Bouvier 1827.

13. At least four lots of squaring tools (*équerres*) are listed in Gauguin's estate auction, September 1903; Société des Études Océaniennes (1903) 1957, p. 33, lots 59–62.

14. Boime 1986, p. 26. To Thomas Couture, their purpose was "to establish, either in imagination or reality a horizontal and vertical line in front of the object one is reproducing. By so doing you simplify it and eliminate detail." Müntz 1889, p. 2, quoted in Boime 1986, n. 17.

15. Field 1973, p. 34.

233

16. Because of its miscibility in water, red chalk was traditionally used for counterproofing by artists and engravers.

17. Another means by which Gauguin may have transferred his drawings is calking, a copying process described in many nineteenth-century manuals, including Bouvier 1827.

18. Ambroise Vollard, letter to Gauguin, from Paris, late 1899; Rewald 1943, pp. 30–31.

19. Gauguin, letter to Ambroise Vollard, from Tahiti, January 1900; Guérin 1978, pp. 204–5.

20. See, for instance, Paris–New York–Amsterdam 1999, p. 226, no. P.G. III–38.

21. The support of *Girl with a Fox* has previously been described as yellow paper, but it is a light tan wove paper.

22. A few particles of gold powder were noted in the examination of this sheet. Although unrelated to the drawing, they are of interest because Gauguin had placed orders in January 1897 and August 1901 for this material; letters to Daniel de Monfreid, from Tahiti; Joly-Ségalen 1950, nos. 28, 77.

23. Pastel is composed of finely ground pigment, chalk or kaolin, and a small amount of gum tragacanth binder.

24. In a letter to André Fontainas (from Tahiti, August 1899; Malingue 1946, no. CLXXII), Gauguin wrote of having made a special journey twelve years earlier to Saint Quentin to see La Tour's pastels.

25. The paper of the Volpini Suite was analyzed with X-ray fluorescence by Akiko Yamazaki-Kleps, Sherman Fairchild Center for Works on Paper and Photograph Conservation, Metropolitan Museum.

26. The brushwork in these pastels raises the possibility that a solvent, such as alcohol (which lacks surface tension) and water (which slows the drying), may have been used. This is indicated by the uniform drying and lack of pigment concentration at the end of the strokes. Four liters of alcohol were listed among Gauguin's effects along with other painting materials; Société des Études Océaniennes (1903) 1957, p. 29, cat in 179.

27. The identification of gum tragacanth in the wash confirms the presence of pastel.

28. Years earlier, Gauguin would have learned of the deadening effects of fixative from Pissarro, who prided himself on his casein fixative recipe because it did not alter high-keyed colors; Camille Pissarro, letter to his son Lucien, from Eragny by Gisors, July 26, 1895; Rewald 1943a, pp. 211–12.

29. See Table for FTIR and Raman analysis of the latter work. Each gum had a slightly different Raman spectrum. Small lumps of a similar gum were found partially embedded in the monotype *Two Tahitian Women with Flowers and Fruit* (cat. no. 106). Gauguin must have had this material in his studio, as well as others adaptable to fixing, including the proteinaceous glue *(colle)* used for his chalk grounds. Gauguin refers to glue for canvas in a letter to Vollard sent upon receipt of a box containing canvas, glue, and Japanese paper, March 1902 (Rewald 1943, pp. 50–51).

30. See Table. The surface coating on *Annette Belfils* showed no UV fluorescence. The material could not be detected in the reserves, but it may account for the staining in these areas.

31. Peres 1991, pp. 40, 46–48; Carlyle 2000, pp. 233–37.

32. More works need to be examined to determine if these fixatives are, in fact, original or of a later date.

33. The issue of presentation also pertains to the *Tahitian Woman with a Flower in Her Hair* (cat. no. 58), in which it is unclear whether the asymmetrical losses and tears at the upper edge and the upper right and lower corners are intentional or accidental. Gauguin's practice of tearing and shaping his drawings to evoke a primitive and decorative aesthetic is discussed in Jirat-Wasiutyński 1997.

34. For Gauguin's painting techniques, see Newton 1991, p. 106, and Christensen 1993.

35. Brooks 1997, p. 27.

36. "Dear Monsieur Vollard, I shall take just a few minutes to write to you again. I have opened your box. Canvas and glue—perfect. Japanese paper—perfect." Gauguin, letter to Ambroise Vollard, from La Dominique, March 1902; Rewald 1943, pp. 50–51.

37. Finer grades of millboard and leather were used for book covers that were lined with paper. Mindell Dubansky, Conservation Librarian, Metropolitan Museum, personal communication.

38. Introduced about 1800, millboard was made of fibrous waste papers, old sails, and tarry hemp ropes. It was commonly used in France as a rigid mounting board for drawings. *Design for a Fan: Breton Shepherd Boy, Ia Orana Maria,* and *Tahitian Woman* (cat. nos. 15, 57, 84) are backed with this material.

39. French (artificial) ultramarine is differentiated from natural ultramarine by particle identification, which was not carried out.

40. See Table. The same brown was also identified in the *Ta Matete* fan (cat. no. 60) and *Te Arii Vahine* (cat. no. 96).

41. Townsend et al. 1995, pp. 65–78. For an analysis of pigments in Gauguin's oil palette, see Newton 1991, pp. 108–9, and Christensen 1993, pp. 83–86, 103.

42. "He favors the accidents of impasto . . . whereas I detest any form of messing with brushwork." Gauguin, letter to Émile Bernard, from Arles, late November 1888, Merlhès 1984, no. 182.

43. Chassé 1921, pp. 46–48; Chassé 1955, pp. 73–74.

44. "J'ai peur que le carton ne soit pas solide pour la colle, le bois la même chose, étant une surface dure qui fait écailler. Mais si vous employez une matière souple comme le papier à gros grains sur toile qui absorbe, agrippe la couleur, vous obtiendrez de très bon résultats. Les décors sont faits ainsi et sont solides." (I'm afraid cardboard is not colorfast [enough] for the glue; same thing with wood, since it's a hard surface that allows [the color] to flake off. But if you use a soft material such as rough-textured paper, which absorbs, clings to, the color, you'll

obtain very good results. The decorations are done that way and are very colorfast.) Gauguin, letter to Émile Bernard, from Arles, 1888; Gauguin 1954, no. 3.

45. For photographs of the ensemble, see Welsh 2001.

46. The ground could not be sampled, but it is unlikely to be oil, which would not absorb water-based paint.

47. The widespread use of chalk grounds in France at the time is discussed in Jirat-Wasiutyński and Newton 1998 and London 1990–91, pp. 47–50.

48. On preparing their own paints and canvases to save money, see Vincent van Gogh, letters to his brother, Theo, from Arles, October 20 and 22, 1888; Van Gogh 2000, nos. 557, 558. "Je n'aime pas les couleurs de Vincent et je veux celles de Tanguy." (I don't like Vincent's colors and I want Tanguy's.) Gauguin, letter to Émile Bernard, from Arles, October 1888; Gauguin 1954, no. 4. Christensen (1993, p. 86) found that Gauguin did not make his own oil colors. Published references to his requests for powdered colors, which he would have prepared for painting, are for Charon blue and gold, both of which were sent to him by Vollard in March 1902 (Rewald 1943, pp. 50–51). The issue of Gauguin's use of homemade colors in his works on paper requires further investigation than was possible with the limited number of drawings examined in this study.

49. The pigments in *Two Tahitian Women with Flowers and Fruit* (cat. no. 106) have a similarly coarse texture, and thus Gauguin may have made some of these paints.

50. This is comparable to his choice of the previously painted rather than unused side of the panel in *Three Tahitian Women* (cat. no. 94) and, as described by Christensen (1993, p. 71), to his intentional revealing of the texture of canvas. The legends surrounding Gauguin's use of exotic materials are still perpetuated: *Kelp Gatherers,* for instance, was described to the author prior to examination as being painted with seaweed. This notion may derive from the fact that the children at Le Pouldu gathered seaweed, which was sold to make iodine; Sweetman 1995, p. 229.

51. Gauguin experimented with lead grounds that were less absorbent and thus left more color on the surface, the latter effect being suggested here. See, for example, Christensen 1993, pp. 70–73. The dense dark blue skirt and the small viscous areas of paint in the *Landscape* resemble the thickened blue paint in *Jacob Meyer de Haan* (cat. no. 46) and suggest the use of tube rather than pan paint for this color.

52. For an overview of watercolor papers available at this time, see Cambridge, Mass., 1977; for an overview of commercial canvases, see London 1990–91, pp. 46–47.

53. See p. 207 above.

54. Some of the variations in the dry surface quality of the pigments may result from differences in how they absorbed moisture.

However, thicker deposits of pigment may distinguish a matrix from its counterproof.

55. Among the watercolors of this type are those dating from 1892–93, such as *Parahi Te Marae* (Fogg Art Museum, Cambridge, Massachusetts), those pasted into the *Noa Noa* manuscript (*Tahitian Landscape*, p. 179, and *Tahitian Hut under Palm Trees*, p. 181), *Ia Orana Ritou*, 1891–94 (private collection), and watercolor transfers such as *Parau No Varua*, 1894 (Washington–Chicago–Paris 1988–89, fig. 193), which has wash additions in the background.

56. Washington–Chicago–Paris 1988–89, p. 399.

57. Field 1973, p. 12.

58. "Watt, James," *Dictionary of National Biography*, vol. 60 (London, 1899), p. 59, cited in Rhodes and Streeter 1999, p. 7.

59. For Gauguin's reference to this pen, see his letter to Daniel de Monfreid, from Tahiti, December 1899; Joly-Segalen 1950, no. 47. Degas had also employed an electric stencil pen, which utilized sparks to perforate paper and was patented in France by Bellet and Arros, the name recorded in his notebook of 1879 as "*Bellet d'Arros / crayon voltaïque*"; Druick and Zegers 1988, p.199. For Gauguin's mimeograph machine, see Société des Études Océaniennes (1903) 1957, p. 41, lot 90.

60. "I like to experiment . . . right now I have a series of experimental drawings that I am pretty pleased with and I am sending you a very small example. It's like an impression and yet it isn't. I use heavy ink instead of pencil, that's all." Gauguin, letter to Ambroise Vollard, from Tahiti, July 1900; Malingue 1946, no. CLXXIII.

61. Gauguin, letter to Daniel de Monfreid, from Tahiti, late January 1900; Joly-Segalen 1950, p. lxi, quoted in Field 1973, p. 49, n. 36. It

was soon after, in April 1900, that Gauguin asked Vollard for drawing pins; Joly-Segalen 1950, p. lxiii, quoted in Field 1973, p. 20. These would have been used to secure the drawing paper and inked paper to a board; the tack holes remain in the tops of the sheets.

62. "First you roll out printer's ink on a sheet of paper of any sort; then lay a second sheet on top of it and draw whatever pleases you. The harder and thinner your pencil (as well as your paper), the finer will be the resulting line. If the paper were covered with lithographic ink, would one be able to find a rapid way to make lithographs? We shall see. I forgot to tell you that if too many spots of ink are deposited on the paper, you have only to see that the ink surface is a bit drier." Joly-Segalen 1950, pp. 201–2, quoted in Field 1973, p. 21.

63. Visually analogous to the Prussian blue oil paint and *peinture à l'essence* outlines of his paintings, blue wax crayon was often used by Gauguin to define the contours in his drawings. Blue-colored wax crayon was a popular artists' medium, but it was more frequently employed in commerce by draftsmen and artist-printers, who utilized a nonphotographic form in the drawing stages of their photo-relief-printed illustrations. Blue crayon was common at the end of the century, for example, in the works of Toulouse-Lautrec and his circle, Henry Somm, and Théophile-Alexandre Steinlin.

64. On Gauguin's oil technique, see Christensen 1993, p. 75.

65. Germain Coulon, the publisher of *Les guêpes*, may have given him the paper (Field 1973, p. 22) as well as the Edison pen.

66. Ibid., p. 12.

67. Rhodes and Streeter 1999, pp. 17–21, 124. Gauguin's effects included the *Dictionnaire des sciences*, consisting of fifty brochures, as well

as twenty-eight volumes of the *Dictionnaire des arts et manufactures*, any of which might have contained information on techniques such as these; Société des Études Océaniennes (1903) 1957, caisse no. 4.

68. See note 62 above.

69. Japanese papers were claimed to be suitable for transferring text for commercial purposes because of their pliancy, wet strength, smoothness, fineness and lightness, and imperviousness to insects and larvae; *Journal of the Society of the Arts* 29 (1880–81), p. 737, quoted in Rhodes and Streeter 1999, p. 55.

70. Danielsson 1965, p. 214; Field 1973, p. 27. Similar highly transparent papers, but with *sha* marks (resembling laid lines in Western paper) from the Japanese paper mold, were used for the watercolors that Gauguin mounted in the *Noa Noa* manuscript and the eleven menus for his dinner party held in Punaauia in 1900 (Rey 1950).

71. Auguste Delâtre is credited with having introduced very fine silk tissues in his etchings for Whistler. The various physical properties of Japanese papers were extolled in 1880 by Maxime Lalanne in *A Treatise on Etching* (1880, p. 60).

72. For their commercial use, see Rhodes and Streeter 1999, p. 57.

73. Ibid., pp. 97–100.

74. Ibid., pp. 38–39. Copy inks were made in many colors, and blue colorants were also added to irongall inks in the nineteenth century. The observations and tests in this study have been limited to the blue inks.

75. To be published in the forthcoming Gauguin catalogue raisonné by Wildenstein and Cooper.

76. For pressing equipment, see Rhodes and Streeter 1999, pp. 13–15, 109–12.

SELECTED BIBLIOGRAPHY

Key to Abreviations

F	Field 1973
G	Gray 1963
M/K	Mongan and Kornfeld 1988
P	Pickvance 1970
R	Rewald 1958
W	Wildenstein 1964
W I	Wildenstein 2001, vol. 1
W II	Wildenstein 2001, vol. 2

Alexandre 1930
Arsène Alexandre. *Paul Gauguin: Sa vie et le sens de son oeuvre*. Paris, 1930.

Andersen 1971
Wayne V. Andersen. *Gauguin's Paradise Lost*. New York, 1971.

Basel 1928
Paul Gauguin, 1848–1903. Exhibition, Kunsthalle, Basel, July–August 1928. Catalogue by Wilhelm Barth. Basel, 1928.

Blanc 1867
Charles Blanc. *Grammaire des arts du dessin, architecture, sculpture, peinture*. Paris, 1867.

Bodelsen 1964
Merete Bodelsen. *Gauguin's Ceramics: A Study in the Development of His Art*. London, 1964.

Bodelsen 1966
Merete Bodelsen. "The Wildenstein-Cogniat Gauguin Catalogue." *Burlington Magazine* 108 (1966), pp. 27–38.

Bodelsen 1970
Merete Bodelsen. "Gauguin, the Collector." *Burlington Magazine* 112 (1970), pp. 590–615.

Boime 1986
Albert Boime. *The Academy and French Painting in the Nineteenth Century*. [New ed.] New Haven, 1986.

Bouvier 1827
P. L. Bouvier. *Manuel des jeunes artistes et amateurs en peinture*. Paris, 1827.

Britton 1913
James Britton. "The Open Eye." *American Art News*, March 8, 1913, p. 3.

Brooklyn 1921
Paintings by Modern French Masters: Representing the Post-Impressionists and Their Predecessors. Exhibition, Brooklyn Museum, March 26–summer 1921. Brooklyn, 1921.

Brooks 1997
Van Wyck Brooks, trans. *Gauguin's Intimate Journals*. New York, 1997.

Brown 1963
Milton W. Brown. *The Story of the Armory Show*. [Greenwich, Conn.], 1963.

Bruce-Gardner, Hedley, and Villers 1987
Robert Bruce-Gardner, Gerry Hedley, and Caroline Villers. "Impressions of Change." In London 1987, pp. 21–34.

Burroughs 1921
B[ryson] B[urroughs]. "Exhibition of French Impressionists and Post-Impressionists." *Bulletin of The Metropolitan Museum of Art* 16, no. 4 (April 1921), p. 70.

Cachin 1992
Françoise Cachin. *Gauguin: The Quest for Paradise*. Translated from French by I. Mark Paris. New York, 1992.

Cachin 1997
Françoise Cachin. "Degas and Gauguin." In New York 1997–98, [vol. 1], pp. 221–33.

Callen 1994
Anthea Callen. "The Unvarnished Truth: Matteness, 'Primitivism' and Modernity in French Painting, c. 1870–1907." *Burlington Magazine* 136 (1994), pp. 738–46.

Callen 2000
Anthea Callen. *The Art of Impressionism: Painting Technique and the Making of Modernity*. New Haven, 2000.

Cambridge, Mass., 1977
Wash and Gouache: A Study of the Development of the Materials of Watercolor. Exhibition, Fogg Art Museum, Cambridge, Mass., May 12–June 22, 1977. Catalogue by Marjorie B. Cohn. Cambridge, Mass., 1977.

Carlyle 2000
Leslie Carlyle. *The Artist's Assistant: Oil Painting Instruction Manuals and Handbooks in Britain, 1800–1900*. London, 2000.

Cary 1936
Elisabeth Luther Cary. "The Color Prints of Paul Gauguin." *New York Times*, May 3, 1936.

Cennini 1954
Cennino Cennini. *The Craftsman's Handbook: The Italian "Il libro dell'arte."* Translated by Daniel V. Thompson. Reprint ed. New York, 1954. First published New Haven, 1933.

Chassé 1921
Charles Chassé. *Gauguin et le groupe de Pont-Aven: Documents inédits*. Paris, 1921.

Chassé 1955
Charles Chassé. *Gauguin et son temps*. Paris, 1955.

Chicago–Amsterdam 2001–2
Van Gogh and Gauguin: The Studio of the South. Exhibition, Art Institute of Chicago, September 22, 2001–January 13, 2002; Van Gogh Museum, Amsterdam, February 9–June 2. Catalogue by Douglas W. Druick and Peter Kort Zegers, with Britt Salvesen, Kristin Hoermann Lister, and Mary C. Weaver. Chicago, Amsterdam, and New York, 2001.

Chicago–New York 1959
Gauguin: Paintings, Drawings, Prints, Sculpture. Exhibition, Art Institute of Chicago, February 12–March 29, 1959; The Metropolitan Museum of Art, New York,

April 23–May 31. Catalogue by Theodore Rousseau Jr. Chicago, 1959.

Childs 2001
Elizabeth C. Childs. "The Colonial Lens: Gauguin, Primitivism, and Photography in the Fin de Siècle." In *Antimodernism and Artistic Experience: Policing the Boundaries of Modernism*, edited by Lynda Jessup, pp. 50–70. Toronto, 2001.

Christensen 1993
Carol Christensen. "The Painting Materials and Technique of Paul Gauguin." *Conservation Research / Studies in the History of Art* (National Gallery of Art, Washington, D.C.) 41 (1993), pp. 63–103.

Colloque Gauguin 1991
Gauguin: Actes du Colloque Gauguin, Musée d'Orsay, 11–13 janvier 1989. Paris, 1991.

Cologne 1912
Internationale Kunstausstellung des Sonderbundes Westdeutscher Kunstfreunde und Künstler. Exhibition, Städtische Ausstellungshalle, Cologne, May 25–September 30, 1912. Cologne, 1912.

Constantin 2001
Stephanie Constantin. "The Barbizon Painters: A Guide to Their Suppliers." *Studies in Conservation* 46, no. 1 (2001), pp. 49–67.

Cooper 1983
Douglas Cooper, ed. *Paul Gauguin: 45 lettres à Vincent, Théo, et Jo van Gogh*. The Hague and Lausanne, 1983.

Cortissoz 1925
Royal Cortissoz. *Personalities in Art*. New York, 1925.

Cortissoz 1929
Royal Cortissoz. "The New Museum of Modern Art: French Paintings in the Opening Show." *New York Herald Tribune*, November 10, 1929, p. 10.

Couëssin 1991
Charles de Couëssin. "Le synthétisme de Paul Gauguin: Hypothèses." In *Colloque Gauguin* 1991, pp. 81–97.

Cox 1913
Kenyon Cox. "The 'Modern' Spirit in Art: Some Reflections Inspired by the Recent International Exhibition." *Harper's Weekly* 57 (March 15, 1913), p. 10.

Dale 1931
Maud Dale. "Josef Stransky." *Art News* 29 (May 16, 1931), p. 87.

Danielsson 1965
Bengt Danielsson. *Gauguin in the South Seas*. Translated by Reginald Spink. London, 1965.

Dorival 1954
Bernard Dorival. *Carnet de Tahiti: Paul Gauguin*. Text vol. and facsimile of sketchbook. Paris, 1954.

Druick and Zegers 1988
Douglas W. Druick and Peter Zegers. "Scientific Realism: 1873–1881." In *Degas*, edited by Jean Sutherland Boggs, pp. 197–211. Exh. cat. New York: The Metropolitan Museum of Art, 1988.

Edmond 1997
Rod Edmond. *Representing the South Pacific: Colonial Discourse from Cook to Gauguin*. Cambridge, 1997.

Field 1919
Hamilton Easter Field. "Art New and Old in Current Shows." *Arts and Decoration* 12 (December 15, 1919), pp. 108–9.

Field 1973
Richard Field. *Paul Gauguin: Monotypes*. Philadelphia, 1973.

Field 1977
Richard Field. *Paul Gauguin: The Paintings of the First Voyage to Tahiti*. New York, 1977. Originally the author's Ph.D. dissertation, Harvard University, Cambridge, Mass., 1963.

Flint 1931
Ralph Flint. "The Private Collection of Josef Stransky." *Art News* 29 (May 16, 1931), pp. 87–116.

Frankfurter 1936a
Alfred M. Frankfurter. "Gauguin: Fifty Paintings in a First American One Man Loan Exhibition." *Art News* 34 (March 21, 1936), pp. 5, 6.

Frankfurter 1936b
A[lfred] M. F[rankfurter]. "Boston Acquires a Gauguin Masterwork [*D'où venons nous? Que sommes nous? Où allons nous?*]: Its First Showing in New York." *Art News*, 34 (April 25, 1936), p. 5.

Gauguin 1954
Paul Gauguin. *Lettres de Paul Gauguin à Émile Bernard, 1888–1891*. Collection écrits et documents de peintres, 11. Geneva, 1954.

Genauer 1959
Emily Genauer. "Metropolitan Opens Fine Gauguin Show." *New York Herald Tribune*, April 26, 1959, p. 8.

Gettens and Stout 1966
Rutherford J. Gettens and George L. Stout. *Painting Materials: A Short Encyclopedia*. New York, 1966.

Van Gogh 2000
Vincent van Gogh. *The Complete Letters of Vincent van Gogh, with Reproductions of All the Drawings in the Correspondence*. 3 vols. 3d ed. Boston, 2000.

Goodfriend sale 1923
Valuable Pictures by the Barbizon Masters, Their Contemporaries the French Impressionists and Modern French Painters Forming the Private Collection of the Connoisseur Mr. Meyer Goodfriend. Sale cat., American Art Galleries, New York, January 4–5, 1923.

Goodyear 1943
A. Conger Goodyear. *The Museum of Modern Art: The First Ten Years*. New York, 1943.

Gordon 1970
Irene Gordon. "A World beyond the World: The Discovery of Leo Stein." In *Four Americans in Paris: The Collections of Gertrude Stein and Her Family*, pp. 13–33.

Exh. cat. New York: Museum of Modern Art, 1970.

Goupil-Fresquet 1877
F. A. A. Goupil-Fresquet. *Manuel complet et simplifié de la peinture à l'huile*. Paris, 1877.

Gray 1963
Christopher Gray. *Sculpture and Ceramics of Paul Gauguin*. Baltimore, 1963.

Grossvogel 2000
Jill-Elyse Grossvogel. *Claude-Émile Schuffenecker: Catalogue Raisonné*. Vol. 1. San Francisco, 2000.

Guérin 1978
Daniel Guérin, ed. *The Writings of a Savage: Paul Gauguin*. Translated by Eleanor Levieux. New York, 1978.

Hale 1983
Charlotte Hale. "A Study of Paul Gauguin's Correspondence Relating to His Painting Materials and Techniques, with Specific Reference to His Works in the Courtauld Collection." Diploma project, Courtauld Institute of Art, University of London, 1983.

Hartford 2001
Gauguin's Nirvana: Painters at Le Pouldu, 1889–90. Exhibition, Wadsworth Atheneum Museum of Art, January 27–April 29, 2001. Catalogue by Eric M. Zafran, with essays by Stephen Kornhauser et al. New Haven, 2001.

Huneker 1910
James G. Huneker. *Promenades of an Impressionist*. New York, 1910.

Huret 1891
Jules Huret. "Paul Gauguin devant ses tableaux." *L'écho de Paris*, February 23, 1891. English translation in Guérin 1978, pp. 47–48.

Jaworska 1972
Wladyslawa Jaworska. *Gauguin and the Pont-Aven School*. Translated by Patrick Evans. London, 1972.

Jénot (1891–93) 1956
Lieutenant Jénot. "Le premier séjour de Gauguin à Tahiti/d'après le manuscrit Jénot (1891–93)." *Gazette des beaux-arts*, ser. 6, 47 (January–April 1956), pp. 115–26.

Jewell 1929
Edward Alden Jewell. "The New Museum of Modern Art Opens. A Superb Showing of Work by Four Pioneers: Cézanne, Gauguin, Van Gogh and Seurat—Contemporary Frenchman." *New York Times*, November 10, 1929, p. 14.

Jirat-Wasiutyński 1997
Vojtěch Jirat-Wasiutyński. "Decorative Fragments: Paul Gauguin's Presentation of His Own Drawings." In *Historic Framing and Presentation of Watercolours, Drawings and Prints: Proceedings of a Conference . . . June 1996*, edited by Nancy Bell. Worcester, Eng.: Institute of Paper Conservation, 1997.

Jirat-Wasiutyński and Newton 1998
Vojtěch Jirat-Wasiutyński and H. Travers Newton Jr. "Absorbent Grounds and the Matt Aesthetic in Post-Impressionist Painting." In *Painting Techniques, History, Materials, and Studio Practice: Contributions to the Dublin Congress of the International Institute of Conservation, 7–11 September 1998*, edited by Ashok Roy and Perry Smith, pp. 235–39. London, 1998.

Jirat-Wasiutyński and Newton 2000
Vojtěch Jirat-Wasiutyński and H. Travers Newton Jr. *Technique and Meaning in the Paintings of Paul Gauguin*. Cambridge, 2000.

Joly-Segalen 1950
Annie Joly-Segalen, ed. *Lettres de Paul Gauguin à Georges-Daniel de Monfreid*. Rev. ed. Paris, 1950. First ed. published by Victor Segalen, Paris, 1919.

Kelekian sale 1922
The Notable Private Collection of Modern Pictures Belonging to the Widely Known Antiquarian Dikran Khan Kélékian of Paris and New York. Sale cat., American Art Galleries, New York, January 30, 1922.

Kornhauser 2001
Stephen Kornhauser. "A Technical Study of 'Nirvana.'" In Hartford 2001, pp. 143–47.

Lalanne 1880
Maxime Lalanne. *A Treatise on Etching*. Translated from French by S. R. Koehler. London, 1880.

Leblond 1909
Marius-Ary Leblond. *Peintres des races: Hollande, Espagne, Scandinavie, Angleterre . . . Océanie*. Brussels, 1909.

Lewisohn 1939
Sam A. Lewisohn. "Four Memoirs of the Growth of Art and Taste in America: The Collector. Personalities Past and Present." *Art News* 37, no. 22 (1939), pp. 69–70, 154–56.

Lister 2001
Kristin Hoermann Lister. "Tracing a Transformation: Madame Roulin into *La Berceuse*." *Van Gogh Museum Journal* 2001, pp. 63–83.

Lister, Peres, and Fiedler 2001
Kristin Hoermann Lister, Cornelia Peres, and Inge Fiedler. "Tracing an Interaction: Supporting Evidence, Experimental Grounds." In Chicago–Amsterdam 2001–2, app., pp. 354–69.

London 1910–11
Manet and the Post-Impressionists. Exhibition, Grafton Galleries, London, November 8, 1910–January 15, 1911. London, 1910.

London 1987
Impressionist and Post-Impressionist Master-pieces: The Courtauld Collection. Exhibition circulated to Cleveland and other cities by the International Exhibitions Foundation, Washington, D.C. New Haven, 1987.

London 1990–91
Impressionism. Exhibition, National Gallery, London, November 28, 1990–April 21, 1991. Catalogue by David Bomford, Jo Kirby, John Leighton, and Ashok Roy. Art in the Making. London, 1990.

Malingue 1943
Maurice Malingue. *Gauguin*. Les documents d'art. Monaco, 1943.

Malingue 1946
Maurice Malingue, ed. *Lettres de Gauguin à sa femme et à ses amis; recueillies et préfacées*. Paris, 1946. Also published in English.

Malingue 1948
Maurice Malingue. *Gauguin/Le peintre et son oeuvre*. Paris, 1948.

Malingue 1949
Maurice Malingue, ed. *Lettres de Gauguin à sa femme et à ses amis.* Rev. ed. Paris, 1949.

Malingue 1959
Maurice Malingue. "Du nouveau sur Gauguin." *L'oeil,* nos. 55–56 (July–August 1959), pp. 32–39.

Martigny 1998
Gauguin. Exhibition, Fondation Pierre Gianadda, Martigny, Switz., June 10–November 22, 1998. Catalogue by Ronald Pickvance. Martigny, 1998.

Mauclair 1893
Camille Mauclair. "Les portraits du prochain siècle." *Essais d'art libre* 4 (1893), pp. 117–21.

McBride 1920
Henry McBride. "Gauguin's Re-birth." *The Dial* 69 (July–December 1920), pp. 397–400.

Mellow 1974
James R. Mellow. *Charmed Circle: Gertrude Stein & Company.* New York, 1974.

Merlhès 1984
Victor Merlhès, ed. *Correspondance de Paul Gauguin: Documents, témoignages.* Vol. 1, *1873–1888.* Paris, 1984.

Merlhès 1989
Victor Merlhès, ed. *Paul Gauguin and Vincent van Gogh, 1887–1888: Lettres retrouvées, sources ignorées.* Taravo, Tahiti, 1989.

Mongan and Kornfeld 1988
Elizabeth Mongan and Eberhard W. Kornfeld, with Harold Joachim. *Paul Gauguin: Catalogue Raisonné of His Prints.* Bern, 1988.

Monroe 1913
Harriet Monroe. "Bedlam in Art: A Show That Clamors." *Chicago Sunday Tribune,* February 16, 1913, p. 55.

Morice 1919
Charles Morice. *Paul Gauguin.* Paris, 1919.

Munich 1960
Paul Gauguin. Exhibition, Haus der Kunst, Munich, April–May 1960.

Müntz 1889
Eugène Müntz. *Guide de l'École Nationale des Beaux-Arts.* Paris, 1889.

Nathanson 1985
Carol A. Nathanson. "The American Reaction to London's First Grafton Show." *Archives of American Art Journal* 25, no. 3 (1985), pp. 3–8.

Naumann 1980
Francis Naumann. "Walter Conrad Arensberg: Poet, Patron, and Participant in the New York Avant-Garde, 1915–20." *Philadelphia Museum of Art Bulletin* 76, no. 328 (spring 1980).

New York 1913
Association of American Painters and Sculptors. *International Exhibition of Modern Art.* Exhibition, Armory of the Sixty-ninth Infantry, New York, February 17–March 15, 1913; also shown Art Institute of Chicago, March 24–April 16; Copley Hall, Boston, April 28–May 19. Catalogue and supplement published. New York, 1913.

New York 1920
Fiftieth Anniversary Exhibition. Loans and Special Features. Exhibition, The Metropolitan Museum of Art, New York, May–October 1920. New York, 1920.

New York 1921
Loan Exhibition of Impressionist and Post-Impressionist Paintings. Exhibition, The Metropolitan Museum of Art, New York, May 3–September 15, 1921. New York, 1921.

New York 1921a
Loan Exhibition of Works by Cézanne, Redon, Degas, Rodin, Gauguin, Derain, and Others. Exhibition, Museum of French Art, New York, March 16–April 3, 1921. New York, 1921.

New York 1929
First Loan Exhibition: Cézanne, Gauguin, Seurat, Van Gogh. Exhibition, Museum of Modern Art, New York, November 7–December 7, 1929. New York, 1929.

New York 1932
Exhibition of Paintings by Cézanne, Gauguin, and Redon. Exhibition, Durand-Ruel, New York, March–April 1932. New York, 1932.

New York 1934
The Lillie P. Bliss Collection. Exhibition, Museum of Modern Art, New York. Catalogue edited by Alfred H. Barr Jr. New York, 1934.

New York 1936
Paul Gauguin, 1848–1903: A Retrospective Loan Exhibition for the Benefit of Les Amis de Gauguin and the Penn Normal Industrial and Agricultural School. Exhibition, Wildenstein and Co., New York, March 20–April 18, 1936. New York, 1936.

New York 1936a
Where Do We Come From? What Are We? Where Are We Going? Exhibition, Marie Harriman Gallery, New York, April 22–May 9, 1936. New York, 1936.

New York 1946
A Loan Exhibition of Paul Gauguin for the Benefit of the New York Infirmary. Exhibition, Wildenstein and Co., New York, April 3–May 4, 1946. Catalogue by Vladimir Visson and Daniel Wildenstein, with an essay by Raymond Cogniat. New York, 1946.

New York 1956
Loan Exhibition, Gauguin: For the Benefit of the Citizens' Committee for Children of New York City, Inc. Exhibition, Wildenstein and Co., New York, April 5–May 5, 1956. Catalogue by Robert Goldwater and Carl O. Schniewind. New York, 1956.

New York 1958
Masterpieces from the Collection of Adelaide Milton de Groot. Exhibition, Perls Gallery, New York, April–May 1958. New York, 1958.

New York 1959
See Chicago–New York 1959.

New York 1966
Gauguin and the Decorative Style. Exhibition, Solomon R. Guggenheim Museum, New York, June–September 1966. New York, 1966.

New York 1971
Prints by Paul Gauguin. Exhibition, The Metropolitan Museum of Art, New York, February 23–April 18, 1971. Catalogue by Colta Ives. New York, 1971.

New York 1992
The William S. Paley Collection. Exhibition, Museum of Modern Art, New York, February 2–May 7, 1992. Catalogue by William Rubin and Matthew Armstrong. New York, 1992.

New York 1997–98
The Private Collection of Edgar Degas. Exhibition, The Metropolitan Museum of Art, New York, October 1, 1997–January 11, 1998. Catalogue [vol. 1], by Ann Dumas, Colta Ives, Susan Alyson Stein, and Gary Tinterow; [vol. 2], *The Private Collection of Edgar Degas: A Summary Catalogue,* compiled by Colta Ives, Susan Alyson Stein, and Julie A. Steiner, with Ann Dumas, Rebecca A. Rabinow, and Gary Tinterow. New York, 1997.

Newton 1991
H. Travers Newton Jr. "Observations on Gauguin's Painting Techniques and Materials." In *A Closer Look: Technical and Art-Historical Studies on Works by Van Gogh and Gauguin,* edited by Cornelia Peres, Michael Hoyle, and Louis van Tilborgh, pp. 103–11. Cahier Vincent 3. Zwolle, 1991.

O'Brien 1920
Frederick O'Brien. "Gauguin in the South Seas." *Century Magazine* 100 (June 1920), pp. 225–35.

Paris 1893
Exposition Paul Gauguin. Exhibition, Galeries Durand-Ruel, Paris, November 1893. Catalogue preface by Charles Morice. Paris, 1893.

Paris 1919
Paul Gauguin: Expositions d'oeuvres inconnues. Exhibition, Galerie Barbazanges, Paris, October 10–30, 1919. Catalogue preface by Francis Nargelet. Paris, 1919.

Paris 1960
Cent oeuvres de Gauguin. Exhibition, Galerie Charpentier, Paris, January 1960. Catalogue by Raymond Nacenta. Paris, 1960.

Paris–New York–Amsterdam 1999
Cézanne to Van Gogh: The Collection of Doctor Gachet. Exhibition, Grand Palais, Paris, January 28–April 26, 1999; The Metropolitan Museum of Art, New York, May 25–August 15; Van Gogh Museum, Amsterdam, September 24–December 5. Catalogue by Anne Distel and Susan Alyson Stein. New York, 1999.

Peres 1991
Cornelia Peres. "On Egg-White Coatings." In *A Closer Look: Technical and Art-Historical Studies on Works by Van Gogh and Gauguin,* edited by Cornelia Peres, Michael Hoyle, and Louis van Tilborgh, pp. 39–49. Cahier Vincent 3. Zwolle, 1991.

Perlman 1998
Bennard B. Perlman. *The Lives, Loves, and Art of Arthur B. Davies.* Albany, 1998.

Philadelphia and other cities 1989–91
Masterpieces of Impressionism and Post-Impressionism: The Annenberg Collection. Exhibition, Philadelphia Museum of Art, May 21–September 17, 1989; National Gallery of Art, Washington, May 6–August 5, 1990; Los Angeles County Museum of Art, August 16–November 11; The Metropolitan Museum of Art, New York, June 4–October 13, 1991. Catalogue by Colin B. Bailey, Joseph J. Rishel, and Mark Rosenthal, with Veerle Thielemans. Philadelphia, 1989.

Pickvance 1970
Ronald Pickvance. *The Drawings of Gauguin.* London, 1970.

Prather and Stuckey 1989
Marla Prather and Charles F. Stuckey, eds. *Gauguin: A Retrospective*. New York, 1989.

Quinn 1913
John Quinn. "Modern Art from a Layman's Point of View." *Arts and Decoration* 3 (March 1913), pp. 155–58, 176.

Rabinow 2000
Rebecca Rabinow. "Modern Art Comes to the Metropolitan: The 1921 Exhibition of 'Impressionist and Post-Impressionist Paintings.'" *Apollo* 152 (October 2000), pp. 3–12.

Reid 1968
Benjamin L. Reid. *The Man from New York: John Quinn and His Friends*. New York, 1968.

Rewald 1938
John Rewald. *Gauguin*. Paris, 1938.

Rewald 1943
John Rewald, ed. *Paul Gauguin: Letters to Ambroise Vollard and André Fontainas*. San Francisco, 1943.

Rewald 1943a
John Rewald, ed. *Camille Pissarro: Letters to His Son Lucien*. New York, 1943.

Rewald 1958
John Rewald. *Gauguin: Drawings*. New York, 1958.

Rewald 1959
John Rewald. "The Genius and the Dealer." *Art News* 58 (May 1959), pp. 30–31, 62–65.

Rewald 1978
John Rewald. *Post-Impressionism: From Van Gogh to Gauguin*. 3d ed. New York, 1978.

Rewald 1986a
John Rewald. *Cézanne, the Steins, and Their Circle*. New York, 1986.

Rewald 1986b
John Rewald. *Studies in Post-Impressionism*. Edited by Irene Gordon and Frances Weitzenhoffer. New York, 1986.

Rewald 1989
John Rewald, with Frances Weitzenhoffer. *Cézanne and America: Dealers, Collectors, Artists, and Critics, 1891–1921*. Princeton, 1989.

Rewald 1996
John Rewald, with Walter Feilchenfeldt and Jayne Warman. *The Paintings of Paul Cézanne: A Catalogue Raisonné*. 2 vols. New York, 1996.

Rey 1950
Robert Rey. *Onze menus de Paul Gauguin*. Geneva, 1950.

Rhodes and Streeter 1999
Barbara Rhodes and William Wells Streeter. *Before Photocopying: The Art and History of Mechanical Copying, 1780–1938*. New Castle, Del., 1999.

Richardson 1959
John Richardson. "Gauguin at Chicago and New York." *Burlington Magazine* 101 (May 1959), pp. 188–92.

Rostrup 1956
Haavard Rostrup. "Gauguin et le Danemark." *Gazette des beaux-arts*, ser. 6, 47 (January–April 1956), pp. 63–82.

Saint-Paul 1997
La sculpture des peintres: Honoré Daumier. . . . Exhibition, Fondation Maeght, Saint-Paul, July 2–October 19, 1997. Catalogue by Jean-Louis Prat. Saint-Paul, 1997.

Schapiro 1978
Meyer Schapiro. "The Introduction of Modern Art in America: The Armory Show" (1952). In *Modern Art, 19th and 20th Centuries: Selected Papers*, pp. 135–78. New York, 1978.

Schiff 1984
Richard Schiff. *Cézanne and the End of Impressionism: A Study of the Theory, Technique and Critical Evaluation of Modern Art*. Chicago, 1984.

Société des Études Océaniennes (1903) 1957
Dossier de la succession Paul Gauguin, September 1903. Papeete, Tahiti: Société des Études Océaniennes, 1957.

Sweetman 1995
David Sweetman. *Paul Gauguin: A Complete Life*. London, 1995.

Tardieu 1895
Eugène Tardieu. "M. Paul Gauguin." *L'écho de Paris*, May 13, 1895, p. 2.

Thomson 1987
Belinda Thomson. *Gauguin*. London, 1987.

Thomson 1993
Belinda Thomson, ed. *Gauguin by Himself*. Boston, 1993.

Thornton 1938
Alfred Henry Robinson Thornton. *The Diary of an Art Student of the Nineties*. London, 1938.

Van Tilborgh and Hendriks 2001
Louis van Tilborgh and Ella Hendriks. "The Tokyo *Sunflowers*: A Genuine Repetition by Van Gogh or a Schuffenecker Forgery?" *Van Gogh Museum Journal* 2001, pp. 17–43.

Toronto–Amsterdam 1981
Vincent van Gogh and the Birth of Cloisonism. Exhibition, Art Gallery of Ontario, Toronto, January 24–March 22, 1981; Van Gogh Museum, Amsterdam, April 9–June 14. Catalogue by Bogomila Welsh-Ovcharov. Toronto, 1981.

Townsend et al. 1995
Joyce H. Townsend et al. "Later Nineteenth Century Pigments: Evidence for Additions and Substitutions." *The Conservator*, no. 19 (1995), pp. 65–78.

Varnedoe 1984
Kirk Varnedoe. "Gauguin." In *"Primitivism" in 20th Century Art: Affinity of the Tribal and the Modern*, edited by William Rubin, vol. 1, pp. 179–209. Exh. cat. New York: Museum of Modern Art, 1984.

Venturi 1936
Lionello Venturi. *Cézanne: Son art—son oeuvre*. Edited by Paul Rosenberg. 2 vols. Paris, 1936.

Washington 1978
"The Noble Buyer": John Quinn, Patron of the Avant-Garde. Exhibition, Hirshhorn Museum and Sculpture Garden, Smithsonian Institution, Washington, D.C., June 15–September 4, 1978. Catalogue by Judith Zilczer. Washington, D.C., 1978.

Washington–Chicago–Paris 1988–89
The Art of Paul Gauguin. Exhibition, National Gallery of Art, Washington, May 1–July 31, 1988; Art Institute of Chicago, September 17–December 11; Grand Palais, Paris, January 10–April 20, 1989. Catalogue by Richard Brettell, Françoise Cachin, Claire Frèches-Thory, Charles F. Stuckey, with Peter Zegers. Washington, D.C., 1988.

Welsh 2001
Robert Welsh. "Gauguin and the Inn of Marie Henry at Pouldu." In Hartford 2001, pp. 61–80.

Welsh-Ovcharov 2001
Bogomila Welsh-Ovcharov. "Paul Gauguin's Third Visit to Brittany / June 1889–November 1890." In Hartford 2001, pp. 15–59.

Weyhe 1921
H[arry] B. W[eyhe]. "Loan Exhibition of Modern French Paintings." *Bulletin of The Metropolitan Museum of Art* 16, no. 5 (May 1921), pp. 94–96.

Wildenstein 1964
Georges Wildenstein, with Raymond Cogniat and Daniel Wildenstein. *Gauguin: Catalogue*. L'art français. Paris, 1964.

Wildenstein 2001
Daniel Wildenstein, with Sylvie Crussard and Martine Heudron. *Gauguin: Premier itinéraire d'un sauvage. Catalogue de l'oeuvre peint (1873–1888)*. 2 vols. Milan and Paris, 2001.

Wildenstein forthcoming
Daniel Wildenstein, with Douglas Cooper. Forthcoming catalogue raisonné of Gauguin.

Zafran 2001
Eric M. Zafran. "Searching for Nirvana." In Hartford 2001, pp. 103–27.

De Zayas 1996
Marius de Zayas. *How, When, and Why Modern Art Came to New York*. Edited by Francis M. Naumann. Cambridge, Mass., 1996.

De Zayas sale 1923
The Collection of Marius de Zayas of New York. Sale cat., Anderson Galleries, New York, March 23–24, 1923.

Zilczer 1974
Judith Zilczer. "'The World's New Art Center': Modern Art Exhibitions in New York City, 1913–1918." *Archives of American Art Journal* 14, no. 3 (1974), pp. 2–7.

Zilczer 1982
Judith Zilczer. "John Quinn and Modern Art Collectors in America: 1913–1924." *American Art Journal* 14, no. 1 (winter 1982), pp. 56–71.

Zingg 1996
Jean-Pierre Zingg. *Les éventails de Paul Gauguin*. Paris, 1996.

Zug 1913
George B. Zug. "Among the Art Galleries." *Inter Ocean*, Sunday, March 16, 1913, p. 5.

INDEX

Page numbers in *italics* indicate illustrations.

Agostini, Jules, two views of Gauguin's *Head with Horns* (fig. 51), *134*
Agostini, Jules, or Henri Lemasson (d. 1956), *Two Women* (fig. 56), *142*
Allongé, Auguste (1833–1898), 201
Annah la Javanaise (active 1890s), *12*, 14
Annenberg, Walter H. and Leonore, 173
Appian, Adolphe (1818–1898), 201
Arensberg, Walter C. (1878–1954), 157–58
Arles, *56*, 57, *58*, *61*, *62*, *63*
Armory Show (1913), 152, 153–58, *154*, 159, 161, 165, 168, 170
 in Chicago, 153, *154*, 156–57
Arosa, Gustave (1818–1883), 13
Art Institute of Chicago, 168
 Armory Show (1913), 153, *154*, 156–57
 Gauguin exhibition (1959), 173, 177, 190
Atuona, Hiva Oa, Marquesas Islands, *138*

Barnes, Albert C. (1872–1951), 158
Barney, James W., 170
Barr, Alfred H. Jr. (1902–1981), 167
Baudelaire, Charles-Pierre (1821–1867), 4
Belfils, Annette (Mme Georges Daniel de Monfreid) (active 1890s), 21, 125
 portrait of (cat. no. 7), *21*, 202, 203, 206, 216
Bernard, Émile (1868–1941), 29, 57, 59, 61, 63, 65, 67, 70, 72, 73, 77, 185–86, 206, 208
Bliss, Lillie P. (1864–1931), 158, 160, 167, 168, 169, 170
Bollag, Gustav, 166
Bonnard, Pierre (1867–1947), 29
Borobudur, Java, Temple of, reliefs from, 82
 The Tathagata Meets an Ajiwaka Monk on the Benares (fig. 44), 82, *82*
Botticelli, Sandro (1445–1510), 5
 The Birth of Venus (fig. 15), 9, *10*
Bougainville, Louis-Antoine de (1729–1811), 77
Bourgeois, Stephan (d. 1963), 159
Bourgeois Galleries, New York, 159
Boussod, Valadon et Cie, Paris, 13, 57
Buvette de la Plage (Marie Henry's inn), Le Pouldu, *64*, 65
 Gauguin's works for, *74*, 164, 207–9
Bracquemond, Félix (1833–1914), 20
Brault, M., letter to, February 1903 (cat. no. 116), 148–49, *148*, *149*
Brealey, John M., 177
Brittany, 5, *28*, 29–31, *35*, *38*, *68*, 69, *71*
Britton, James (1878–1936), 157
Brooklyn Museum of Art, 165–66
Brussels, La Libre Esthétique exhibition (1894), 14
Buffalo Bill (William Frederick Cody) (1846–1916), *12*, 14
Burroughs, Bryson (1869–1934), 152, 167

Café de la Nouvelle-Athènes, Paris, 13
Café des Arts (Café Volpini), Paris, 13, 23
Cassatt, Mary (1844–1926), 13
Cézanne, Paul (1839–1906), 13, 15, 120, 121, 152, 153–55, 159, 165, 166, 167, 169, 183, 184, 185–86
 Bowl, Glass, Knife, Apples, and Grapes, 183
 Peaches and Pears (fig. 76), *184*, 185, 186
 Still Life with Apples in a Compote (fig. 48), 120, *120*
Chadbourne, Emily Crane (1871–1964), 152, 156
Chappell, Frank V., 168
Chaudet, Georges, 117, 197
Coates, Dorothy, 157
Cologne, Sonderbund exhibition (1912), 153, 155
Cone, Claribel (1864–1929) and Etta (1870–1949), 158
Cooper, Douglas (1911–1984), 183, 187, 188, 190
Cortissoz, Royal (1869–1948), 162
Cox, Kenyon (1856–1919), 157
Cranach, Lucas the Elder (1472–1553), 5
 Venus Standing in a Landscape (fig. 13), 9, *9*
Cranach, Lucas the Younger (1515–1586), *Nymph of the Spring* (fig. 49), *123*
Cubists, 151, 155

Dadaists, 155
Dale, Chester (1883–1962), 165
Dasburg, Andrew (1887–1979), 152
Daubigny, Charles-François (1817–1878), 57
Daumier, Honoré (1808–1879), 57, 63
David, Gerard (ca. 1445–1523), *The Crucifixion* (fig. 4), *5*, 8
Davies, Arthur B. (1862–1928), 152, 153, 156, 157, 158, 164, 165, 167, 168, 170
Degas, Edgar (1834–1917), 13, 14, 57, 71, 95, 159, 160, 165, 168, 200, 204, 205
Delacroix, Eugène (1798–1863), 10
 Jacob Wrestling with the Angel (fig. 2), *4*, 5
Derain, André (1880–1954), 165, 166
De Zayas Gallery, New York, Gauguin exhibition (1920), 163–64, 170
Diderot, Denis (1713–1784), 78
Dreier, Katherine Sophie (1877–1952), 158
Druet, Eugène (1868–1916), 152, 155, 156, 157
 photograph of Gauguin's *Tahitian Women Bathing* (fig. 72), *181*, 182
Duchamp, Marcel (1887–1968), *Nude Descending a Staircase*, 155
Du Pont, Maxime Bopp (1890–1966), photograph by (fig. 42), *76*
Durand-Ruel, Paul (1831–1922), 13, 183. *See also* Galeries Durand-Ruel
Dürer, Albrecht (1471–1528), *Knight, Death, and the Devil*, 141

École des Beaux-Arts, Paris, 201
Egyptian, wall painting from the tomb of Nebamun, Thebes (fig. 46), *88*
Exposition Universelle (Paris, 1889), *12*, 13, 14, 23, 65, 77
 Café des Arts, 13, 23
Expressionists, 151

Fauves, 151
Favre, Antoine ("le Marsouin") (1847–1873), letter to (cat. no. 34), *54*, *55*, 55
Fayet, Gustave (1865–1925), 171, 212, 213
Field, Hamilton Easter (1873–1922), 160
Field, Richard, 177
Filiger, Charles (1863–1928), 65, 72
Fontainas, André (1865–1948), 22, 132, 146, 170
Forbes-Robertson, Eric (1865–1935), 43
Frankfurter, Alfred M. (1906–1965), 170
French Réunion des Musées Nationaux, 169
Fry, Roger (1866–1934), 153, 167
Fusainists, 201
Futurists, 155

Galerie Barbazanges, Paris, 163, 164
Galerie Barc de Boutteville, Paris, 14, 23
Galerie Vollard, Paris, 152, 155, 161
Galeries Durand-Ruel, Paris, 14, *26*, *27*, 152
Gauguin, Aline (daughter) (1877–1897), 78
Gauguin, Aline, née Chazal (mother) (1825–1867), 3, 36
Gauguin, Clovis (father) (1814–1849), 3
Gauguin, Clovis (son) (1879–1900), 32
Gauguin, Emil (son) (1874–1954/55), 16
 portrait of (cat. no. 1), *16*, 170, 173
Gauguin, Mette-Sophie, née Gad (wife) (1850–1920), 13, 14, 16, 20, 22, 24, 29, 30, 32, 36, 45, 47, 49, 52, 68, 77, 78, 104, 108, 139, 151, 153
Gauguin, Paul (1848–1903)
 artworks, photographs, and illustrations owned by, 9, 13, 15, 82, 88, 120, 121, 139, 141, 183, 192, 199
 as a businessman, 13, 212
 calling card of (cat no. 11), *26*
 as a ceramicist, 29, 37, 50, 110
 children of, 9, 13, 32, 45, 77, 140
 drawing practice, materials, and duplication techniques, 197–215
 as an editor and publisher, 79, 212, 213–14
 exhibitions, 13, 14, *26*, *27*, 152–58, *154*, 159, 160, 163–68, *167*, *169*, 169–71, *172*, 172–73, 177, 190
 Invitation to the opening of Gauguin's Exhibition at Galeries Durand-Ruel, Paris, on November 9, 1893 (cat. no. 12), *26*
 grave site, Atuona, Hiva Oa, Marquesas Islands, *138*

likenesses of
 Manzana Pissarro drawing (fig. 20), 27
 photographs, 12, 14, 24
 self-portraits: (cat. no. 10), 2, 25, 171; (fig.
 55), 140; (W 323), 164
in the merchant marine, 3, 13, 29
painting procedures and techniques, 177–79,
 181, 182, 183–85, 188, 189, 190–91,
 192–93, 194, 195, 198
as a printmaker, 14, 197, 212–15
as a "savage," 3, 45, 68, 71, 72, 75, 81, 85,
 135
travels and stays, 3, 14
 in Arles, 57, 59, 61, 62, 63, 77, 189
 in Atuona, Hiva Oa, 140, 141, 148
 in Brittany, 3, 14, 29–31, 42, 57, 65, 77,
 194
 in Copenhagen, 18, 19, 120
 in Hiva Oa, 135, 140, 141, 143, 148, 161
 in Le Pouldu, 9, 14, 24, 29, 39, 65, 67, 68,
 69, 70, 72, 73, 153
 in the Marquesas Islands, 3, 14, 31,
 139–41, 143, 148–49, 170
 in Martinique, 3, 45, 46, 47, 49, 52, 55, 77
 in Panama, 3, 45, 47
 in Paris, 9, 12, 13–15, 20, 22, 32, 36, 45,
 65, 104, 153
 in Peru, 3, 13, 29
 in Pont-Aven, 24, 29, 31, 33, 34, 57, 65,
 67, 71, 110, 151, 185
 in Provence, 3, 77
 in Quimperlé, 24, 60
 in Tahiti, 3, 8, 9–10, 16, 22, 24, 45, 53, 57,
 65, 77–79, 81, 83, 96, 98, 99, 100,
 101, 102, 104, 108, 110, 112, 116,
 117, 121, 122, 125, 126, 127, 128,
 132, 136, 139, 146, 151, 158, 171,
 175, 182, 187–88, 191, 194, 212
as a wood carver, 27, 29, 110, 188
works by
 Among the Mangoes (fig. 30), 48, 48, 200
 Arlésienne, L' (Mme Ginoux) (R 15) (in fig.
 67), 172
 Artist's Portfolio, Pont-Aven, The (cat. no.
 26), 42, 173, 207, 208, 217
 Auti Te Pape (The Fresh Water Is in Motion)
 (cat. no. 74), 101, 171
 Bathers (W 618) (fig. 60) (in figs. 59, 64),
 155, 154, 155, 156, 167, 167, 170
 Bathers (W 572) (in figs. 62, 64), 160, 165,
 167, 168, 169
 Bathers in Brittany (cat. no. 45), 71
 Be in Love and You Will Be Happy (G 76)
 (in fig. 67), 172
 Black Woman, The (cat. no. 33) (in fig. 67),
 53, 53, 172, 173
 Bonjour Monsieur Gauguin (W 321), 164,
 165
 Breton Girls Dancing, Pont-Aven (W 251)
 (fig. 24), 30
 Breton Women by a Fence (cat. no. 20), 37
 Caribbean Woman (W 330) (fig. 63) (in fig.
 64), 160, 164, 164, 167, 167
 Carnet de Tahiti, two drawings in, 193–94
 Coco de Mer (cat. no. 111), 144
 Crouching Nude Woman, Seen from the
 Back (cat. no. 115), 147, 173, 211
 Day of God, The (Mahana Atua) (cat. no.
 90), 113, 165, 168

Day of the Evil Spirit (Mahna No Varua
 Ino) (cat. no. 78), 104, 171
Day of the God (Mahana No Atua) (fig. 47),
 114
Delightful Land (Nave Nave Fenua) (paint-
 ing) (W 454) (fig. 12), 9; reworked
 study for (figs. 71a,b), 180, 180, 181
Delightful Land (Nave Nave Fenua) (wood-
 cut) (cat. no. 80), 106, 139
Delightful Land (Nave Nave Fenua) (wood-
 cut) (cat. no. 81), 107, 139, 171
Delightful Land (Nave Nave Fenua) (wood-
 cut) (cat. no. 82), 107, 139, 171
Design for a Fan: Breton Shepherd Boy
 (cat. no. 15), 33, 197
Dessins lithographiques (Volpini Suite),
 156, 157, 168, 204. See also cat.
 nos. 17, 20, 23, 25, 27, 30, 36, 37,
 39, 40, 42, 45
Drama of the Sea, The (cat. no. 40), 66
Drama of the Sea, Brittany, The (cat. no.
 42), 68
Emil Gauguin (Born 1874), the Artist's Son,
 as a Child (cat no. 1), 16, 170, 173
Eve (cat. no. 101), 127, 214
Fa Iheihe (Tahitian Pastoral) (W 569) (in
 fig. 59), 154, 156
Fan Design with Motifs from Ta Matete
 (The Market) (cat. no. 60), 88, 206
Fare (cat. no. 50), 80
Farm in Britanny, A (cat. no. 18) (in fig.
 64), 35, 166, 167, 167–68
Flowers in a Basket (W 182) (in fig. 67),
 172
Follies of Love (R 24) (in fig. 67), 172
Four Breton Women, 204
Four Seated Tahitian Women (fig. 94), 214,
 215
Four Seated Tahitian Women, from Noa
 Noa (fig. 95), 215, 215
Fragrance (Noa Noa) (small block wood-
 cut) (cat. no. 83), 108, 171
Fragrance (Noa Noa) (woodblock) (cat. no.
 71), 98
Fragrance (Noa Noa) (woodcut and stencil)
 (cat. no. 72), 99
Fragrance (Noa Noa) series (woodcuts),
 14, 23, 165, 168, 203. See also cat.
 nos. 65, 69, 71, 72, 74–82, 89
Fresh Water Is in Motion, The (Auti Te
 Pape) (cat. no. 74), 101, 171
Girl with a Fox (cat. no. 44; fig. 86), 70,
 200, 200, 202, 206
God, The (Te Atua) (cat. no. 69), 96
Grape Harvest at Arles, The (Human
 Misery) (fig. 34), 58
Grasshoppers and the Ants: A Souvenir of
 Martinique, The (cat. no. 27), 46, 158
Hail Mary (Ia Orana Maria) (drawing) (cat.
 no. 57; fig. 87), 85, 85, 166, 173,
 200, 202, 203, 203, 204, 205–6
Hail Mary (Ia Orana Maria) (lithograph)
 (cat. no. 56), 84
Hail Mary (Ia Orana Maria) (painting)
 (cat. no. 55; fig. 5) (in fig. 64), 6, 6,
 8, 83, 84, 160, 165, 166, 167, 168,
 170, 189, 193, 195
Head of a Breton Boy (cat. no. 14), 32
"Head of a Man," 160

Head of a Tahitian (in fig. 59; fig. 85a),
 154, 156, 193, 194
Head of a Tahitian Woman (recto) (cat. no.
 93a), 117
Head with Horns (cat. no. 108; fig. 51),
 134, 135
Hibiscus Tree (Te Burao) (W 486) (in fig.
 64), 167, 168, 189
Hina's Head and Two Vivo Players (cat. no.
 86), 111, 171
Hina Tefatou (The Moon and the Earth)
 (cat. no. 70) (in fig. 64), 97, 97, 160,
 166, 167, 168, 169, 170
House for Eating (Te Fare Amu) (cat. no.
 112), 145
Human Misery (lithograph) (cat. no. 36), 59
Human Misery (woodcut) (cat. no. 35), 58
Ia Orana Maria (Hail Mary) (drawing) (cat.
 no. 57; fig. 87), 85, 85, 166, 173,
 200, 202, 203, 203, 204, 205–6
Ia Orana Maria (Hail Mary) (lithograph)
 (cat. no. 56), 84
Ia Orana Maria (Hail Mary) (painting)
 (cat. no. 55; fig. 5) (in figs. 62, 64),
 6, 6, 8, 83, 83, 84, 160, 160, 165,
 166, 167, 168, 170, 189, 193, 195
Idol with a Shell, 139
Illustrated Letter to an Unknown Collector
 (cat. no. 91), 114, 115, 182
In the Vanilla Grove, Man and Horse (cat.
 no. 53) (in figs. 64, 65), 81, 167,
 168, 171
Jacob Meyer de Haan (cat. no. 46), 72, 209,
 210, 211
Joys of Brittany, The (cat. no. 17), 35, 158
Jugs in "Chaplet" Stoneware (cat. no. 24),
 40, 173, 206–7
Kelp Gatherers (W 392) (figs. 89, 90), 164,
 207–9, 208, 209
Landscape with Figures (W 480), 192–93
("Leda") Design for a Plate: Shame on
 Those Who Evil Think (first edition)
 (cat. no. 25), 41, 168
("Leda") Design for a Plate: Shame on
 Those Who Evil Think (proof impres-
 sion) (cat. no. 23), 40, 157, 168
Little Tahitian Trinkets (cat. no. 63; fig. 88),
 91, 181, 200, 205, 205, 209, 210,
 211, 216
Loss of Virginity, The (W 412) (in fig. 67),
 85, 172, 200
Love and You Will Be Happy (cat. no. 98), 124
Luxury (Rupe Rupe) (W 585) (fig. 50), 132
Mahana Atua (The Day of God) (cat. no. 90),
 113, 165, 168
Mahana No Atua (W 513) (Day of the God)
 (fig. 47), 114
Mahna No Varua Ino (Day of the Evil
 Spirit) (cat. no. 78), 104, 171
Manao Tupapau (Spirit of the Dead
 Watching) (lithograph) (cat. no. 66),
 93, 93
Manao Tupapau (Spirit of the Dead
 Watching) (painting) (cat. no. 64;
 fig. 7) (in fig. 65), 7, 8, 92, 92, 93,
 169, 169
Manao Tupapau (Spirit of the Dead
 Watching) (woodcut) (cat. no. 89),
 113, 171

242

Marquesan Landscape with a Horse (cat. no. 114), *146*

Martinique Women with Mangoes (cat. no. 29), *49*, 200

Maternity (W 582) (in figs. 62, 64), *160*, 166, *167*, 168

Meal (Bananas) (W 427), 177

Moon and the Earth, The (Hina Tefatou) (cat. no. 70) (in fig. 64), 97, *97*, 160, 166, *167*, 168, 169, 170

Morning (Te Poipoi) (cat. no. 73; fig. 10), *8*, *100*

Mysterious Water (Pape Moe) relief ensemble. *See* cat. nos. 85–87

Nafea Faaipoipo (When Will You Marry?) (W 454), 180, 181

Nave Nave Fenua (Delightful Land) (painting) (fig. 12), *9*; reworked study for (figs. 71a,b), 180, *180*, 181

Nave Nave Fenua (Delightful Land) (woodcut) (cat. no. 80), *106*, 139

Nave Nave Fenua (Delightful Land) (woodcut) (cat. no. 81), *107*, 139, 171

Nave Nave Fenua (Delightful Land) (woodcut) (cat. no. 82), *107*, 139, 171

Night, The (Te Po) (cat. no. 65), *93*, 171

Nirvana: Portrait of Meyer de Haan (W 320) (in fig. 67), *172*

Noa Noa (Fragrance) (small block woodcut) (cat. no. 83), *108*, 171

Noa Noa (Fragrance) (woodblock) (cat. no. 71), *98*

Noa Noa (Fragrance) (woodcut and stencil) (cat. no. 72), *99*

Noa Noa (Fragrance) series (woodcuts), 14, 23, 165, 168, 203. *See also* cat. nos. 65, 69, 71, 72, 74–82, 89

Old Women of Arles (lithograph) (cat. no. 39), *63*

Old Women of Arles (painting) (fig. 35), *62*

Olympia, after Manet (W 413) (fig. 8), *7*, 8

Oviri (Savage) (bronze cast on Gauguin's grave), 9, *138*, 141

Oviri (Savage) (stoneware) (fig. 14), 9, *10*, 116

Oviri (Savage) (watercolor monotype) (cat. no. 92), *116*, 210

Pape Moe (in fig. 59), *154*

Pape Moe (Mysterious Water) relief ensemble. *See* cat. nos. 85–87

Parau Na Te Varua Ino (Words of the Devil) (W 458) (fig. 61) (in fig. 59), *154*, *156*, 156–57; reworked study for, 180, 199

Parau Parau (Whispered Words) (W 472) (fig. 83), *192*, 192–93

Pastoral Scene in Martinique (Pastorales Martinique) (cat. no. 30), *50*, 158

Peasant Woman and Cows in a Landscape (cat. no. 43) (in fig. 67), *69*, 164, *172*, 207–9, 211

Polynesian Beauty and Evil Spirit (recto; transferred drawing) (cat. no. 109a; fig. 92), *136*, 171, 212–13, *213*, 215

Polynesian Beauty and Evil Spirit (verso; drawing) (cat. no. 109b), *137*, 171, 212

Portrait of Annette Belfils (cat. no. 7), *21*, 202, 203, 206, 216

Portrait of a Seated Man (cat. no. 5) (in fig. 67), *19*, *172*

Portrait of a Woman (cat. no. 2), *17*

Portrait of a Woman, with Still Life by Cézanne (W 387) (in fig. 67), *172*, 183

Portrait of Louis Roy (cat. no. 9), *23*

Portrait of Meyer de Haan (W 317), 164

Portrait of Stéphane Mallarmé (cat. no. 8), *22*

Profile of a Tupapau (Spirit), The (cat. no. 85), *110*, 171

Queen of Beauty, The (Te Arii Vahine) (painting) (W 542), 122, 211

Queen of Beauty, The (Te Arii Vahine) (watercolor) (cat. no. 96), *122*, 200, 209, 211

Queen of Beauty—Tired, The (Te Arii Vahine—Opoi) (cat. no. 97), *122*

Reclining Tahitian (cat. no. 88), *112*

Reverie (W 424), 169

Rupe Rupe (Luxury) (fig. 50), *132*

Savage (Oviri) (bronze cast on Gauguin's grave), 9, *138*, 141

Savage (Oviri) (stoneware) (fig. 14), 9, *10*, 116

Savage (Oviri) (watercolor monotype) (cat. no. 92), *116*, 210

Scene of Worship with Hina's Head in Profile (cat. no. 87), *111*, 171

Schuffenecker Family (W 313), 156

Seed of Areoi, The (Te Aa No Areois) (cat. no. 61), *89*, 170

Self-Portrait (fig. 55), *140*

Self-Portrait with Halo (W 323), 164

Self-Portrait with Palette (cat. no. 10), *2*, *25*, 171

Siesta, The (cat. no. 68), *95*, 173, 189

Skaters at Frederiksburg Park (W 148) (in fig. 67), *172*

Smile: Tahiti, The (cat. no. 103), *129*

sourire, Le (The smile), 213–14

Soyez Mystérieuses (wooden relief), 206

Spinner, The (Joan of Arc) (fig. 40), *74*

Spirit of the Dead Watching (Manao Tupapau) (lithograph) (cat. no. 66), *93*, *93*

Spirit of the Dead Watching (Manao Tupapau) (painting) (cat. no. 64; fig. 7) (in fig. 65), *7*, 8, 92, *92*, 93, 169, *169*

Spirit of the Dead Watching (Manao Tupapau) (woodcut) (cat. no. 89), *113*, 171

Statuette of a Martinique Woman (cat. no. 32), *52*, 164

Still Life "Ripipoint" (W 376), 164

Still Life with Apples (fig. 78), *186*, *186*

Still Life with Apples (gouache) (in fig. 67), *172*

Still Life with Japanese Print (W 375) (in fig. 59), *154*, 155–56

Still Life with Onions, Beetroot, and a Japanese Print (cat. no. 47), *73*

Still Life with Teapot and Fruit (cat. no. 95; fig. 74), *121*, 173, 183–84, *184*, 185

Still Life with Three Puppies (cat. no. 16) (in fig. 67), *34*, *172*

Study of Two Tahitian Women (verso) (cat. no. 93b), *118*

Sunflowers (W 602) (in fig. 57), *152*

Tahiti (Change of Residence) (cat. no. 54), *82*, 214

Tahitian Carrying Bananas (cat. no. 102), *128*

Tahitian Child (in fig. 59), *154*

Tahitian Faces (Frontal Views and Profiles) (cat. no. 104), *130*, 200, 202, 203, 205–6, 217

Tahitian Girl in a Pink Pareu (cat. no. 67), *94*, 171, 210

Tahitian Pastoral (Fa Iheihe) (W 569) (in fig. 59), *154*, 156

Tahitian Woman (cat. no. 84), *109*, 166, 204, 206

Tahitian Woman with a Flower in Her Hair, A (cat. no. 58), *86*, 170, 173, 200, 204–5, 217

Tahitian Women Bathing (cat. no. 62; figs. 68–70, 72), *90*, 173, 175–82, *176*, *178*, *179*, *181*, 191, 193, 211

Ta Matete (fan) (cat. no. 60), *88*, 206

Taoa (cat. no. 49), *80*

Te Aa No Areois (The Seed of Areoi) (cat. no. 61), *89*, 170

Te Arii Vahine (The Queen of Beauty) (painting) (W 542), 122, 211

Te Arii Vahine (The Queen of Beauty) (watercolor) (cat. no. 96), *122*, 200, 209, 211

Te Arii Vahine—Opoi (The Queen of Beauty—Tired) (cat. no. 97), *122*

Te Atua (The God) (cat. no. 69), *96*

Te Burao (Hibiscus Tree) (W 486) (in fig. 64), *167*, 168, 189

Te Fare Amu (House for Eating) (cat. no. 112), *145*

Te Faruru (To Make Love) (cat. no. 79), *105*, 171

Te Po (The Night) (cat. no. 65), *93*, 171

Te Poipoi (Morning) (cat. no. 73; fig. 10), *8*, *100*

Te Raau Rahi (W 439) (in fig. 66), *171*

Tetua (cat. no. 52), *80*

Three Polynesians and a Peacock (cat. no. 113), *145*

Three Tahitian Women (cat. no. 94), 114, *119*, 173

To Make Love (Te Faruru) (cat. no. 79), *105*, 171

Tomatoes and a Pewter Tankard on a Table (cat. no. 4), *18*

Two Standing Figures (verso of *Head of a Tahitian*) (fig. 85b), 193, *193*, 194

Two Tahitian Women (cat. no. 105) (in fig. 66), *131*, 171, *171*, 189

Two Tahitian Women in a Landscape (in fig. 59), *154*

Two Tahitian Women with Flowers and Fruit (cat. no. 106; fig. 91), *133*, 207, 210, *211*, 216

Two Women (cat no. 110), *143*, 171, 173

Under the Palm Trees (W 444) (in fig. 59), *154*, 156

Universe Is Created, The (woodblock) (cat. no. 75), *102*

Universe Is Created, The (woodcut) (cat. no. 76), *103*, 171

Universe Is Created, The (woodcut, second state) (cat. no. 77), *103*

Vase of Peonies II (WI 146) (fig. 77), 185, *185*

Vessel Decorated with Goats and Girls from Martinique (cat. no. 31), *51*

Vessel in the Form of the Head of a Breton Girl (cat. no. 19), *36*

Vessel in the Shape of a Grotesque Head (cat. no. 6), *20*

View of Pont-Aven near Lézavan (W 370), 164

Vision after the Sermon, The (Jacob Wrestling with the Angel) (W 245) (fig. 1), *4*, 5–6, 10, 29

Volpini Suite: *Dessins lithographiques*, 156, 157, 168, 204. *See also* cat. nos. 17, 20, 23, 25, 27, 30, 36, 37, 39, 40, 42, 45

Walking Stick with a Female Nude and a Breton Sabot on the Handle (cat. no. 13) (in fig. 67), 14, *27*, 170, *172*, 173

Washerwomen (cat. no. 37), *60*

Washerwomen at the Roubine du Roi, Arles (cat. no. 38), *61*, 170, 171, 173

Wave, The (cat. no. 41), *67*

Wayside Shrine in Brittany (cat. no. 21), *38*

When Will You Marry? (Nafea Faaipoipo) (W 454), 180, 181

Where Do We Come From? What Are We? Where Are We Going? (W 561), 10, 78, 171

Whispered Words (Parau Parau) (W 472) (fig. 83), *192*, 192–93

Woman Sewing (W 358), 85

Woman Sewing and Other Figure Studies, A (cat. no. 3), *17*, 202

Woman with a Shawl (cat. no. 51), *80*

Woman with Figs (cat. no. 48), *75*

Women, Animals, and Foliage (cat. no. 100), *126*

Women in the Mango Grove, Martinique (cat. no. 28), *47*

Woodcut with a Horned Head (cat. no. 107), *134*

Wooden Shoes (G 81) (in fig. 67), *172*

Words of the Devil (Parau Na Te Varua Ino) (painting) (W 458) (fig. 61) (in fig. 59), *154*, 156, 156–57; reworked study for, 180, 199

Yellow Christ, The (cat. no. 22; fig. 3), *5*, 6, 8, *39*, 170, 171

Young Man with a Flower (cat. no. 59) (in fig. 64), *87*, *167*, 168, 170

writings and publications, 14, 165, 198

ancien culte mahorie, L', 14, 78, 89, *97*

"Cahier pour Aline," 93, 127

esprit moderne et le catholicisme, L' (Modern thought and Catholicism), 140

guêpes, Les (The wasps), 79, 212

Letter to Antoine Favre ("le Marsouin") (cat. no. 34), *54*, *55*

Letter to Daniel de Monfreid, from Papeete, Tahiti, November 1898 (cat. no. 99), *125*

Letter to M. Brault from Atuona, Hiva Oa, Marquesas Islands (cat. no. 116), 148–49, *148*, *149*

"lettre de Paul Gauguin à propos de Sèvres et du dernier four, Une" 37

Memoirs, published as *Avant et après* (Before and after), 27, 33, 36, 62, 85, 90, 95, 130, 140, 141, 142, 144, 145, 207, 210

Noa Noa, 14, 78, 81, 86, 92, 94, 98, 99, 100, 101, 112, 128, *134*, 156, *214*, 215, *215*; "Diverse choses," 88, 119, 129

"Notes sur l'art à l'Exposition Universelle," 37, 50

"Notes Synthétiques," 17

Racontars de Rapin (A dauber's gossip), 140

sourire, Le (The smile), 79, *129*, 185, 212, 213–14

"Sous deux latitudes," 102

Gauguin, Paul, attributed to, *Tahitian Landscape* (cat. no. 119; figs. 81, 82), 171, 173, 175, 190–94, *190*, *191*

Gauguin, Paul, style of, *Still Life* (cat. no. 117; figs. 73, 75), 175, 183–86, *184*

Gauguin, Pola (son), 168

Genauer, Emily (b. 1910), 172

Gershwin, George (1898–1937), 170

Ginoux, Mme, as *L'Arlésienne* (R 15) (in fig. 67), *172*

Gloanec, Marie-Jeanne (1839–1915), 42, 43

Gogh, Theo van (1857–1891), 13, 48, 57, 60, 65

Gogh, Vincent van (1853–1890), 15, 33, 39, 45, 48, 57, 62, 63, 69, 72, 77, 153, 155, 159, 160, 161, 165, 166, 167, 169, 189, 198, 202, 206, 207, 209, 210

portraits by (in fig. 65), *169*

Goodfriend, Meyer, 164, 165

Goodyear, A[nson] Conger (1877–1964), 165, 169–70

Goupil, Auguste (1847–1921), 78

Goya, Francisco (1746–1828), 168

Grafton Galleries, London, *Manet and the Post-Impressionists* (1910–11), 152–53, 167

Groot, Adelaide Milton de (1876–1967), 170, 173, 183

Groupe Impressioniste et Synthétiste, 23

Guggenheim, Harry F. (1890–1971), 173

Guggenheim Museum, New York, 168

Hammer, Armand (1897–1990), 165

Harriman, E. H. (1848–1909), 157

Harriman, Marie (1903–1970), Gallery, New York, 171

Harriman, W. Averill (1891–1986), 157

Haviland, Paul (1880–1950), 158

Henry, Marie (1859–1940), 14, 65, 159, 160, 163, 164

inn of. *See* Buvette de la Plage

Hirschland, Dr. and Mrs. F. H., 170

Hiva Oa, Marquesas Islands, *138*, 139–41

Hôtel Drouot, Paris, auction, 14

Huneker, James Gibbons (1860–1921), 155, 157

Promenades of an Impressionist, 152

Huret, Jules, "Paul Gauguin devant ses tableaux," 3, 75

Huysmans, Joris-Karl (1848–1907), 102

Impressionists, 4, 13, 23, 29, 95, 121, 153, 165, 166, 191, 197, 199, 206

Ingres, Jean Auguste-Dominique (1780–1867), 57

Ipona, Puamau, Hiva Oa, Marquesas Islands, *138*

Ivins, William M. Jr. (1881–1961), 168–69

Jénot, Paulin (active by 1886, died after 1930), 182, 187–88, 189

Jénot, Paulin, attributed to
Captain Swaton (cat. no. 118; fig. 79), 175, *187*, 187–89
Young Creole Girl (W 417) (fig. 80), *187*, 189

Jénot, Paulin, son of, 187, 188, 189

John, Augustus (1878–1961), 155

Kann, Alphonse (1870–1948), 177

Kelekian, Dikran K. (1868–1951), 166, 168

Keppel, Frederick, and Co., New York, 159, 168, 171

Knoedler, M., and Co., New York, 159, 160

Kuhn, Walt (1880–1949), 153–55, 156

Lacombe, Georges (1868–1916), *12*

La Rochefoucauld, Comte Antoine de (1862–1960), 85

Larrivel, *12*

Lasker, Loula D. (1888–1961), 173

La Tour, Maurice Quentin de (1704–1788), 204

Laval, Charles (1861–1894), 29, 45, 55

Le Carbet, Martinique, 45

Lefranc et Cie, 188

Lehman, Robert (1891–1969), 173, 177

Lemasson, Henri (1870–1956), photograph by (fig. 43), *76*. *See also* Agostini, Jules, or Henri Lemasson

Le Pouldu, 29, 31, *64*, 65, 68
Marie Henry's inn, *64*, 65

Lewisohn, Adolph (1849–1938), 158, 159, 160, 165, 168, 169, 170

Lewisohn, Sam A. (1884–1951), 160

Libri, Girolamao dai (1474–1555), *Madonna and Child with Saints* (fig. 6), *6*, 8

Loiseau, Gustave (1865–1935), 185–86

London Missionary Society, 77

Loti, Pierre. *See* Viand, Julien

McBride, Henry (1867–1962), 161

Mallarmé, Stéphane (1842–1898), 15, 22
portrait of (cat. no. 8), *22*

Manet, Édouard (1832–1883), 13, 199, 152
Olympia, 8; Gauguin's painting after (fig. 8), *7*, 8

Manzi, Michel (1849–1915), 159, 160

Marquesas Islands, 3, *138*, 139–41

Martinique, *44*, 45, 46, *46*, 47, *47*, 49, *49*, *50*, *51*, 52

Matisse, Henri (1869–1954), 152, 166, 168, 177

Mauclair, Camille (1872–1945), *French Impressionists*, 152

Maugham, W. Somerset (1874–1965), *Moon and Sixpence*, 161–62, 163

Maury, 36

May, Joseph M. (d. 1948), 170, 173

Meier-Graefe, Julius (1867–1935), *Modern Art*, 152

Meltzer, Charlotte, *Loverene*, 157

Melville, Herman (1819–1891), 78, 139
Typee, 139

Metropolitan Museum of Art, New York, 152, 153, 165, 171, 175–95
Gauguin acquisitions, donations, exhibitions, and bequests, 160, 165, 166, 168–69, 171, 173, 177, 183, 191
Gauguin exhibition (1959), 172, *172*, 173, 177, 190
Impressionist and Post-Impressionist Paintings (1921), 165, 166–68, *167*

Meyer, Agnes Ernst (1887–1970), 158, 167
Meyer, Eugene (1875–1959), 158
Meyer de Haan, Jacob (1852–1895), 65, 72, 77, 183, 185–86
 portraits of: (cat. no. 46), *72*, 209, 210, 211; (W 317), 164; (W 320), *172*
Millet, Jean-François (1814–1875), 33, 201
Modern Gallery, New York, 159
Moerenhout, Jacques-Antoine (1796–1879), *Voyages aux îles du Grand Océan*, 78, 97
Monet, Claude (1840–1926), 152
Monfreid, Georges Daniel de (1856–1929), 21, 24, 53, 83, 110, 116, 122, 140–41, 151, 158, 161, 162, 182, 195, 197, 212
 letter to, November 1898 (cat. no. 99), 125, *125*
Morice, Charles (1861–1919), 135, 141, 162
Mt. Temetiu, Atuona, Hiva Oa, Marquesas Islands, *138*
Museum of Fine Arts, Boston, 171
Museum of French Art, New York, 165
Museum of Modern Art, New York, 168, 169, 170
 Cézanne, Gauguin, Seurat, Van Gogh (1929), 167, 169, *169*

Neo-Impressionists, 4, 29, 85, 164, 206
Neurdein Frères, photograph by (fig. 17), *12*
Nolet, Dr., 114

O'Brien, Frederick (1869–1932), 161–62
O'Conor, Roderic (1860–1940), 43, 185–86
Orau, 78
Osborn, William Church (1862–1951), 170–71

Pach, Walter (1883–1958), 152, 153, 157, 158
 photograph by (fig. 58), *154*
Paley, William S. (1901–1990), 170, 173
Panana Canal, 45
Papeete, Tahiti, *76*, 78
Pellew, Anna, 168
Péron, François, and Louis de Freyeinet, *Voyages de découvertes aux Terres Australes...*, lithograph from, *Mother Carrying a Child on Her Shoulder, New Zealand* (fig. 45), *84*
Peru, 3, 13, 29, 45, 71, 139
Peru (Moche), *Portrait-Head Bottle* (fig. 25), *36*
Picasso, Pablo (1881–1973), 166
 Demoiselles d'Avignon, 8
Pissarro, Camille (1830–1903), 3, 13, 33, 29, 120, 179, 197, 205, 208
Pissarro, Manzana (1871–1961), *Gauguin with a Cape and Walking Stick Attending His Exhibition at Galeries Durand-Ruel* (fig. 20), 14, *27*
Poe, Edgar Allan (1809–1849), 86
 The Raven, 22
Pont-Aven, 6, *28*, 29–31, *30*, 65
 Trémalo Chapel, *Crucifixion* (fig. 26), 6, *38*
Pont-Aven artists, 29, 57, 151, 185–86, 202, 208

Post-Impressionists, 153, 165, 166, 167, 172, 208
Puvis de Chavannes, Pierre-Cécile (1824–1898), 63, 200

Quinn, John (1870–1924), 155, 156, 157, 158, 160, 164, 165, 167, 170

Raphael (1483–1520), 5, 57
Redon, Odilon (1840–1916), 15, 65, 77, 102, 165, 202
Rembrandt van Rijn (1606–1669), 5
Renoir, Pierre-Auguste (1841–1919), 13
Rewald, John (1912–1994), 183
Richardson, John (b. 1924), 177
Rodin, Auguste (1840–1917), 165
Rosenberg, Paul (d. 1959), 170
Rousseau, Jean-Jacques (1712–1778), 78
Rousseau, Théodore (1812–1867), 57
Roy, Louis (1862–1907), 23
 Noa Noa prints, 23. *See also* cat. nos. 69, 72, 77
 portrait of (cat. no. 9), *23*
Rubens, Peter Paul (1577–1640), workshop of, *Susanna and the Elders* (fig. 11), 8, *8*
Rumsey, Charles C. (1879–1922), 157
Rumsey, Mrs. Charles C. (née Mary Harriman) (1881–1934), 157, 158
Russell, Morgan (1886–1953), 152

Sadahide (1807–1873), *The Seaweed Gatherer* (fig. 39), *66*
Saint-Pierre, Martinique, *44*, 45
Schnedklud, Fritz, *12*
Schuffenecker, Amédée (1854–1936), 183, 186
Schuffenecker, Claude-Émile (1851–1934), 10, 13, 18, 19, 24, 29, 31, 34, 45, 46, 57, 60, 65, 67, 71, 77, 110, 120, 183, 186
Seguin, Armand (1869–1903), 43
Sérusier, Paul (1864–1927), *12*, 65, 81, 96, 183, 185–86
 Talisman, 29
Sérusier, Paul, attributed to, "Breton Dancers," 164
Seurat, Georges (1859–1891), 29, 33, 167, 169, 198, 208
 Models, 156–57
Sixty-ninth Regiment Armory. *See* Armory Show
Slewinski, Wladislaw (1856–1918), 185–86
Société Nationale des Beaux Arts, Paris, 14
Spingarn, Arthur (1878–1971), 157, 158
Spitz, Charles (1857–1894), 192
 photograph probably by, *Tahitian Landscape* (fig. 84), 192, *193*
Stein, Gertrude (1874–1946), 151–52
Stein, Leo (1872–1947), 151–52, *152*, 158
Stern, Mr. and Mrs. Henry Root, 173
Stevenson, Robert Louis (1850–1894), 78, 139
Stieglitz, Alfred (1864–1946), 153, 159, 166
Stone, Irving (1903–1989), *Lust for Life*, 161
Stransky, Josef (1872–1936), 158, 168, 169, 170

Strauss, W. C., 156
Studio of the South, 57
Studio of the Tropics, 45, 57, 77
Swaton, Captain, 187, *187*, 188
 portrait of (cat. no. 118; fig. 79), 175, *187*, 187–89
Symbolists, 4, 15, 202, 207
Synthetists, 13, 23

Tahiti, 6, 9, 45, 65, *76*, 77–79, *82*, 85, 99, 102, 108, 119, 128, *190*, *193*
Tardieu, Eugène, 34, 99, 107
Tathagata Meets an Ajiwaka Monk on the Benares Road, The (relief from the Temple of Borobudur, Java) (fig. 44), 82, *82*
Teha'amana, 8
Têtes de Bois, 15
Teuraheimata à Potoru, 188
Thannhauser, Justin K. (1892–1965), 168
Thaw, Mr. and Mrs. Eugene V., 173
Tison, Mrs. Alexander (née Annie H. Stevens), 156
Titian (1488 or 1490–1576) and workshop, *Venus and the Lute Player* (fig. 9), 7, 8
Trémalo Chapel, Pont-Aven, *Crucifixion* (fig. 26), 6, *38*
Tristan, Flora (1803–1844), 3
Tucker, Allen (1866–1939), 157
291 gallery, New York, 153, 159, 166

Vaeohoa, 140
Velázquez, Diego (1465–1524), 5
Verkade, Jan (1868–1946), 183
Viaud, Julien (Pierre Loti) (1850–1923), 78
 Le mariage de Loti, 78
Vollard, Ambroise (1868–1939), 4, 14, 79, 117, 121, 126, 136, 152, 155, 157, 158, 159, 161, 168, 177, 182, 197, 201, 207, 209, 210, 212
Volpini (active late 1880s), 13. *See also* Café des Arts
Vuillard, Édouard (1868–1940), 29

Whitney, Gertrude (née Vanderbilt) (1875–1942), 167
Wildenstein, Georges (1892–1963), 190
Wildenstein Galleries, New York, 171, 172
 Gauguin retrospective (1936), 170–71, *171*
Winterbotham, Joseph (1854–1925), 168
Worcester Art Museum, 168

"Yellow House," Arles, *56*, 57

Zayas, Marius de (1880–1961), 159, 163, 164, 165, 168. *See also* De Zayas Gallery
Ziem, Félix (1821–1911), 57
Zizi (Isidore Gauguin, Gauguin's uncle) (ca. 1818–1893), 15

PHOTOGRAPH CREDITS

Photographs were in most cases provided by the owners of the works and are reproduced by their permission; their courtesy is gratefully acknowledged.

New photography of works in the Metropolitan Museum collection by Mark Morisse, the Photograph Studio, The Metropolitan Museum of Art

Additional credits appear under some illustrations and in the following list.

The Art Institute of Chicago, All Rights Reserved: fig. 35

© The Art Institute of Chicago, All Rights Reserved: figs. 47, 85a, 85b

Photograph reproduced with the permission of the Barnes Foundation, © 2002. All Rights Reserved: fig. 76

Bibliothèque du Musée de L'Homme, touts doits reservés. Photograph by Elizabeth Childs from *Autour du monde*, Paris, 1895: fig. 84

Cliché Bibliothèque Nationale de France, Paris: fig. 72

Gerard Biot, Réunion des Musées Nationaux / Art Resource, NY: fig. 95

C. Chesek: fig. 54

From Chicago-Amsterdam 2001–2: figs. 31, 33

Photograph by Erwin Christian from Guy Dening. *The Marquesas*, 1982: p. 54

Keith Evans: fig. 52

IRR computer assembly by Alison Gilchrist: figs. 69, 70

David Heald, © The Solomon R. Guggenheim Foundation, New York: cat. no. 53

Colta Ives: figs. 38, 53

Daniel Le Nevé, copyright Réunion des Musées Nationaux / Art Resource, NY

From *Lewisohn* 1939, p. 69: fig. 62

© Sotheby's, Inc.: fig. 89

Bruce M. White: cat. nos. 32, 112

Reproduced by courtesy of the Wildenstein Foundation; copyright Réunion des Musées Nationaux / Art Resource, NY: fig 77

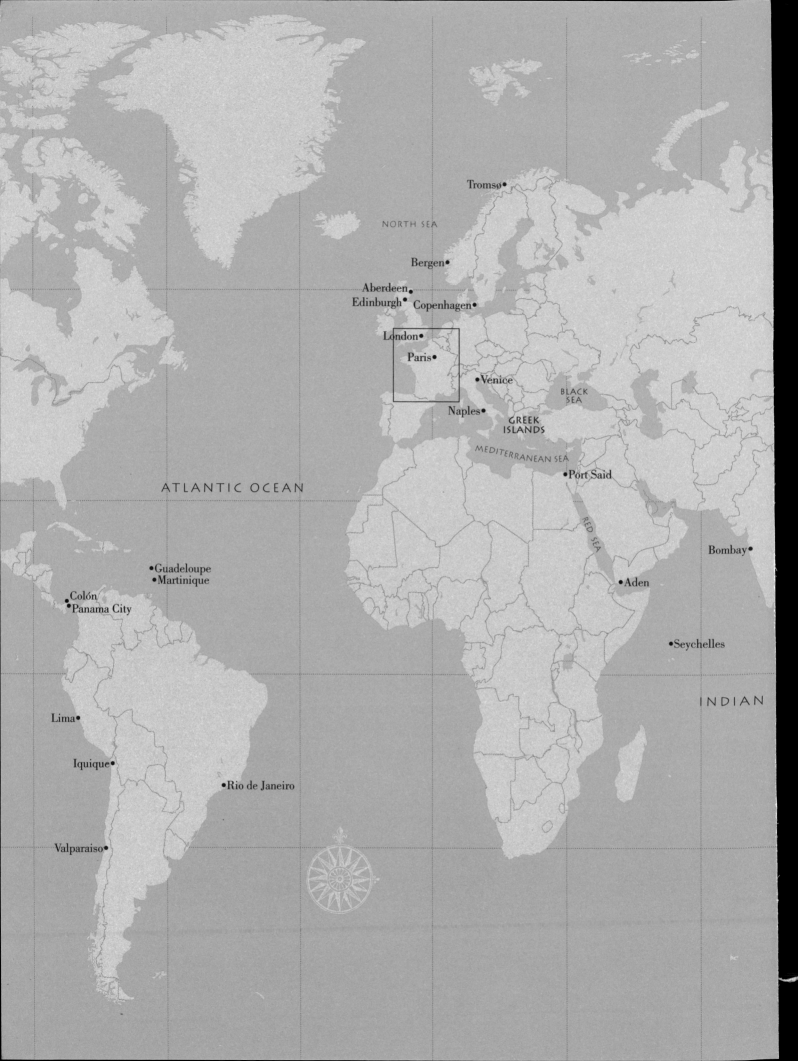